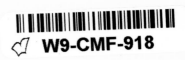

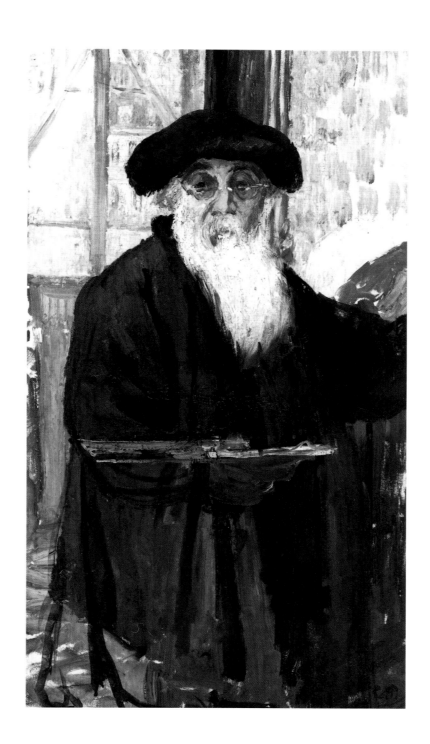

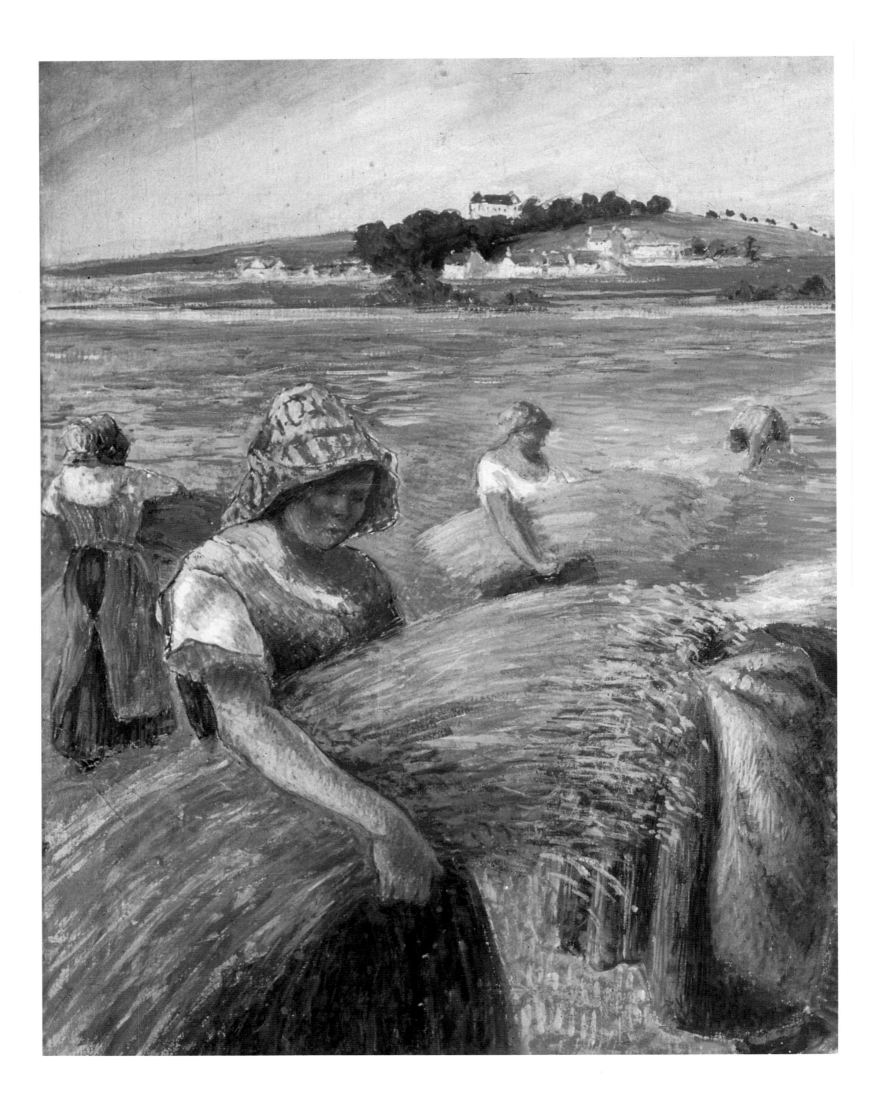

JOACHIM PISSARRO

Camille Pissarro

HARRY N. ABRAMS, INC., PUBLISHERS

For my mother

And to the memory of Ludovic-Rodo

and Paulémile

Note on Titles
Titles are given in French or English, according to the wishes of the
owners. Where no preference was indicated, English has been used.

A map of Pissarro's France appears on page 310

Half title: Fig. 339. *Portrait of C. Pissarro Painting.* c. 1900. See page 284

Facing the title page: Fig. 224. *The Harvest* (detail). 1882. See page 193

Editor: *Phyllis Freeman*
Designer: *Maria Miller*
Photo Research: *Catherine Ruello*

Library of Congress Cataloging-in-Publication Data

Pissarro, Joachim.
 Camille Pissarro / by Joachim Pissarro.
 p. 312 cm.
 Includes bibliographical references and index.
 ISBN 0-8109-3724-7
 1. Pissarro, Camille, 1830–1903—Criticism and interpretation.
 I. Title.
 ND553.P55P488 1993
 759.4—dc20 93–12280
 CIP

Published in 1993 by Harry N. Abrams, Incorporated, New York
A Times Mirror Company

Printed and bound in Italy

Contents

INTRODUCTION ——————————— 7

ONE ——————————— 18

Beginnings 1830–55:
Saint Thomas, Caracas, Saint Thomas

TWO ——————————— 38

The Early Works in France: 1855-69

THREE ——————————— 58

Louveciennes: 1870-72

FOUR ——————————— 74

London 1870-71: The Franco-Prussian War

FIVE ——————————— 88

Pontoise and Auvers 1872-82: Impressionism

SIX ——————————— 136

Montfoucault

SEVEN ——————————— 152

Figures, Harvests, Market Scenes

EIGHT ——————————— 212

Neo-Impressionism

NINE ——————————— 224

Late Landscapes

TEN ——————————— 242

Travels and Series Campaigns

ELEVEN ——————————— 268

Interiors: Still Lifes, Portraits

ACKNOWLEDGMENTS ——————————— 291

NOTES ——————————— 294

SELECTED BIBLIOGRAPHY ——————————— 301

INDEX ——————————— 303

PHOTOGRAPH CREDITS ——————————— 309

INTRODUCTION

*L*iving in Saint Thomas in 1852, [although] employed in a well-paying business, I could not endure the situation any longer, and without thinking, I abandoned all I had there and fled to Caracas, thus breaking the bonds that tied me to bourgeois life. What I suffered is incredible, but I have lived; what I am suffering now is terrible, much worse even than when I was young, full of zeal and enthusiasm. Now I am convinced that my future is dead. Yet I think that if I had to start all over again, I would not hesitate to follow the same path.[1]

Here, in a rare autobiographical flashback at the end of a letter to the painter, dealer, and collector Eugène Murer, forty-eight-year-old Camille Pissarro looked back in 1878 to the beginning of his artistic career, when, at twenty-two, he left his native Saint Thomas for Caracas.

This letter sets the tone for any interpretative analysis of Pissarro's work by placing special emphasis on a concept central throughout Pissarro's correspondence: freedom. It stresses the acts of self-liberation and self-assertion which inaugurated the young Pissarro's career as he set off on that initial voyage, leaving behind family ties, a secure income, and a comfortable position as a clerk in order to venture on a new life as an artist. During his lifetime, the grasp at freedom—asserting his own position independent of accepted rules—took several forms: he distanced himself from the values and conventions imposed by his bourgeois background; when he reached Paris, in 1855, he gradually and increasingly came to resist the aesthetic dogmas conveyed by the Académie des Beaux-Arts and by the Salons, even though a few of his works were initially accepted for Salon exhibitions.

From the 1870s onwards, Pissarro professed passionate disdain for the Salons and refused to exhibit at them. Among the Impressionists, only he and Degas persisted in their unwavering defiance of the Salons: they asserted their own beliefs with an almost militant resolution. Degas was, incidentally, the artist to whom Pissarro referred the most often throughout his correspondence; their intense and mutual admiration was based on a kinship of ethical as well as aesthetic concerns.

1

Woman Carrying a Pitcher on Her Head, Saint Thomas. c. 1854–58

Oil on canvas, 13 x 9½" (33 x 24 cm)
Foundation E. G. Bührle Collection, Zurich (PV1)

Pissarro remained attached to several fundamental values during his life; they are reflected to various extents throughout his work. The letter to Murer suggests some of the mainstays of Pissarro's ethics as a painter: a headstrong courage and tenacity to undertake and sustain the career of an artist stubbornly unmoved by current fashions and market trends; a lack of fear of the immediate repercussions of such a choice—isolation from his well-to-do family and an extremely precarious financial situation, which he faced until he was in his sixties; a profound belief in the benefits of what he called "enthusiasm" and "ardor"; a confidence that his love of work was strong enough to bolster his morale and keep him going; and an unshakable conviction that he had made the right choice ("if I had to start all over again, I would not hesitate to follow the same path"). Pissarro remained committed to these values, which in turn later endowed "Père Pissarro" with a known mark of integrity that made others willingly turn to him for advice. His pivotal role in the formation and the preservation of the Impressionist group illustrates this. In fact, he was the only artist who showed his work at all of the eight Impressionist exhibitions, from 1874 to 1886.

His unending search for freedom or autonomy—which meant not so much the capacity to do anything, but rather the capacity to invent new rules and to experiment with them—can be seen readily throughout his work.

From his arrival in Paris in 1855 until his death in 1903, Pissarro displayed a profound and insatiable curiosity about the work of his younger colleagues: Paul Cézanne, with whom he worked and shared ideas and methods intermittently from 1872 to 1882; Paul Gauguin, who was his pupil and close colleague from 1879 to 1883; Paul Signac, Maximilien Luce, and in particular, Georges Seurat, with whom from 1886 to 1890, he shared a short-lived interest in Neo-Impressionism. Of course, Pissarro was also influenced by the work of his two eldest sons, Lucien and Georges, and a few years before his death, Pissarro was providing advice and guidance to two of his sons' friends: Henri Matisse and Francis Picabia.

Pissarro was as determined to strive for the freedom necessary to conduct his own work as to keep an open mind about the works of others, to be a recipient and a beneficiary of tolerance. Of course, this does not in any way imply that he blindly accepted anything that happened in the contemporary art world: his severe comments on Bonnard's work, for instance, offer a strong case in point: "Another of these Symbolists who has just produced a fiasco. All the painters who respect themselves— Puvis, Degas, Renoir, Monet, and your servant—are unanimous in finding the exhibition of that artist organized at Durand hideous. That Symbolist goes by the name Bonnard."[2]

Pissarro's attachment to freedom extended into specifically technical aspects. Not only is it impossible to classify his style into neat chronological categories, but furthermore, his style often varies even within the same painting: his brushwork techniques, together with his compositional devices, seldom follow a single formulaic pattern within any given work. A comparison of two paintings as different and as far apart chronologically as *Upper Norwood, Crystal Palace, London* (fig. 2) of 1870, and *The Siesta, Eragny* (fig. 3), done nearly thirty years later, indicates clearly the extent to which these two works radically differ from each other technically, chromatically, and compositionally. More intriguing is that each work in itself displays at least four or five juxtaposed and distinct techniques. The speckled surface in the foreground of *Upper*

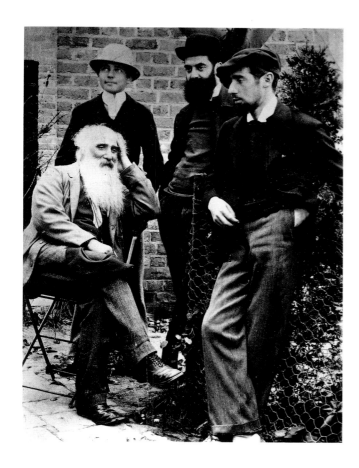

Pissarro with sons Ludovic-Rodolphe, Lucien, and Félix at Knocke. 1894

Pissarro (right) and his son Lucien (center) with Paul Cézanne (seated) in the garden at Pontoise. 1877

Pissarro with his wife, his son Paul-émile, and his daughter Jeanne in their garden at Eragny. 1897

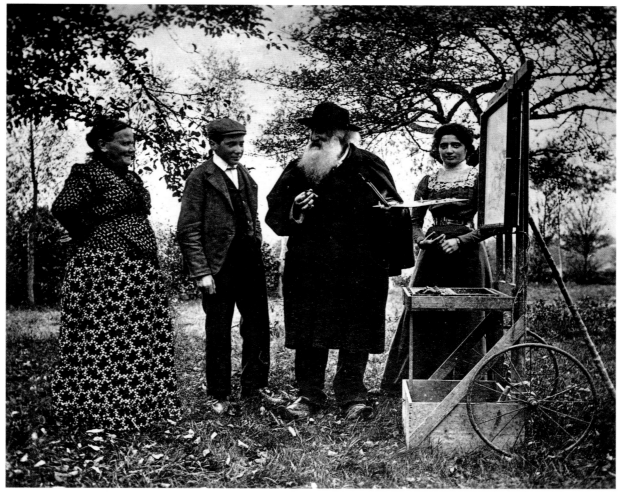

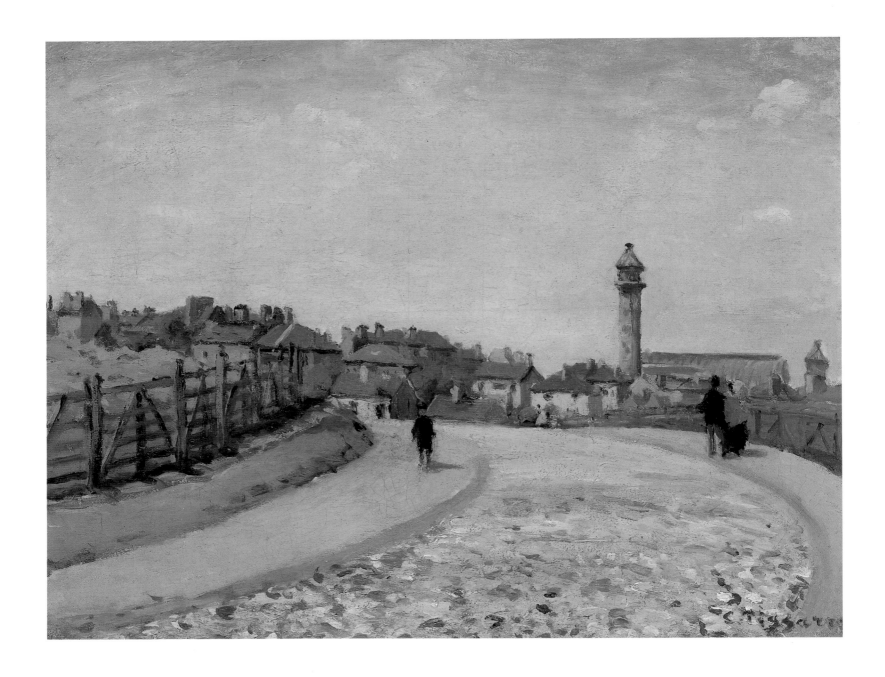

2

Upper Norwood, Crystal Palace, London. 1870

Oil on canvas, 15¼ x 19½" (39 x 50 cm)
Private collection (PV 107)

Norwood, Crystal Palace, London and its rather tight, agitated brushwork are in stark contrast with the more ample, serene swirls of paint that make up the sky; these in turn are offset by the smooth, homogeneous, earthy blocks of paint that form the sidewalks; all this, in turn, is heightened by many regular touches of paint which, in combination, suggest small, cubical units of architecture in the central part of the painting.

Similar observations could be made of *The Siesta, Eragny,* though there again the range of techniques used is considerably different. Here a crust of thick layers of flecks of paint (foliage) is intertwined with an accumulation of long, thin or thick threads of paint (haystack) with a more or less rhythmical juxtaposition of intermediate brushstrokes (foreground). In short, Pissarro's use of a broad repertoire of techniques is characteristic both within single works and throughout his career: each single work itself went through different phases, acting like a microcosm of his whole career.

Pissarro's conception of painting was in this sense analogous to his conception of print making: his prints and his paintings on the whole reveal an amazing degree of

3

The Siesta. Eragny. 1899

Oil on canvas, 25¼ x 31½" (65 x 81 cm)
Archives Durand-Ruel (PV 1078)

curiosity and of concern for new technical devices. The artist with whom he most shared this passionate technical audacity was again Degas, whose methods he studied and regularly mentioned in his correspondence with his son Lucien, with whom he collaborated on certain prints in the late seventies. This ongoing technical exploration not only underscored his free, almost playful approach to painting but also elevated pictorial technique from its traditionally ancillary role.

In Salon or academic practice, techniques do not call attention to themselves. A technique well-mastered should first serve to represent something well; the better the representation, the less noticeable the technique should be. By heightening our awareness of the welter of techniques he resorted to, Pissarro did the precise reverse. He thus also suggested that techniques were plastic equivalents not necessarily subservient to their representational functions. Throughout Pissarro's work, techniques acquired a certain autonomy.

In his correspondence, Pissarro consistently established a distinction between what he called "literary painting" and what he called "a painter's painting."[3] In the former group he would place any work whose *raison d'être* is external: whose

function is narrative, whose point is to tell a story—be it literary, historical, senti-mental, social, mythological, or political. Thus, he was opposed to painters such as Louis Welden Hawkins, of whose painting Pissarro wrote: "His painting, like that of many [other] English artists, is literary—which is not a drawback—but it lacks some-thing on the painterly side; it is thin and tough, and the values are weak; however, it is intelligent, a little Puvis de Chavannes–like; sentimental and feminine . . . but . . . it is not painting."[4]

Among the other category—the true painters, those who do do painting—Pissarro would place the Impressionists at large, and among them, Degas and Cézanne in particular. He viewed Cézanne's 1895 exhibition at Vollard's with wild enthusiasm: "I was thinking of Cézanne's exhibition, where exquisite things can be seen, still lifes of an irreproachable finish, others very worked out and yet left halfway; however, the latter are even more beautiful than the others; one can see landscapes, nudes, some heads that are unfinished and yet truly grandiose, and it is so painterly, so supple." So one might ask, What stands in the way of a painting's becoming a true painting—or a painter's painting? Referring specifically to Puvis de Chavannes again, Pissarro answered: "It was not made to be seen as a picture." It may look astonishing when presented in the right environment, "but it is not painting."[5]

To the parallel question, What makes a true painter? Pissarro would answer that a true painter is very seldom found: he is one who can put two tones of color in harmony. In other words, Pissarro defines the nature of true painting in specifically visual terms.

With painting liberated from its traditional hierarchy of subjects, Pissarro's work could draw upon a wide choice of subjects, themes, and motifs—the diversity of which escapes conventional categories. Throughout his career, exotic landscapes and indigenous figures are painted just before views of Montmartre or of the outskirts of Paris; riverscapes appear next to kitchen-garden landscapes in Pontoise or Louveciennes and are succeeded by winter scenes in London. Twenty years later, views of London parks interrupt the continuum created by his series of Paris boulevards or avenues; his London bridges announce, in part, and collide with, his series of Rouen bridges. All of these look very different from his quiet and almost subdued, solitary, asocial Eragny landscapes, or from his intimate and seldom-seen family portraits, or from his exquisite still lifes—all of which were executed within the last decade of his life. Bare landscapes are offset by bustling market scenes, with milling crowds deeply engaged in socializing and commerce. All of this again seems to have little to do with his monumental single or dual figure paintings of the 1880s.

Though in different ways, his biography also stresses the importance of freedom in Pissarro's life. Born on July 10, 1830, he was brought up in Saint Thomas, which was, at the time, a possession of the Danish crown. The island became a privileged independent trading zone after the King of Denmark made it a "free port" in 1764.

Pissarro was a descendant of a family from Braganza, a Portuguese medieval fortified city near the Spanish border. The family were Marranos—Sephardic Jews who had been prohibited to practice their own creed and forced to convert to Christianity or suffer at the hands of the Inquisition. Pissarro's parents, Frédéric and Rachel, had married away from the synagogue. Pissarro's father had come from France to Saint Thomas in 1824 to serve as the executor of his late uncle's will and to help

the widow sort out the affairs of the estate. Frédéric's liaison with Rachel, his uncle's widow, resulted in their expecting a child, and they soon announced their intention to marry. However, the elders of the synagogue refused to acknowledge the wedding, which in some ways contravened Jewish religious tenets; it was not until 1833, eight years later, that the synagogue agreed to recognize the marriage officially.

After his death, in 1865, Frédéric's will revealed that he had left a bequest of an unusual kind—a sum to be shared equally between the synagogue and the Protestant church in Saint Thomas. This unorthodox bequest may simply have stemmed from a survival of the Marranos' ambiguous religious position: a foot in the church and a foot in the synagogue, or it may have been a reflection of Frédéric's annoyance at the Elders for having refused at first to legitimize his marriage. It was in Braganza, where Pissarro's forefathers had originated, that, in the eighteenth century, one of his ancestors was awarded the knighthood of the Order of Christ and the Pope himself granted him the special and rare privilege of building his own chapel there.

The duality in religious allegiances was clearly still alive with Pissarro's father and may have generated in the son's mind a strong sense of not wanting to belong to either. Camille, who later married a Catholic-born woman in a civil wedding, always professed a strong atheism, defining himself as a freethinker. In the 1880s, he became a fervent adept of the libertarian anarchism preached by Pierre-Joseph Proudhon (although he had earlier in life professed more conservative views).

Yet what appears particularly clear-cut about Pissarro is that he was able to act both as a painter and as a political or social thinker without mixing or confusing the two fields: his art cannot be seen as an illustration of a political thesis—he does not use his colors and paints to depict a set of anarchistic "ideas" or "ideals"—and his political positions were certainly not solely dependent on his own interests as a painter. His art raises our awareness of the fact that a painting need not carry a revolutionary message in order to perform a revolutionary function. To depict the miseries and sufferings of the toiling masses or of the peasantry could indeed be seen as a fine and noble task; Pissarro knew, however, that these images did nothing to relieve oppression. He viewed commentaries which read illustrations of class opposition or visual commentaries of sociological treatises into his work as prototypes of reactionary thinking. Even if the narratives are of a sociological order rather than a religious or mythological one, the thinking process is identical. A recent trend of interpretations puts the image, or the "message," before or above the action of painting. Its practitioners continue to envisage painting as "literary," with a pointed meaning—be it social or otherwise[6]—and the action of painting as consequently subservient to the message or thesis to be understood. It has been my choice in this book to consider these questions through Pissarro's own thoughts; his letters have been a principal source of analysis. There one finds that his reflections, pictorial and epistolary, are rivetingly alive and that their dynamics consistently escape the grasp of any preconceived monolithic "meaning."

Pissarro's radicalism is commensurate with the extent to which he subverted this traditional order of things; within his art, what grants signification to a painting is not so much its "meaning" as its "praxis," the fact that before anything, it was painted as a painting, not as a literary painting. That is one reason that he rejected first and foremost sentimentality in art: "In my opinion, the art that is the most corrupt is

5

The Market at Gisors. 1899

Tempera, 20¾ x 24¾" (52 x 63 cm)
Private collection (PV 1433)

4

La Bonne (The Maidservant). 1867

Oil on canvas, 36½ x 28¾" (93.6 x 73.7 cm)
The Chrysler Museum, Norfolk. Va. (PV 53)

sentimental art."[7] He also rebelled against anything that stands in the way of "art—and art seen through our *sensations*."[8] The kinds of art that involves are many: religious, social, mythological, historical art—i.e., art with a narrative, art based on hypocrisy, on pretense, on careerism, or on false motives: he rejected any art that goes against the artist's *sensations*.

"Sensation" here evokes the intimate subjectivity of the artist's vision, or to put it otherwise, what is irreducibly idiosyncratic in his way of looking at things. Pissarro's pictorial reflection was a complex, self-questioning, recurrent, disparate, often paradoxical process. The chapters of this study tend to follow a broadly chronological progression, and in turn, the places where he lived—Caracas, Paris, Pontoise, London, Louveciennes, and Pontoise again—put their mark upon his work.

From 1882 onwards, after he left Pontoise, he essentially lived in the same village, Eragny, creating there the largest bulk of his work and, paradoxically, the work least often seen or reproduced. He also made increasingly frequent visits to Paris, where he generated a new interest in urban pictorial imagery in his series of cityscapes. Throughout the 1880s, he also developed a keen, though not exclusionary, interest in figures, set in isolation or in groups.

Pissarro's art, it is essential to remember, escapes neat categorization or chronologies. The market theme, for instance, archetypical of his later years, was first developed in Caracas; his earliest view of Pontoise, *Banks of the Oise in Pontoise* (fig. 102), was executed while he lived in Louveciennes; his first major figure paintings were created, not in the 1880s, but in Paris, shortly after his arrival from the West Indies, *Woman Carrying a Pitcher on Her Head, Saint Thomas* (fig. 1), and then in Pontoise, *La Bonne* (fig. 4), in the late sixties. In the midst of his intense Neo-Impressionist phase, Pissarro nonetheless executed market scenes, such as *The Market at Gisors* (fig. 5) or *Le Marché de Pontoise* (fig. 6), which display almost nothing of the dot-to-dot fragmented application of color or of other technical aspects of his Neo-Impressionism. Neither the successive places where he lived, nor the successive technical periods that traditionally divide his work can satisfactorily explain, or exhaustively encompass, his *oeuvre*.

Essentially complex, his work made use of a phenomenal imagination, an unusually rich, innovative visual mind, a vast curiosity about techniques of all sorts, a profound poetic sensitivity, and an unquenchable passion for painting, as well as a strongly defined set of intellectual positions.

6

Le Marché de Pontoise
(The Market at Pontoise). 1887

Gouache, 12 x 9½" (31 x 24 cm)
Columbus Museum of Art, Ohio. Gift of Howard
D. and Babette L. Sirak, the Donors to the
Campaign for Enduring Excellence, and Derby
Fund (PV 1413)

C. Pissarro. 1887.

Beginnings 1830–55:
Saint Thomas, Caracas, Saint Thomas

C amille Pissarro was born on July 10, 1830, in Charlotte Amalie, the harbor capital of Saint Thomas, the largest of the Virgin Islands and at the time a possession of the Danish crown (it was subsequently purchased by the United States). By virtue of this fortuitous geopolitical oddity Pissarro received Danish citizenship at birth, and he retained it throughout his life.

Camille was twelve years old when his parents, prospering from a haberdashery and dry-goods trade (which probably also included artists' paints), decided to send him to France for his high-school education.

Pissarro's father, Frédéric, though of Portuguese origin, was a Frenchman born in Bordeaux, and the family kept an apartment in Passy (then in the suburbs of Paris and now part of the sixteenth arrondissement), not far from Camille's school. During the five years he spent at the Pension Savary, he acquired some training in drawing, which was taught by M. Savary's second son. On Thursdays and Sundays, Camille would regularly visit the Louvre. Upon graduation in 1847, he returned to Saint Thomas, a voyage which in those days took two weeks. He left Paris shortly before the revolution that brought the July Monarchy to its end. Louis-Philippe I was toppled in 1848, and the short-lived Second Republic was established.

Pissarro, now seventeen, reached his native Saint Thomas only to discover that the political situation there was in equal turmoil. The slaves of Sainte Croix, a neighboring island, had begun a revolt which eventually led to the freedom of all slaves in the Virgin Islands. It was in such a context that Pissarro increasingly felt the desire to break "the bonds that tied [him] to bourgeois life."[1]

Camille Pissarro stayed in Saint Thomas for five years after his return from France. During this time, he was meant to learn the rudiments of the family trade. It is certainly doubtful, however, that he ever showed much enthusiasm or zeal for

business. While in charge of checking the loading or offloading of merchandise to and from ships, he managed also to make a considerable number of sketches.

About 1851, a meeting occurred that had an important bearing on his future: Fritz Melbye, a Danish artist, noticed Pissarro on one of the docks in Charlotte Amalie, where he was checking cargo and making sketches of the bustling activity around the ships. Melbye, who was four years his elder, was professionally settled; he was traveling to the Caribbean and South America on a Danish government mission, with the official task of studying the fauna and flora of this region.[2] A friendship quickly developed between them, based on their mutual interest in art. Presumably Melbye obtained his painting supplies from the Pissarro store, and certainly that would have cemented their common interest.

We know almost no details of the actual relationship between Pissarro and Melbye in Charlotte Amalie. We do know, of course, that Pissarro considered his work as a clerk in the family store onerous, and his family's disapproval of his penchant for sketching must have been a further irritant.

This frustration may well explain why Camille had to resort to the somewhat dramatic trick of leaving "secretly" for Caracas, when Melbye proposed it to him.[3]

On November 12, 1852, Pissarro embarked with his new friend on the journey. In Caracas, where he was to spend two years, Pissarro could at last dedicate himself fully to drawing and painting. This date is therefore the first crucial victory in his artistic career; from that moment onwards, he was determined to make every effort necessary in order to become an artist. The abruptness and clandestine aura of Pissarro's departure, in defiance of parental authority and material constrictions, partly explains why he felt he could at last release his plastic energy in Venezuela, and he did so profligately, with over two hundred drawings!

This step was obviously of some consequence to the way Pissarro retrospectively saw his career. Cézanne testified to this in a conversation with Joachim Gasquet:[4] "He [Pissarro] had the good fortune to be born in the Antilles; there he learned to draw without a teacher. He told me all this."[5] Here, Cézanne's words suggest that Pissarro was emphatically aware of this particular and original beginning—apparently far away from all possible sources of academic influences or visual traditions.

These couple of years Pissarro spent in Saint Thomas after his return from France constituted, and before his departure for Caracas, a very tentative beginning for his artistic career; the few pencil drawings that survive from this period betray a certain timidity. This can be observed in the drawing titled and dated by the artist "Frederick David / 12 avril 52" (fig. 7), where a certain hesitation in the artist's hand is manifest in the contours of the little native boy's figure. For instance, the contour of his forearm has been emphasized with several lines or strokes of pencil. The diagonal hatching, a simple, almost instinctive method quintessential to Pissarro's drawings in those early years, undergoes various rhythms and degrees of intensity according to whether the artist is emphasizing the shadow of the brim of the boy's torn straw hat, the rough texture of his oversized garment, or the dark pigment of his skin. The right-hand part of the sheet contains a foreshortened study of the sole of a foot and a study of a calf, seen from the rear, rising from the soil, pointing forward and forming the first step of departure.

7

Frederick David. April 12. 1852

Pencil. 7¾ x 11" (19.9 x 28.2 cm)
Ashmolean Museum. Oxford

8

Study of a Mule. 1852

Pencil. 8¼ x 36¼" (21.1 x 93 cm)
Ashmolean Museum. Oxford

9

*Two Studies of a Young Boy with Faint
Indications of a Female Figure. 1852*

Pencil with pen and ink. 7¾ x 11" (19.9 x 28.2 cm)
Ashmolean Museum. Oxford

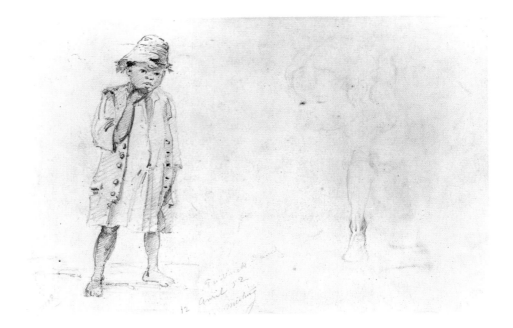

Opposite:

10

Route de Bussy. 1852

Pencil. 8⅜ x 11¼" (21.4 x 28.7 cm)
Ashmolean Museum. Oxford

11

The Lovers' Well. 1851

Pencil. 11 x 6¾" (28.2 x 17.3 cm)
Whereabouts unknown

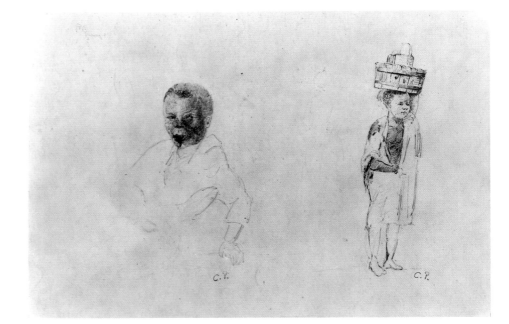

C.P.

Route des Linots 13 avril 1852 S.J.

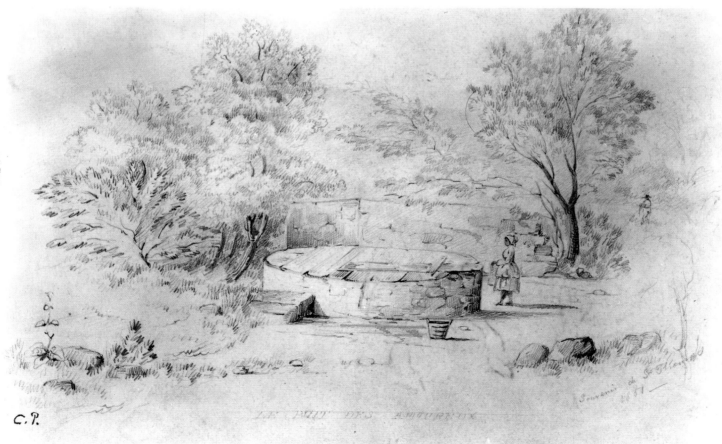

C.P.

LE PETIT DES AMOUREUX Souvenir de St Thomas 1851

It is remarkable, however, how much of the artist's future visual concerns is foretold surreptitiously in this unassuming work—one of Pissarro's first known works. Here, he has chosen to depict an ordinary person, as he was wont to do throughout his life, in simple terms; no sentimentality, condescension, moralizing, or social comment can be detected. The child stands gazing with curiosity at the viewer's eye level, engaging in a straightforward dialogue with an artist who listens to him visually.

The few other sheets of drawings that survive from this first Saint Thomas period also reveal a certain awkwardness.[6] A somewhat odd-looking mule drawn the previous day, April 11, 1852 (fig. 8), with its legs and hooves clumsily close together and a rather heavy neck, seems to stand for the gravity of labor, the oppressive weight of animal existence, and the heavy banality of quotidian chores. The mule or donkey will continue to be an important subject. To the right of the mule, there is a vise tightened around a piece of wood. The intensity of the bold dark pencil lines that form the contours of the vise seem to suggest a visual equivalent of the pressure of the cast iron tightly compressing the wood inside.

Another drawing, *Two Studies of a Young Boy* (fig. 9), is probably also of Frederick David, here carrying a wooden basin on his head, with two pails inside the basin. Both these early drawings emphasize Pissarro's preoccupation with toil, labor, effort, and tension. This concern is evident even in a more complex composition: In a pencil landscape, inscribed by the artist "Route de Bussy / 13 avril 1852" (fig. 10), women carry loads of washing on their head. The group to the right can be identified as a mother, supporting an infant in her arms and the heaviest load on her head, with a child standing on her right and a teenager standing farther right, also carrying a load on her head, presumably helping her mother. The surrounding landscape is rather sketchily drawn, left unresolved, and patchily brought together, suggesting that it was executed in haste.

The scarcity and tentativeness of the drawings made in Saint Thomas can partly be explained by the pressure the budding artist felt from his immediate family to abandon this useless hobby.

In a somewhat earlier drawing, *The Lovers' Well* (fig. 11), despite a certain tightness and restraint in his handling of the pencil, the subject emerges unmistakably. Although the well is covered with a wooden top, and no lovers are to be seen—a woman is there by herself, and the small figure of a man can be seen walking away in the distant background—and the narrative content suggested by the title is thus abrogated; this lovers' well is all about absence, distance, and departure. Fittingly, an inscription on the right reads, "Souvenir de St. Thomas," suggesting that this drawing may have been given as a keepsake to somebody who was leaving Saint Thomas, or that the artist, who was going away, or about to go, left this drawing as a souvenir. In spite of this nostalgic-melancholic context, the drawing manages to remain conspicuously unsentimental and altogether simple. In a sketch in pen and ink over pencil, *Lovers' Meeting* (fig. 12), the desentimentalizing is even more apparent: the well is used as a public laundry where women and children gather to do their washing and gossip. No trace of romantic encounters can be detected in this matter-of-fact depiction of a daily chore. The theme of laundry or washerwomen appears throughout his entire pictorial career. His earliest works carry strong evidence of his fascination with this particular theme, as in *Native Women Washing, Saint Thomas*

12

Lovers' Meeting, 1852-54

Pen and ink over pencil, 6⅞ x 11¾" (17.7 x 30 cm)
Museo de Bellas Artes, Caracas

13

Native Women Washing, Saint Thomas, 1852

Pencil, 6½ x 9" (16.5 x 22.9 cm)
Private collection

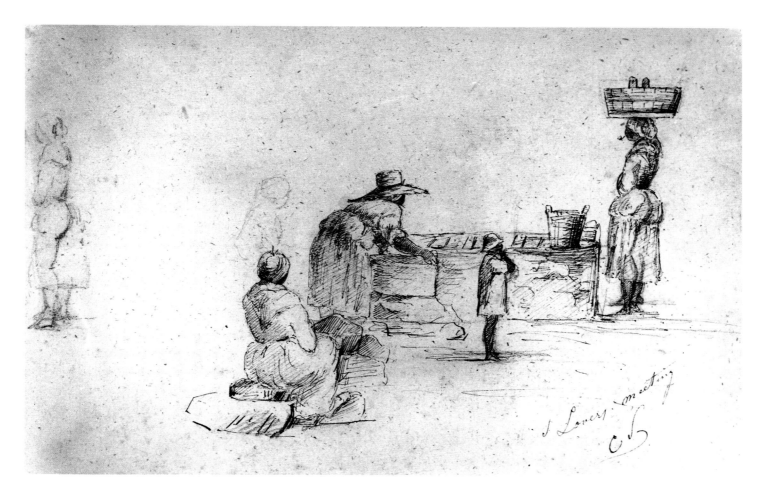

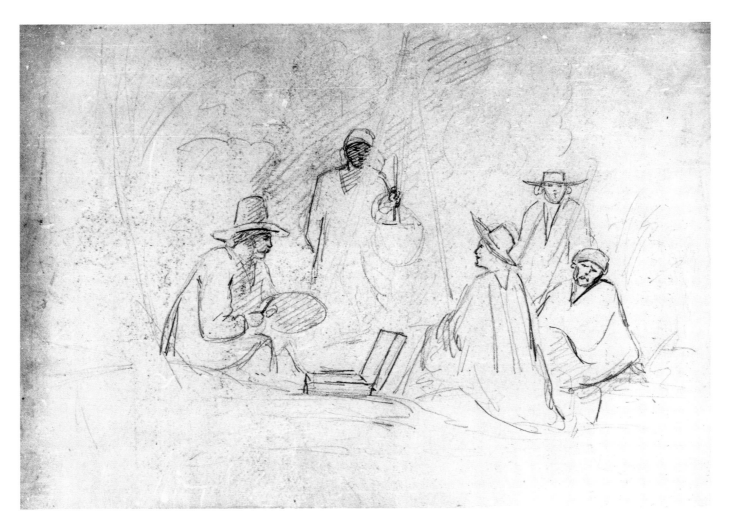

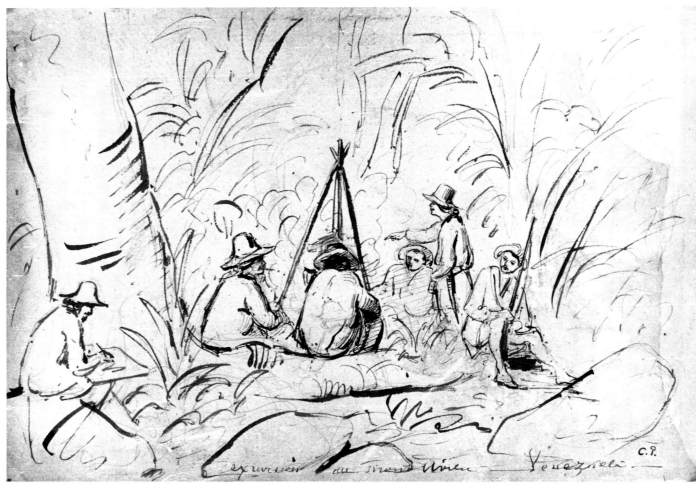

(fig. 13). (This drawing could fruitfully be related to *The Pont Neuf: A Winter Morning* [fig. 314], a work executed only three years before his death.)

Shortly before, on September 20, 1851, Flaubert, who was just starting *Madame Bovary*, summarized his efforts in a letter to Louise Colet that equally could provide the most apt epigraph for Pissarro's entire future *oeuvre*: "It is not a simple thing to be simple."[7] Cézanne, who understood this very well, suggested that Pissarro had introduced this notion to the Impressionists when he said: "We may all descend from Pissarro."[8] Certainly, the notion of rendering simplicity was already in evidence in Camille Pissarro's early drawings.

Pissarro may, of course, have been tempted to stress the particularly unique context in which he started to develop his career as an artist. In Pissarro's eyes, not to have been under the influence of the official Salon artists as a student and to have begun his career in the exotic remoteness of Latin America may have held extra value for an artist who was a staunch opponent of any form of compromise with the traditional, official system of exhibitions and honors.

Pissarro, however, had not evolved artistically in a total cultural vacuum. Undoubtedly, Fritz Melbye had already acquired a developed experience as a botanical artist. Alfredo Boulton was among the first to point out the effect of Melbye's example on Pissarro:

> the influence of Fritz Melbye upon Pissarro's early works cannot be overlooked. What had happened was that the Danish painter's life and work were virtually unknown, until we were lucky enough to discover his paintings a few years ago. That is the reason why nobody had been able to evaluate his tremendous importance upon the mind of Pissarro, who, by 1856, was still painting, in Paris, Venezuelan subjects, with a pictorial concept—impasto, choice of colours, and plastic feeling—that was then considered quite unacademic. . . . Pissarro could not have learned such modality from any other but from Melbye, whom he had seen using certain tones nobody dared to use in those days to depict nature . . . which would be used later on by the founders of the Impressionistic School.[9]

Each artist followed his own complex and intricate pictorial itinerary in Venezuela. Plastic similarities between the drawings of both artists occasionally appear so evident that, as John Rewald has noted, it is "difficult to ascertain whether they were done by Melbye or by Pissarro."[10] Nevertheless, it is possible to determine the noteworthy and distinctive features of Pissarro's work in Caracas. Rewald observed "a tendency for more forceful shadings as well as for greater subtlety," noting, for instance, that Pissarro appeared "less timid than his master, infusing his drawings with an exquisite balance of observation and feeling." The sequence of three drawings (figs. 14–16) illustrates this clearly. A strong indication of Pissarro's later development is that "very seldom does he succumb to the picturesqueness of his subjects."[11]

> Melbye's surviving works reveal a tendency to over-elaborate which one seldom finds in Pissarro's drawings. The Danish artist relied on carefully delineated contours and on a traditional system of hatching. Indeed, direct comparison between the two artists leads one to suspect that, in nearly every case, Pissarro's own artistic instincts were already comparatively well-developed before his association with the Danish painter. . . .[12]

14

An Artist Sketching a Camping Scene. c. 1853

Pencil. 10½ x 14¾" (26.9 x 37.7 cm)
Ashmolean Museum, Oxford

15

Excursion au Mont Avila—Venezuela. 1854

Pen and India ink with brush over pencil.
10½ x 14¾" (26.9 x 37.7 cm)
Ashmolean Museum, Oxford

16

Campfire Scene. c.1853

India ink, 5½ x 4½" (14.1 x 11.5 cm)
Private collection, United States
Courtesy of Angela Nevill

The Venezuela trip revealed lifelong characteristics of Pissarro's work that were initially evident in these years. First, the sheer number of works produced there not only underscores his tremendous zeal, but also radically distinguishes this period from his previous stay in Saint Thomas, between 1847 and 1852, and his return to Saint Thomas in the latter part of 1854, before his final departure to France in 1855. During the two years in Caracas (1852–54) Pissarro produced well over two hundred works on paper, compared with a handful of works executed in Saint Thomas during almost seven years. One explanation for the small number from Saint Thomas may be that very few works actually survived. However, knowing how carefully Pissarro preserved a large number of his Caracas works, it seems unlikely that he would not have had the same instinct in connection with his Saint Thomas works, particularly those done in Saint Thomas after his stay in Caracas and before his departure for France.

It is, of course, possible that Pissarro himself deliberately destroyed most of these works. But it is hard to understand why he would have destroyed works done in Saint Thomas in 1854–55, after his return from Caracas, for those that remain

already convey a maturity, a visual experience, and a technical audacity that present a strong kinship with many of his drawings done in France during the 1860s. In *Wooded Landscape on Saint Thomas* (fig. 17), the range of hatching technique has been pushed to the extreme. Also see *Saint Thomas Gris-Gris* (fig. 18); the title carries a double-entendre not only in that it refers to a voodoo practice, but its repetition of the French word for "gray" hints at the intensity of grays in the work.

A more plausible explanation for the paucity of work is that, despite the inevitable loss of some of his work in Saint Thomas, Pissarro would have actually produced very little there, hindered as he was by the encumbrance of family and business pressure. Although this hypothesis runs counter to anecdotes often found in early biographies of Pissarro, it is quite probable that the two periods spent in Saint Thomas were characterized by utter frustration and ensuing artistic unproductivity.

A certain documentary exactness can be seen in much of Melbye's artistic output in Venezuela, which is seldom to be found in Pissarro's work. This is to be explained, probably, by the fact that he was on a scientific mission. But for Pissarro the focus was quite different. Even in some of Pissarro's studies of tropical plants, such as *Caracas, Treescape* (fig. 19), the intense attention to detail does not altogether supersede an effort to construct his leaf study compositionally in three parts, thus balancing the overall space of his sheet of paper while also devising a subtle passage from right to left, from pencil to watercolor through a subtle gradation of nuances.

Among Pissarro's abundant output in Venezuela there are few works on canvas but a vast number on paper. One can rightfully assume that Pissarro executed several oil paintings during his stay in Venezuela. In *Pissarro and Melbye's Studio* (fig. 20), several oils can be seen hanging on the walls, and Pissarro himself is depicted standing with a palette of oil colors, probably about to start a painting. However, it is safe to assert that comparatively little was painted on canvas during this period. In fact, one could say that Pissarro the draftsman was indeed born in Venezuela, while Pissarro the painter was born in France after 1855. Of course, it is also important to remember that Pissarro's precarious financial status in Venezuela would have made canvases a rarity.

The importance of drawing as a medium throughout Pissarro's *oeuvre* can scarcely be overemphasized. It has been observed recently that Pissarro produced a considerably larger number of works on paper than Monet, Sisley, Renoir, or even Cézanne.[13] In quantitative terms, Pissarro's drawings can only be compared to Degas's.

Pissarro's career started with drawing, and it was, for him, an intense, serious, autonomous activity. In retrospect, it looks as though this period of fervent and hectic experimentation with drawings and watercolors marked a starting point in time and a methodological foundation for Pissarro's entire *oeuvre*. An excellent illustration of his intense interest in drawing is provided by a group of three works (figs. 14–16) in which the artist depicts himself drawing; one can note a visual progression in the elaboration of the three drawings, starting with the barely sketched outlines of the pencil drawing, followed by the same theme treated in pencil and ink, and finally the much more resolved and richly executed pen and ink version.

While Pissarro was in Venezuela, a battle of authority was taking place simultaneously in the capital of the arts, Paris. It was being fought between the supporters of the supremacy of line over color versus those supporting the reverse;

Opposite:

17

Wooded Landscape on Saint Thomas. c. 1854-55

Pencil. 13½ x 10¼" (34.5 x 27.7 cm)
Ashmolean Museum, Oxford

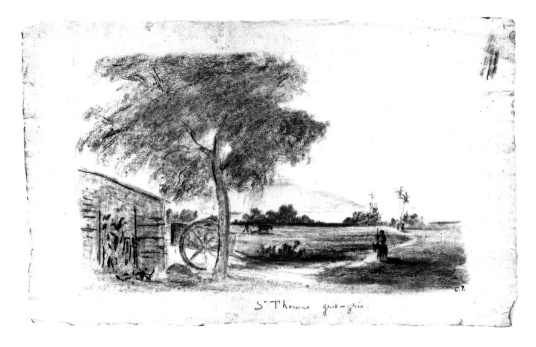

18

Saint Thomas Gris-Gris. 1854-55

Dimensions unknown
Whereabouts unknown

19

Caracas, Treescape. 1852-54

Watercolor, dimensions unknown
Banco Central de Venezuela, Caracas

20

Pissarro and Melbye's Studio. 1852-54

Watercolor, dimensions unknown
Banco Central de Venezuela, Caracas

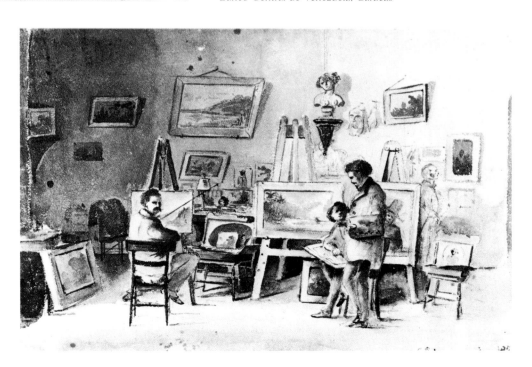

that is, between Ingres and Delacroix, who, perhaps in spite of themselves, personified this struggle—Delacroix championing color and Ingres favoring line.[14]

There, in the various studios where Pissarro would later complete his training, "Ingres' spirit governed uncontested, in spite of the fact that his system began to be attacked more and more violently."[15] The irony, of course, was that while Pissarro passionately continued drawing in Venezuela between 1852 and 1854 unaware of what was going on in Paris, he was contributing to the redefinition of the role that was to be played by drawing in the following decades, and thus to the modification of this dual balance of powers.

Pissarro's drawings and watercolors in Venezuela rejected the simplistic antinomy of priorities—line before color or color before line. By the same token, they symbolize the rejection of any form of regimented authority or of extraneous principle, whether it be immediate forms of pressure, or a doctrinaire code of aesthetic regulations.

The Venezuelan work evidences Pissarro's incipient concern about certain visual themes that were to underlie his entire *oeuvre*. The images, surprisingly, do not jar with the Pissarros of Gisors, executed some forty years later, such as *Market at Gisors (Rue Cappeville)* (fig. 21). In his early twenties, he had already demonstrated a fascination with markets in his work, such as *Study of Figures at a Market* (fig. 23). The earlier work, however, still contained some anecdotal aspects, as with the droopy-eyed dog in front of a woman squatting on the ground in the lower left.

A vast array of themes caught Pissarro's attention during his Venezuelan stay. In the same sketchbook one can see market scenes, close-up studies of females, such as the *Fruit Merchant* (fig. 22), and a landscape executed with his typical diagonal hatching technique and various intensities of shading, *Trees and Figures* (fig. 24). Across the trees, in the background of this landscape, some houses can be seen—the forerunners of a theme in many paintings by Pissarro over the decades, as in *Village Street (Pontoise)* (fig. 25), done about 1868. Again, the theme of female workers in conversation will also enjoy a privileged place in Pissarro's iconography in the eighties and nineties: see, for example, *Two Young Peasant Women* (fig. 26).

In *Cardplayers in Galipán* (fig. 27), Pissarro depicts a scene of cardplaying in a popular café. What lifts it at once out of the ordinary is his incredibly deft and dynamic treatment of the hatching background. With the exception of the two central figures facing the viewer, little attention is given to characterization. Rather, this work is about noise and smoke, movement, interaction, and the confusion of perception in a space filled with thick, dark tobacco smells. It is about coarse exchanges of words, looks, cards, money, stakes, drinks, and yells. Although Pissarro did not explore further this genre-like theme, reminiscent of Jan Steen's drinking bouts, one may wonder whether Cézanne might have seen this drawing before painting his own *Cardplayers*.

The bearded man with a tall, rough straw hat in this drawing can be recognized in another drawing, where he is portrayed in a street: *Study of a Seated Man* (fig. 29). There the "burriquero" (the inscription, lower left, reveals the sitter's occupation) is seen with his professional attribute: a tall stick, used in order to force donkeys to move. The character's face remains as undemonstrative as when he is seated at a café table watching a game of cards.

21

Market at Gisors (Rue Cappeville). 1894-95

Hand-colored etching. 7⅞ x 5½" (20.2 x 14.2 cm)
The Art Institute of Chicago

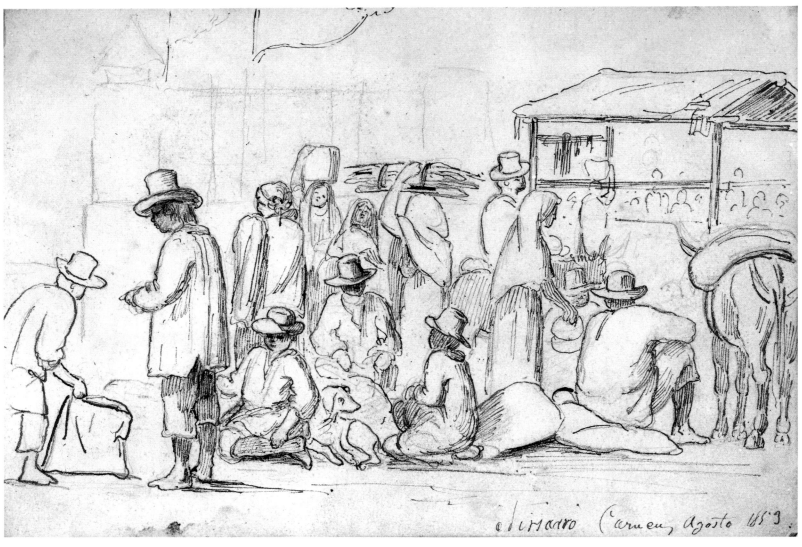

24

Trees and Figures. 1852-54

Pencil, dimensions unknown
Whereabouts unknown

22

Fruit Merchant. 1852-54

Pen and ink over pencil, dimensions unknown
Private collection, Venezuela

23

Study of Figures at a Market. August 1853

Pen and ink over pencil, 7 x 10½" (18 x 27 cm)
Private collection, Venezuela

25

Village Street (Pontoise). c. 1868

Oil on canvas. 18 x 21½" (46 x 55 cm)
Private collection (PV59)

26

Two Young Peasant Women. 1892

Oil on canvas, 35¼ x 47⅞" (89 x 165 cm)
The Metropolitan Museum of Art, New York.
Gift of Mr. and Mrs. Charles Wrightsman, 1973
(PV792)

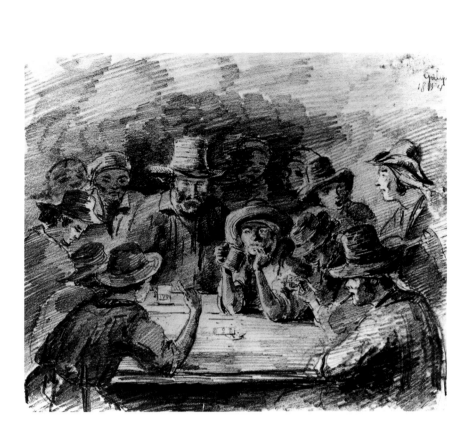

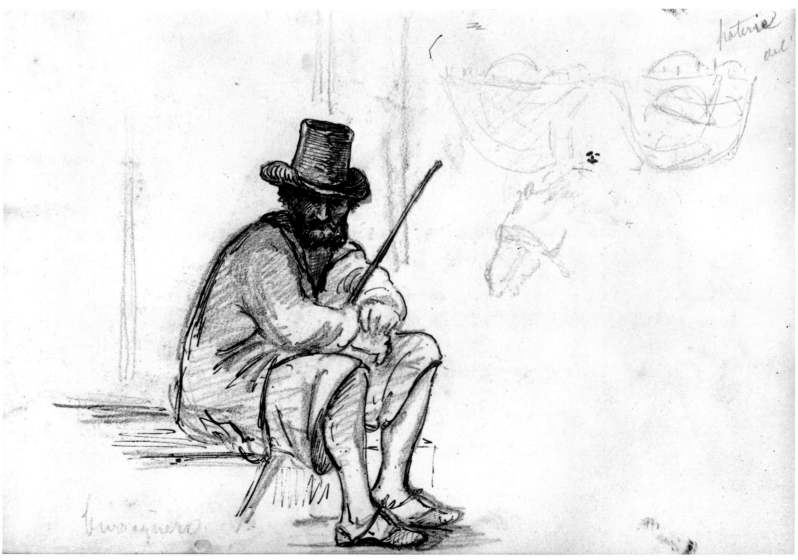

Pissarro, here, as throughout his *oeuvre*, presents a certain simple distance between the viewer/artist and the sitter/subject depicted. This distance, however, paradoxically emphasizes the sheer presence of his model without any attempt to breach the sitter's intimacy. With pen and ink, the artist has subtly adumbrated the striking and piercing features of the model, modulating the areas of shade projected by the brim of the rather heavy hat onto the face of the sitter, while, at the same time, moderating the purely psychological, sentimental effect inherent in portraiture.

This gentle, simple attitude in front of a model can be directly contrasted with Gauguin's symmetrically opposed attitude when discovering Tahiti some thirty-five years later: the latter embodies an exotic curiosity that nurtured his aestheticism, in direct contrast to Pissarro's natural, almost indigenous attitude.

Despite the obvious proximity of interests—a shared curiosity about exotic worlds—between Gauguin and the aesthetic principles that are given shape through comparable works by Pissarro in Venezuela, such as *Head of a Seated Woman* (fig. 28), no mysterious distance, no exotic draperies, no "Raphaelesque harmony,"[16] no enigmatic veiling of faces unwilling to yield up their sibylline secrets are to be found in his work. Instead, the closeness of the model constitutes a disconcerting presence, transliterated with rather sober means (a few quick hatchings and some crossed lines). This drawing is not very distant from Pissarro's figure paintings in the 1880s, a quarter of a century later. In fact, the poetic suggestiveness of the *Head of a Seated Woman* certainly points towards Corot. Small wonder therefore, that once back in France, after 1855, Pissarro would be looking at Corot's work and seeking his artistic tutelage.

Corot seemed a natural choice for an artist who, in the exotic context of Venezuela, had sought to render the simplicity of everyday life. For there, Pissarro resorted to a plainspoken plastic language in order to express or record the flickering sensations in experiencing the givens in everyday life. One could perhaps, in this sense, refer to Pissarro's works in Venezuela as proto-Impressionist.

Pissarro's Venezuelan trip lasted from 1852 to 1854. On August 1854, he sailed back to Saint Thomas and stayed there for just over a year, replacing his brother Alfred in the family business while the latter was taking time off in France.

Having made this concession, Camille was granted permission to go to France and begin the career of an artist. By mid-September 1855, shortly after Alfred's return, Pissarro was off again on a transatlantic steamer bound for Europe, about to be confronted with the intricate, complex Paris art world: its Salons, exhibitions, academies, its sets of options and oppositions.[17] He was never to return to the Americas.

27

Cardplayers in Galipán. 1854

Pencil. 10 x 11⅜" (25.4 x 29 cm)
Banco Central de Venezuela, Caracas

28

Head of a Seated Woman. 1852-54

Pencil, dimensions unknown
Museo de Bellas Artes, Caracas

29

Study of a Seated Man. 1852-54

Pencil and pen and ink. 7 x 10½" (18 x 27 cm)
Private collection, Venezuela

The Early Works in France: 1855–69

P issarro's first fifteen years in France seem to follow a rather slow, prudent rhythm, in contrast to his short intermezzo in Venezuela where he was seized by a frenetic ardor to work. It is as though Pissarro was, in a sense, weighing carefully the different visual options offered to him, aware that these years would be of critical importance for the rest of his artistic life and his personal life as well.

One of the most momentous events of that period, certainly, was his meeting with Julie Vellay about 1859, when she was working as the cook's helper at his parents' home in Paris. She became pregnant with his child at the end of 1860; that pregnancy ended in a miscarriage.[1] This liaison with a servant was vehemently opposed by his parents. When Pissarro's father died in 1865, Camille and Julie, however, already had a two-year-old child, Lucien, and Julie was again pregnant with their first daughter, Jeanne. It was not until 1871, in London, away from Pissarro's mother, with her continuing disapproval, that they were finally wed.

Pissarro seems to have been somewhat ambivalent about his marriage, never quite wanting to confront his parents with the issue directly. Pissarro depended on his mother for financial support until 1873, when he was in his forties. It was then that Durand-Ruel began to find buyers for his work. In those ten years of unmarried life with the mother of his children, an interesting trait of Pissarro's character is revealed: he certainly knew what he wanted and was determined to act accordingly, but never to the extent of hurting unnecessarily those closest to him. Naturally, every compromise is in some way unsatisfactory, and it seems certain that Julie resented the fact that an official seal had not sooner legitimized her common-law union with Camille.

Julie was, however, an ideal partner in the frequently insecure existence that she shared with Camille. A mother of eight children, she undeniably suffered greatly from Camille's impecunious situation. But she always provided him with advice and

wholehearted support, and eagerly amassed a collection of his work, sometimes even opposing the sale of a work she had decided she wanted—as various letters testify, and as well as the catalogue of sale of her own collection.[2] In addition, she tried to accommodate her husband by making herself available as a model, although sometimes grudgingly.

The "unaffected simplicity"[3] that characterized most of Pissarro's output through-out his long career can already be seen as a unifying element within the work of his first fifteen years in France.

This said, the early years of his career were not without tensions or problems. Although he essentially spent his later years in only two places, the villages of Pontoise and Eragny, the early years of his life in France were marked by constant moves, first to Paris, where he lived and worked in various quarters after arriving from Saint Thomas, and then later shuttling regularly between the city and the country. The opposition between rural and urban imagery is one of the principal themes in his early works. An analogous dichotomy between town and country was consciously and systematically reactivated in the last decade of his life; eventually this gave way to his series of urban views.

During the 1850s and 1860s, he seemed to zigzag from one subject to another until he decided to settle more or less permanently outside Paris. A list of his addresses documents how frequently he moved: in 1856, he was sharing a studio with Anton Melbye, Fritz's brother, in Montmartre (49, rue Notre-Dame de Lorette)[4] and was close to a circle of Danish artists. Some months later he moved a few blocks down the street to his father's offices. He probably also sojourned with his family in Montmorency, about forty miles west of Paris (fig. 30). He spent the summer of 1857 in Montmorency again, and then stayed for some time in La Roche-Guyon (fig. 31) and Fourges—both on the border of Normandy, west of Paris.

In 1858, Pissarro remained mostly in Paris at his parents' flat and then used a studio at 54, rue Lamartine; he summered again in La Roche-Guyon. The next year he moved to 38 bis, rue Fontaine-Saint-Georges, spending part of the summer in Montmorency and La Roche-Guyon. In 1860 and 1861, he lived at 39, rue de Douai, where he painted *The Telegraph Tower in Montmartre* (fig. 32). During that time, he also made a short trip with the young Monet to Champigny-sur-Marne, where he painted *La Varenne-Saint-Hilaire, View from Champigny* (fig. 33).

He moved to 23, rue Neuve Breda in 1863, and to 57, rue de Vanves, in Paris, spending the summer in La Varenne-Saint-Maur, near Chennevières, and Champigny. He finally moved out of Paris in 1865, first to La Varenne-Saint-Maur, before settling down in Pontoise in 1866 (all the while keeping a *pied-à-terre* in Paris). It is an astonishing fact that Pissarro never stayed more than six months in any place until he reached Pontoise,[5] where he lived from 1866 until 1869, and then from 1872 until 1882.

Another paradox of Pissarro's early years was his choice (at least in the very first years of his life in France) of exotic subjects—see *Woman Carrying a Pitcher on her Head, Saint Thomas* (fig. 1) and *Two Women Chatting by the Sea, Saint Thomas* (fig. 34)—while at the same time evolving a more vernacular source of imagery in which the landscapes outside Paris during the summer would play a considerable role, as in *Entering a Village* (fig. 35).

Opposite:

30

Montmorency. c. 1859

Pencil and conté crayon. 9 x 11¾" (23 x 30 cm)
Whereabouts unknown

31

La Roche-Guyon. 1859

Ink and sepia over pencil. 11¾ x 17½" (30 x 45 cm)
Whereabouts unknown

32

The Telegraph Tower in Montmartre. 1863

Oil on canvas. 15½ x 12½" (40 x 32 cm)
Courtesy of Gallery Urban (PV24)

The first eight paintings known to have been done in France all depict Saint Thomas landscapes or figures. These were executed mainly in Paris between 1855 and 1858—probably from drawings or sketches. During these ten early years a complex and manifold exchange was initiated between paintings and drawings. In Paris, Pissarro initially received training in various schools such as the Académie Suisse, where students would execute life drawings, and where he was to meet Monet in 1859[6] and a little later, Cézanne. The drawings Pissarro made there of models, however distinguished and delicately sensitive, never led to paintings of figures. With the exception of the major *La Bonne* (see fig. 4), and works based on his experiences in Saint Thomas, also executed within the first ten years of his arrival in Paris, figure paintings are conspicuously absent.

Instead, he concentrated on exploring rural imagery. Several artists provided examples of interesting visual data, to which Pissarro responded significantly. Corot was perhaps the most obvious mentor: Pissarro owned two known drawings by Corot[7] and formally referred to himself as "pupil of Corot" when he submitted works to the Salons of 1864 and 1865. As a pupil or an observer, he also knew the work of Gustave Courbet, Charles-François Daubigny, and Antoine Chintreuil, and other Barbizon artists. These were major mainstream painters, quite different in stature from Fritz Melbye, and the heterogeneous aspects of Pissarro's drawings between 1855 and 1869 probably stem in part from the imprint of these artists.[8]

Opposite:

33

La Varenne-Saint-Hilaire. View from Champigny.
c. 1863

Oil on canvas, 19¼ x 29" (49.6 x 74 cm)
Szépművészeti Múzeum (Museum of Fine Arts),
Budapest (PV 31)

34

Two Women Chatting by the Sea, Saint Thomas.
1856

Oil on canvas, 11 x 16⅛" (28 x 41 cm)
National Gallery of Art, Washington, D.C.
Collection of Mr. and Mrs. Paul Mellon (PV 5)

35

Entering a Village. c. 1863

Oil on canvas, 13 x 16" (33 x 41 cm)
Collection S. John Hernstadt and Robert Darwin
(PV 32)

Indeed, the drawings reproduced in this disparate chapter, even though they form only a fragment of Pissarro's graphic output during the period, offer strong visual confirmation of this, as in *La Roche-Guyon* (fig. 31), *Le Pâtis, Pontoise* (fig. 36), and *View of Pontoise* (fig. 37). None of these individually reflects one single influence: they all amalgamate in an idiosyncratic manner a manifold quasi-kaleidoscopic visual exposure. The several techniques visible include diagonal hatching, reminiscent of the Venezuelan drawings, to which some early French drawings still resort principally; a subtle blending of a linear scaffolding with hatched shading and with a stress put on fragments of lines, delineating tree trunks, for instance (in a Corot-like manner); a predominant spare architectonic structure—seen particularly in early Pontoise pen-and-ink drawings. Or again, the exact opposite in some drawings where linear structure and diagonal hatchings are almost entirely superseded by a subtle palette of different shades, achieved with charcoal and white chalk, modulating all the intermediate values and creating a dramatic set of chiaro-scuro effects that also help to elaborate the depth of the receding space within the drawing—here a riverscape.

This extraordinary profligacy of styles in the drawings becomes all the more complex when set within the context of the paintings. It is impossible to explore satisfactorily the relation between these two mediums because most of the paintings Pissarro did prior to 1870 were destroyed during the Franco-Prussian War of 1870–71. However, comparing the list of paintings published by Ludovic-Rodolphe Pissarro and Lionello Venturi in the *catalogue raisonné* of 1939 with the corpus of drawings known today—although largely unpublished—one can seldom observe any direct, sequential relationships between drawings and paintings. Pissarro does not seem to have used his drawings as studies for paintings, apparently conceiving his early paintings without preliminary works.

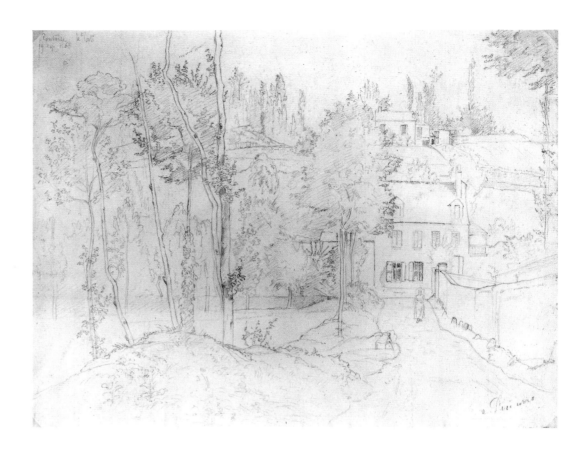

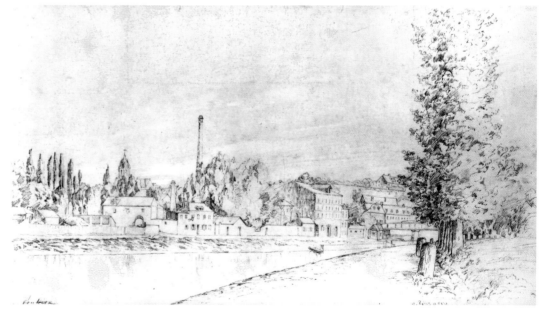

36

Le Pâtis, Pontoise. 1868

Pencil, 9¼ x 11⅞" (23.6 x 30.5 cm)
Graphische Sammlung im Städelschen
Kunstinstitut und Städtische Galerie,
Frankfurt am Main

37

View of Pontoise. 1867

Pencil, 11 x 17½" (28 x 45 cm)
Private collection

One noteworthy exception should be underlined: a pen and ink drawing, *View of Pontoise* (fig. 37), and a painting seldom reproduced, *Landscape with Factory* (fig. 38), depicting almost exactly the same motif. One could at first be tempted to deduce that the drawing was conceived in preparation for the painting, although, even in this particular case, a closer scrutiny of both works reveals telling divergences. The angle of composition and the vantage points are different, suggesting that the artist sat on this particular spot on two separate occasions: for the painting sitting farther from the water's edge and giving more prominence to the towpath.

Further, the rigorous exactness and minute attention to architectural detail in the drawing is in strong contrast with the far more dynamic, lively mood of the compo-

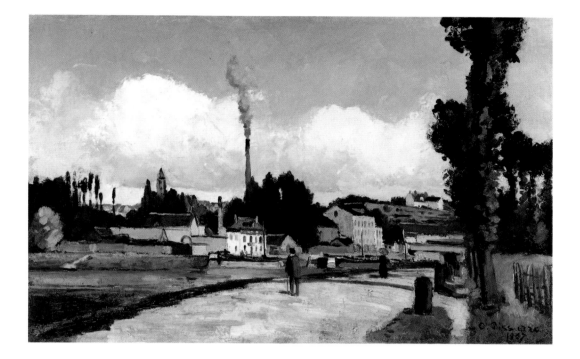

38

Landscape with Factory, 1867

Oil on canvas, 17¾ x 27⅞" (45.7 x 71.5 cm)
Putnam Foundation, Timken Museum of Art,
San Diego, California

sition in the painting. The cross of the Tour Saint-Maclou has been omitted in the painting, as have the little turrets crowning the roof of the spire and a row of three windows on one of the foreground buildings on the far bank. Instead, more emphasis has been placed on life, movement, atmosphere, cycles of energy exchanges, with a smokestack spewing smoke into and above the clouds. This smokestack and its column of smoke and the near-horizontal shadow projected by the poplar tree tend to frame two sides of a composition within a composition into which the lady in the black dress with a blue sunshade is thrusting, while the male figure, dressed in symmetrically opposite colors (a blue coat jacket and a black hat), stands just outside this inner square. The drawing, in contrast, depicts a wide-open space where everything stands still, and no such oppositions or divisions can be seen.

By 1867, however, when the painting was executed, it is fair to say that Pissarro had made a breakthrough, and by 1868 Zola could write: "This is all painted with masterly accuracy and energy. . . . How the devil do you expect that such a man with such works could please anybody?"[9]

Two years earlier there was little hint of the breakthrough from apprenticeship—*The Marne at Chennevières* (fig. 39), executed around 1864–65 and exhibited in the Salon of 1865, has often been criticized for its lack of audacity. Writers charge the artist with virtually surrendering to his immediate circle of pictorial sources—here particularly, Charles-François Daubigny in, for instance, his *The Village of Gloton* (fig.40), 1857. An eminent historian has praised *The Marne at Chennevières* for its "fresh and ingratiating" color surface; the artist's brushwork becomes "delicate and almost pretty"! But this is intended to reinforce the general notion that from 1850 to 1865 Pissarro was a student; this is seen climactically in *The Marne at Chennevières*, since after it, "Pissarro never again plunged so completely and so uncritically into the style of Daubigny," who himself reveals the influence of John Constable.[10] It is as if the visual influences that determine the very existence of the work one could summarize in the following formula: (Constable + Daubigny) = Camille Pissarro (*The Marne at Chennevières*).

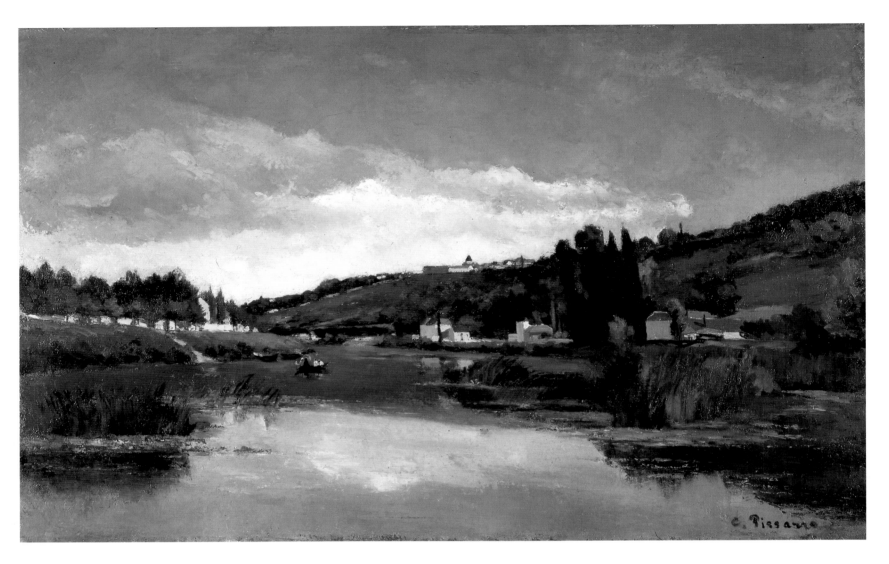

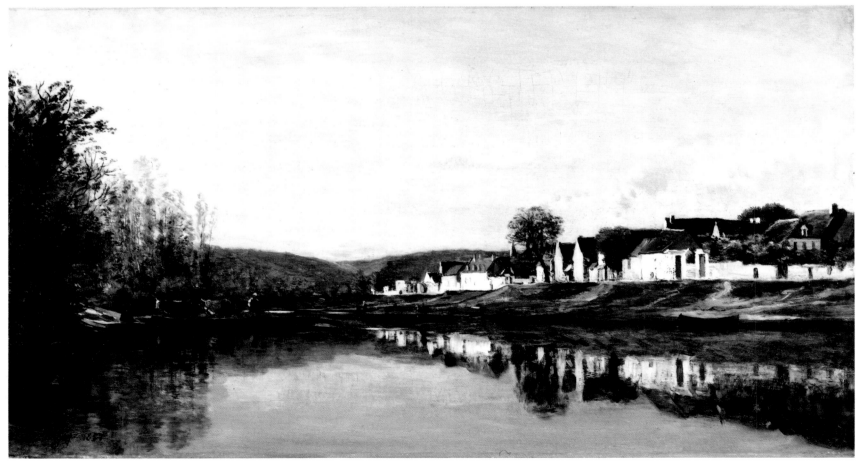

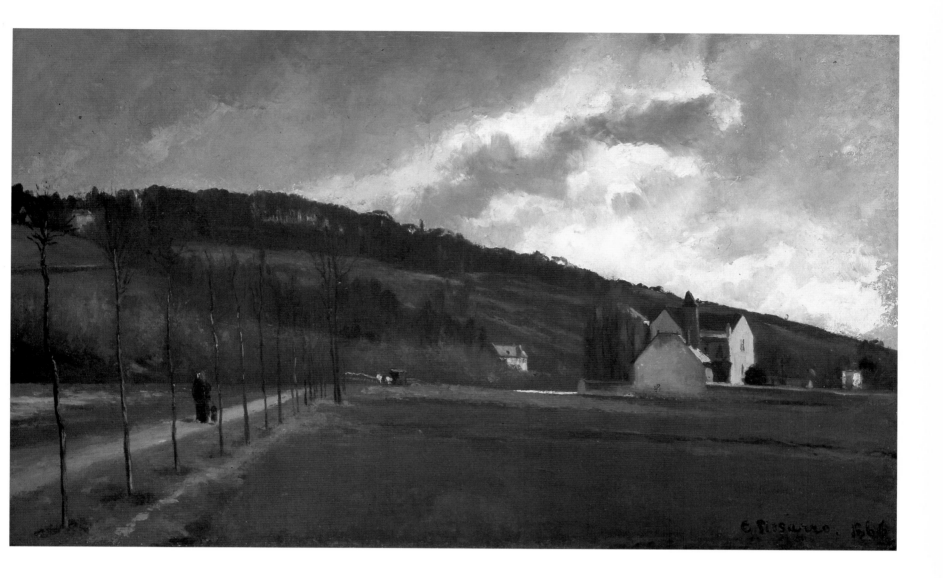

Opposite:

39

The Marne at Chennevières. c. 1864–65

Oil on canvas, 36 x 60¼" (91.5 cm x 154.5 cm)
National Gallery of Scotland (PV46)

40

Charles-François Daubigny.
The Village of Gloton. 1857

Oil on canvas, 11¾ x 21⅛" (30 x 54.2 cm)
Mildred Anna Williams Collection, California
Palace of the Legion of Honor, San Francisco

Above:

41

The Banks of the Marne in Winter. 1866

Oil on canvas, 35¼ x 58¾" (91.8 x 150.2 cm)
The Art Institute of Chicago. Mr. and Mrs. Lewis
Larned Coburn Memorial Fund. 1957.306 (PV47)

It is, however, rewarding visually and exciting intellectually to engage in a brief analysis of what radically separates *The Marne at Chennevières* from the Daubigny in order to understand the distinct pictorial qualities of each.

Daubigny's work depicts (narrates) a ferryman taking a couple of oxen across a river for a fee. One could say that the integral movement of the ferry crossing the river is contiguous with the narrative axis of the work—there is a beginning and an end to this movement from one side to the other: everything makes sense.

Daubigny's use of the widely elongated perspective structure provides a perfect framework for what goes on. The spatial context supports the narrative content in the picture: analogously, the water of the river sustains the ferryboat while reflecting the images of each bank: the inhabited world on one side, the uninhabited "natural" world on the other. The animals shuttle back and forth between the two, while the water surface duplicates (almost literally) the givens of each world, harmoniously suffusing both reflections with each other, and both are represented into and onto a coherent, orderly, symmetrical picture by Daubigny.

The case is different with Pissarro: no such narrative content can be found in his work. His vast painting is, in a sense, its own emblem. There is no easy external referential system, no geometric or symmetrical echoes evoking well-ordered nature: here, the boat does not seem to be going anywhere, and the reflections do not

42

Study of River Landscape with Boats. 1866

Pen and dark ink over black chalk with gray wash.
12 x 18½" (30.7 x 47.3 cm)
Ashmolean Museum, Oxford

43

Donkey Ride in La Roche-Guyon. c. 1864-65

Oil on canvas, 14½ x 20⅞" (37 x 53 cm)
Collection Tim Rice (PV45)

duplicate the real world. In fact, his treatment of much of the landscape and the buildings moves very close to abstraction.[11]

Furthermore, the rounded bulk of reflection in the lower left corner, conspicuously detached from the fairly regular horizontal mass of reflections that crosses the river in the middle section, does not seem to correspond precisely to the overall regular silhouette of the trees on the left bank. Thus Pissarro underscores the chasm between the real world and its pictorial representation—a chasm which, judging from the vast, dark, open surface of the water on this canvas, might appear unbridgeable. In fact, both artists' works seem, in this light, to be symmetrically opposed in intentions and in contents. Daubigny's pictorial depiction is, in a way, closing a world. Pissarro's plastic construction is opening another. The array of plastic issues in which Pissarro's picture engages are essentially nonfunctional. The elaborated spatial construction reflects considerations that are alien to Daubigny: the vast expanses of sky and water, one mirroring the other and squeezing the rather narrow band of earth; the breaking and enlargement of the perspectival axis into two axes appear all the more conspicuous as one compares the treatment of the same motif in a drawing, *Study of River Landscape with Boats* (fig. 42).[12] One meeting point of the axes can be seen at the closing of the water surface, left of the central group of houses; another can be found farther left at the intersection of the edge of trees on the left bank and of the hillsides on the right bank, forming a wide, open **V**. All this indicates that Pissarro, unlike Daubigny, was, by 1865, already committed to deconstructing the components of pictorial practice handed over by tradition and to questioning the adequacy of a given pictorial space and its assigned representational function in at least two ways. First, the artist, as in *The Marne at Chennevières*, or *The Banks of the Marne in Winter* (fig. 41), asked himself what a picture should (or should not) represent after abandoning anecdotes and anthropocentric imagery, and how it should be represented. For this end he then committed himself to juggle with a whole new range of plastic combinations and spatial constructions.

With *The Banks of the Marne in Winter*, two perspectival triangles are even more clearly detached from each other than in the earlier *Marne* painting. If one imagines a point at the end of the lower edge of the canvas, one can draw an imaginary diagonal to the left, meeting with the end of the road and forming the first perspectival space. One can draw a second diagonal from the same lower center point, focusing on the church and forming a second perspective triangle with a diagonal drawn from the lower right-hand corner of the picture. One can even imagine a third triangle whose two sides stem from one-third of the width of the canvas off the lower right corner and off the lower left corner, and whose summit meets in the center of the picture between the white horse and its carriage and the isolated house. Each of these imaginary triangles is gently suffused into the other through a multitude of other intermediary triangles that help to cement "the barrenness of this winter scene"[13] into a cohesive whole.

One cannot obtain a satisfactory account of this amazing picture by applying a traditional, monolithic perspectival system: no single perspective triangle will account for the vast expanse of space stretching/being stretched in front of the viewer/painter, encompassing altogether the mother and child, the horse and carriage, the church and its wall. The range of vision within this picture has been stretched to encompass

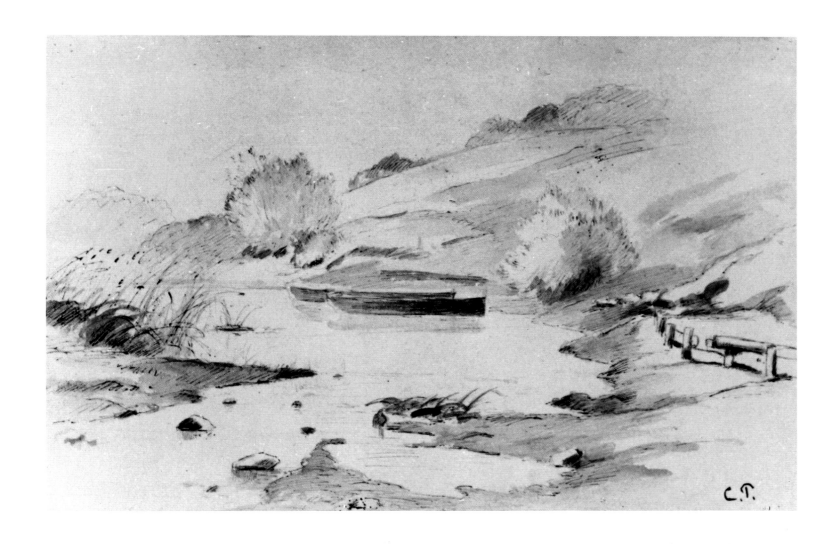

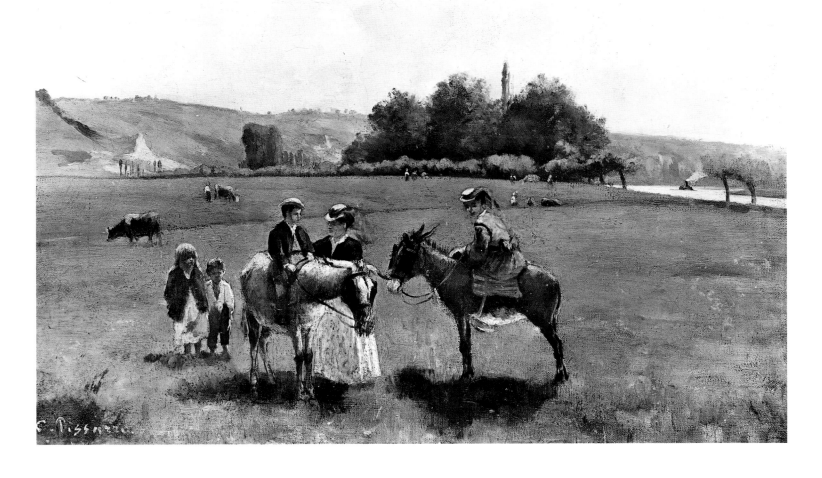

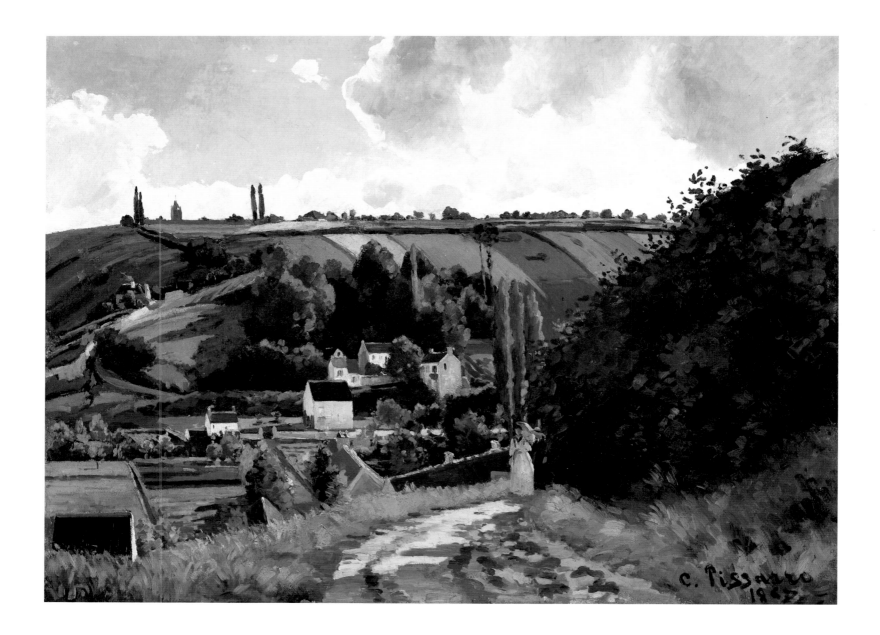

44

The Jallais Hills, Pontoise. 1867

Oil on canvas, 34¼ x 45¼" (88 x 116 cm)
The Metropolitan Museum of Art, New York.
Bequest of William Church Osborn, 1951 (PV55)

a wider block of space than actual vision would allow. The representation is larger than life; the scenery bulges out of its perspective.[14] An even greater widening of the panoramic view occurs in *Donkey Ride in La Roche-Guyon* (fig.43), where the perspectival axes have been pushed back on both sides to form a rotund, curvilinear horizon. The figural elements, unlike in the Marne picture, have been brought forward in focus and are used as a counterpoint to accentuate the effect of excessive breadth, which suffuses the whole landscape.

It is certainly worth bearing in mind here the critical reception given to this unprecedented picture. Zola first wrote in *L'Evénement*:

> M. Pissarro is an unknown and probably no one will talk about him. . . . Thank you, Monsieur, your winter landscape refreshed me for a good half hour, during my trip through the great desert of the Salon. I know that you were admitted only with great difficulty and I congratulate you on that. Besides which, you ought to know that you please nobody and that your painting is thought to be too bare, too black. So why the devil do you have the arrant awkwardness to paint solidly and study nature so honestly?

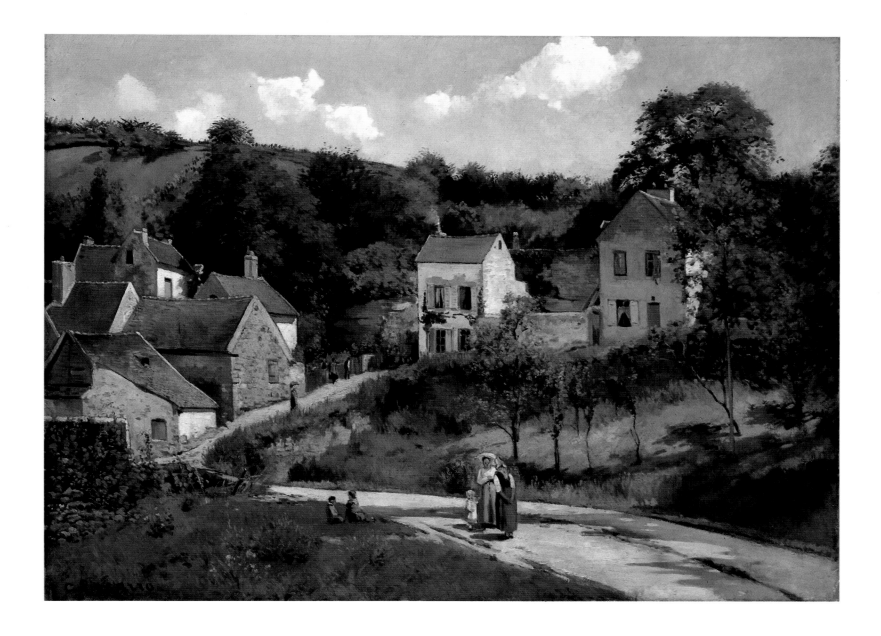

45

The Hermitage at Pontoise. c.1867

Oil on canvas, 59⅝ x 79" (152.8 x 202.6 cm)
Solomon R. Guggenheim Museum, New York.
Justin K. Thannhauser Collection, 1978 (PV58)

Look, you choose wintertime, you have there a simple bit of a road, then a hillside in the background and open fields to the horizon. Not the least delectation for the eye. A grave and austere kind of painting, an extreme care for truth and rightness, an iron will. You are a clumsy blunderer, sir—you are an artist that I like.[15]

In 1868, the Salon jury felt more relaxed in its modes of selection, probably under the sympathetic influence of Daubigny, who was sitting among them.[16] Pissarro had two very important paintings accepted: presumably *The Jallais Hills, Pontoise* (fig.44), and *The Hermitage at Pontoise* (fig.45), according to Ludovic-Rodolphe Pissarro.[17] These two works—together with *The Gardens of L'Hermitage, Pontoise* (fig.46), *L'Hermitage at Pontoise* (fig.47), *View of L'Hermitage, Jallais Hills, Pontoise* (fig.48), *Landscape at Les Pâtis, Pontoise* (fig.49), and *Village Street (Pontoise)* (fig.25)—are the kernel of works that bring Pissarro's breakthrough to a culmination.[18] Seen in the context of Pissarro's work of the mid-sixties, the group gains a singularly powerful identity, demonstrating Pissarro's impulse to technical and compositional innovations at the end of these formative years.

In addition they lead us to question the traditional contrast drawn between Pissarro and Degas, best known for the clarity of their pictorial intentions, as opposed to Cézanne and Manet, whose formal endeavors were much more complex and refined.[19] In fact, these seven paintings suggest that this traditional opposition between Pissarro and Cézanne is far from clear-cut.

Zola's remarks on the two paintings in the Salon are worth considering further, as he probably best understood the paradoxes in Pissarro's work at the time: "His canvases are devoid of all pyrotechnics, all the artifice that intensifies the extremely powerful and harsh reality of nature." Later in the article Zola compares Pissarro's work to some of the Salon's overprettified works: "Among these well-groomed canvases, Camille Pissarro's canvases look bleakly naked." Continuing to take issue with the Salon painters who claim to follow the rules of tradition and of the Renaissance, Zola contends that these very Salon painters are incapable of seeing and understanding those—Velázquez and Veronese—whom they acknowledge as their masters. According to Zola, the real "descendants of the masters," who keep the tradition alive, are the Camille Pissarros and his like. His whole argumentation is grounded on the notion of "rule": the Salon painters allegedly follow the "rules" inherited from tradition; but these rules are ossified, fetishized formulas comparable to cooking recipes. The genuine followers of tradition are those who, Pissarro first among them, have the capacity to reinvent and transform these rules. Defining more specifically "the grand path of truth and might" that they follow, as far as Pissarro is concerned, Zola remarked that Pissarro's touch is "solid" and "broad" and that "he paints lushly," just like the masters. These comments were pointedly applied to *The Banks of the Marne in Winter* (fig. 41).[20]

Zola's text ambiguously carries both references to an objective approach to reality and suggestions that the artist ultimately resorts to his subjectivity as a "maker" of skies and grounds. The artist, aware of himself as an artist, takes special care to perform his artistic activity to the best of his ability, conscientiously endeavoring to represent the truth. The artist (Pissarro) "sits in front of nature confronting external reality in its 'truth,' while 'assigning himself to the task of horizons.'"

Fundamentally, the dialectical pairs "reality" and "dream," "truth" and "interpretation," "nature" and "temperament" are inseparable in Zola's text on Pissarro.[21] Thus it offers a critical springboard of surprising modernity for the interpretation of Pissarro's work in the 1860s. The complex, ambivalent processes of work alluded to by Zola could be observed and epitomized in Cézanne's work, in particular from the seventies onwards. Cézanne became acquainted with Pissarro around 1859 or 1860, and they became more intimate at approximately the time when *The Banks of the Marne in Winter* was painted.[22] The first author who discerned ambivalences in Cézanne's work analogous to those noted by Zola in Pissarro's paintings was Meyer Schapiro, in his celebrated preface to his monograph on Cézanne:

> The visible world is not simply represented on Cézanne's canvas. It is re-created through strokes of color among which are many that we cannot identify with an object and yet are necessary for the harmony of the whole. If his touch of pigment is a bit of nature (a tree, a fruit) and a bit of sensation (green, red), it is also an element of construction which binds sensations or objects. The whole presents itself to us on the one hand as an object-world that is colorful, varied, and harmonious, and on the other hand as the minutely ordered

creation of an observant, inventive mind intensely concerned with its own process. The apple looks solid, weighty, and round as it would feel to a blind man; but these properties are realized through tangible touches of color each of which, while rendering a visual sensation, makes us aware of a decision of the mind and an operation of the hand. In this complex process, which in our poor description appears too intellectual, like the effort of a philosopher to grasp both the external and the subjective in our experience of things, the self is always present, poised between sensing and knowing, or between its perceptions and a practical ordering activity. . . .[23]

It seems clear that Pissarro, in his own terms (and perhaps in a way that, through his work of 1867 or 1868, exerted a certain influence on Cézanne later on), had reached an unprecedented degree in the complex interaction of subjectivity versus objectivity, sensation versus construction, or of self versus nature. This subtle opposition and fragile equilibrium between self and nature can be seen as one of the basic equations at the very core of modern art.

One remembers Matisse's observation in the context of a discussion that took place with Pissarro in 1897, "A Cézanne is a moment of the artist while a Sisley is a moment of nature."[24] It could be said that in 1867, Pissarro was bringing together both opposed pictorial vectors in his work. This opposition in the early works took a very original and interesting form. Simply put, it could be seen as a contrast between line and color, or between drawing and modeling—except that within Pissarro's paintings of 1867 or 1868, neither defines the contours of the painted objects. As paradoxical as it may sound, the delineation of the painted objects (such as the houses in *View of L'Hermitage, Jallais Hills, Pontoise* [fig. 48]) is obtained through the absence of both drawing and paint. The contours of houses or trees in this painting, for instance, are suggested through an extremely thin furrow of unpainted canvas that runs along the edges of the represented objects, letting through the nearly untouched web of primed canvas.

Pissarro thus subverted the traditional academic hierarchical opposition between line and color (Ingres and Delacroix) by refusing plastically to take a position on either side. In fact, Pissarro (anarchistically) introduced a logical contradiction right into the core of the traditional debate on painting, which can thus be summarized: the plastic contours of objects require neither paint nor drawn line but can be outlined in *negative*—by withholding the brush at the seam of two planes of color.

This logical contradiction invalidates previous judgments about the superior merits of either line or color. Line no longer seems to inform color; color may function by itself, as in *View of L'Hermitage, Jallais Hills, Pontoise*, or *L'Hermitage at Pontoise* (fig. 47), to produce a shape or a plane. Further, color informs itself as soon as it is placed on the canvas, creating an edge—a noncolor line—that is neither line nor color but draws or etches the silhouettes of the objects that give the color planes or masses their own contours and density. As obvious as this innovation may sound today, after Matisse and Ellsworth Kelly, it was not so in 1867.

One can, however, better understand why Cézanne could have been struck by these paintings. Over ten years later, he referred to *L'Hermitage at Pontoise* in a letter to Pissarro written from L'Estaque on July 2, 1876: "As soon as possible, I shall come and spend a month in this area, for I must paint at least [six-foot]-long canvases, just like the one you sold to Faure."[25]

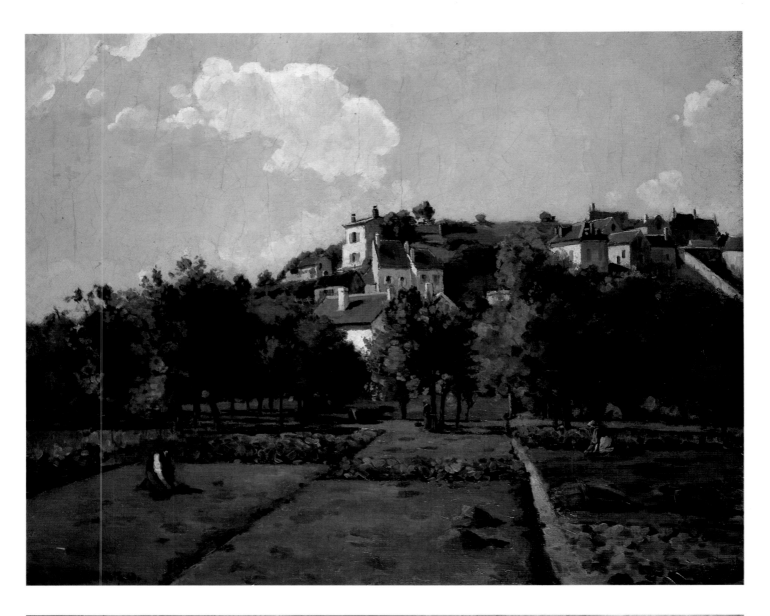

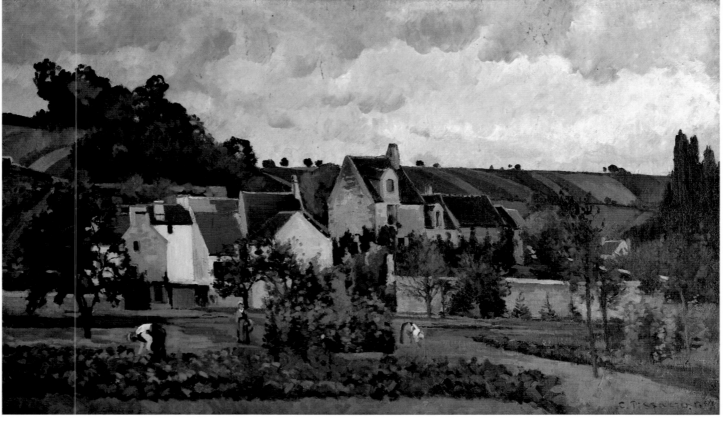

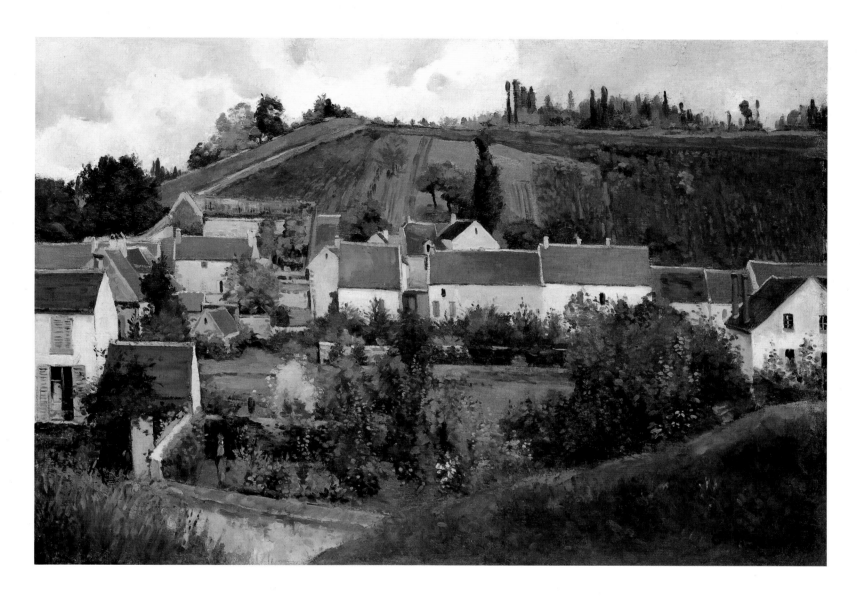

48

View of L'Hermitage, Jallais Hills, Pontoise.
c. 1867

Oil on canvas, 27¼ x 39" (70 x 100 cm)
Fondation Rau pour le Tiers-Monde, Zurich
(PV57)

46

The Gardens of L'Hermitage, Pontoise. c. 1867

Oil on canvas, 31½ x 39" (81 x 100 cm)
Národni Galeri, Prague (PV52)

47

L'Hermitage at Pontoise. 1867

Oil on canvas, 35⅞ x 58½" (91 x 150.5 cm)
Wallraf-Richartz-Museum, Cologne (PV56)

This often-quoted sentence becomes all the more significant when read in its immediate context:

There are motifs that could be found here and that would demand three to four months of work, because the vegetation here never changes. These are olive trees and pines which keep their leaves all year round. The sun here is so frightening as to make the silhouettes of the objects look as though they have been cut out, not only in black or white, but also in blue, in red, in brown, in purple. I may be wrong, but it seems to me that this is the absolute opposite of modeling. How happy our sweet landscape painters from Auvers would be here.[26]

This letter, while specifically referring to the six-foot-long *L'Hermitage at Pontoise* sold to the famous opera singer and collector Jean-Baptiste Faure, emphasizes this vital opposition between "silhouettes of the objects [that] look as though they have been cut out" and "modeling": the somewhat ambivalent expression used here by Cézanne is virtually untranslatable, although it renders well the turgid, ample, volume of the masses of color thus separated from each other, as seen in the L'Hermitage paintings, and later on in Cézanne's work in Auvers and in L'Estaque. During a conversation with the late Sir Lawrence Gowing shortly before his death, referring to the letter from Cézanne to Pissarro quoted above, Gowing mentioned that Cézanne could be seen there repeating back to Pissarro a lesson taught to him by the older artist a few years earlier. The specific reference to *L'Hermitage at Pontoise* would indeed corroborate this very interesting remark. Additionally, in order to emphasize this application of clear, rich masses of color, juxtaposed but never overlapping or even touching each other, Pissarro resorted, in this crucial group of works, to the combined use of a brush and a palette knife, thus adding to the intensity and the almost leather-like tactility of certain planes of color, as in *View of L'Hermitage, Jallais Hills, Pontoise*.

This analysis of Pissarro's paintings in L'Hermitage is not to suggest a deterministic link between Pissarro and Cézanne, according to which Pissarro could be seen as an inventor of formal possibilities out of which Cézanne extrapolated, stepping towards Cubism, for instance. It is rather that Pissarro's daring in eliminating drawn contours together with modeling in his paintings of the late 1860s is unique and analogous only to Cézanne's daring invention of the "passage" praxis later on.

This complex opposition between undrawn lines—or contours—and planes of color as reconstructed by Pissarro in 1867 receives an enlarged significance in the perspective of modern literary criticism, where in the writings of the early Formalist critic Mikhail Bakhtin, the very same notions are at work. Indeed Bakhtin opposed two main tendencies in literature: the linear style as opposed to the pictorial style (borrowing the linear/pictorial distinction from Heinrich Wölfflin).[27]

The later directions of Pissarro's work illustrate what could be called (after Bakhtin) the gradual "pictorialization" characteristic of modern literature, proportional to the absorption of a multitude of genres, a corollary to the shattering of the linear, self-bound unity of ancient novels. This can be seen in his borrowing of excerpts of popular culture (representations of fairs, rural market scenes, chats between peasants) within the more traditional representational space of exhibition pictures. In 1867, however, Pissarro reexamined the traditional opposition between pictorial and linear

49

Landscape at Les Pâtis, Pontoise. 1867

Oil on canvas, 31½ x 39" (81 x 100 cm)
Private collection (PV61)

units within a more formal context—even though it can be seen in retrospect that what was at stake in his pictorial experiments was a whole redefinition of the representational function of painting.

Finally, shortly before his death Maurice Merleau-Ponty made an analogy which is most revealing of Pissarro's works at L'Hermitage:

Anyone who thinks about the matter finds it astonishing that very often a good painter can also make good drawings or good sculpture. Since neither the means of expression nor the creative gestures are comparable, this fact [of competence in several media] is proof that there is a system of equivalences, a Logos of lines, of lighting, of colors, of reliefs, of masses—a conceptless presentation of universal Being. The effort of modern painting has been directed not so much toward choosing between line and color, or even between the figuration of things and the creation of signs, as it has been toward multiplying the systems of equivalences, toward severing their adherence to the envelope of things. This effort might force us to create new materials or new means of expression, but it could well be realized at times by the reexamination and [reinvigoration] of those which existed already.[28]

Louveciennes: 1870–72

50

*Printemps à Louveciennes
(Spring in Louveciennes).* c. 1870

Oil on canvas, 20⁷/₈ x 32" (53 x 82 cm)
The National Gallery, London (PV85)

51

Road to Saint-Germain, Louveciennes. 1871

Watercolor, 11⁷/₈ x 19" (30.4 x 49.2 cm)
Private collection

*T*héodore Duret, the subject of portraits by Manet, Whistler, and Vuillard, was an early champion of the Impressionists. He opened his discussion of Pissarro's work in a review of the Salon of 1870 with the following remark, "While [Paul] Guigou has started to cover his canvases with raw tones and an overly bright surface, Pissarro on the other hand has started painting landscapes lacking light and often totally dull and drab."

This harsh observation referred to Pissarro's work of 1867–68, executed in Pontoise immediately before his move in the spring of 1869 to Louveciennes, a small village near the Seine River about twenty miles away from Paris.

Duret then commented on Pissarro's recent Louveciennes work, also in the exhibit: "Today, he is more daring in both respects, and so the pictures that he painted more recently, and in particular those in this year's Salon, appear to us to have achieved tremendous progress over his previous productions. . . .

"In certain ways, Pissarro is a realist. He will never compose a picture, and will not rearrange nature in a landscape. A landscape on a canvas, for him, must be the exact reproduction of a natural scene and the portrait of a corner of the world."

At the end of his article Duret qualified his judgment of Pissarro as a realist: "[H]e is not a realist to the extreme point where, as with some other artists, he sees nothing in nature but its real and external aspect, and remains oblivious to nature's soul and its intimate dimension. On the contrary, he endows his slightest canvases with a feeling of life."[1] Duret focuses acutely on the pictorial tensions inherent in the Louveciennes works (of 1870 at least) between a "realist" art and an art that conveys the "feeling of life."

A century after Duret, the noted contemporary scholar Richard Brettell confirmed Duret's insight into the subtlety of Pissarro's "realism":

A simple examination of his many paintings of the route de Versailles [the street Pissarro lived on] in Louveciennes will show that he altered the size, character, length, and gradient of the street as well as the relative position of the buildings that lined it. One

curious pairing of 1872 shows an identical winter landscape on the route de Versailles both with and without a large Second Empire country house next to the auberge that Pissarro painted so often. . . . This simple example is clear evidence that Pissarro did not view nature photographically.[2]

What Brettell and Duret both identify is the characteristic dynamism or tension between the eye and "soul" of the painter that can be perceived in the Louveciennes work.

Since the change of locale is strongly reflected in Pissarro's work, the chronology of the family's moves is especially significant. In 1866, Pissarro moved his family to Pontoise for the first time—always alternating with short sojourns in Paris. They settled in Louveciennes in the spring of 1869. However, their stay in Louveciennes was soon interrupted by the Franco-Prussian War, which broke out on July 19, 1870. The war caused a vast number of people to flee because the Prussian soldiers had in a short time come dangerously close to the capital; the war ended after the devastating Paris siege, during which the Paris population was totally cut off by the Prussian Army, and great numbers fell victim to famine or disease. The Pissarros, however, managed to take refuge with their close friends the Piettes in the tiny hamlet of Montfoucault, on the border of Brittany, where they spent the autumn of 1870. They left for London in December 1870 and returned in July of 1871.

When the Pissarros arrived back in Louveciennes,[3] they found that their house had been inhabited by the Prussians, who had pillaged and ransacked. Shortly afterwards, on November 22, Julie gave birth to their third child, Georges. They stayed in Louveciennes for nearly a year, until 1872, when they moved to Pontoise for the second and last time, remaining there for eleven years.[4]

All these separate stays in different locations seem to be so closely interlocked that Duret's remark about Pissarro's work in Louveciennes having achieved "tremendous progress over his previous works" may appear paradoxical. However, the perceptible contrast between these paintings and those of Pissarro's first Pontoise period (1866–68) is made even stronger by the fact that there are no known works dated 1869 (Pissarro's first year in Louveciennes): these would presumably form a visual transition between Pontoise and Louveciennes.[5]

However, since thirty-four pictures from 1870 survived, and none from 1869, the historian must search for explanations other than the war. It is perhaps more convincing to suppose that many, or most, of the undated pictures representing Louveciennes currently considered to date from c.1870, c.1871, or even c.1872 were in fact painted in 1869. There are eighteen such pictures in the *catalogue raisonné* that, when considered as a unit, might form an *oeuvre* for 1869 and bridge the gap visually between the Pontoise and Louveciennes periods.

One of the works that calls for a revision of date is *Printemps à Louveciennes* (fig. 50). Here larger, lusher, ampler slabs of brushwork are gently infused with a subtle painterly subsurface; the format is much larger than the average size of the paintings dated 1870 in the *catalogue raisonné* (his 1870 paintings depicting Louveciennes average approximately 19 x 23", a staggering difference from the average format of works depicting Pontoise in 1867, which is approximately 27 x 38"). But above all, it is the compositional and topographical choices in the organization of this work that

most obviously link it to the hinge period between Pontoise and Louveciennes. These include the wide perspective on the road turning around a hedge of bushes, and the overall formal contrast between geometrized architectural units and the baroque effervescence of natural shapes—an opposition that is central to, and archetypical of, the group of paintings of L'Hermitage and one that was soon to become also a predominant concern in Cézanne's work for the rest of his career.

In *Printemps à Louveciennes*, Pissarro had set his easel at the rue de la Gare[6] looking away from Louveciennes, and towards Renoir's village: Voisins. This painting in fact can almost be seen, structurally, as a symmetrical opposite or as a mirror image of *The Jallais Hills, Pontoise* (fig.44). Both share a wide perspective that leads the viewer's gaze from right to left in the former and from left to right in the latter, where it veers around a bushy hedge that sets the highest point within the composition. A woman, rather simply dressed, is walking away from the gazer's visual field in the former while her social counterpart, shading herself with a parasol, is entering into the visual field of the painter/viewer in the latter.

The bushy mass of hedge or trees in each picture is offset by an almost perfect horizontal which both accentuates the level format of the picture plane and sets a rather high horizon line. As opposed to this high point, in both central parts of the compositions, the gazer's look is induced to plunge downward into a space filled with near-cubical houses, built below the level of the road. Both pictures articulate a multidimensional space structure of complex levels, which creates an overall dynamism relentlessly soliciting the viewer's gaze to thrust into the picture plane in all directions. Thus the artist can be seen composing the space for an aerial reverie; indeed this reverie, according to Gaston Bachelard, for instance, can often be solicited by the theme of a gently climbing path, or "a smooth path, without an abyss, without vertigo."[7] This aerial reverie, in these two paintings, is motivated not only by the plunging, downward perspective on the roofs of the village below the side of the road, but also by the soft rhythm of the steps of the figures passing by. This rhythm is incorporated within the continuum and the silence of the landscape, introducing into the painting a slight discordance of tempos, propitious to poetic reflection. Very much the same ambience is evident in the watercolor *Road to Saint-Germain, Louveciennes* (fig. 51). Renoir did not remain indifferent to these qualities of *Printemps à Louveciennes* in particular, when a few years later he too tackled the same motif in *A Road in Louveciennes* (fig. 71).

The larger number of paintings of Louveciennes are ensconced compositionally within a more traditional rigid framework of dual perspective axes. In such pictures as *The Road to Saint-Cyr at Louveciennes* (fig. 55), *The Road: Rain Effect* (fig. 52), *The Road to Versailles at Louveciennes* (fig. 54), and the monumental *The Road to Versailles at Louveciennes* (fig. 58) or within the second Louveciennes period, *Outskirts of Louveciennes, the Road* (fig. 56) and *Entrée du Village de Voisins* (fig. 57), both sides of the road organize the spatial layout of the composition, but they lead the viewer's gaze straight into the center of the composition. Unlike Monet, in *Road to Versailles at Louveciennes, Snow Effect* (fig. 53), Pissarro, even though he plots his Louveciennes imagery within the well-configured architectural structure of a village, never resorts to the more geometrized X-shaped perspectival system that Monet used, where both perspective axes meet at their center.

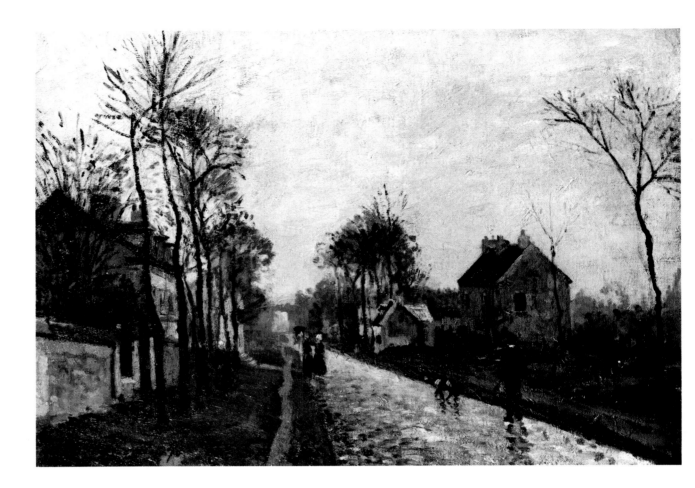

52

The Road: Rain Effect. 1870

Oil on canvas, 15¹³⁄₁₆ x 22³⁄₁₆" (40.2 x 56.3 cm)
Sterling and Francine Clark Art Institute,
Williamstown, Massachusetts (PV76)

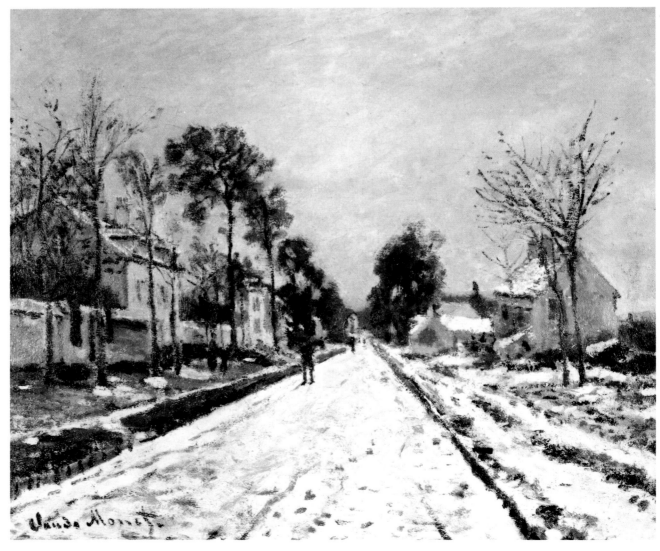

53

Claude Monet.
*Road to Versailles at Louveciennes,
Snow Effect.* 1870

Oil on canvas, 22 x 25½" (56¼ x 65.3 cm)
Private collection

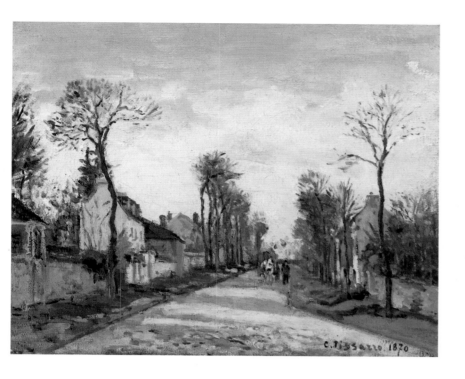

54

The Road to Versailles at Louveciennes. 1870

Oil on canvas, 12⅞ x 16³/₁₆" (32.8 x 41.1 cm)
Sterling and Francine Clark Art Institute,
Williamstown, Massachusetts (PV77)

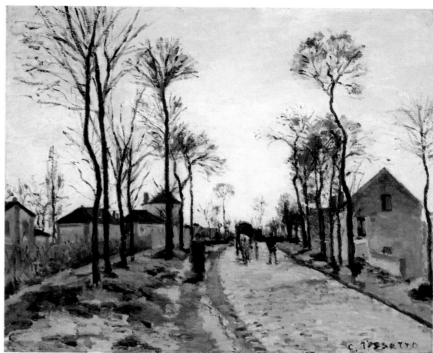

55

The Road to Saint-Cyr at Louveciennes. c. 1870

Oil on canvas, 18 x 21½" (46 x 55 cm)
Private collection (PV78)

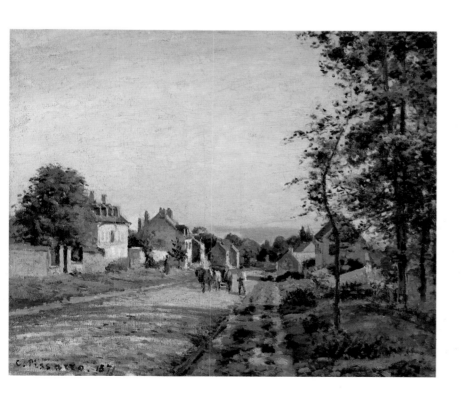

56

Outskirts of Louveciennes, the Road. 1871

Oil on canvas, 18 x 21½" (46 x 55 cm)
Collection Rosengart (PV119)

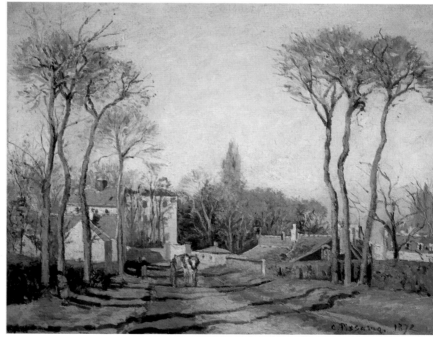

57

Entrée du Village de Voisins
(Entering the Village of Voisins). 1872

Oil on canvas, 18 x 21½" (46 x 55 cm)
Musée d'Orsay, Paris (PV141)

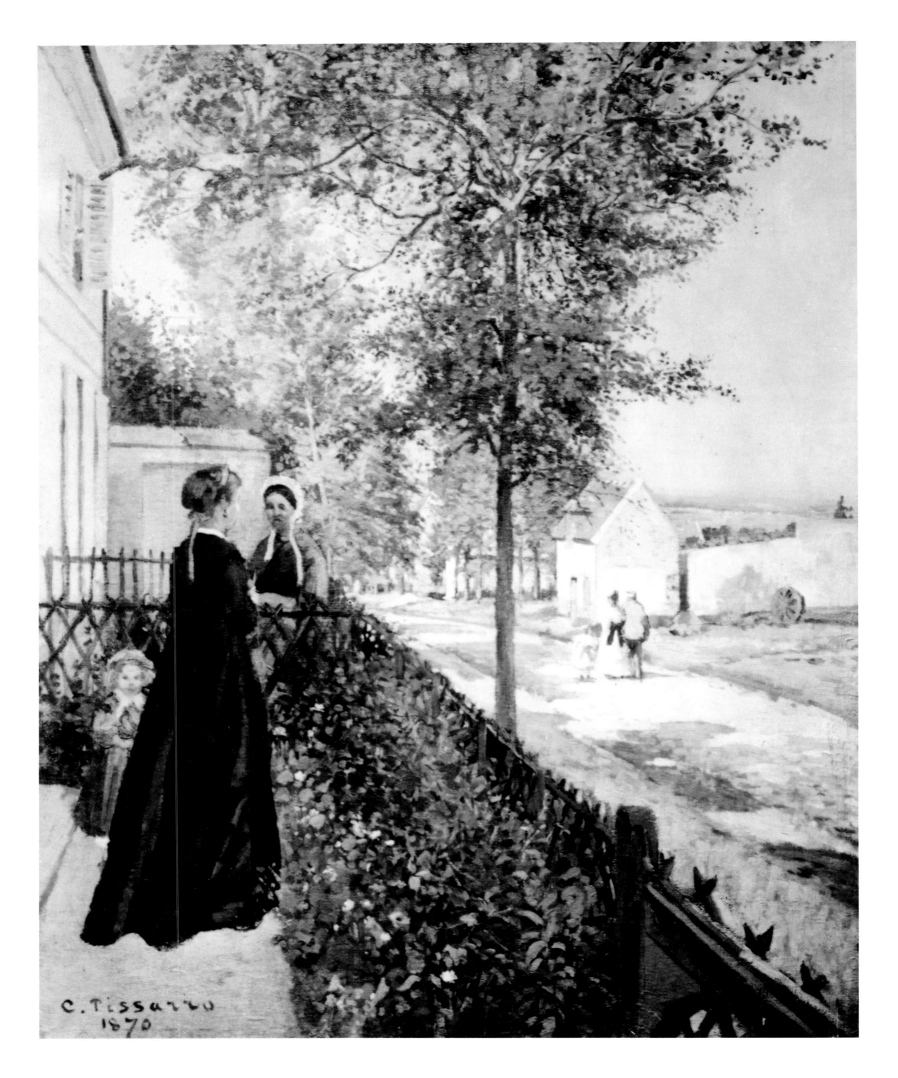

C. Pissarro
1870

Opposite:

58

The Road to Versailles at Louveciennes. 1870

Oil on canvas, 39 x 31½" (100 x 81 cm)
Foundation E. G. Bührle Collection, Zurich
(PV96)

59

Road to Louveciennes. c. 1870

Oil on canvas, 15 x 18" (38 x 46 cm)
Private collection (PV75)

60

View of Marly-le-Roi. 1870

Oil on canvas, 18¼ x 27¾" (47 x 71 cm)
Private collection (PV93)

It is patent that Pissarro in his Louveciennes work conspicuously exploited and experimented with all sorts of perspectival devices. Instead of taking a wide-focus angle embracing a vast slice of vista on a river, as in *The Marne at Chennevières* (fig. 39), or on a field, as in *The Banks of the Marne in Winter* (fig. 41), Pissarro, after painting *Printemps à Louveciennes* (fig. 50), planted his easel inside the village, and tended to crop (or to limit) the breadth of his visual field. As ever with Pissarro, a few notable and astonishing exceptions are to be noted: *Road to Louveciennes* (fig. 59), for instance, or *View of Marly-le-Roi* (fig. 60), and in particular, *The Road to*

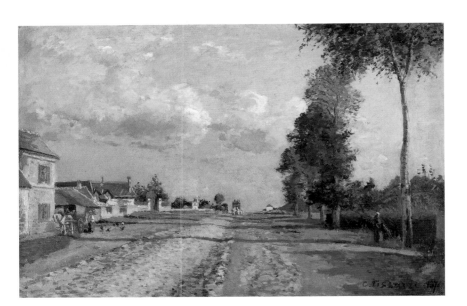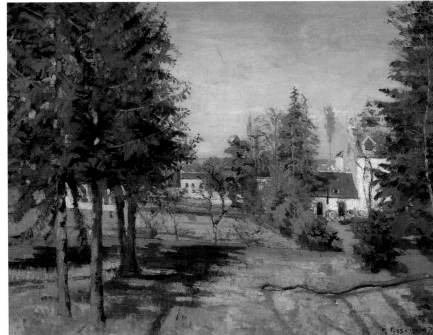

The Road to Rocquencourt. 1871

Oil on canvas, 20 x 30¼" (51 x 77.6 cm)
Private collection (PV 118)

62

The Pine Trees at Louveciennes. 1870

Oil on canvas, 27 x 30½" (69 x 78 cm)
Private collection (PV 86)

Opposite:

63

Groves of Chestnut Trees at Louveciennes. 1872

Oil on canvas, 16 x 21" (41 x 54 cm)
Mr. and Mrs. Alexander Lewyt (PV 148)

64

Chestnut Trees at Louveciennes, Spring. 1870

Oil on canvas, 23½ x 28¾" (60 x 73 cm)
The Langmatt Foundation, Sidney and Jenny
Brown, Baden, Switzerland (PV 88)

Rocquencourt (fig. 61), executed during the latter part of his Louveciennes stay and in which the composition embraces a very wide perspective on a subtle ascent up a street so as to produce a truly spectacular impact.

Even in a picture as apparently simple as *The Pine Trees at Louveciennes* (fig. 62), the perspective also appears to be of central concern to the artist. The subject matter consists of little more than a few pine trees, the backs of some houses, a plot of sky, grass and earth, a dead branch, and a signature. Yet everything is organized by a fragmented perspective system, with a row of pines progressing diagonally from the lower left corner to the center, the axis of which is emphasized by an oblique parallel shadow of an unseen tree trunk also pointing towards the center of the composition. This shadow is met by its counterpart: a successive row of shadows of other unseen trees in the lower right foreground, pointing from the lower right corner towards the center, and thus creating the second edge of the perspectival triangle.

These shadows are interrupted by a jagged tree branch lying on the ground. Their progression is, however, resumed by another row of pine trees which start, within this composition, at the level where the shadows of the first row of trees (from lower left to center) have been neatly clipped—at the cutting edge of a plot of worked land. If these two complementary rows of trees could meet, although one (left) has no background and the other (right) has no foreground, they would probably meet in front of the house, more or less at the center of the composition where, precisely, nothing happens.

Two notions summarize in a general way what Pissarro's Louveciennes period was about: shadow and structure. The shadows point to the immaterial, the perpetually changing, and yet plastically unavoidable mark of things; they can be shadows of trees, *Groves of Chestnut Trees at Louveciennes* (fig. 63), *Chestnut Trees at Louveciennes, Spring* (fig. 64), *The Road to Rocquencourt* (fig. 61), or of trees, buildings, and figures, as in the autumn scene *Landscape near Louveciennes*

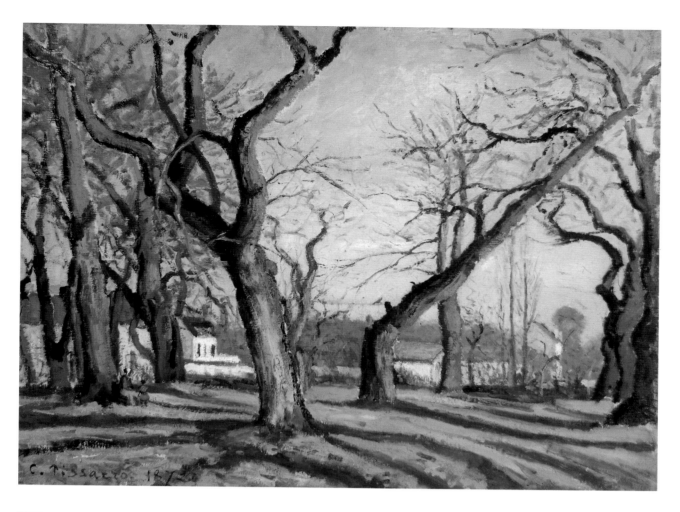

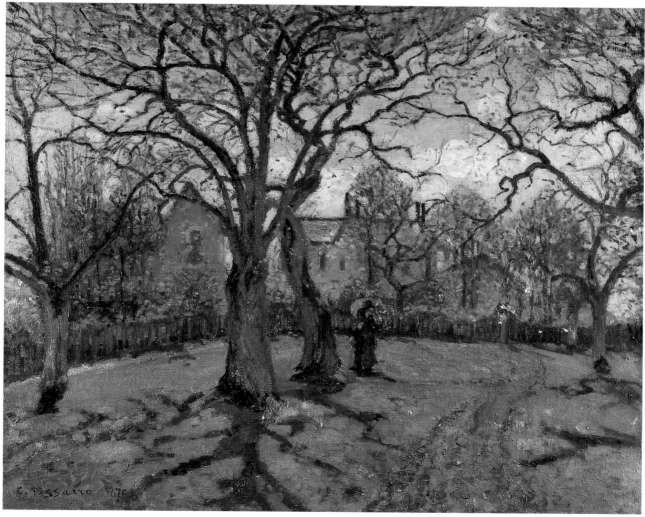

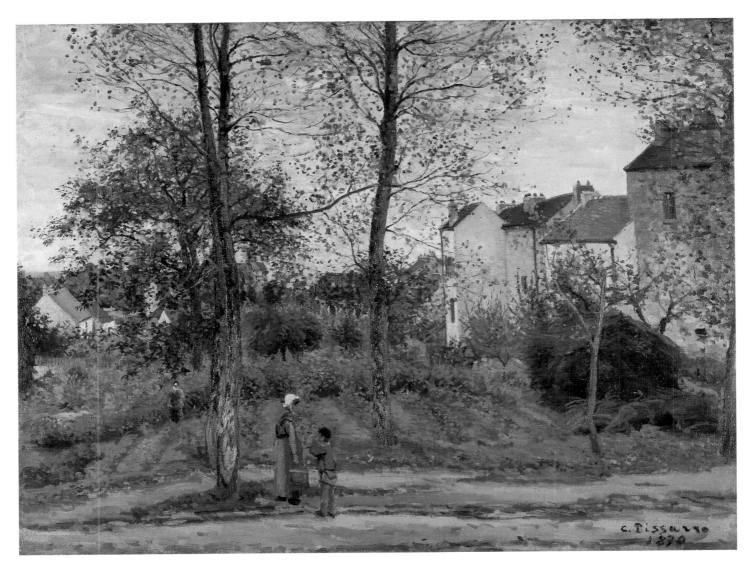

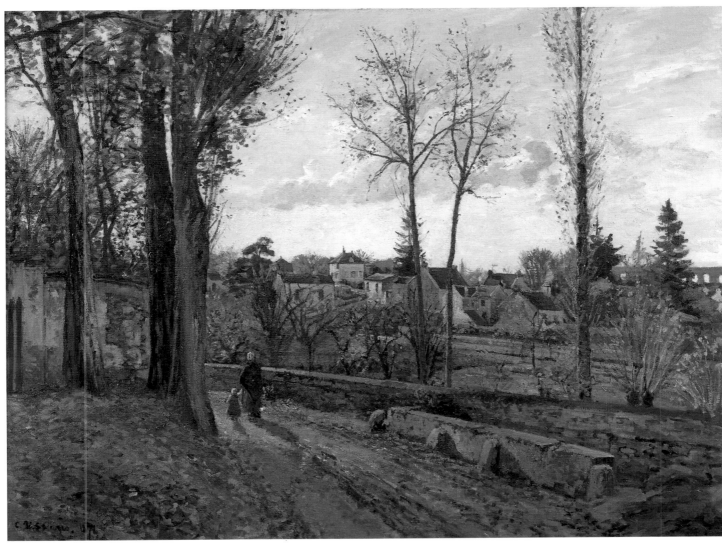

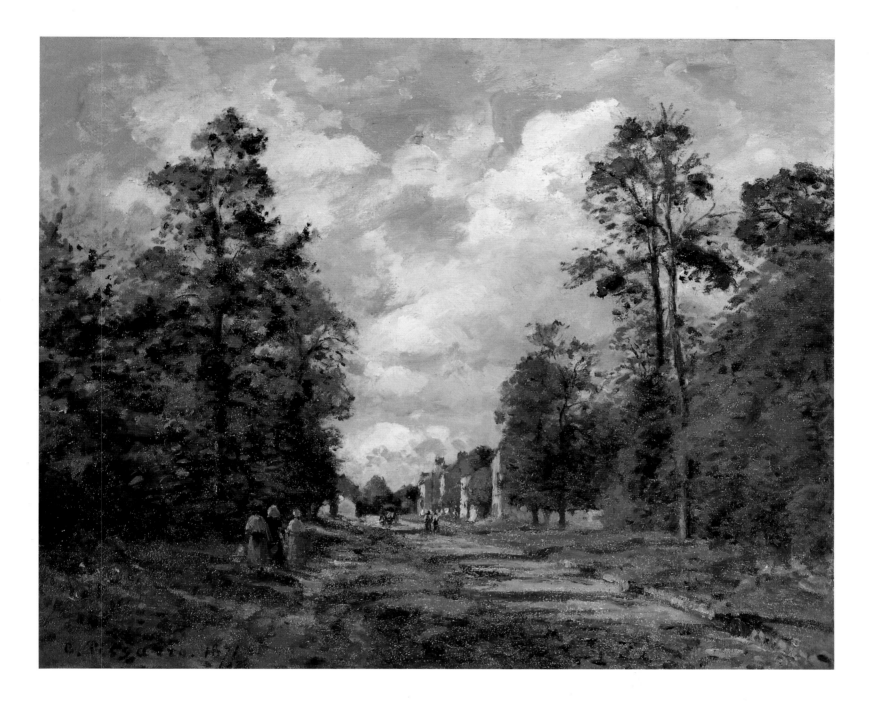

Opposite:

65

Landscape near Louveciennes. 1870

Oil on canvas, 35¼ x 45¾" (89 x 116 cm)
Collection J. Paul Getty Museum, Malibu,
California (PV87)

66

Louveciennes. 1871

Oil on canvas, 43 x 62½" (110 x 160 cm)
Private collection (PV 123)

Above:

67

*The Road to Louveciennes, at the Outskirts
of the Forest.* 1871

Oil on canvas, 15 x 18" (38 x 46 cm)
Private collection (PV 120)

(fig. 65), *The Road to Versailles at Louveciennes* (fig. 58), and *Louveciennes* (fig. 66).
Structures are provided by the street contexts, inducing the gaze of the viewer inside
the picture plane through their sidewalks, whose street-edge lines never quite meet.

Alleys of trees, groupings of houses intermittently placed along the sidewalks,
and even the figures gently evolving on the neatly delineated streets, all contribute to
evoke a sense of subtle order inherent in the quiet rhythm of a rural French village.

Shadows, particularly in the second Louveciennes period, disrupt the gentle,
quiet order which infuses those rural dwellings, as in *The Road to Rocquencourt*
(fig. 61), *Outskirts of Louveciennes, the Road* (fig. 56), and *The Road to Louveciennes,
at the Outskirts of the Forest* (fig. 67). In *The Road to Versailles at Louveciennes*
(fig. 58), they give the monumentality of the unusual vertical format an air of fragility
or, at least, of experimentation. The same contrast can be observed through *Landscape
near Louveciennes* (fig. 65) or *Louveciennes* (fig. 66).

In *Chestnut Trees at Louveciennes, Spring* (fig. 64) and *Groves of Chestnut
Trees at Louveciennes* (fig. 63) shadows seem to determine the whole visual field;

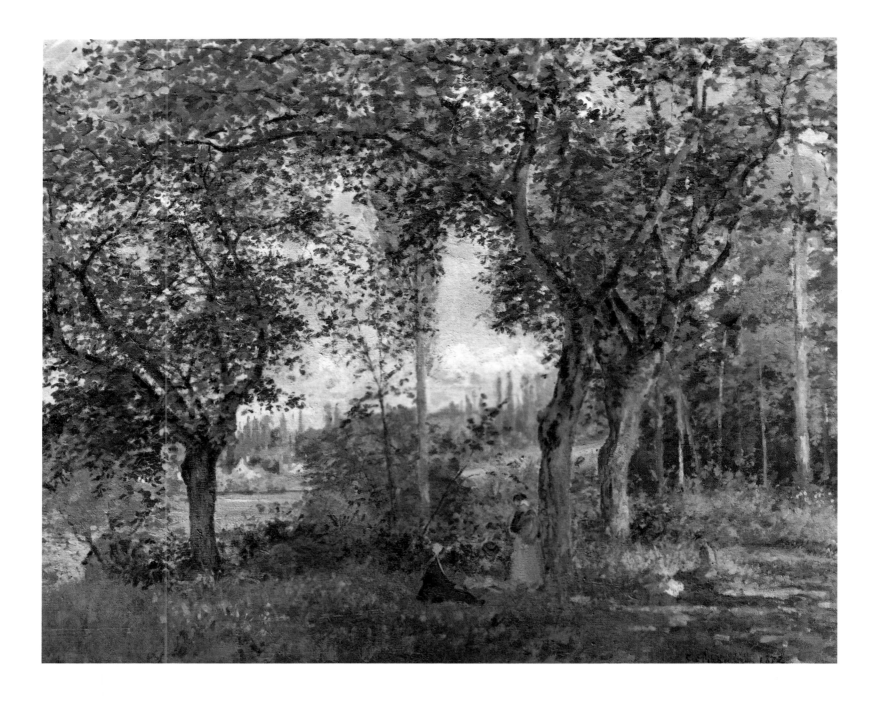

68

Landscape with Strollers Resting Under Trees.
1872

Oil on canvas, 29 x 36" (74 x 92 cm)
Thyssen-Bornemisza Collection, Lugano,
Switzerland (PV 167)

they have almost taken over the entire ground. Both these pictures offer apt examples for Jules-Antoine Castagnary's remarks a few years later: "Pissarro is sober and strong. His synthesizing eye embraces the whole scene at a glance. He commits the grave error of painting fields with shadows cast by trees placed outside the frame. As a result the viewer is left to suppose they exist, as he cannot see them."[8]

One of the persistent beliefs about Impressionism is that the artistic, innovative movement was all about painting light or atmospheric effects. It would be more exact to say that the Impressionists painted light insofar as it produced its inevitable countereffect—shadow. Furthermore, perhaps one of the inventions of the Impressionists was that light was made visible only through its absence or its opposite—*shadow*; the exquisite silvery patches of light spiking on the ground or the freckling light screened through foliage was an archetype of the Impressionist vision. *Landscape with Strollers Resting Under Trees* (fig. 68) and *The House in the Forest* (fig. 69) exist only through the exact diagram of their negative: the shadows define and

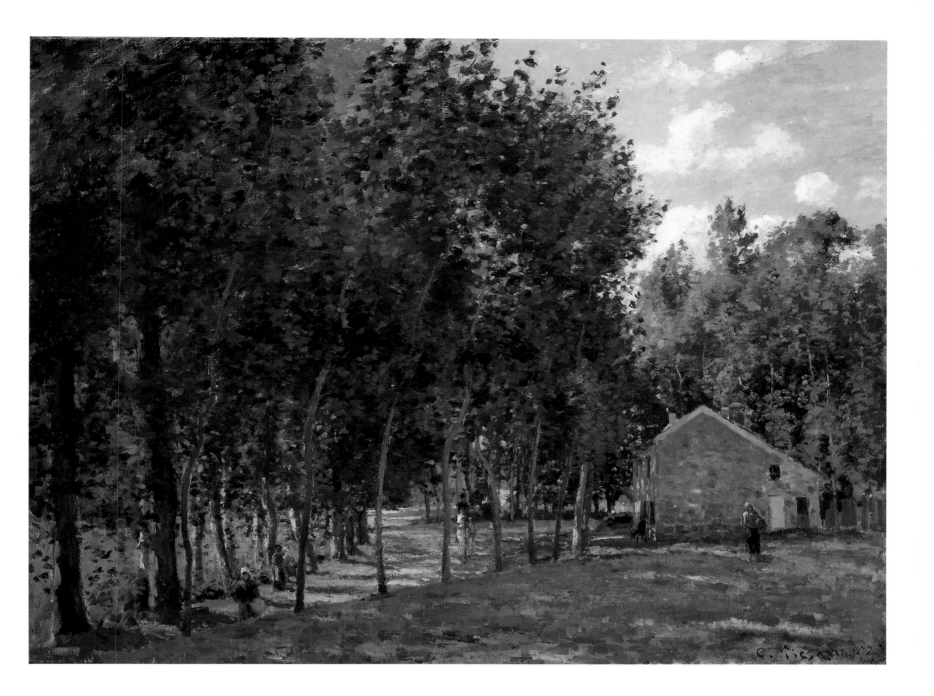

69

The House in the Forest. 1872

Oil on canvas, 19½ x 25¼" (50 x 65 cm)
Private collection, United States (PV 181)

distribute light, and vice versa, light projects and constructs the shadows. These constant flows of light changes, along with atmospheric changes, are measurable and perceptible only through the unchanging contextual reality—the walls, streets, trees, and sidewalks that look the same from one day to the next, and guide our steps and gazes.

To the extent that the Louveciennes works depict the polymorphic oppositions between those permanent structures and the transient variations affecting those structures, they are preeminently Impressionistic. Hence the sense of dichotomy in Pissarro's Louveciennes pictures, emphasized by Duret in his criticism—a dichotomy inextricable from vision itself.

Simply put, Pissarro was grappling with identifiable locations in Louveciennes; they are one of the easiest groups to situate because Pissarro took close vantage points for each composition: *The Road: Rain Effect* (fig. 52), *The Road to Versailles at Louveciennes* (fig. 58), *Outskirts of Louveciennes, the Road* (fig. 56), *La Route*

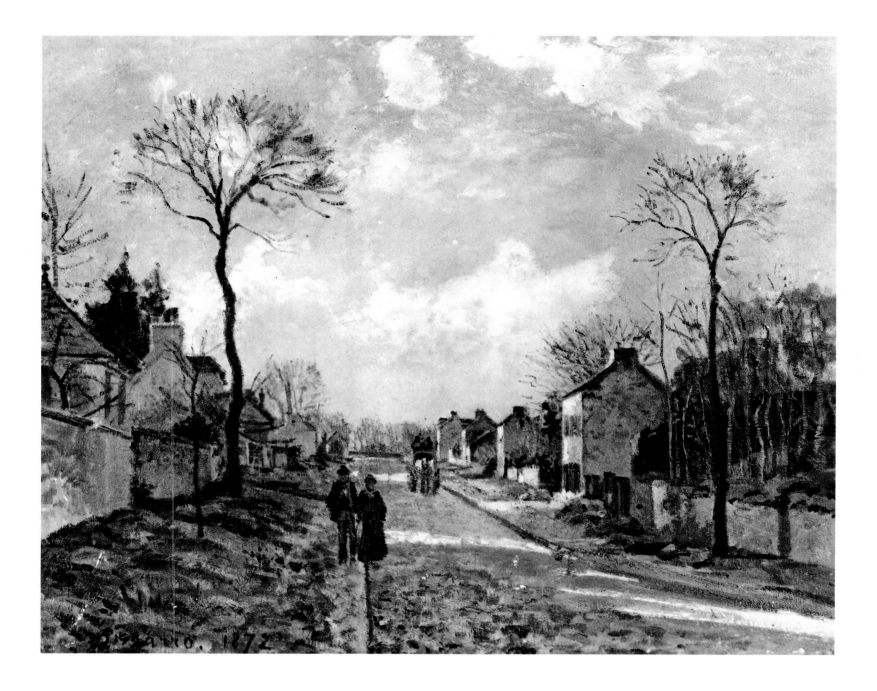

70

La Route de Louveciennes. 1872

Oil on canvas, 23½ x 28¾" (60 x 73 cm)
Musée d'Orsay, Paris (PV 138)

Opposite:

71

Pierre-Auguste Renoir
A Road in Louveciennes. c. 1870–75

Oil on canvas, 15 x 18¼" (38.5 x 46.8 cm)
The Metropolitan Museum of Art, New York.
Bequest of Emma A. Sheafer, 1974. The Lesley
and Emma Sheafer Collection

72

Paul Cézanne
Louveciennes. 1872

Oil on canvas, 28¾ x 36" (73 x 92 cm)
Private collection (V 153)

de Louveciennes (fig. 70). Renoir gives a comparable scene a distinctly more rural treatment in *A Road in Louveciennes* (fig. 71).

Each composition offers a different study of the same road to Versailles where Pissarro lived, under different weather or light effects and from slightly shifting viewpoints: thus, these riveting works emphatically illustrate the fact that "the difference of a temporal interval and thus also an element of otherness is inherent in the spontaneity of the living moment."[9] Thus the Louveciennes works by Pissarro, and, to various extents, by most of the other Impressionists, offer not merely an immediate precedent for the opening of the Impressionist decade but also point towards the end of Impressionism, in the 1890s, when serial procedures were explored by Monet, Pissarro, Sisley, and Cézanne.[10] In this sense it is perhaps not just a coincidental occurrence that the first pair of paintings with an identical motif by both Pissarro and Cézanne happened to depict a view of Louveciennes (figs. 66 and 72, respectively).

London 1870–71: The Franco-Prussian War

*P*issarro's sojourn in London can be seen as a parenthesis within the larger Louveciennes period. It represented a crucial time in his artistic career, despite the fact that his output may appear very meager. There, too, Pissarro and the mother of his children were married.

As we know, when the Franco-Prussian War threw Pissarro's plans into total disarray, he and Julie and their two children first took refuge with Ludovic Piette and his family in Montfoucault. Pissarro had met Ludovic Piette at the Académie Suisse around 1860; both artists became very close friends and remained so until Piette's death in 1878.

It is largely unclear why Pissarro decided to leave for London with his family while enjoying welcoming shelter at the Piettes' home. Two letters, unpublished until recently and never before published together, shed light on Pissarro's intense personal problems at the time, which, in all likelihood, overruled any artistic considerations for a short period.

The first letter is from Piette, written shortly after war broke out, expressing his own and his wife's joy at the prospect of having the Pissarros stay with them. The letter is filled mainly with practical instructions about how to go from Paris to their tiny hamlet in Brittany. The letter is so precise and detailed about all the possible alternatives that it easily deserves a place among the archives of the history of transportation.

What demands attention in the present context, however, is Piette's postscript: "You know, my dear Pissarro, that we have to live with wolves; living in a land of prejudice, I am forced to accept it in order to avoid gossips. Consequently, as the rule goes, I must pretend that you are married, and you have to let them believe it; this will cut short all the ramblings. I should think that you will agree with me; this is stupid but necessary."[1] Without a doubt, this note would have fueled Julie's already

grave anxieties about her own situation; she was not married to the father of her children and was now eight months pregnant with a third child. Worst of all, she was still totally rejected or ignored by Camille's family, his mother in particular.

Julie undoubtedly put pressure on Camille to marry her and legalize their union. This is evidenced by a letter from Pissarro's mother, who, having first given way to Camille's pressing request to consent to a wedding, wrote to him to express her acceptance of the *fait accompli*. Extraordinarily, however, she soon wrote a second letter, which sheds light on why Pissarro and Julie went to London:

> As a mother, to make you happy, and without reflection, I have answered yes. That caused me to be ill the night long and I have decided to write to say that this consent distresses me very much. I rely on you then and if you have any consideration for me you will send me back the letter because I had written it without sufficient thought for a matter of such importance. . . . Wait until all these events [probably a reference to the Franco-Prussian War] are over, then you could go to London and there marry without my consent and without anyone knowing about it. I will supply you with the money for this trip. God willing.[2]

Things went from bad to worse as far as Camille and Julie's situation was concerned. Julie gave birth to a little girl, Adèle-Emma, October 21, while in Montfoucault. The infant caught an intestinal infection from a wet nurse and died three weeks later, November 15.[3] In the meantime, Pissarro's mother, in fear of the Prussian army, left for London, where one of her daughters lived. There she was able to send a condolence notice to her son which needs no comment: "You announce to me the death of the little girl Adèle. I am very upset for you but then one must console oneself in thinking that the poor little one is out of this world where there are very few pleasures for very many sorrows."[4]

Two weeks later, Camille, Julie, and their two other children, Lucien and Jeanne (aged seven and five), left Montfoucault for London. Pissarro was determined to resolve his family situation for good and was probably still hoping that he could convince his mother to reconsider her decision once more and agree to recognize Julie. This was in vain. Pissarro married Julie quietly, June 14, 1871, at the City Hall of Croydon. Two weeks later their seven-month stay in London came to an end and they returned to Louveciennes. Pissarro had been relatively unimpressed by England, as he had explained in a letter to Duret only a few weeks before his departure from London, although it should be noted that two decades later, he traveled regularly to England, mainly in order to visit his son Lucien, who lived there. In 1870, he however found little that appealed to him in London:

> I am here for only a very short time. I count on returning to France as soon as possible. Yes, my dear Duret, I will not stay here, and it is only abroad that one feels how beautiful, great, and hospitable France is. What a difference here! One gathers only scorn, indifference, and even rudeness; among colleagues there is the most selfish jealousy and resentment. Here there is no art; everything is a question of business. As far as matters of sales are concerned, I have done nothing except with [Paul] Durand-Ruel, who has bought two small paintings from me. My painting doesn't catch on, not at all; a fate that pursues me more or less everywhere.[5]

During his short stay in London (December 1870–July 1871), Pissarro had left a painting at Durand-Ruel's gallery and soon received a friendly note from the dealer, whom he had not yet met: "My dear sir, you brought me a charming picture and I regret not having been in my gallery to pay you my respects in person. Tell me, please, the price you want and be kind enough to send me others when you are able to. I have to sell a lot of your work here. Your friend Monet asked me for your address. He did not know that you were in England."[6]

This letter seems to confirm that Pissarro's main motivations for going to England were not artistic ones. He had not specifically arranged to meet Durand-Ruel or written to notify him of his trip to London. Instead, he dropped by casually, as it made sense for a French artist of the younger generation who was in London to come and visit the gallery of the "son of the man who for many years had been the dealer of the Barbizon painters and had—by obstinacy and courage—contributed to their final recognition."[7]

It is quite remarkable that Pissarro, having spent only seven months in London, produced around fifteen paintings and a number of works on paper of considerable variety. By contrast, there is not one painting known of Montfoucault during his four-month stay there. In fact, it is highly likely that he had taken his Louveciennes paintings to Montfoucault and reworked them there (while most of his time there must have been consumed by his family worries). This is the only way to explain how so many of his 1870 Louveciennes views survived while, as we have seen, so few works prior to the Franco-Prussian War survived.

London, with all the troubles associated with the sojourn there, marked a total pictorial break for Pissarro. New images, colors, techniques, and poetics were suddenly introduced into his work, momentarily interrupting the more rigid, architectonic concerns he had in Louveciennes.

When his eldest son, Lucien, was twenty, and in his turn reached London, Pissarro relived his memories in a letter not without a few poetic overtones: "I remember perfectly those multicolored houses, and the desire I had at the time to interrupt my journey and make for myself some interesting studies. But it would be a long trip indeed if one had to stop at every attractive town or village, at every beautiful motif—although this would be a dream for a painter to be able to stop and then go on his way and always go on and stop."[8]

This is precisely what Pissarro had done. He interrupted his journey, executed a few curious studies, and resumed his course, with a wife on his arm.

In fact, in London, Pissarro was very much on his own, artistically. As he wrote in 1902 to Wynford Dewhurst, an English landscape painter, "Monet worked in the parks, whilst I, living at Lower Norwood, at that time a charming suburb, studied the effects of fog, snow, and springtime."[9] Any Londoner would readily appreciate the distance between the central High Street Kensington, where Monet lived and worked—unbeknown to Pissarro—and Lower Norwood, across the Thames, in the southern suburbs of London. Monet would paint various motifs of nearby Hyde Park, with wide expanses of green contrasting with the rather strictly organized perspectival views with which he had depicted Louveciennes. When he and Pissarro met, it was to go and look at the Turners and the Constables at the South Kensington Museum (later the Victoria and Albert) rather than to paint side by side.

73

*La Route de Sydenham, Londres
(The Avenue, Sydenham, London).* 1871

Gouache, 5⅞ x 9¾" (15 x 25 cm)
Musée du Louvre, Cabinet des Dessins
(Fonds du Musée d'Orsay) (PV 1320)

74

The Avenue, Sydenham. 1871

Oil on canvas, 19¼ x 28¾" (49 x 73 cm)
The National Gallery, London (PV 110)

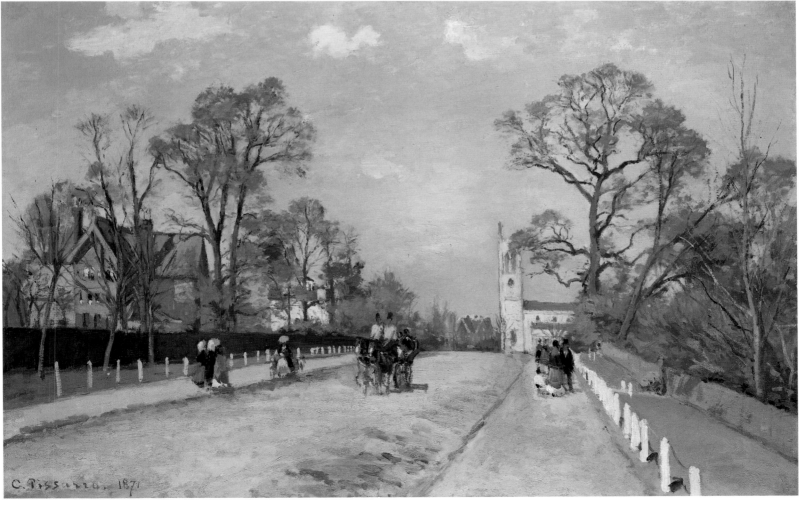

75

View from Upper Norwood. 1871

Pen and brown ink over pencil,
5⅞ x 8" (15 x 20 cm)
Ashmolean Museum, Oxford

76

Landscape at Lower Norwood. 1870

Gouache, 9¾ x 15" (25 x 38 cm)
Whereabouts unknown

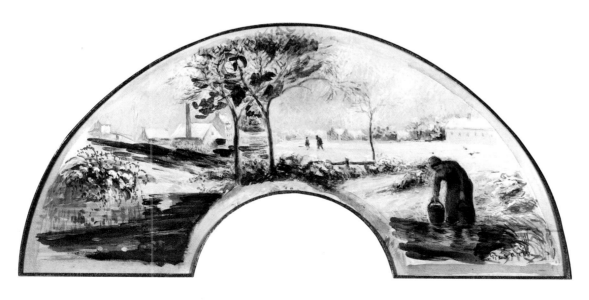

77

Winter Scene. 1879

Gouache and watercolor on paper,
10⅞ x 22¾" (27.9 x 584 cm)
Museum of Fine Arts, Springfield,
Massachusetts. The Robert J. Freedman
Memorial Collection

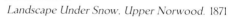

78

Landscape Under Snow, Upper Norwood. 1871

Oil on canvas, 17¼ x 21½" (44.5 x 55 cm)
Collection Rosengart

One should, of course, bear in mind that in 1902, when Pissarro wrote his letter to Dewhurst, he was in the midst of painting his series of urban views under different effects. Therefore, he may well retrospectively have wished to emphasize himself as nourishing the same pictorial concerns in 1870 in London as he did at the time he wrote that letter. He may also have been prompted to stress that long before Monet's much acclaimed Parliament series, he had been concerned with rendering atmospheric effects in London, while Monet was only painting "in the parks." In reality, Pissarro's London output presents several noteworthy departures from his previous work. He concentrated on several major groups of studies towards paintings. It is the first time that a solid complementary connection can be noticed between his work on paper and his canvases. One of the most straightforward examples of this can be observed in the direct relationship between the gouache of the Avenue, Sydenham (fig. 73) and the finished oil painting (fig. 74) which resulted from it.

Two of these groups of preparatory works are especially revealing. Each work within the group is differentiated by a different medium, format, weather effect, or vantage point or by wholly different compositional elements. All the works within a group, however, depict the same rather circumscribed area or subject.

The first group consists of broad renderings of a portion of the landscape around Upper and Lower Norwood: a drawing, *View from Upper Norwood* (fig. 75), a gouache of the same view, *Landscape at Lower Norwood* (fig. 76),[10] a painting, *Landscape Under the Snow, Upper Norwood* (fig. 78), and a fan, *Winter Scene* (fig. 77).[11]

To understand what is at stake in the formation and conception of these works, one must look at the formal, poetic, and imaginative decisions which presided over their creation. The subject of *View from Upper Norwood, London* at first looks simple: the rather tranquil, bucolic mood of the landscape with cows grazing in the foreground is upset by the turbulent, industrial background, with smoke emerging from tall chimneys, offering a fertile ground for certain types of socioeconomic interpretations. These clouds of smoke are brought in to fuse and intermingle with the atmospheric environment in many of Pissarro's industrial pictures—the smoke dissolving into the clouds so that it is difficult to dissect each component.

Another opposition can be noted between the dynamic composition of this drawing and the staticness of some of its components: between the train, for instance, speeding across the drawing sheet and over the vast expanse of landscape represented there, and the slow, nearly immobile life rhythm of the cows; this in turn could point to a link between the dynamic speed and movement within the scene and the distinctly contrasting tempos of the artist's nib lines (swiftly executed doodles versus gently plotted units). An unusual recourse to an **X**-shaped system of double perspective further emphasizes the duality of Pissarro's compositional procedures, whereby the first perspective triangle (whose base joins together the lower left and right corners and whose summit meets at the point of the trees in the middle ground) is counteracted by an asymmetrically opposed triangle (going from the base of the trees in the middle, upward left and right, and encompassing the whole horizon line).

Landscape at Lower Norwood, in contrast, is much more traditional in its composition. No oppositions can be found. Instead, the liquid texture of the gouache serves as an equivalent for the swampy thawing ground. Every topographical element in the gouache is also recognizable in the painting, *Landscape Under Snow, Upper Norwood*—except the snow. This brings us back to Pissarro's letter of 1902, where he emphasized his interest in studying "fog, snow, and springtime" effects, rather than any particular subject matter.

In keeping with this claim that he had painted atmospheric effects in London, the "modernist" industrial smoke becomes an aspect of his complex interpretation of the overall atmospheric envelope—the smoke interfering with the mist or the clouds is a theme that finds a particularly rich echo throughout Pissarro's *oeuvre*.

Contemporary, but in utter contrast to these works, are several drawings of All Saints' Church, Upper Norwood,[12] and a painting, *All Saints' Church, Upper Norwood* (figs. 79–84),[13] which all represent the church from different angles, in different mediums and supports, in different formats, with different weather effects, and different forms of traffic.

The drawing, *View from Upper Norwood* (fig. 75), distinctly features a train crossing the West Norwood urban landscape from right to left, from the Norwood Junction to the Crystal Palace station. In London for the first time trains took on an important role within Pissarro's iconography; see, for instance, the striking frontal treatment of *Lordship Lane Station* (fig. 86) or the background animated by the train's smoke in *Near Sydenham Hill* (fig. 85).

Abundant emphasis has been placed on the frequent representations of trains in Impressionism. This can, of course, be paralleled with the numerous documents which convey "how the first railroads revolutionized the contemporary experience of

79

Study for *All Saints' Church, Upper Norwood.* 1871

Gouache, dimensions unknown
From the collection of Senator E. Leo Kolber
and Sandra Kolber

80

All Saints' Church, Upper Norwood. 1871

Oil on canvas, 18 x 21½" (46 x 55 cm)
Private collection (PV 108)

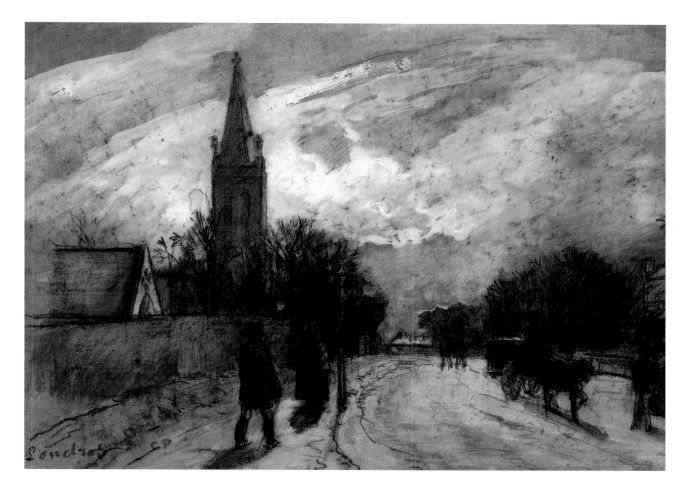

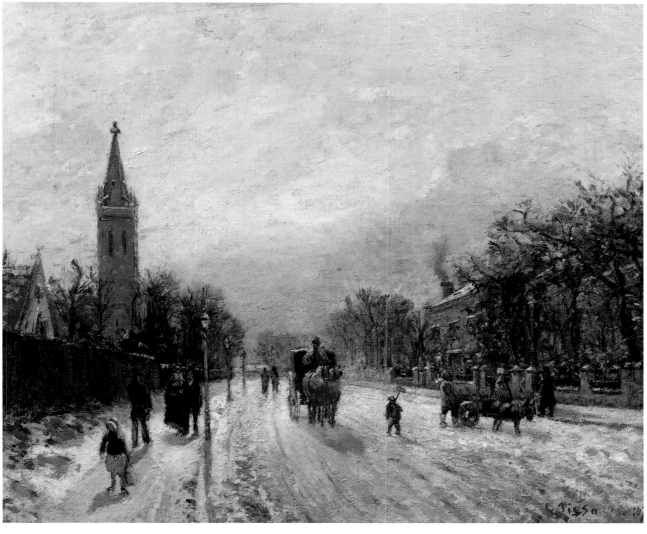

81

Study of *Upper Norwood, London,*
with All Saints' Church. 1871

Pencil, 6 x 7¾" (15.6 x 19.8 cm)
Ashmolean Museum, Oxford

82

Study of *All Saints' Church,*
Upper Norwood, London. 1871

Pencil, 6 x 7¾" (15.6 x 19.8 cm)
Ashmolean Museum, Oxford

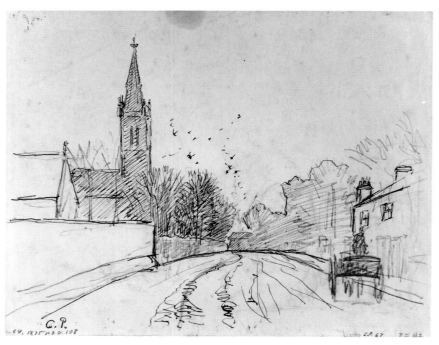

83

Study of *Upper Norwood, London,*
with All Saints' Church. 1871

Pen and brown ink over pencil,
6 x 8" (15.5 x 20 cm)
Ashmolean Museum, Oxford

84

Study of *Upper Norwood, London,*
with All Saints' Church. 1871

Watercolor over black chalk with traces
of pencil, 9¾ x 15" (24.9 x 38.5 cm)
Ashmolean Museum, Oxford

85

Near Sydenham Hill. 1871

Oil on canvas. 17 x 21" (43.6 x 53.8 cm)
Kimbell Art Museum. Fort Worth. Texas (PV 115)

space and time."[14] More precisely, even if the railway did not itself create the modern consciousness of time, it unquestionably tended to transform the modern time consciousness. "The locomotive became the popular symbol of the dizzying mobilization of all life-conditions that was interpreted as progress. It was no longer only intellectual elites who experienced the release of the day-to-day world from boundaries fixed by tradition."[15]

In the terms of the most extreme functionalist or deterministic interpretations, the frequent occurrence of trains in Pissarro's London works has to be seen as a mark or a symptom of his awareness of industrial progress. Marxian interpreters might go on from this to see his trains as testifying to the "uninterrupted disturbance of all social conditions, everlasting uncertainty and agitation," which eventually leads to the "revolution in the modes of production and exchange."[16]

Within today's art historical discourse, the eruption of trains among other elements of modernist paraphernalia within Pissarro's imagery in the 1870s calls for a novel type of questioning, for although without the Industrial Revolution, Pissarro

86

Lordship Lane Station. 1871

Oil on canvas, 17½ x 28¾" (45 x 73 cm)
Courtauld Institute Galleries, London
(Courtauld Collection) (PV 111)

87

Dulwich College, London. 1871

Oil on canvas, 19½ x 23¾" (50 x 61 cm)
Private collection (PV 116)

could not possibly have represented trains, it logically does not follow at all that the Industrial Revolution intrinsically implied that Pissarro had to represent trains, and certainly, it does not explain why he represented trains as he did.

Again, what is fascinating here is the passage from trains to churches or vice versa—or both, as in *Near Sydenham Hill* (fig. 85). In a totally undoctrinaire fashion, Pissarro noted what might crop up in front of his eye and mind: a church or a factory or the Crystal Palace, cows or crowds, a street scene or an open landscape, a snow effect, a rain effect, or a smoke effect. Within his compositions, these all acted as pictorial equivalents, though performing different symbolic or other functions.

In the same way, as Pissarro wandered around the tower of All Saints' Church, sketching it from north (fig. 81) and south (fig. 82), he seemed to emphasize that even when painting or drawing the divine, or a place of worship, one cannot escape the contingent, the ever-changing reality.

These drawings of All Saints' Church should all be seen as complementing each other. They do not follow the same trail, but rather, although they are drawn from different angles and use different techniques, formats, and effects, they each inform the other around the same motif. All of this can be seen converging in *All Saints' Church, Upper Norwood* (fig. 80), where, compared to the drawings, the church spire has been trimmed, the turrets reduced, and the spire cross enlarged. Furthermore, it is as though the snow had just covered the ground in the painting, even obscuring part of the artist's signature.

In London, Pissarro experimented not only with a greater array of techniques than in France, which combined and complemented each other, he also used all sorts of innovative compositional devices, creating new links among his London works. In *Upper Norwood, Crystal Palace, London* (fig. 2), depicting the back of the Crystal Palace, a sharply turning road provides a brilliant variation on the straight lane, with busy pedestrian and carriage traffic, that runs in front in *The Crystal Palace* (fig. 88). The architectural reflection in the water in *Dulwich College, London* (fig. 87) can be seen as a counterpoint to *Near Sydenham Hill* (fig. 85). In the former, the distorted reflection provides the only existing spatial depth, and it acts as a metaphoric mirror of the artist's activity. Otherwise, the painting offers a completely closed perspective field. The latter painting opens onto a vast vista, with no other limitation than the horizon line in the misty distance, yet the two works present certain structural parallels. Both are centered inside a space defined by two vertical axes, left and right, held by two groups of trees (and their reflections or shadows), which constitute an inner frame inside the picture. (The dual perspective axes recall several of the road scenes Pissarro had done a few years earlier in Louveciennes.)

The recourse to strict perspective, as in *The Crystal Palace* (fig. 88) and *La Route de Sydenham, Londres* (fig. 73), or to a turning perspective, as in *Lordship Lane Station* (fig. 86) and *Upper Norwood, Crystal Palace, London* (fig. 2), fulfills functions analogous to those of the *repoussoir* trees in figs. 85 and 87. They direct the viewer's gaze inside the picture and offer an anchoring point to our eyes amid all these vividly animated surfaces.

Despite the severe circumstances during his seven months in London, Pissarro could have hardly been more inventive, more pictorially daring, or more broadminded. It was in London that Pissarro's work took a resolutely modernist turn.

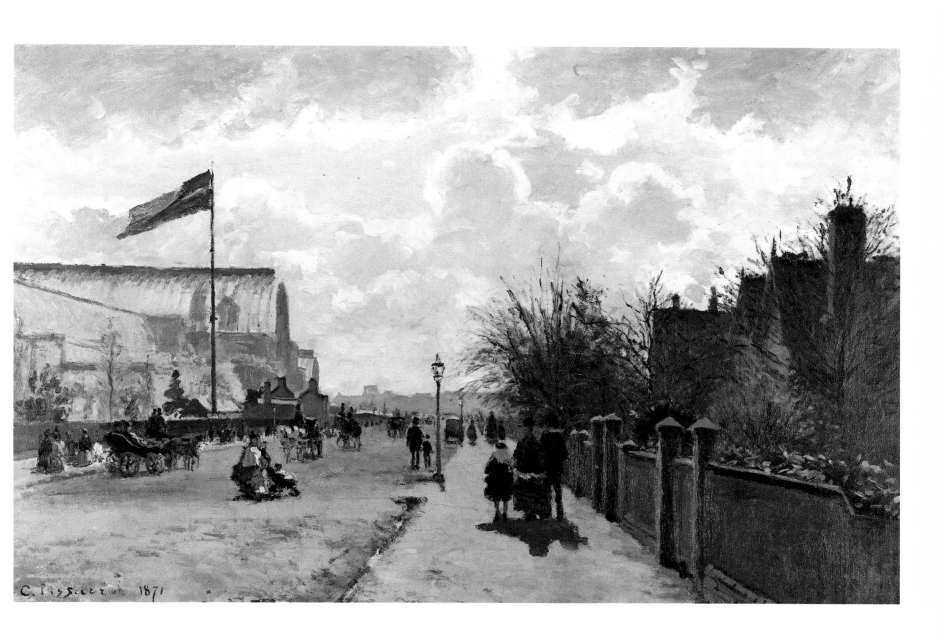

88 _____

The Crystal Palace. 1871

Oil on canvas, 18½ x 28⅞" (47.2 x 73.5 cm)
The Art Institute of Chicago
Gift of Mr. and Mrs. B. E. Bensinger.
1972.1164 (PV 109)

Pontoise and Auvers 1872–82: Impressionism

89

View of Pontoise, the Wooden Train. 1872

Oil on canvas, 23 x 31" (59 x 80 cm)
Private collection (PV159)

90

*The Railroad Crossing at Les Pâtis,
near Pontoise.* 1873-74

Oil on canvas, dated twice,
25¼ x 31½" (65 x 81 cm)
The Phillips Family Collection (PV266)

*I*n August 1872, Pissarro left Louveciennes, where he had returned after his short sojourn in London, and moved to Pontoise for the second time. Over the next ten years, Pissarro, whom Cézanne called "the first Impressionist,"[1] developed his contribution to Impressionism in his own way, and concurrently with Cézanne and Degas, in particular, while living in the Pontoise region.

Pontoise, located some twenty-five miles northwest of Paris, had been an important town in the Middle Ages. Its hilltop situation enabled it to serve as a fortress, while the River Oise, which passes through it, made it an inland port, as is evident in *View of Pontoise, the Wooden Train* (fig. 89). Agriculture had dominated the town's economy until the nineteenth century, and the construction of factories and a railway line in the nineteenth century helped the town to recover from the decline it had suffered by the end of the previous century.

In contrast to Louveciennes, a village of a few hundred inhabitants, Pontoise had a population of several thousand and was a bustling center of poultry and vegetable supplies. Pissarro's new home had a rich variety of architecture that reflected superimposed layers of history, which, along with the ceaseless activity of its budding industry and the railway linking it to the capital—visible in *View of Pontoise, the Wooden Train* and *The Railroad Crossing at Les Pâtis, near Pontoise* (fig. 90)—presented the painter with a varied and complex range of subjects.[2]

In and around Pontoise, Pissarro alternated his work almost entirely among three zones of interest: the complex multifaceted market town of Pontoise; L'Hermitage, a rural district on the outskirts of the town, and Auvers, a small elongated village right next to Pontoise and squeezed between the River Oise and the high chalk cliffs which run alongside it.

Probably the most important reason for Pissarro's decision to move to the Pontoise-Auvers area was the fact that the homeopathic doctor and engraver Dr.

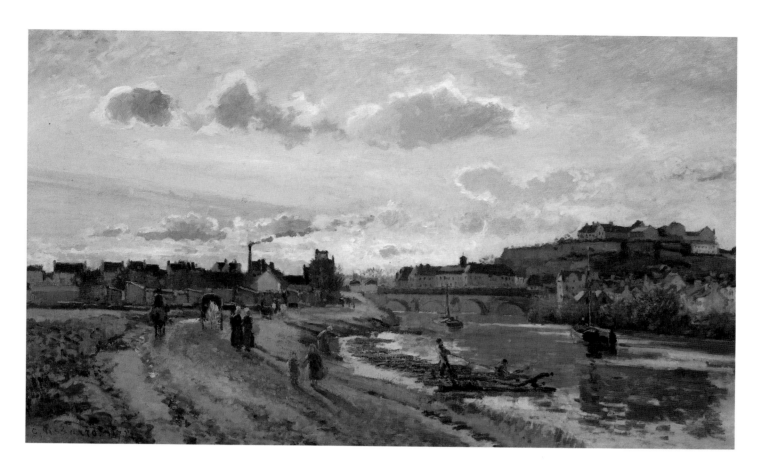

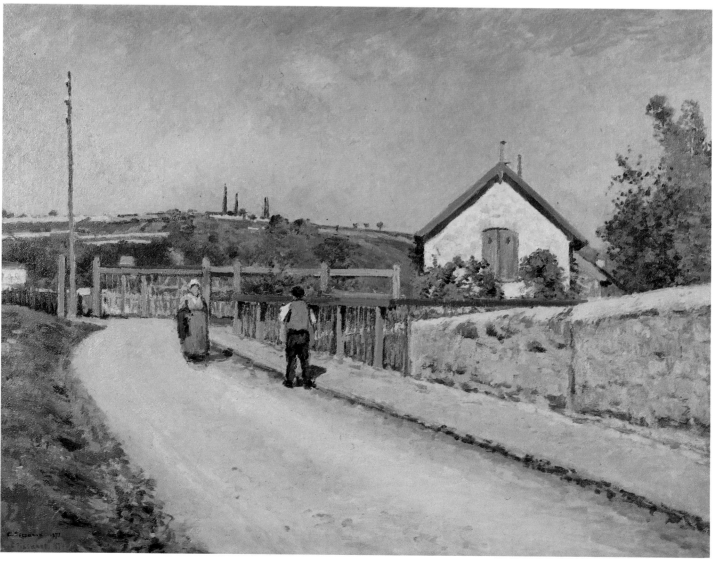

Paul Gachet, had bought a house in Auvers, in the spring of 1872 (when Pissarro was still in Louveciennes). Dr. Gachet had treated Rachel, Pissarro's mother, in Paris in 1865 and for many years after. (Gachet was Van Gogh's last doctor and the subject of three portraits by him.)

Before Pissarro decided to move to Pontoise, several artists who were important to him had settled in the vicinity. Corot had lived in Pontoise itself. Daubigny had kept his boat-studio moored in Auvers, and at the end of his life owned two houses there. Daumier had lived in Valmondois, a village nearby. Shortly after the Pissarros moved to Pontoise, Cézanne, who had befriended the older artist at the Académie Suisse in the sixties, came to stay with Pissarro and his family. This marked the beginning of a relationship truly crucial to the formation and development of Impressionism.

Cézanne soon brought his wife-to-be, Hortense, and their six-month-old baby, Paul; they stayed in a little hotel on the other side of the Oise River, in Saint-Ouen-l'Aumône. At the end of 1872 Cézanne and his family moved to the neighboring village of Auvers, where Gachet had found a house for them. Cézanne was to stay there for two years. He returned to Pontoise and Auvers in 1877 in order to work with Pissarro again. He came back to Pontoise in 1881 (living at the Quai de Pothuis) and once more in 1882.[3] This was the last time the two artists worked side by side, but even after that date, certain works by Pissarro, such as *Gisors, New Section* (fig. 91), offer evidence that Pissarro continued to see Cézanne's work after 1882. The amazing (and for Pissarro highly untypical) diagonal hatching of the paint and the palette of various shades of cool greens are strongly reminiscent of Cézanne's work of about the same time.

During his years in Pontoise, Pissarro was deeply involved with the Impressionist group and was seen not only as a committed Impressionist artist until at least 1882, but also as an ardent defender of the group's function as an alternative to the Salons. In fact, he created the legal structure of the Impressionist group by establishing the only legal document defining its purpose and aim. He was the only artist to exhibit in all eight Impressionist exhibitions—but it must be emphasized that he insisted upon being seen as an outsider in the final exhibition, where he exhibited as a Neo-Impressionist, in a separate room together with Seurat, Signac, Luce, his son Lucien, and others. Cézanne, in marked contrast, exhibited in only two of the eight exhibitions, playing both a marginal and critical role throughout the enterprise.[4] Though it was Pissarro who introduced Cézanne to Impressionism, one could argue that after 1882, it was Cézanne who, if only indirectly, contributed to leading Pissarro away from the movement.

Pissarro's second sojourn in Pontoise and Auvers certainly marks a turning point in his career. Until 1872, he had never spent more than two years in one place. But for the next ten years he remained in Pontoise, striving to exhaust the resources that this varied, but by no means exceptional or unusual, rural/suburban environment could offer him.[5] Cézanne spent a much shorter period in Pontoise and Auvers, but his stay was nonetheless of critical importance for his own development as well as for the exchange generated between Pissarro and himself.

This intense, irregular, and relatively brief pictorial dialogue affected their work both within and outside their collaboration. In a letter written in 1895, Pissarro noted

with surprise and some dismay, that the critics of Cézanne's first show at Vollard's gallery were insensitive to the effects of their short-lived though significant joint experimentation:

> They [the critics] do not suspect that Cézanne, just like all of us, experienced influences and that this after all does not impair his qualities; they do not know that Cézanne, just like all of us, was first influenced by Delacroix, Courbet, Manet, and even Legros; in Pontoise, he experienced my own influence, and I experienced his. You will remember Zola's and Béliard's blunt remarks about this: they thought that painting is invented from scratch and that to be original meant to resemble nobody. What is curious in that Cézanne exhibition at Vollard's is that one can see a kinship between some of his Auvers or Pontoise landscapes and mine. My goodness, we were always together! but what is certain is that each of us kept the only thing that matters, "one's own sensation" . . . this would be easy to demonstrate . . . are they not dumb![6]

The French Impressionist concept of *sensation* is almost impossible to translate into English. It corresponds perhaps best to the notion of physical, sensorial experience—although it carries none of the psychological connotations of the term "emotion." It could be translated as "feeling," though "feeling" carries none of the idiosyncratic and singular connotations of *sensation*. *Sensation* is always related to oneself as a subject: the only thing that matters, says Pissarro, is not so much the *sensation* as one's *own* sensation: "sa sensation." Several sequences of works by Pissarro and by Cézanne representing similar motifs clearly substantiate Pissarro's point: each work, indeed, retains an intangibly individual *sensation*, while drawing on a large amount of common experience. For instance, *Pontoise, Les Mathurins (Former Convent)* (fig. 92), executed in 1873 by Pissarro, *The Saint-Antoine Road at L'Hermitage, Pontoise* (fig. 93), painted by Pissarro in 1875, and *The Meadow of Les Mathurins at Pontoise (L'Hermitage)* (fig. 94), by Cézanne, dated around 1875–77, all depicted the same onetime convent of the Order of the Holy Trinity in the section of Pontoise known as L'Hermitage. This group of three works provides a visual demonstration of the manifold exchange between the two artists.

The work painted first, *Pontoise, Les Mathurins (Former Convent)*, its surface gently suffused in an overall pink-gray-mauve harmony, epitomizes the pictorial concerns of early Impressionism as interpreted by Pissarro. It is a picture about the subtle interaction of atmosphere, light, and energy, as well as the pace of movement within the space represented. It shows a crisp, cold, autumn morning, in which almost everything seems to be arrested. This immobilizing cold is balanced by the various sources of energy which animate the scene: the light of the sun gently warms up the landscape and casts purplish shadows from the tall, bare, scraggly tree trunks on the ground. The domestic sources of energy are indicated by the tendrils of smoke and the movement of horses and people on the road. However, the effect of biting cold is accentuated by the presence of a tiny thread of unpainted canvas which delineates the contours of houses and trees and gives greater volume to both the objects represented and the paint.

There is far less of this poetic evocation of atmosphere in the two later paintings of the same motif by Pissarro and Cézanne (figs. 93 and 94, respectively). In these, "the stylistic innovation overwhelms the illustration."[7] Far less documentation is to be

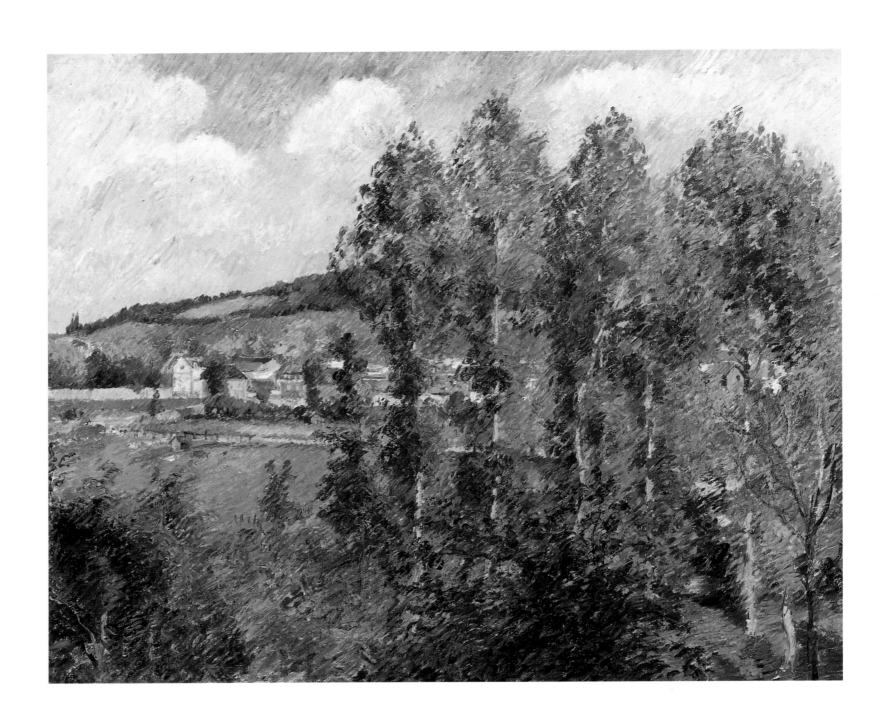

91

Gisors, New Section. c. 1885

Oil on canvas, 19½ x 23¾" (50 x 61 cm)
Private collection (PV672)

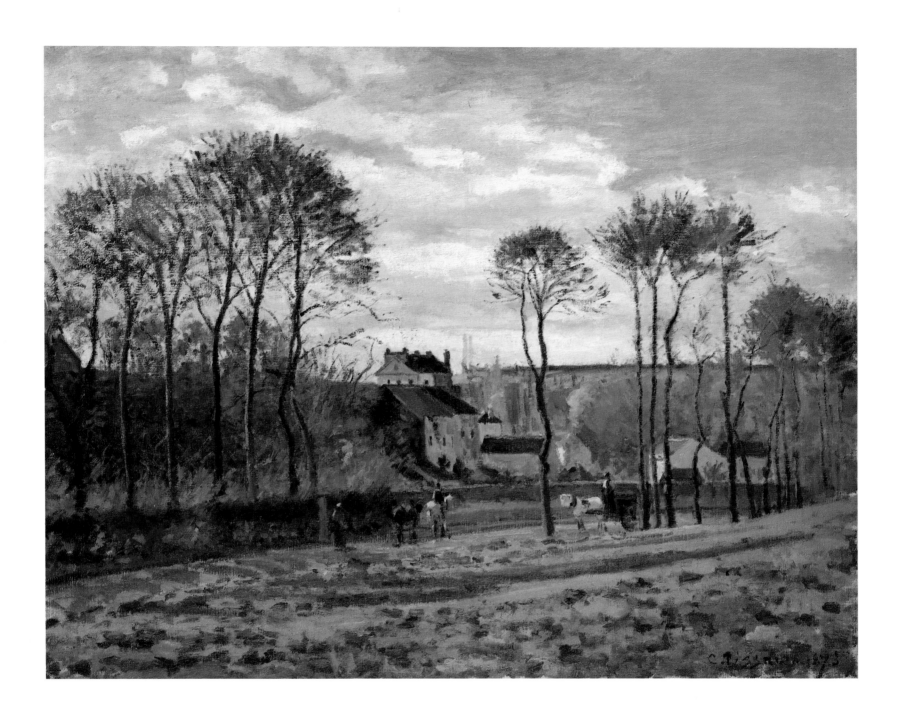

92

Pontoise. Les Mathurins (Former Convent). 1873

Oil on canvas, 23 x 28¼" (59 x 73 cm)
Courtesy of Richard Green (PV 212)

found that Cézanne and Pissarro were side by side when painting these two later works, but it is my strong conviction that they were. Both works seem to depict rather neutral weather effects of spring, although clearly much less emphasis has been placed on atmospheric data in these two works than in the 1873 work by Pissarro (fig. 92), and less space has been devoted to the sky. Cézanne has, however, taken up Pissarro's vantage point in the 1873 painting, as can be ascertained from the position of the middle tree in relation to the roof; it is perpendicular to the road in both. In contrast to Cézanne, Pissarro, in his later work, pushes the same tree to the left of the picture, creating a far bigger gap between that tree and the group of trees to its right. Pissarro's 1875 picture seems more distant from his own 1873 depiction of the motif than from the Cézanne of 1875.

Though the two paintings by Cézanne and Pissarro of 1875 are relatively close, there also are several stark differences. Both works have recourse to the combined use of palette knives and brushes; however, Cézanne seems to have more freely used the knife than Pissarro, who alternated more evenly between the two tools. If Cézanne and Pissarro were both painting the same scene at the same time, these two works illustrate acutely their distinctive chromatic senses: what, in each painter's eye, constituted a green or an orange. Cézanne's green, at least in this picture, is more green than Pissarro's. It stands by itself and, due to the manipulation of the palette knife, has more intensity, volume, and density. It is also far less varied than Pissarro's green, which incorporates all sorts of shades of different colors: yellows, siennas, blues, ochers. On the whole, Pissarro's painting is based on dynamic transitions and passages and interferences of shades. Cézanne's painting is more about contrasts and volumes, static presences, thick matter, definitions, and oppositions.

Revealingly, Cézanne's road is empty though it plays a crucial role within the painting by segmenting the whole picture into two parts, formally marking the polarity between the two sections of the painting. Pissarro's road is not so severed from its representational function: it carries some traffic, emphasizing the length of the wall and introducing the tempo of human life. Pissarro's painting retains an anecdotal or narrative element, even though the anecdotal content (people passing on the road) has been stripped of all characteristics and fully integrated within the whole picture. No anecdote, no narrative, is to be found in Cézanne's painting. This is all the more interesting as this equation seems to contradict what had occurred within Cézanne's work only a few years earlier, before he joined Pissarro. Cézanne's early imagery was fraught with bizarre and violent narratives, reflecting the popular illustrations he found in tabloid newspapers chronicling "the horrible and the miraculous, the bizarre, the catastrophic and momentous . . . at once ludicrous, comic and grave," as Robert Simon observed, and he detected analogies between the graphic ferocity of these cheap newspaper illustrations and Cézanne's "aggressive, abbreviated handling" of paint.[8] This is clearly apparent in Cézanne's allegorical treatment of the four seasons, dating from 1860–62 and now at the Musée du Petit Palais, Paris. Here awkwardness and clichés can be seen competing with comical elements and kitsch.

Pissarro's own treatment of the four seasons (figs. 95–98) is a direct contrast to Cézanne's. Pissarro's group constitutes a transitional work between Louveciennes and Pontoise; it was executed around 1872 as a commission from the banker

Gustave Arosa. The winter scene, which was painted first, represents a Louveciennes landscape, whereas the other three works were executed subsequently in Pontoise and depict Pontoise landscapes.

Surprisingly, given this subject, one finds no allegorical elements in any of the four compositions. *Spring*, for instance, is not treated here as a metaphor for birth, virginal innocence, or the Golden Age, as tradition would have us expect. It is simply a landscape in spring, though discreet symbols of springtime can be found, such as the figures sowing or the blossoming tree. These do not refer to extraneous concepts or myths, but to themselves: the bent sower has no story whatsoever to tell nor does he illustrate any moral. He attends the earth; his gesture is self-referential, and self-sufficient—no myths or sentiments are to be derived from it. This is a far cry from Cézanne's earlier kitsch allegories, although the presence of kitsch in his works served an ironical, iconoclastic function.

In light of the importance of this group and the fact that its execution coincides with the period of close collaboration between the two artists, it seems highly likely that Cézanne would have seen the works. It is here that Pissarro may have played a crucial role with regard to Cézanne's early development, perhaps convincing him to drop the allegorical genre altogether. Extrapolating from Simon's analysis, one might surmise that, seeing Pissarro's landscape treatment of the theme and throughout his *oeuvre*, Cézanne may gradually have been led to pictorialize his aggression. Instead of depicting scenes of violence which performed "a critical work on the materials of contemporary high-art" by transgressing "acceptable forms of painting narrative or figural subjects,"[9] he internalized this transgressional process within his own pictorial practice. He thus predominantly confined himself to landscapes, while pushing experimentation with painting to its limits: leaving some works blatantly unfinished—see *The Path from the Ravine, Viewed from L'Hermitage* (fig. 99)—taking vast liberties with the representational function traditionally ascribed to painting, and concentrating on forging a deeply idiosyncratic pictorial idiom—see *The Meadow of Les Mathurins at Pontoise (L'Hermitage)* (fig. 94).

Pissarro, in turn, enjoyed in Cézanne the example of someone who did not, to say the least, pay an ounce of respect to the academic tradition: asked one day by Manet what he was preparing to submit to the Salon of that year, Cézanne answered candidly, with a pre-Duchampian accent: "A pot of shit."[10] A notion absolutely crucial to Cézanne's art and to its dual relationship to Pissarro's art is that of excess: after Cézanne had failed the examination for the Ecole des Beaux-Arts, M. Mottez, one of his examiners, gave the following reasons: "M. Cézanne has the temperament of a colorist; unfortunately, he paints with excess."[11] Pissarro helped Cézanne to internalize this "excess" instead of directing it against the outside world (institutions, teachers, colleagues, etc.), and to sublimate it pictorially. To express this notion of excess, Cézanne called his and Pissarro's work "painting with real balls,"[12] which was opposed in his idiom to the work of the others. Pissarro probably had an analogous notion in mind when, asked to define what Impressionism was about, he replied by listing the artists the Impressonists liked: "We like Delacroix, Courbet, Daumier and all those who have something in their guts."[13]

It is more than apparent that Pissarro and Cézanne prized the same notions: painting with "balls" or with "guts" for both artists alluded to certain values which

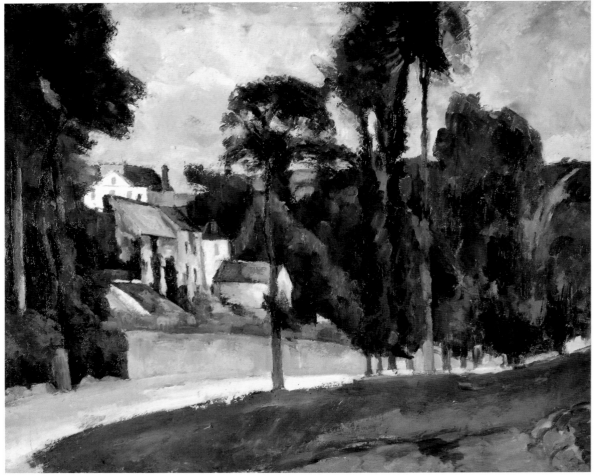

93

*The Saint-Antoine Road at L'Hermitage.
Pontoise.* 1875

Oil on canvas, 20¾ x 31½" (52 x 81 cm)
Private collection, on loan to the
Kunstmuseum, Basel, Switzerland (PV 304)

94

Paul Cézanne
*The Meadow of Les Mathurins at
Pontoise (L'Hermitage).* 1875-77

Oil on canvas, 22½ x 27¾" (58 x 71 cm)
Pushkin State Museum of Fine Arts,
Moscow (V 172)

illustrated their radicalism. The first of these was the complete rejection of school authority. Pissarro claimed: "As a matter of principle, we rejected any school."[14] Directly echoing Pissarro's statement, Cézanne said: "Institutes, pensions, honors can only have been made for cretins, jokers, and clowns. . . . Let them go to school and take throngs of teachers. I don't give a damn. . . . For a painter, sensation is at the basis of all, I shall repeat it endlessly."[15]

Having discarded the rules and solutions imposed by tradition, Pissarro and Cézanne then had to rediscover the rules and methods of their artistic exchange and of their shared pictorial research. Pissarro himself characterized precisely the nature of his artistic activity in a letter to his son: "this is not given; it must be felt."[16] Under the weight of a universally valid rule (a school), the individual *sensation* is crushed; this leads to a form of classicism or academicism. Hence, they constantly had to put their own work, their own search to the test; their pursuit was by its nature inexhaustible. Hoping to generate in his son the same passionate taste for work, Pissarro wrote him: "[The main thing] is the will to get up early in the morning and to run to work, to withdraw oneself in it, to create a whole world . . . the will to create a work that the others will have to understand."[17]

In a vital text, Cézanne paid an understated homage to Pissarro, emphasizing the work ethic which Pissarro communicated to him as well: "Until the [Franco-Prussian] war, as you know, I lived in a mess, I wasted my whole life. When I think about it, it was only at L'Estaque that I came to fully understand Pissarro—a painter like myself —a workaholic. An obsessive love of work took hold of me."[18]

Pissarro is described by Cézanne as an "acharné": someone who is possessed by a need or a passion, who literally has it in his "flesh"; this is a notion that becomes clearer as one reads Pissarro's correspondence in relation to his pictorial work. Not to give this work ethic its due is to miss an important aspect of Pissarro's career.

A fundamental paradox seemed to govern Pissarro and Cézanne's unique and intense working relationship: while Pissarro was adamant that each retained his unique *sensation*, and that *sensation* was "the only thing that matters," both were deeply affected by their collaboration:[19] Pissarro insistently dwelt upon the matter twenty years later (in the letter quoted above) and was upset with the critics for failing to recognize the influence he exerted on Cézanne. While Cézanne could write: "The advice and method of somebody else must never make you modify your way of feeling,"[20] a year after Pissarro's death, in 1904, he exhibited as "a pupil of Camille Pissarro" and earlier referred to the older artist in a reverent tone: "Pissarro was like a father for me, he is a man to turn to for advice and something like the Good Lord."[21]

Pissarro and Cézanne were clearly pursuing their collaboration reflexively. Neither artist was satisfied with a pictorial monologue, however remarkable. Instead, they held an artistic ideal as a shared horizon, which oriented their individual steps, maintaining the possibility of their own *sensation* while offering a common base for artistic discussion and an intense search for harmony.

Pissarro and Cézanne, between Pontoise and Auvers, opened a sphere of intersubjectivity that forms a basic and central aspect of Impressionism. In keeping with the principles that informed Impressionism (a rejection of traditional rules and a common search for new methods), they both—Cézanne before Pissarro—became

99

Paul Cézanne
*The Path from the Ravine,
Viewed from L'Hermitage.* 1875-77

Oil on canvas, 19½ x 23¾" (50 x 61 cm)
Private collection (V 170)

aware that they had to abandon Impressionism when it congealed into an accepted canon. This is evident in Pissarro's letter to Lucien of March 1886: "I do not accept the judgment of the romantic [Impressionists] whose whole interest is to fight new tendencies. I accept struggle, that's all."[22]

It must be remarked that this was the year of the last Impressionist exhibition, and Pissarro was already fifty-six years of age and still seeking. A few years later, when Neo-Impressionism in turn seemed to prove an ossified formula, Pissarro gradually abandoned it as well.

The interchange with Cézanne by no means excluded other artistic exchanges in Pissarro's career: in 1879 and 1880, he engaged in a period of intense collaboration and shared research with Degas. This collaboration, like that with Cézanne, constituted a nexus in the development of Impressionism. Together they explored the extraordinarily wide range of plastic possibilities offered by printmaking. In 1879, Degas launched a publishing project, an album of special prints to be issued

100

Paysage sous bois à L'Hermitage (Woods and Undergrowth at L'Hermitage) . 1879

Etching and aquatint. 8⅜ x 10⅝" (21.9 x 26.9 cm)
Bibliothèque Nationale, Paris (D 16)

periodically, bearing the title *Le Jour et la Nuit*. Contributors were to include Mary Cassatt, Félix Bracquemond, Pissarro, and Degas. Sadly, although some of the prints were pulled, the project was dropped before the first issue. Pissarro had planned to contribute the sixth state of *Paysage sous bois à L'Hermitage* (fig. 100); he exhibited four states of the same print in the 1880 Impressionist exhibition.

Degas owned an etching press and often let his colleagues use it; occasionally, even Pissarro would send his engraved plates to Degas, who would print them himself; this certainly constitutes a climactic example of pictorial exchange and close collaborative research. In a letter from Degas to Pissarro, the closeness of their technical collaboration is apparent:

> I compliment you on your enthusiasm. . . . Here are the proofs: the prevailing blackish or rather greyish shade comes from the zinc which is greasy in itself and retains the printer's black. The plate is not smooth enough. I feel sure that you have not the same facilities at Pontoise. . . . In spite of that you must have something a bit more polished.

In any case you can see what possibilities there are in the method. It is necessary for you to practice dusting the particles in order, for instance, to obtain a sky of a uniform grey, smooth and fine. That is very difficult, if one is to believe Maître Bracquemond. It is, perhaps, fairly easy if one wants only to do [prints] after original art.[23]

Pissarro and Degas broke with the traditional concept of printmaking in that they subverted the conventional procedure in which each state of a print was conceived as a step toward the fabrication of a properly finished and static last state. Degas and Pissarro regarded each separate state of a print as interesting in its own right and, at the same time, mutually enriching to the other states. Having undermined the notion of a linear hierarchical and chronological order between the various states, they introduced the practice of numbering and signing each state. In 1880, Pissarro exhibited a frame containing four states of *Paysage sous bois à L'Hermitage*, thus emphasizing the formal link between each state.

Complex innovations and outright inventions, such as *manière grise* (a technique invented by Degas and Pissarro, by which they would rub a pencil-shaped roll of sandpaper on their plate and thus obtain a fine-grain gray texture), and the use of "acid accidents" or "printing imperfections" as creative devices, resulted in prints so individual that the sequence of states was no longer readily apparent.

The paradox that seems to embody his artistic endeavor there was put down by himself in a letter to his son: "Don't forget that one must only be oneself. But you will have to work at it!"[24]

As Pissarro, Cézanne, and Degas were always eager to insist, collaborating with others could not dispense with individual research. Pissarro's own phenomenal output during his stay in Pontoise (1872–82) illustrates this point in detail and reveals another basic paradox of his work: an astonishing diversity technically and iconographically. What defines and sustains all Pissarro's work in and around Pontoise is a peculiar representation of space—of the particular space(s) defined by the suburban environment of Pontoise—of a space made palpable through distance and separation, a space that is uniform in some parts and, yet, ceaselessly different, compartmented, and prone to variations in others.

Two paintings of 1872, *View of Pontoise, the Wooden Train* (fig. 89) and *Pontoise, Banks of the Oise* (fig. 101), represent the same motif: the city of Pontoise and its citadel observed from across the River Oise, from two very close vantage points. As compositions, however, the two are almost extreme opposites; while the right-hand half in each painting is clearly recognizable, with the Pontoise hill and its bridge, the left-hand halves are different in both. In *Pontoise, Banks of the Oise*, Pissarro consciously decided to block the view of the opposite bank (Saint-Ouen-l'Aumône) behind trees, used as *repoussoirs*, offering a bucolic counterpoint to the vertical accumulation of architectural units that make up the old Pontoise. In *View of Pontoise, the Wooden Train*, in contrast, the left-hand side (a smokestack spewing its gray-mauve puffs of smoke into the clouds) articulates and sets off the old city of Pontoise at the right from the new, modern industrial background of Saint-Ouen-l'Aumône. Through this symmetric and complementary pair, Pissarro clearly indicates that he is neither a bucolic nor an urban painter. He is neither a painter of the old nor a painter of the new, neither classical nor modern. He is all of these, as is seen in these two exquisite works.

101

Pontoise, Banks of the Oise. 1872

Oil on canvas, 21 x 28¾" (54 x 73 cm)
Private collection (PV 182)

102

Banks of the Oise in Pontoise. 1870

Oil on canvas, 21 x 25¼" (54 x 65 cm)
Private collection (PV 92)

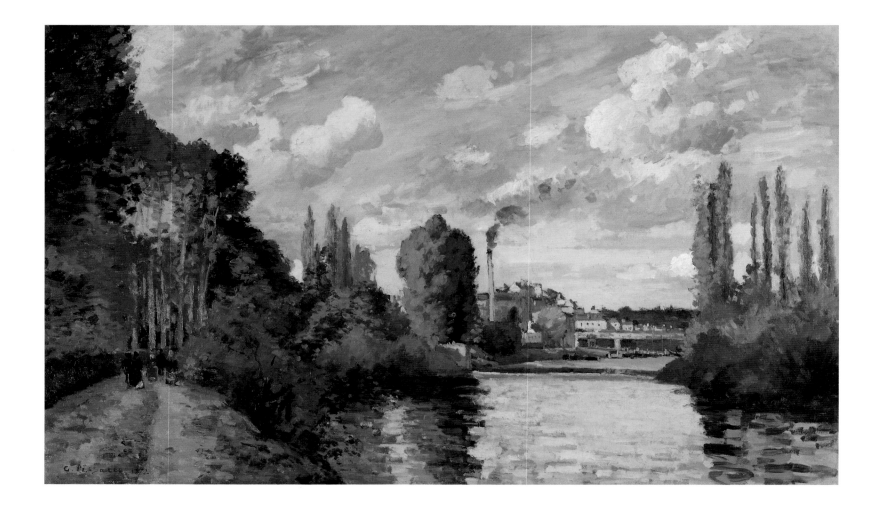

103

Riverbanks in Pontoise. 1872

Oil on canvas, 13½ x 35⅞" (35 x 91 cm)
Private collection (PV158)

His different treatment of the same motif at the same time, here, can be paralleled with the different treatment of the same motif at different times, 1870 and 1872—*Banks of the Oise in Pontoise* (fig. 102) and *Pontoise, Banks of the Oise* (fig. 101). This discloses the complexity of Pissarro's practice, which conspicuously escapes a linear method of understanding. The differences between these two canvases with a nearly identical motif and a nearly identical composition point not only to a difference of dates but also to a difference, however slight, of techniques and of pictorial methods. The vantage point of *Banks of the Oise in Pontoise* is more frontal: the artist faces the Oise and the town of Pontoise, whereas he turns slightly to the left in *Pontoise, Banks of the Oise*, producing an oblique perspective axis on the Oise, closing with the bridge. Thus the group of houses seen at the very right in the latter painting is recognizably the first group of houses seen above the three figures in the former work. This slight difference is accentuated by a slight difference of formats: the canvases are the same in height but not in length. The more rectangular format (21 x 28¾") of *Pontoise, Banks of the Oise* allows the artist to elongate his represented field of vision, and the work is more about unity while the somewhat squarer *Banks of the Oise in Pontoise* (21 x 25¼") is more about contrasts. In the former, there is greater chromatic harmony, every tone suffused in a velvet of mauves, which can be compared with *Pontoise, Les Mathurins (Former Convent)* (fig. 92). *Banks of the Oise in Pontoise*, in marked contrast, sets up different groups of oppositions. The foliage to the left completely blocks the light while in its counterpart, the foliage gently filters the light. In the former painting, the river marks a complete separation between the

two banks (the upper and lower parts of the picture). The river is made of large strokes of discrete tones set in contrast, and it reflects nothing. In the latter painting, however, the Oise is made up of a subtly unified texture of fused brushstrokes, creating the overall mauve harmony which defines the rest of the composition and reflects both the architecture and the sky. Significantly, it does not cut the composition but leads to the bridge which allows passage from one bank to its opposite.

Riverbanks in Pontoise (fig. 103) was executed the same year as Pontoise, Banks of the Oise and represents the same motif from the opposite bank and the opposite end of the town. It absorbs and juxtaposes three components of Pissarro's representational concerns: the old, the new, and the bucolic. Two alternative perspectival axes frame and highlight the central theme of the composition, slightly off-center in the pictorial space: Pontoise. The two perspectives are the towpath at the left and, veering right, the River Oise. Both form a wide V or a chasm slightly reminiscent of Pissarro's very large compositions of 1866 or 1867—for instance, L'Hermitage at Pontoise (fig. 47). Although Banks of the Oise in Pontoise (fig. 102) seems to be based on a set of frontal oppositions, Riverbanks in Pontoise seems, in contrast, to function around tripartite groupings: sky, water, earth; nature, old architecture, industrial architecture; main path (left), river, island (right); sky, clouds, smoke; or from left to right: poplars, smokestack, poplars; three modes of transportation: pedestrians, train (on the bridge), barges; three techniques, at least: schematic slabs of paint (as in the treatment of the water), gestural swirls lathing paint (as in the clouds), specks of paint (as in the foliage); or chromatically, three dominants: blues, greens, ochers.

These paintings (figs. 101, 102, and 103) all representing a town seen at a distance, by a river, executed within a close span of time, between 1870 and 1872, display the variety of plastic and poetic concerns Pissarro dealt with. They offer sufficient evidence to the fact that it is almost pointless to attempt to characterize a stylistic or formal evolution of Pissarro's work over the years; his "style" did not change from year to year, but quite often, several times within the same year, if not within the same painting. More to the point, different themes called for different techniques and vice versa. This is not to say, of course, that his "style" did not considerably transform itself, as can be seen in the treatment of such similar motifs as A Cowherd on the Route du Chou, Pontoise (fig. 104) and Landscape near Pontoise, the Auvers Road (fig. 105) over a period of seven years. It is only to say that an account, year by year, of his manifold technical transformations is insufficient, although it is one element that contributes to a closer understanding of what really went on in Pissarro's art.

The extraordinarily complex and supremely subtle contrast of the freckling sunlight screened through the foliage and the patch of light on a group of houses across the bank, seen from a vantage point set under the shade in Landscape with Strollers Resting Under Trees (fig. 68) provides a strong contrast to The Haystack, Pontoise (fig. 106), with its wide, open vista set on a rural horizon, its theatrically staged haystack, and its smooth, leathery, subtly patinated paint surface. The former painting can also be contrasted to the busy composition September Celebration, Pontoise (fig. 107), with its bustling market fair, its accumulation of meticulous details, and its attention to fragmentary objects of everyday life: flags, balloons, toys, and

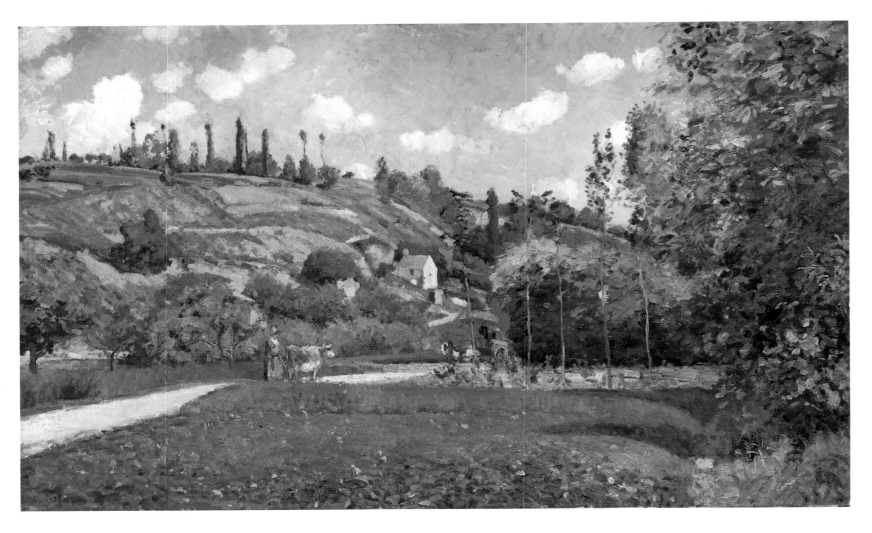

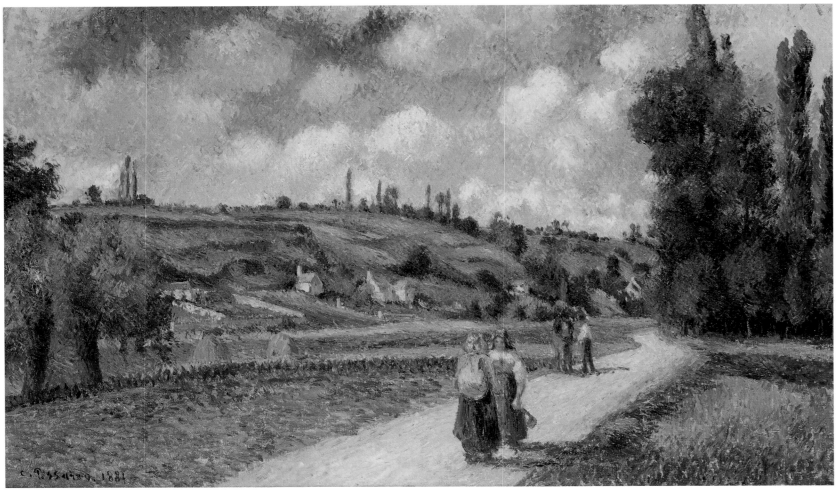

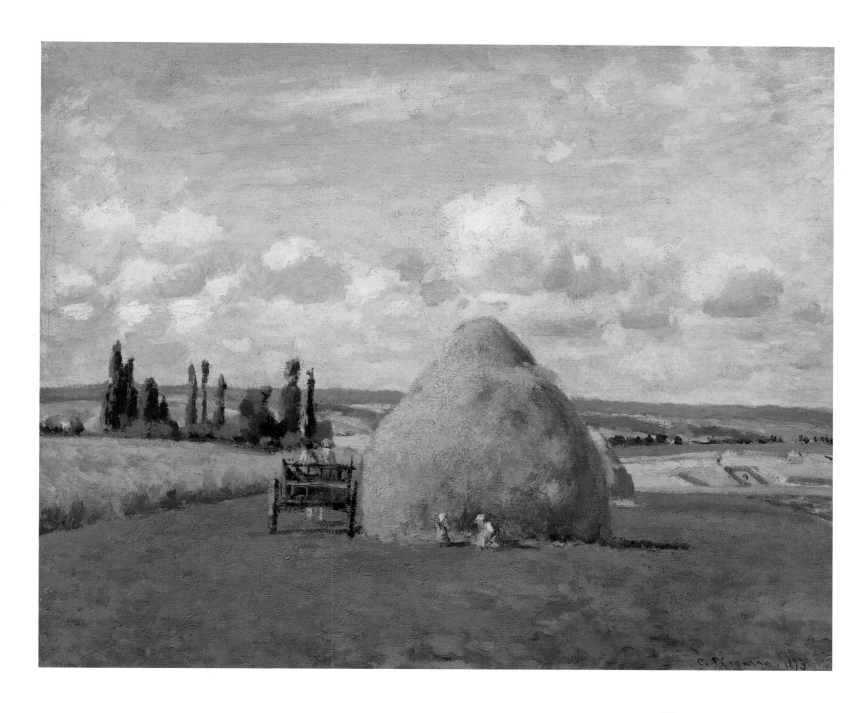

106

The Haystack, Pontoise. 1873

Oil on canvas, 18 x 21½" (46 x 55 cm)
Archives Durand-Ruel, Paris (PV223)

104

A Cowherd on the Route du Chou, Pontoise. 1874

Oil on canvas, 21⅝ x 36¼" (54.9 x 92.1 cm)
The Metropolitan Museum of Art, New York.
Gift of Edna H. Sachs. 1956 (PV260)

105

Landscape near Pontoise, the Auvers Road. 1881

Oil on canvas, 21 x 35" (54 x 90 cm)
Private collection (PV504)

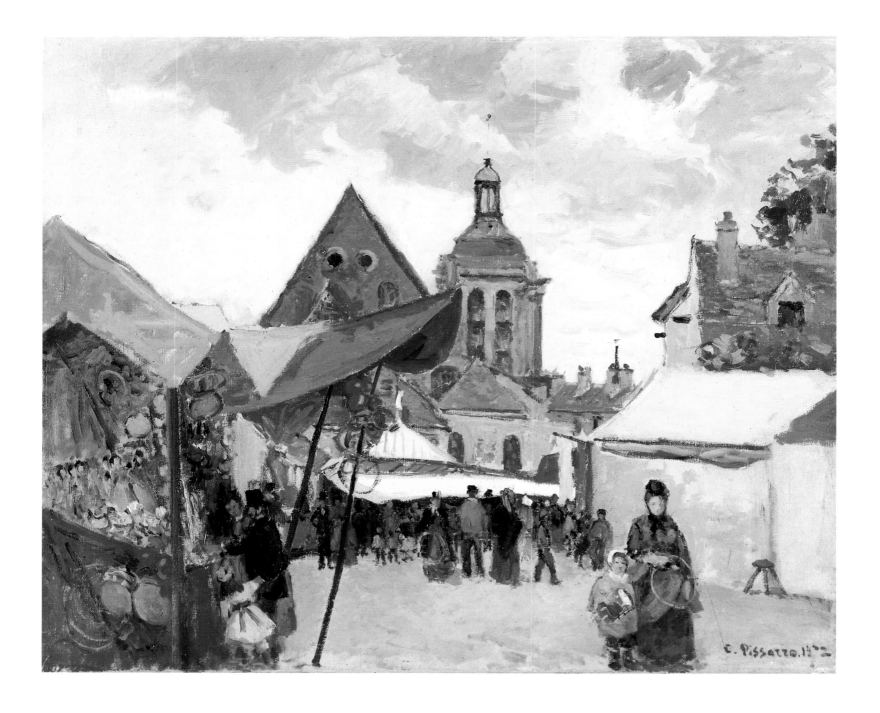

107

September Celebration, Pontoise. 1872

Oil on canvas, 18 x 21½" (46 x 55 cm)
Private collection (PV 188)

hats. All three works painted within one year offer further evidence that Pissarro's technical, compositional, and iconographical concerns continually underwent serious transformations in the Pontoise period.

These endless combinations of contrasts and variable forces lend themselves, however, to a thematic three-part opposition—intrinsic to the suburban world— between town, country, and their limits, or the intermediary formations that bind them together: the fringe, the villages nearby, the paths that lead to the town, the river, the kitchen gardens—all forms of transitions between field and town. Examples of such triangular structures are abundant: for instance, *View of Pontoise* (fig. 108) and its preparatory study in watercolor (fig. 109), as well as *The Flood, Saint-Ouen-l'Aumône* (fig. 110), resort to the same structure as *Flood in Pontoise* (fig. 111) of nearly ten years later: a band of built-up land squeezed between sky (the upper limit) and earth (*View of Pontoise*) or between sky and water (*The Flood, Saint-Ouen-l'Aumône* and *Flood in Pontoise*). In the latter two, of course, the water is over the

limit and is threateningly occupying the intermediary spaces of the fields. Tensions of this type—rural/urban/suburban; nature/architecture/path; fields/path/building(s); city/river/bridge—are absolutely central to Pissarro's output in Pontoise, and clearly represent the focal points of his grasp of the antinomies inherent in suburban spaces.

Out of these, Pissarro composed a poetical-pictorial ensemble with resounding evocative power. There emerged several possibilities: he may be seen at times creating an equilibrium between architecture and nature; the *jardins potagers* (kitchen gardens) offer a privileged vantage point from which to study such contrasts, as seen in *Potager et arbres en fleurs, printemps, Pontoise* (fig. 112) and *Landscape with a White Horse in a Meadow, L'Hermitage* (fig. 113), and a motif also studied by Cézanne (fig. 99) and studied again a few years later by Pissarro in *L'Hermitage at Pontoise* (fig. 114) and *Kitchen Gardens, Pontoise* (fig. 115). In the same vein, Pissarro may sometimes look at the synthesis of the urban world and nature: the domestic floral garden is magnificently treated in *The Garden at Pontoise* (fig. 116). The monumentality of the composition is all the more striking and obvious when one sees it next to its minuscule preparatory study (fig. 117).

Pissarro may look at one extreme—pure townscapes, as in *Rue de la Citadelle, Pontoise* (fig. 118) or *Rabbit Warren at Pontoise, Snow* (fig. 122), where the rigorous structure and the angularity of the close-set dwellings are counterbalanced by the amorphous and malleable mass of snow, and the background opens onto the urban space set off by the countryside, or the closed square in *September Celebration, Pontoise* (fig. 107)—or he may be studying another extreme, pure landscapes, as in *The Haystack, Pontoise* (fig. 106) or *March Sun, Pontoise* (fig. 119), where nature seems to be almost its own architect, with its mounds and pyramids. These pure landscapes are, however, fairly infrequent in Pissarro's Pontoise output. More often the city or the village space may be displaced into the background as a foil to the otherwise all-encompassing rural "envelope" within the composition, as in *Outskirts of Pontoise, Grouettes Hill* (fig. 121), *La Sente du Chou, Pontoise* (fig. 120), and *The Ridge at Le Chou, Pontoise* (fig. 123), each work displaying a path with one or more figures, suggesting a movement to or from the town. Also to be noted are *Landscape: The Harvest, Pontoise* (fig. 124), with the village in the background and a hidden path crossing a field, or *Paysage près de Pontoise* (fig. 125). What configures this landscape close to the town is of course the cycle of rural work, itself determined by the seasons: workers organize, shape up, segment, turn over the land, and give it its appearance: *The Woods of Saint-Antoine, Landscape at Pontoise* (fig. 130), *Girl Tending a Cow in a Pasture* (fig. 126), *The Plowman* (fig. 131), and *The Potato Harvest* (fig. 127).

Pissarro concentrated his attention mainly on these intermediary sites—the villages on the outskirts of Pontoise. These clusters of hamlets were always close to the fields and never far from town, as in *View of Osny near Pontoise* (fig. 132), *Snow Effect at L'Hermitage* (fig. 133), *La Côte du Jallais, Pontoise* (fig. 134), and *Path of L'Hermitage at Pontoise* (fig. 128). Streets, fields, suburban hamlets, and rural spaces were combined with a subtle and warm incandescent sunset in the exquisite *Sunset at Valhermeil, near Pontoise* (fig. 129). Village streets and corners gave way to Pissarro's exploration of the spatial limits inherent in village structures, as in *Cottages at Auvers* (fig. 135), *Village Street, Auvers-sur-Oise* (fig. 136), and *La Mare à Ennery* (fig. 137).

108

View of Pontoise. 1873

Oil on canvas, 21½ x 31½" (55 x 81 cm)
Private collection (PV 210)

109

View of Pontoise. 1873

Pen and watercolor, 45 x 27½" (1154 x 70.5 cm)
Private collection

110

The Flood, Saint-Ouen-l'Aumône. 1873

Oil on canvas, 17½ x 21½" (45 x 55 cm)
Private collection (PV 207)

111

Flood in Pontoise. 1882

Oil on canvas, 25¼ x 21" (65 x 54 cm)
Private collection (PV 557)

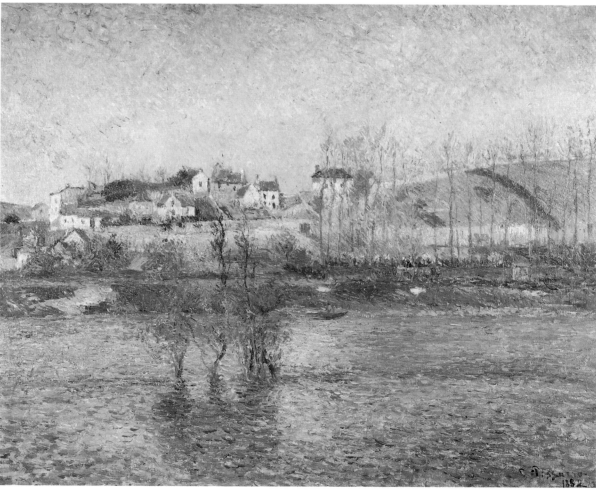

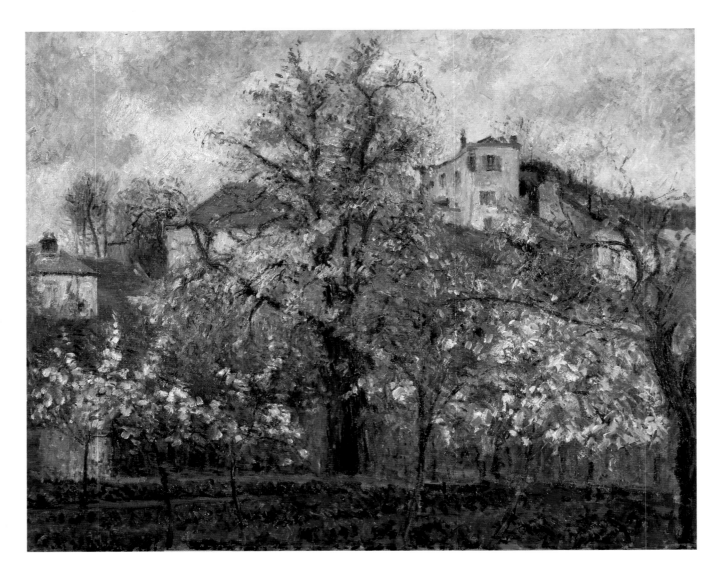

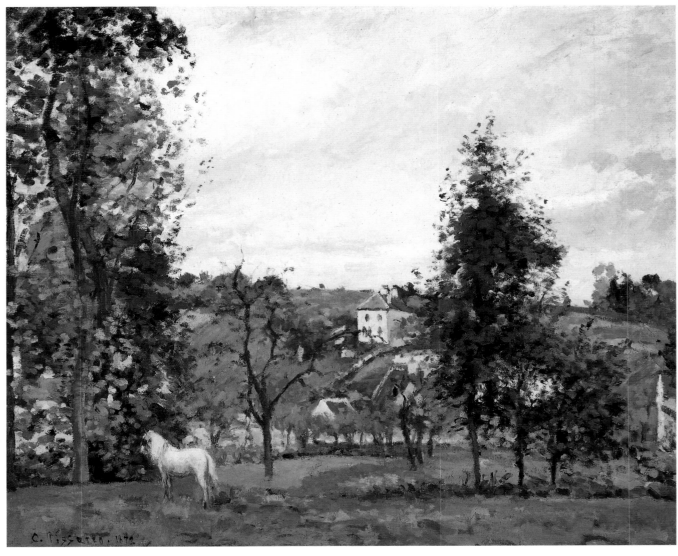

112

Potager et arbres en fleurs, printemps, Pontoise (Kitchen Garden and Trees in Bloom, Spring, Pontoise). 1877

Oil on canvas, 25¼ x 31½" (65 x 81 cm)
Musée d'Orsay, Paris (PV 387)

113

Landscape with a White Horse in a Meadow, L'Hermitage. 1872

Oil on canvas, 18 x 21½" (46 x 55 cm)
Private collection, New York (PV 164)

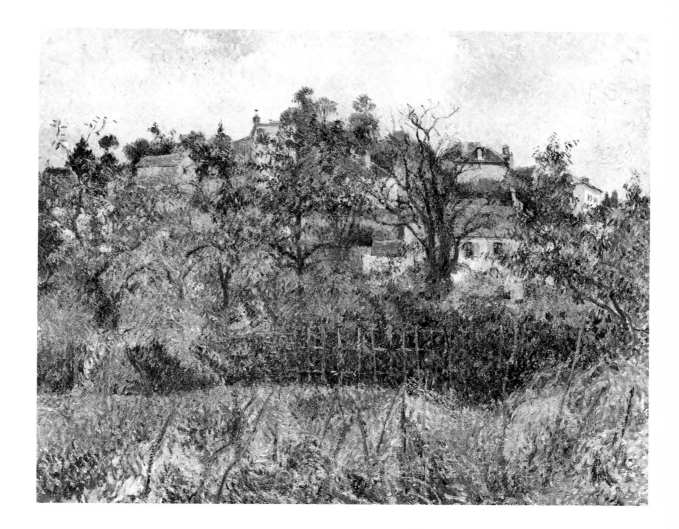

114

L'Hermitage at Pontoise. 1881

Oil on canvas, 23½ x 29" (60 x 74 cm)
Private collection, Japan (PV 529)

115

Kitchen Gardens, Pontoise. 1881

Oil on canvas, 23¼ x 29" (60 x 74 cm)
Collection Samir Traboulsi (PV 514)

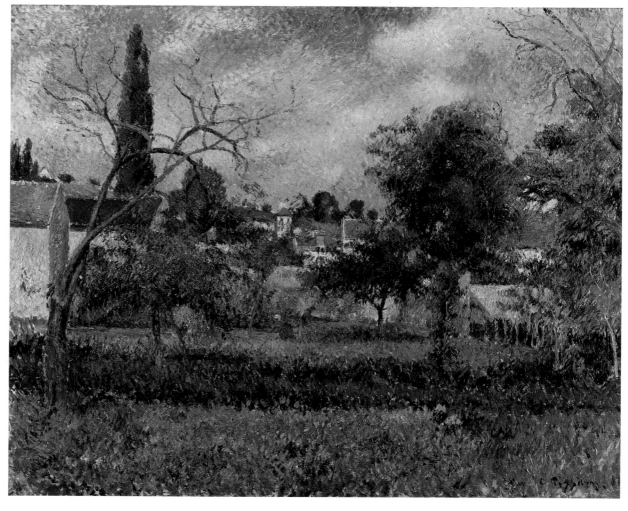

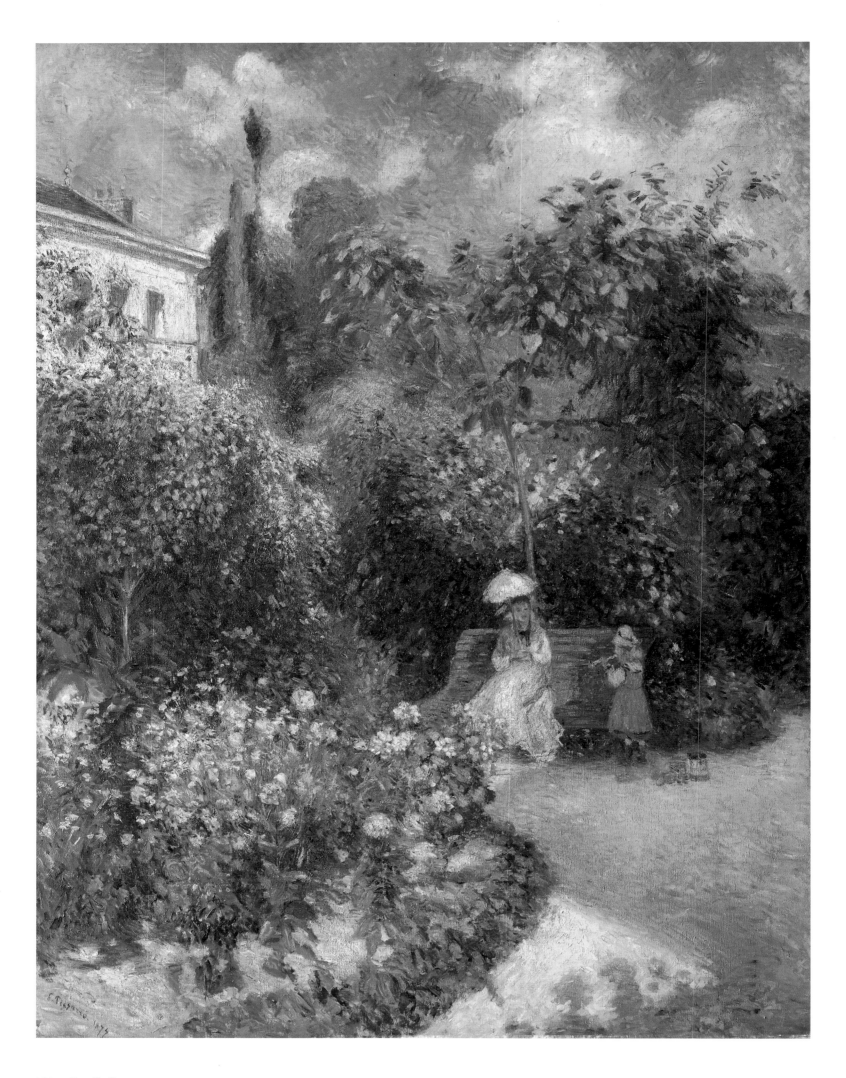

116
—
The Garden at Pontoise. 1877
—
Oil on canvas, 64⅛ x 48¼" (165 x 125 cm)
Private collection (PV 394)

117
—
Study for *The Garden at Pontoise.* 1877
—
Pencil, 4¼ x 3¼" (11 x 8.5 cm)
Private collection

Another important theme is that of buildings seen through the woods, such as *The Little Bridge, Pontoise* (fig. 141). At times, this motif gave rise to some of his largest paintings: *The Côte des Boeufs at L'Hermitage, near Pontoise* (fig. 143) and *Le Fond de L'Hermitage* (fig. 138).

It is easy to see that the gamut of options and dynamic oppositions in this phase of Pissarro's task is nearly endless. For example, in *The Railroad Crossing at Les Pâtis, near Pontoise* (fig. 90), an old way (a road) is crossed and barred by a new way (a railway); the barrier cuts the road perpendicularly (the train is about to arrive), while the two figures are about to cross each other—and in all likelihood engage in a dialogue. The darting sunlight digs thick, vibrant shadows. "There is nothing colder than full sunlight in summer," Pissarro once observed.[25]

This poetic system of contrasts is staged against the background of L'Hermitage hilltops—a component of *The Hermitage, Effect of Snow* (fig. 139) and many other Pontoise paintings. The scant vertical of the telegraph pole brings forth the tiny, distant verticals of the poplars on the hilltop in *The Railroad Crossing at Les Pâtis, near Pontoise,* emblematically expressing the transformations of the landscape. At the same time, the painting seems to emphasize the quiet permanence of things, despite the transformations imposed by the railway. This paradoxical combination was quintessential in Cézanne's pictorial developments, as well: Pissarro once said to Matisse that Cézanne had only been painting the same painting all his life. He should have added that this painting had, however, constantly metamorphosed itself. In Aix, Cézanne remembered the Pâtis painting (fig. 90) and wrote to his friend, "Now that I have seen this part of the country again, I believe that it will give you complete satisfaction, for it is surprisingly reminiscent of your full sun study of the rail crossing in high summer."[26]

Pissarro's work in Pontoise reaches a depth and a potency of distinction and complexity that induce the onlooker to share his experience of space, of distance, and of separation.[27] Pissarro essentially painted "the invisible plenitude of the world";[28] he transposed, in a multitude of constantly different painterly techniques, the distance and the separation of things and beings between urban, suburban, and rural spaces, thus emphasizing how the suburban space where he lived for ten years was essentially divided and subdivided by myriad mediations or intermediary spaces. He depicted the pathways that link and mediate these subspaces, thereby making manifest the distances between things and places. By the same token, he pointed out the human time required to link one to another: in most of his Pontoise works, as in *La Route d'Osny* (fig. 140), a figure or group of figures can be seen walking along a path, indicating the tempo of his/her steps, the immediate proximity of the surrounding space, and distance of the background—where he/she/they are going or coming from—creating another intermediary step between close and far, or city and country, or society and solitude, and incarnating the living tension between the two, exemplified by *The House in the Fields, Rueil* (fig. 142).

What seemed to fascinate Pissarro about a provincial town, like the district he had just explored in London, was the interaction of rural and urban themes and the fragile division between the two. Later on, his *oeuvre* in Eragny and Paris in the 1890s made the division between town and country themes complete and unbridgeable.

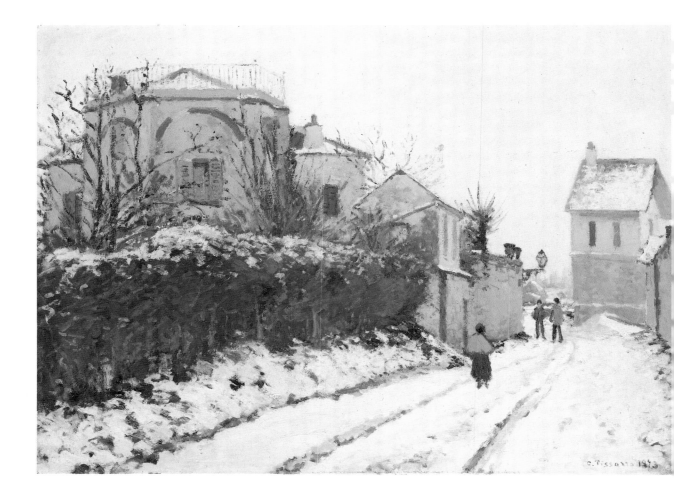

118

Rue de la Citadelle, Pontoise. 1873

Oil on canvas, 21 x 28½" (54 x 73.5 cm)
Private collection, United States (PV 201)

119

March Sun, Pontoise. 1875

Oil on canvas, 21½ x 36¼" (55.3 x 92.8 cm)
Kunsthalle, Bremen (PV 303)

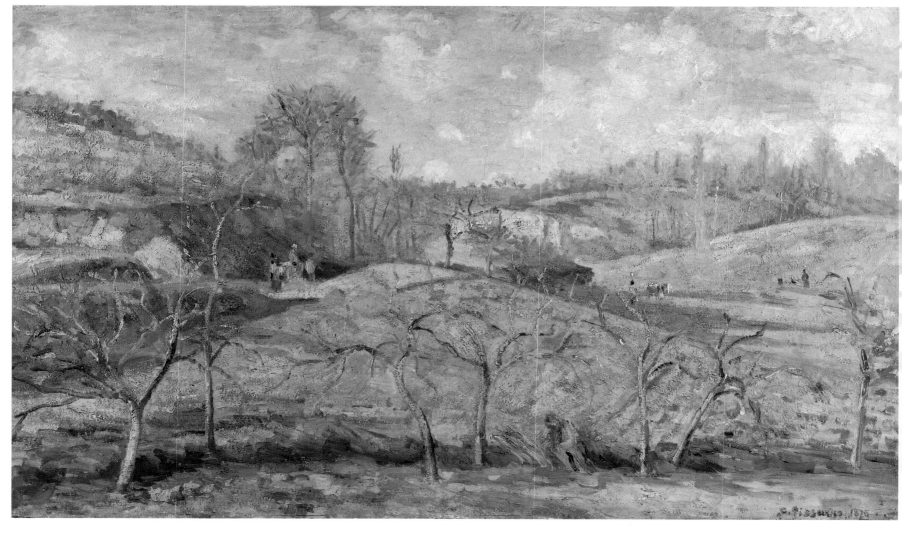

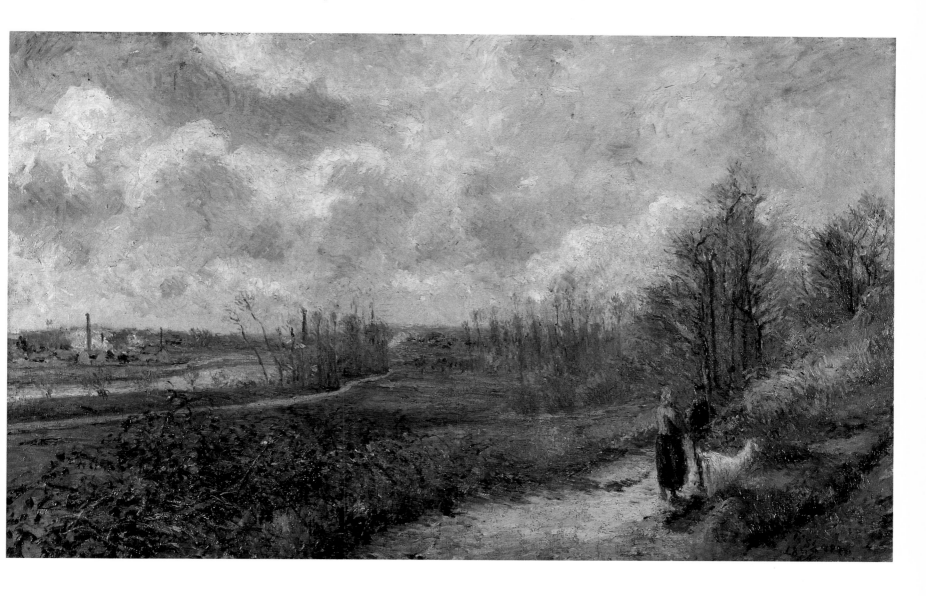

120

La Sente du Chou, Pontoise. 1878

Oil on canvas, 19⅞ x 36" (50.5 x 92 cm)
Musée de la Chartreuse, Douai (PV452)

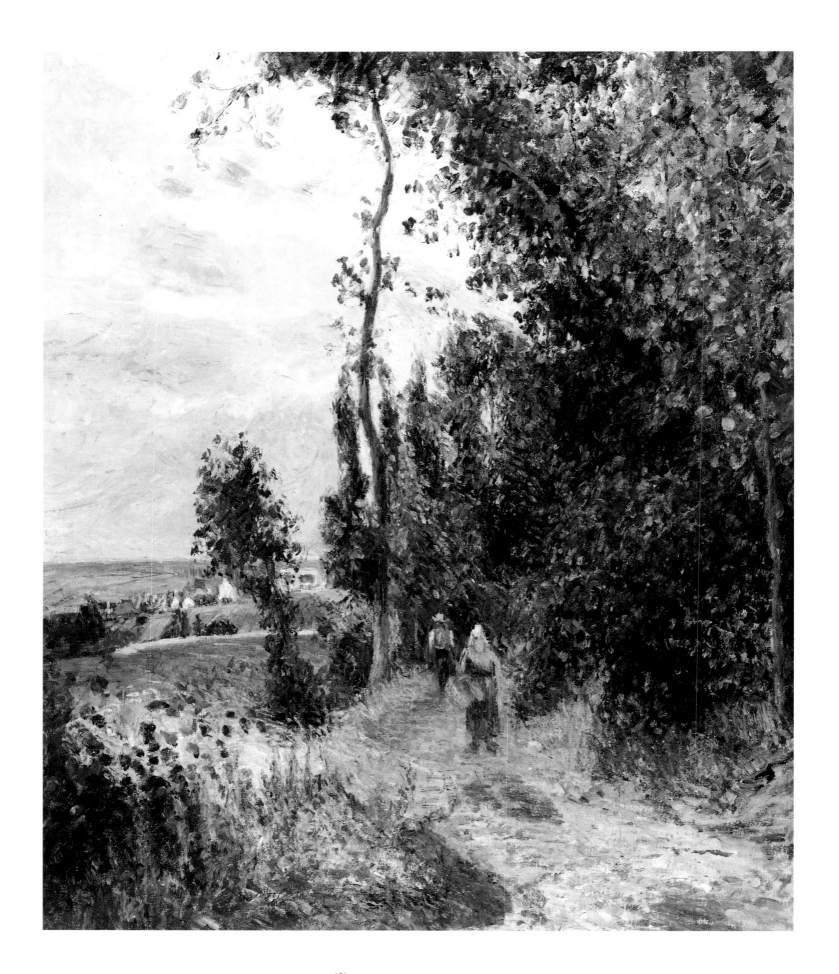

121

Outskirts of Pontoise. Grouettes Hill. 1878

Oil on canvas. 29 x 23½" (74 x 60 cm)
Collection Janice H. Levin (PV465)

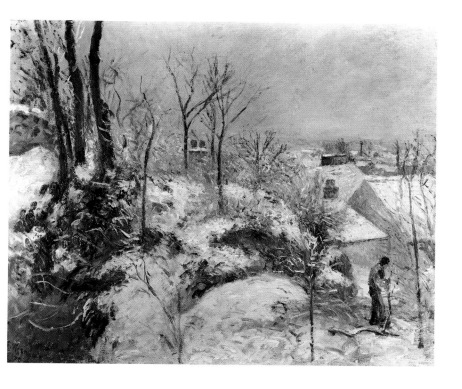

122

Rabbit Warren at Pontoise, Snow. 1879

Oil on canvas, 23 x 28¼" (59.2 x 72.3 cm)
The Art Institute of Chicago. Gift of Marshall
Field, 1964.200 (PV478)

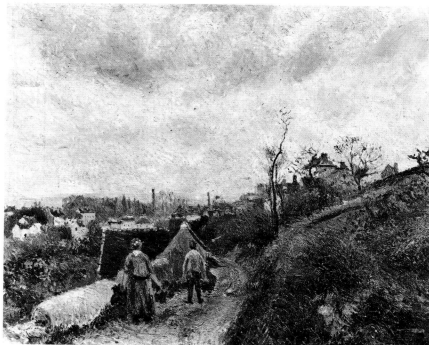

123

The Ridge at Le Chou, Pontoise. 1879

Oil on canvas, 18⅛ x 25⅝" (46.5 x 65.7 cm)
Photograph courtesy of Wildenstein & Co.,
New York

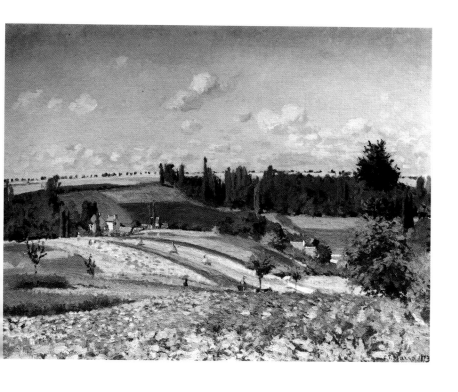

124

Landscape: The Harvest, Pontoise. 1873

Oil on canvas, 25¼ x 31½" (65 x 81 cm)
Private collection (PV235)

125

Paysage près de Pontoise. 1879

Oil on canvas, 21¼ x 25½" (54.5 x 654 cm)
Columbus Museum of Art, Ohio. Gift of Howard
D. and Babette L. Sirak, the Donors to the
Campaign for Enduring Excellence, and Derby
Fund (PV491)

Opposite:

126

Girl Tending a Cow in a Pasture. 1874

Oil on canvas, 18 x 21¼" (46 x 54.5 cm)
Private collection (PV263)

127

The Potato Harvest. 1874

Oil on canvas, 13 x 16" (33 x 41 cm)
Private collection, London (PV295)

128

Path of L'Hermitage at Pontoise. 1872

Oil on canvas, 21 x 28¾" (54 x 73 cm)
Private collection (PV165)

129

Sunset at Valhermeil, near Pontoise. 1880

Oil on canvas, 21 x 25¼" (54 x 65 cm)
Courtesy of Christie's, London (PV508)

Opposite:

130

The Woods of Saint-Antoine.
Landscape at Pontoise. c.1879

Oil on canvas, 25¼ x 31½" (65 x 81 cm)
Private collection (PV492)

131

The Plowman. 1876

Oil on canvas, 21 x 25¼" (54 x 65 cm)
Private collection (PV340)

132

View of Osny near Pontoise. 1882

Oil on canvas, 23½ x 28¾" (60 x 73 cm)
Private collection (PV584)

133

Snow Effect at L'Hermitage. 1875

Oil on canvas, 21 x 28¾" (54 x 73 cm)
Private collection, Kunstmuseum, Basel (PV307)

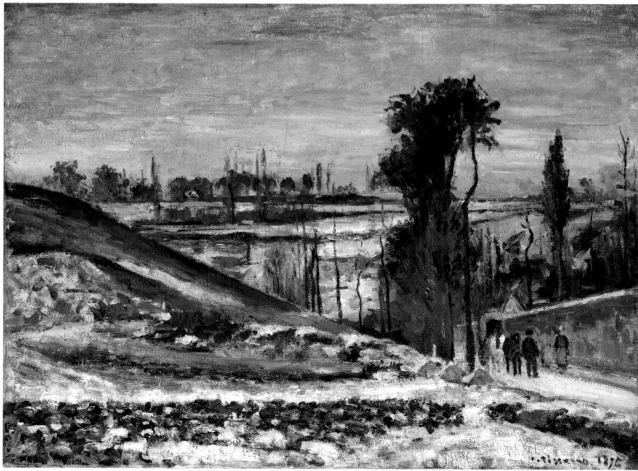

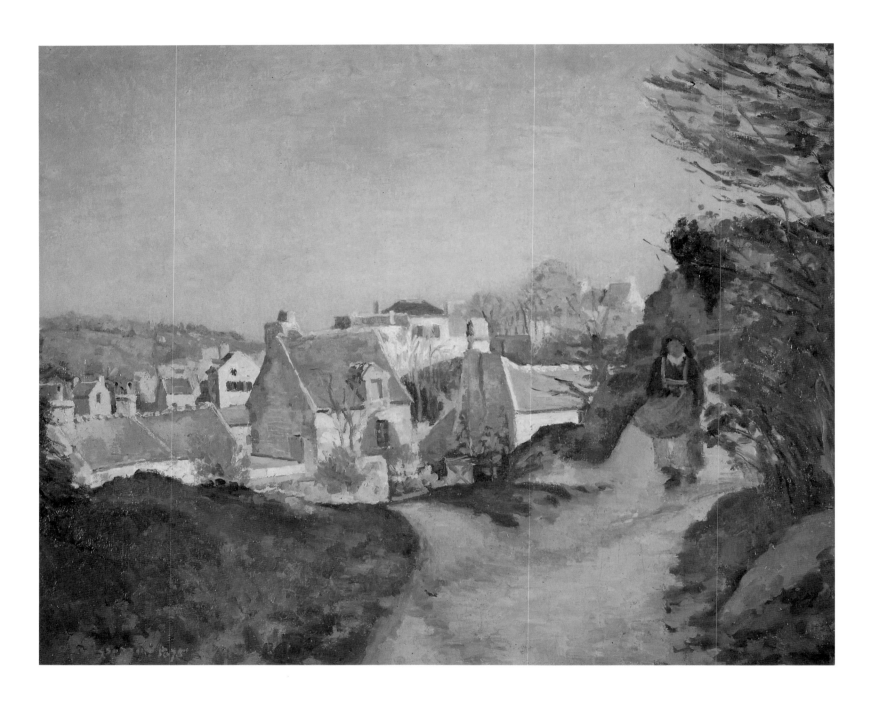

134

La Côte du Jallais. Pontoise. 1875

Oil on canvas, 23½ x 29¼" (60 x 75 cm)
Private collection (PV 311)

135

Cottages at Auvers. 1879

Pastel, 23½ x 28¾" (60 x 73 cm)
The Wohl Family (PV 1544)

136

Village Street. Auvers-sur-Oise. 1873

Oil on canvas, 21 x 25¼" (54 x 65 cm)
Private collection (PV 229)

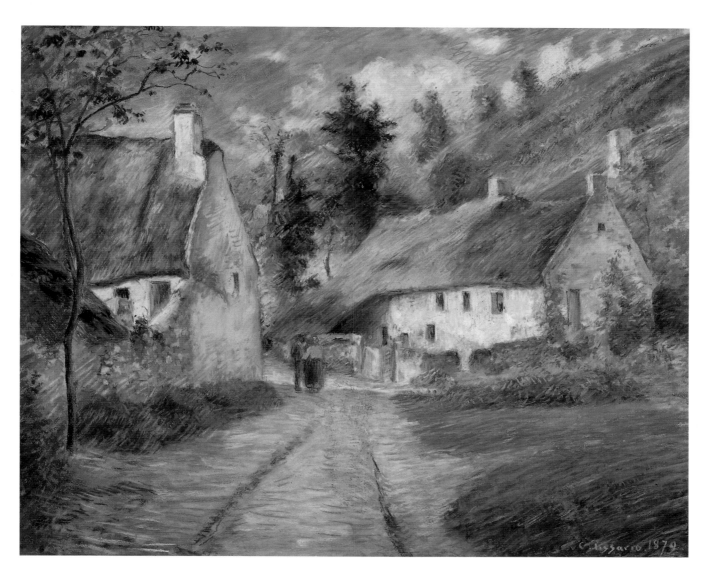

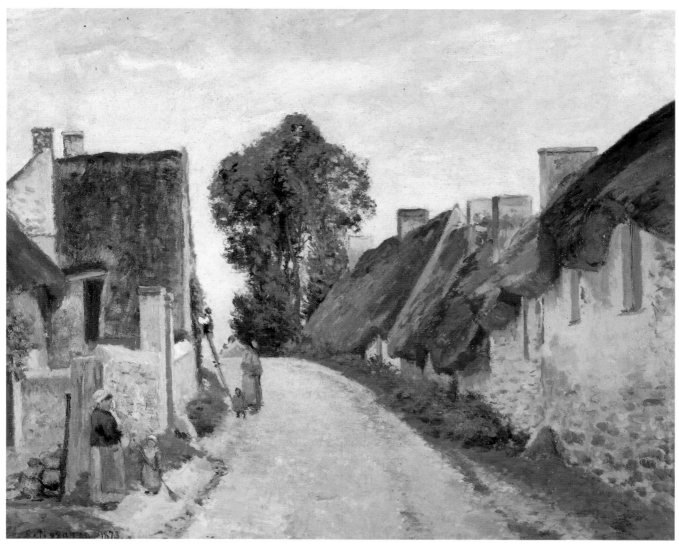

137

La Mare à Ennery (The Pond at Ennery). 1874

Oil on canvas, 21 x 25" (53.1 x 64.2 cm)
Yale University Art Gallery. Lent by Mr. and Mrs.
Paul Mellon (PV259)

138

Le Fond de L'Hermitage
(The Woods of L'Hermitage). 1879

Oil on canvas, 49¼ x 64¼" (126.3 x 164.7 cm)
The Cleveland Museum of Art. Gift of the Hanna
Fund, 51.356 (PV489)

139

The Hermitage. Effect of Snow. 1874

Oil on canvas, 21 x 25¼" (54 x 64.8 cm)
Courtesy of The Fogg Art Museum,
Harvard University, Cambridge
Gift of Mr. and Mrs. Joseph Pulitzer, Jr.
(PV240)

140

La Route d'Osny. 1883

Oil on canvas, 21½ x 25¼" (55 x 65 cm)
Private collection (PV591)

141

The Little Bridge, Pontoise. 1875

Oil on canvas, 25½ x 31¾" (65.5 x 81.5 cm)
Kunsthalle, Mannheim (PV 300)

142

The House in the Fields, Rueil. 1872

Oil on canvas, 16 x 20" (41 x 51.3 cm)
Private collection

Opposite:

143

*The Côte des Boeufs at L'Hermitage,
near Pontoise.* 1877

Oil on canvas, 45¼ x 34½" (116 x 88.5 cm)
Reproduced by Courtesy of the Trustees,
The National Gallery, London (PV 380)

Montfoucault

*I*f Pontoise has symbolic importance within the decade of Pissarro's alliance with Impressionism (1872–82), Montfoucault offered him isolation from Paris, from Pontoise, from the so-called school of Pontoise (Cézanne, Armand Guillaumin, and others), and a vital temporary solution to one of his most arduous financial crises during the mid-seventies. This break enabled him to reflect on his Pontoise output and pursue it. At the same time, it allowed him to sow the seeds of pictorial crops to come, while also enjoying the comforting friendship of the Piettes.

Montfoucault also provided him with a totally new source of visual topics: there, his work reflected a tentative interest in genre subjects. His treatment of space was conspicuously different also: the Montfoucault fields were enclosed, the horizon line often blocked. He painted the inside of farmyards and, equally, farm interiors. His color scheme turned to a much narrower range of silvery grays, blacks, golds, siennas, and slate blues.

While Pontoise provided the pretext to depict the manifold ambiguities of suburban life in the second half of the nineteenth century, Montfoucault, in contrast, presented an opportunity to study peasant life on its own, in direct terms. There Pissarro's first haymaking scenes, such as *La Moisson de Montfoucault* (fig. 144), were executed in 1876.

The spatial units Pissarro represented in Montfoucault tend to be smaller and less frequently open onto broad vistas than those of Pontoise. Perhaps this reflects Montfoucault's relative diminutiveness: it is a tiny hamlet, with approximately fifty inhabitants, consisting of two or three farms and some five or six houses. It is too small to appear on the Michelin road map. Attached administratively to the village of Melleraye, which lies between two *départements*, the Mayenne and the Orne— Montfoucault is virtually on the border between Brittany and Normandy. It is actually set at the end of a cul-de-sac, a few miles away from the nearest village, and there is no town for twelve or fifteen miles and so, of course, no museum or other cultural institution of any sort.

144

*La Moisson de Montfoucault
(The Harvest at Montfoucault).* 1876

Oil on canvas, 25¼ x 36" (65 x 92 cm)
Musée d'Orsay, Paris (PV 364)

145

Landscape with Rocks, Montfoucault. 1874

Oil on canvas, 25¼ x 36⅝" (65 x 94 cm)
The Wohl Family (PV 282)

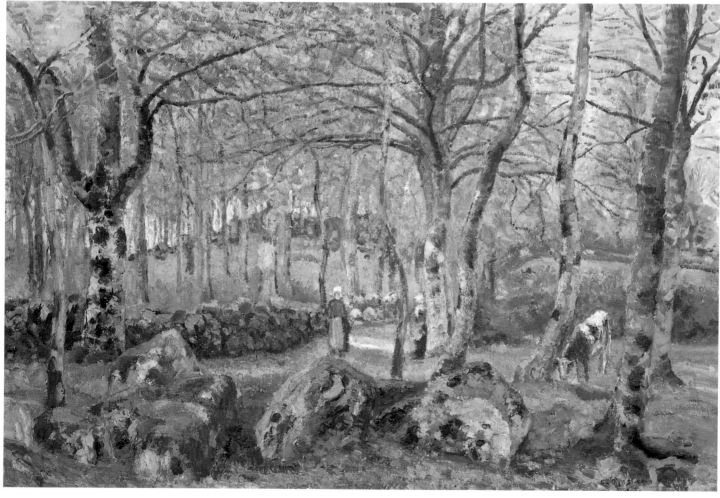

In 1871, when Pissarro started to look for a new place away from Louveciennes, he had considered moving towards the Mayenne, near his old friend. Piette looked at a few houses for the Pissarros. The dilemma in Pissarro's mind was between the practical appeal of a spot close enough to Paris (the inescapable center of the art market and art world) and one distant enough to penetrate the rural world.

Pissarro's friendship with Piette obviously weighed strongly in favor of the small hamlet, and equally, the romantic, if unrealistic appeal, of keeping far away from the hectic gathering centers of the art world. A rather touching letter from Piette (circa August 1871) revealed the problem:

> do not think that the pleasure I would have if you stay with us makes me so oblivious to your interests as to try to influence you to leave the Paris region while it is in your interest to remain there. Only you and Martin [Pissarro's main dealer at the time] know best. . . . Just like you, if you allow me to express an opinion, I even think that you feel the pulse of life in Paris far more than here, where a benumbing and hopeless languor paralyzes you, no matter what you do.[1]

Pissarro resolved the matter by choosing neither place exclusively, but both intermittently. Pontoise offered the perfect compromise—a rural city or a suburban market town; hence all the ambiguities of the Pontoisian landscape (and of Pissarro's representations of it). Pontoise was not far from his Paris dealers, "Le Père" Martin, Latouche, and Durand-Ruel, and at the crossroads between urban and rural worlds. But from time to time he would retire with his family to Piette's house in Montfoucault.

A reader at the end of the twentieth century will have difficulty understanding how complicated, painstaking, and time-consuming it was to journey from Paris to Montfoucault a hundred years ago. As Piette explained in a letter to Pissarro in 1874, it took at least an entire day to reach Montfoucault from Paris. After a train ride of up to nine hours, the passengers arrived at the railway station of Céancé; they then had to walk for some two hours before reaching Montfoucault. Since the Pissarros came, not from Paris, but from Pontoise, they probably had to leave their home the previous day in order to catch the early train from Paris to Céancé. An extract of Piette's travel advice and his suggested itinerary conveys a sense of the distance between the capital and Piette's hamlet:

> When you are set to go, decide upon your definite date of departure at least two days in advance. Then go to the Montparnasse or the Saint-Lazare stations; then book a family omnibus to come and fetch you, so that you arrive at least half an hour in advance; you set the time yourself. The price is the same for seven people or less with all your luggage: 5.05 francs. The train to aim for is either the seven o'clock or the express at 8:55. . . . Book your seats in Paris for Céancé: I was told for sure that it is possible to do this at the Montparnasse information desk; the train arriving in Flers is partially dispatched with its luggage onto another train going from Flers to Mayenne, and arriving in Flers five minutes earlier than the Paris train. Once in Céancé, we will send for you, providing that you have warned two days in advance of your arrival, in order to leave us time to find horses and to inform Gounet from Lassay to go and pick you up. If we have to count on him, you must make sure to travel on the following days: either Sundays, Mondays, or Tuesdays (Wednesday is a difficult day); on Thursdays and Fridays I have nobody else (unless you come on a Saturday, which is my day). You should arrive at Céancé at 3:55; in two hours maximum, you should reach Montfoucault, i.e., 5:55.[2]

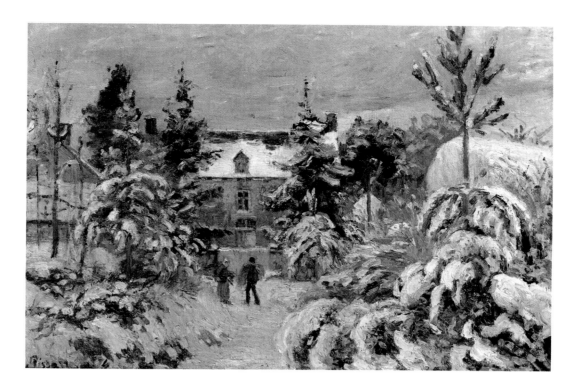

146

Piette's House at Montfoucault. 1874

Oil on canvas. 18 1/16 x 26 5/8" (45.9 x 68.3 cm)
Sterling and Francine Clark Art Institute,
Williamstown, Massachusetts (PV 287)

Such a sense of distance and isolation conspicuously pervades Pissarro's Montfoucault works. For example, in *Landscape with Rocks, Montfoucault* (fig. 145). where, unlike most of the Pontoise works, the painting offers little "way out"—no roads, no opening onto a different space, except for a small entrance within the wall through which the two female peasants have taken a cow to graze. The pictorial space is cluttered with trees, rocks, and enclosing walls. This painting—together with much of Pissarro's Montfoucault production—is very evocative of the actual sense of detachment, isolation, nowhereness felt when visiting Montfoucault even today.

The sense of a terminal space in this picture is reinforced by the close overall tonality; an overwhelmingly dominant silvery gray is used, with different shades of light mauve, to make up the sky, the trunks of the trees, the rocks in the foreground, and the walls. This unique sense of chromatic gray harmony itself endows the picture overall with a formidable cohesiveness, giving the sky, the air, the rocks, and the birch trees a universal mineral quality and creates a forceful visual impact. As though to underline the dominating role of gray in this work, the artist signed his work twice— once in dark marine blue and the second time over his first signature using the same silvery gray that chromatically unites the whole composition.

However, the sense of distance, detachment, and isolation in Pissarro's Montfoucault work never gave way to any form of sentimentalism or narrative. The two figures standing amid the trees are there: what matters only is their presence, represented pictorially, and not the stories of their lives, or any sympathy or touching grandeur they might arouse. The same remark applies vividly to *Piette's House at Montfoucault* (fig. 146), a conspicuously nonnarrative picture.

In contrast to his Pontoise figures, who always seem represented in movement on a path, either on their way from somewhere or toward somewhere else, Pissarro's Montfoucault figures are static: they stay where they are. Unlike Pontoise, a crossroad of paths, roads, walks, bridges, and railways, Montfoucault appears to be a place from

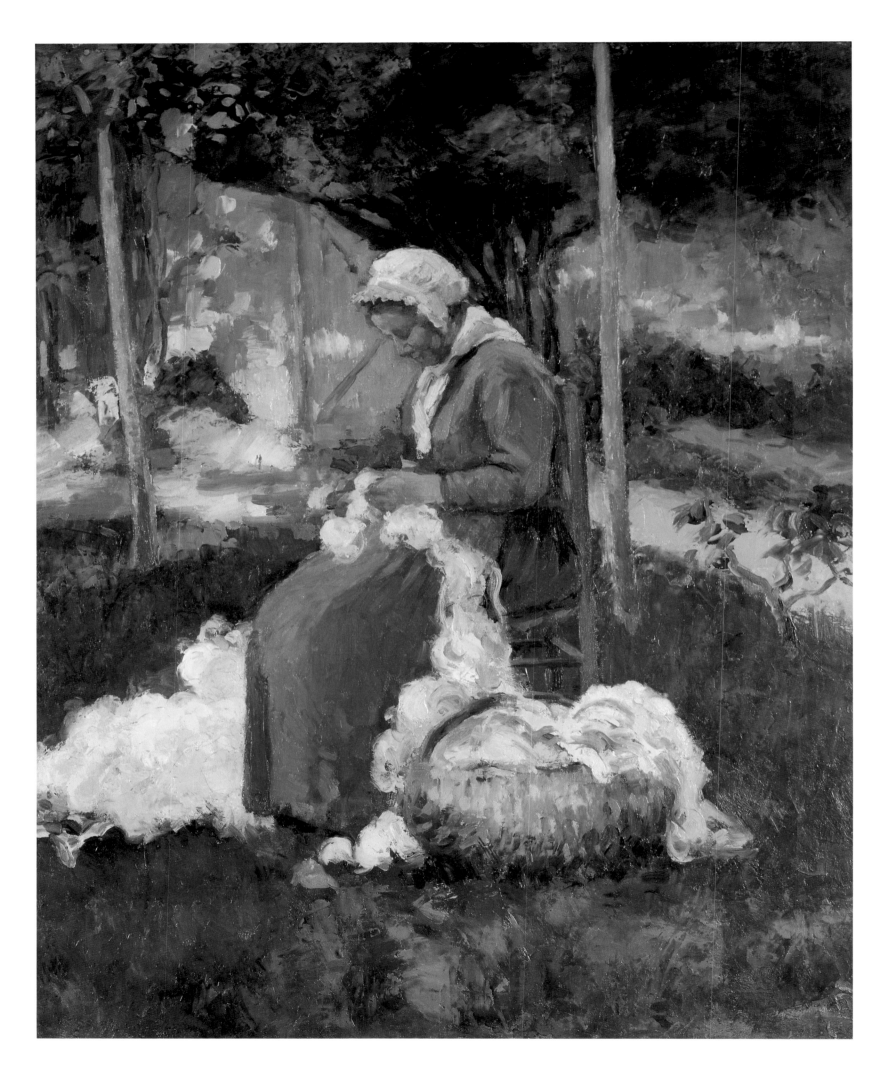

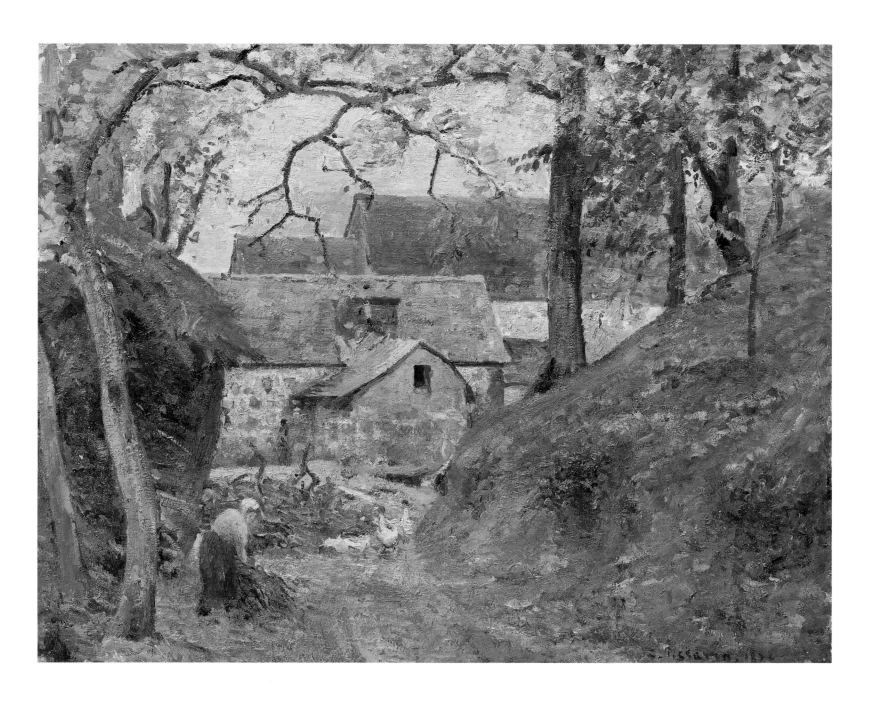

148

Farm at Montfoucault. 1874

Oil on canvas, 23¼ x 28¾" (60 x 73 cm)
Musée d'Art et d'Histoire, Geneva (PV 274)

147

Peasant Untangling Wool. 1875

Oil on canvas, 21¼ x 18" (55 x 46 cm)
Foundation E. G. Bührle Collection, Zurich
(PV 270)

149

Montfoucault. c. 1875

Charcoal on Lalanne laid paper,
12¼ x 18½" (31.4 x 47.4 cm)
Reproduced courtesy of J.P.L. Fine Arts, London

which there is virtually nowhere else to go. There, Pissarro's figures are most often female peasants—frequently seen tending cows, as in *Landscape with Rocks, Montfoucault*. Peasant women can also be seen harvesting (haymaking or carrying hay) as in *La Moisson de Montfoucault*, or sawing, or preparing wool, as in *Peasant Untangling Wool* (fig. 147). Even in some works that clearly represent a transitory movement, the figure seems to be plotted in her immobility—*Farm at Montfoucault* (fig. 148), or *La Mère Presle, Montfoucault* (fig. 150).

Of course, there are exceptions: the vibrant *Snow Effect in Montfoucault* (fig. 151), for example. Pissarro would not be Pissarro if there were not exceptions to almost every general statement that can be made about his work. This painting, however, was executed as an afterthought six years after his last stay in Montfoucault.

During his sojourns at Montfoucault in the mid-seventies, he addressed the problem of the figure and its integration into the landscape in novel ways. He delineated figures and objects with angular contours that are fragmented into many short straight lines, forming a polygonal, almost crystal-like outline. This is evident, for example, in a drawing inscribed "Montfoucault" at the lower left and stamped with the initials "C.P." (fig. 149), which is clearly very close (although not directly related) to *Farm at Montfoucault*. As Brettell and Lloyd have noted, "The purpose of this systematic method of drawing the human form was to allow its ready integration into an ordered composition, thereby solving the problem of tension between the figure and the background that had constrained so many painters in the second half of the nineteenth century in France."[3]

The family went to Montfoucault around mid-August 1874, a few months after the death of their second daughter, Jeanne, and a month after the birth of their third son, Félix. Distressed and almost penniless, they stayed at the Piettes all summer and returned to Pontoise before coming back to Montfoucault around October 20 of the same year. On this second sojourn, the Pissarros stayed all winter and returned to Pontoise in the early days of February 1875. Their last stay was during the autumn of 1876. (Piette died of cancer on April 15, 1878.)

These three separate sessions witnessed a phenomenal turning point in Pissarro's career. His subjects now incorporated a much more diverse range of interests than his concurrent Pontoise productions, and included genre subjects, harvest scenes, and female peasants studied in large scale. He explored his drawing and painting techniques self-consciously and critically and resolved them into new systems. He first exploited gouache in 1878 on a fan. The subject he picked was a motif from Montfoucault. Certain works—*La Moisson de Montfoucault* (fig. 144), for instance—appear remarkably bold and varied in technique, exhibiting parts where the paint (hay) has been buttered into thick voluminous sheaves, while the clouds have been scumbled into dry, frothy masses of off-whites, whereas the brush-strokes, whirling away, have left out whole gaps of unprimed, unpainted, light-brown canvas—something difficult to conceive of finding in his Pontoise work.

What prompted Pissarro in the mid-1870s to distance himself from his Pontoise work and reflect upon his pictorial research while in the isolated context of Montfoucault, and to turn to a new range of subject matter, experimenting with defter and more adventurous techniques, has occasioned much conjecture. The elements of the suggested answers to this problem are twofold: the critical advice provided by Théodore Duret and the visual influence exerted on Pissarro by Jean-François Millet.

Duret in a letter to Pissarro dated December 6, 1873, referred first to an 1862 painting of his with three donkeys and a female peasant that he had just bought—*Donkeys Out to Pasture* (PV 19, not illustrated):

> I do not care to know how this was done or whether this was your light or your dark manner. . . . All I know is that your landscape with animals is as beautiful as a Millet, as it leaves a powerful impression.
> I still believe that rustic nature, with its fields and animals, is what best suits your talent. You do not have Sisley's decorative feeling, or Monet's fantastic eye, but you have what they do not have: an intimate and deep feeling for nature as well as a powerful brushstroke, so that a beautiful picture by you is something with an absolute presence. If I could give you a piece of advice, I would tell you: do not think about Monet or Sisley; do not care about what they are doing; go your own way, towards rural nature; thus you will explore a new avenue, and will go further and higher than any master.[4]

Even though Pissarro's imagery, initiated in Montfoucault a few months after he received Duret's letter, seems to follow the critic's advice, it is worth examining the problem from a wider perspective, by first taking into consideration Pissarro's ambiguous answer to Duret's letter:

> Thanks for your advice; surely, you must know that I have been thinking for some time about what you are saying. What has stopped me from doing nature from life has simply been the lack of available models, not only to do pictures, but even to study the subjects seriously. Yet, it will not be long until I attempt to do some of it again; it will not be easy as you must know that these pictures cannot always be done after nature, i.e. outdoors. This will be quite difficult.[5]

Pissarro's thanks sound in part redundant, if not reluctant, when indicating that he had not waited for Duret's advice about subjects to paint. In addition, the diffi-culties Pissarro mentions in tackling "rural subjects" can obviously be lessened in

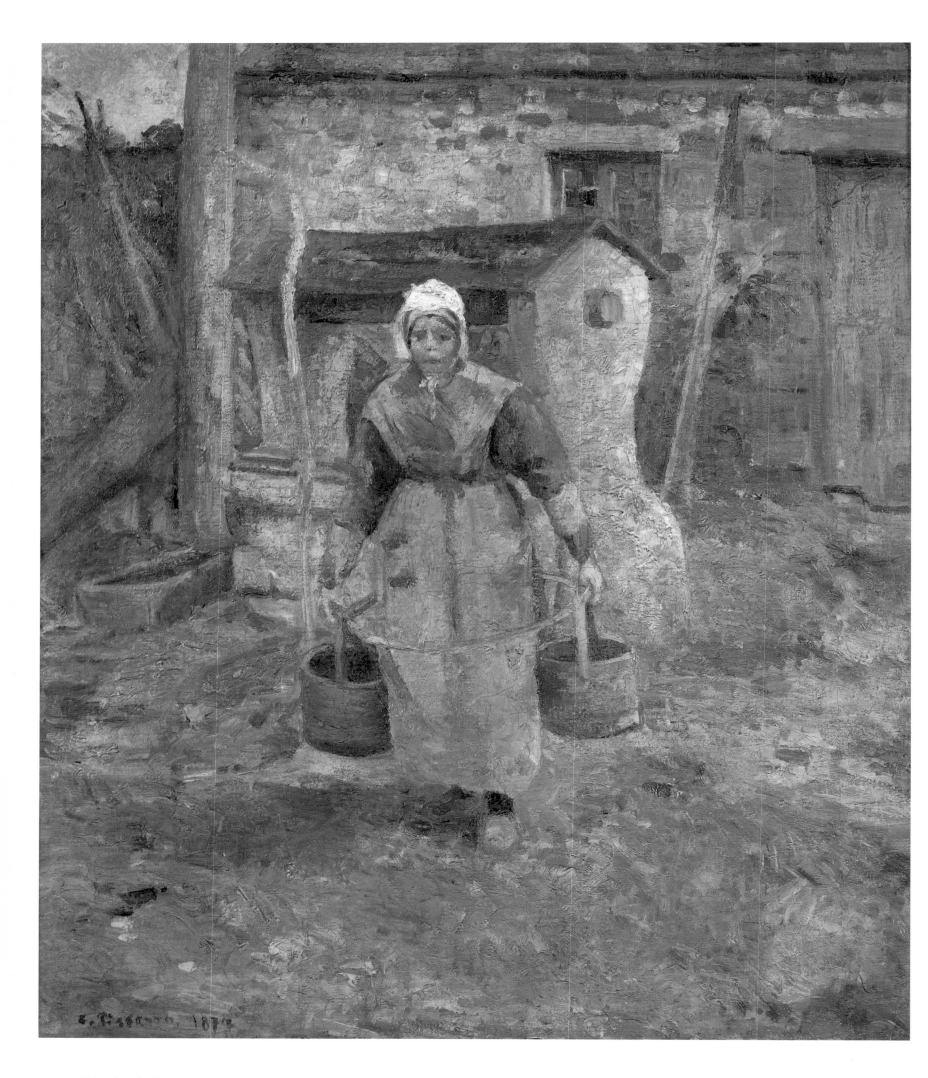

144 · Camille Pissarro

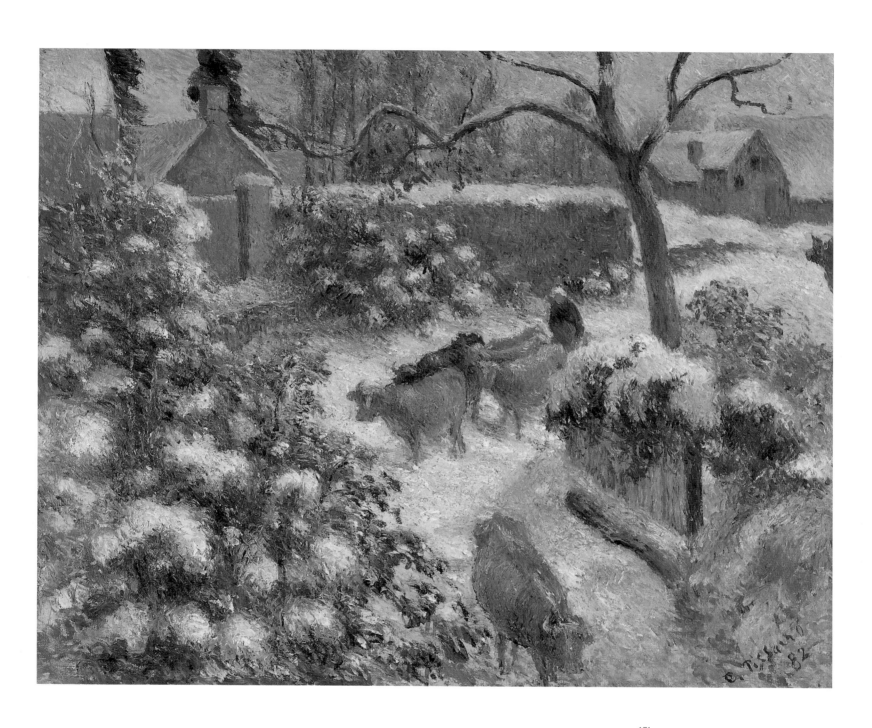

151

Snow Effect in Montfoucault. 1882

Oil on canvas, 18 x 21½" (46 x 55 cm)
Collection Mr. and Mrs. Y. Hatano, Tokyo
(PV554)

150

La Mère Presle, Montfoucault. 1874

Oil on canvas, 28¾ x 23½" (73 x 60 cm)
Private collection (PV288)

Montfoucault (with Piette's help). It was easier (and certainly cheaper) to find models there who would agree to pose indoors and/or outdoors for sufficient lengths of time. The drawing *Pond at Montfoucault* (fig. 152) offers a particularly striking example of a study for the standing figure seen in the painting of the same name (fig. 153), itself used for the vast decorative panel *Winter at Montfoucault, Snow Effect* (fig. 155), or *Autumn: Montfoucault Pond* (fig. 154).

In a letter, written about ten years later (May 9, 1883), Pissarro looked back on the Duret letter, emphasizing his previous strong reservations about the critic's advice:

> If one should follow the ideas of all the gentlemen who write their feelings upon us, we would have quite a program . . . I remember only too well, in ca. 1874, that Duret (of whom there is nothing to fear) was telling me as diplomatically as he could that I was going the wrong way, that everybody thought so, even my best friends, those who even thought the best of me. I must admit that, on my own, without advice from anybody, I addressed myself the same reproach; I was fathoming myself; this was a tough time. Should I persist in the same way: yes or no? Or should I alternatively explore a totally different way? I decided that I should go on, thinking about how inexperienced I was in any other way; I was right to persist.[6]

The brief and impressive flashback in this letter provides a remarkable account of what happened to him pictorially in Montfoucault, partly as a result of Duret's advice. A few pointed phrases in Pissarro's letter aptly describe here a period of estrangement—loneliness (as opposed to the Cézanne-Pontoise period)—"on my own, without advice"; intense reflection or self-analysis—"I was fathoming myself." This, incidentally, corresponds exactly to what was described in the previous chapter, except that in Montfoucault it gave way to pure, solitary research.

Just before leaving Pontoise for Montfoucault, Pissarro, seemingly abiding by Duret's advice, wrote: "I am informing you that I shall soon depart for my friend Piette's country; I will not be back until January. I am going there in order to study figures and animals in the true countryside."[7] (Note the distinction implied in the phrase "the true countryside," as opposed to the suburban countryside: i.e., Pontoise.)

Before returning from Montfoucault to Pontoise, Pissarro warned Duret:

> I think I shall soon leave the woods where I have been living for a month and come back to Pontoise; I am therefore asking you to send me a check of 100 Francs for the price of the picture [*Girl Tending a Cow in a Pasture* (fig. 126)], for I shall be short of cash to pay for the fares for all my family. . . . I have worked quite a lot here, I have started working on figures and animals. I have several projects of genre paintings. I am timidly experimenting with this branch of art, so much illustrated by first-rank artists: this is rather bold, I fear that it might be a complete flop.[8]

The timid, tentative approach to genre subjects during the Montfoucault period was short-lived (though successful); see for instance, the extraordinary works *La Mère Presle, Montfoucault* (fig. 150), *Piette's Kitchen, Montfoucault* (PV 276, not illustrated), or *Peasant Untangling Wool* (fig. 147). Nevertheless, it was of crucial importance in that it laid a foundation for Pissarro's continuing exploration of the figure in a totally rural environment. He put a clear emphasis on the rusticity of Montfoucault in this letter to Duret when he wrote, "the woods where I have been living for a month." In referring to "first-rank artists," Pissarro seemingly echoed Duret's

earlier letter where the critic said that the Pissarro "landscape with animals" that he had just purchased was "as beautiful as a Millet."

Pissarro's choice of subject matter, his treatment of figures, and his approach to genre in Montfoucault can easily be reminiscent of Millet's work. But Degas succinctly captured the essential distinction between Millet's figures and Pissarro's, when he exclaimed: "Millet? Yes, his sower sows for Humanity. Pissarro's peasants work for their bread."[9]

Pissarro himself was wary of having his work compared to Millet's: "they are all throwing Millet at my head, but Millet was biblical! For a Hebrew, there is not much of that in me. It's curious!"[10] Thus, Pissarro consciously reflects on one of the paradoxes inherent in his art. He expressed his opposition to Millet's sentimentality, moral embellishment, nostalgia, and mythologies in vehement terms throughout his letters; and in one in particular, took Millet's *Angelus* to task:

> this painting, one of the painter's poorest, a canvas for which in these times 500,000 francs were refused, has just this moral effect on the vulgarians who crowd around it: they trample one another to see it! This is literally true and makes one take a sad view of humanity. Idiotic sentimentality which recalls the effect Greuze had in the 18th century: the Bible reading, the broken jar. These people see only the trivial side in art. They do not realize that certain Millet drawings are a hundred times better than his paintings, which are now dated.[11]

The novelist and critic J.-K. Huysmans, without naming Millet, also summarized the sharp distinction between the two artists: Pissarro "paints his peasants without false grandeur, simply as he sees them."[12] One thus understands more fully why Pissarro felt ambivalent in his references to Millet in the letter to Duret quoted above, in which he describes his attempt at genre painting while in Montfoucault.

As a result of Pissarro's stay in Montfoucault, he consolidated the technical and pictorial discoveries he and Cézanne had made together in Pontoise, while simultaneously striking out on his own by using much larger formats when he stayed with the Piettes—see *L'Abreuvoir de Montfoucault* (fig. 153), *Winter at Montfoucault, Snow Effect* (fig. 155), and *Autumn: Montfoucault Pond* (fig. 154). He was also being innovative with new subjects and deftly juxtaposing different methods of work. In this sense, Montfoucault was as significant for Pissarro as L'Estaque was for Cézanne. As Cézanne much later recalled, "When I think about it, it was only at L'Estaque that I came to fully understand Pissarro—a painter like myself—a workaholic. An obsessive love of work took hold of me."[13]

Applying the analogy to Pissarro, one could say that while in Montfoucault, Pissarro came to understand Cézanne fully and from the depths of his Montfoucault "woods" also started to engage in a cycle of works, some of monumental importance, which contributed to forge the hallmark of his pictorial process in his late years.

As the two artists were able to realize the fruits of their common psychological insight best when they were physically distant from each other, so it is the notion of distance, physical as well as psychological, which Montfoucault best represented in Pissarro's work. Piette knew that this aspect of his countryside would lure Pissarro when he wrote to his friend in December 1871: "Ah! If only it were just the two of us where I come from! What splendid things to do, and in these places, one could think

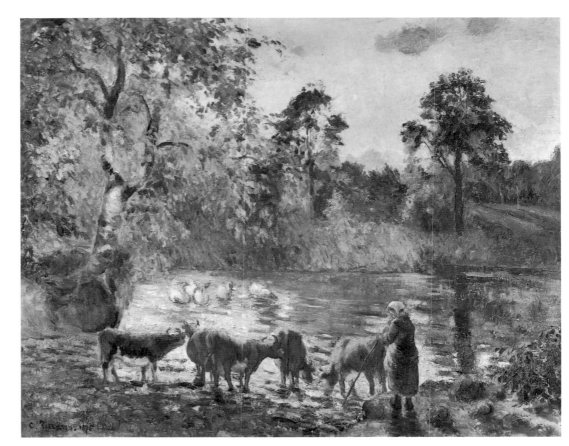

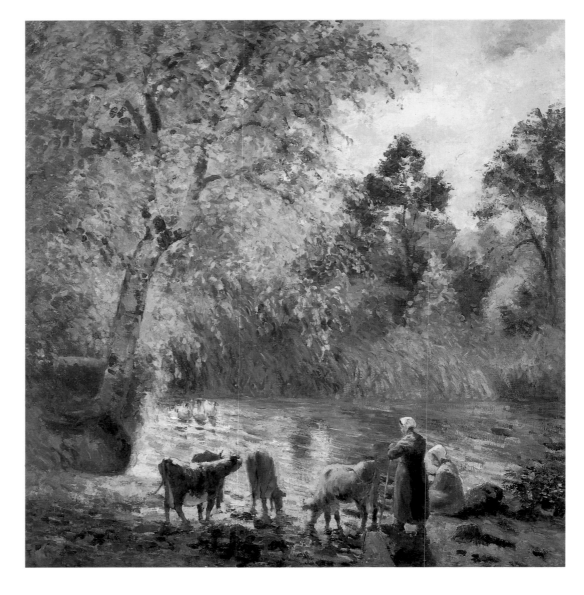

152

Pond at Montfoucault. c. 1875

Charcoal, 11⅜ x 9" (29 x 23 cm)
Collection Arkansas Arts Center, Little Rock

153

L'Abreuvoir de Montfoucault
(Pond at Montfoucault). 1875

Oil on canvas, 28¾ x 36¼" (73.7 x 93 cm)
The Barber Institute of Fine Arts, The University
of Birmingham, England (PV 320)

154

Autumn: Montfoucault Pond. 1875

Oil on canvas, 44½ x 43" (114 x 110 cm)
Private collection (PV 329)

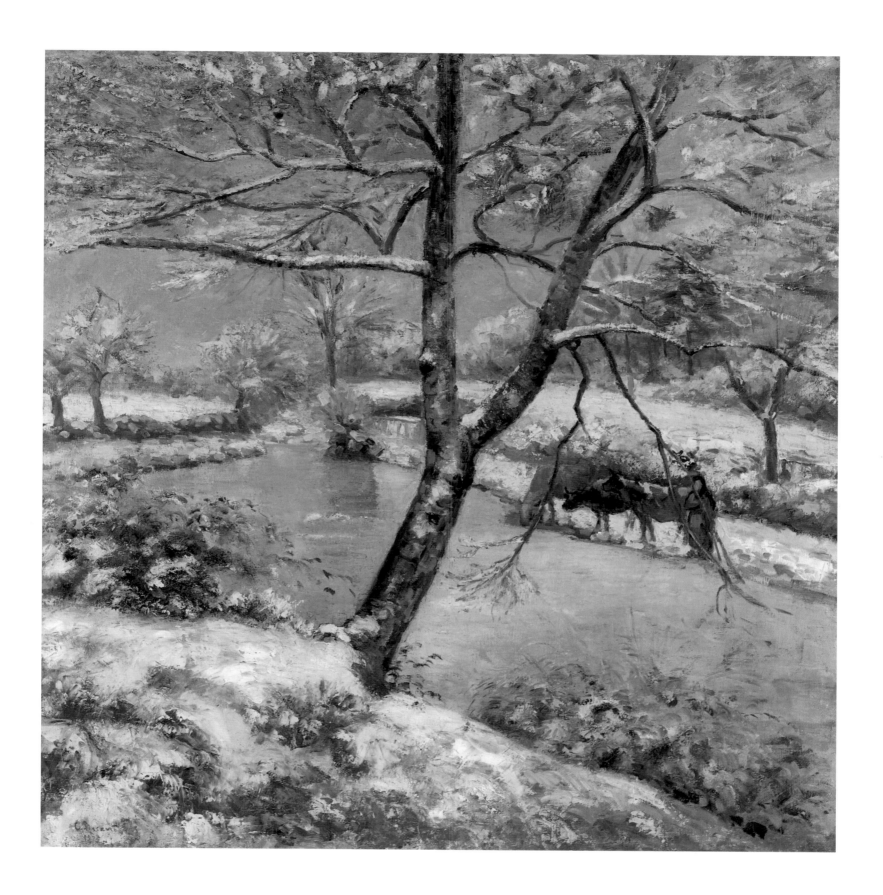

155

Winter at Montfoucault, Snow Effect. 1875

Oil on canvas, 44½ x 43" (114 x 110 cm)
Private collection (PV 328)

that one is thrown 1,000 or 2,000 years back: no traces of man left, it is just as wild as after a century or two of flood; trees and rocks of such color! [see *Landscape with Rocks, Montfoucault* (fig. 145).] But each has to work by himself. Everything strongly demands it."[14]

Piette, in this, appeared diametrically at the opposite pole from Cézanne: with the latter in Pontoise and Auvers, Pissarro would regularly work together; with the former, however, solitude was not only encouraged, it was deemed necessary.

In another letter, written on Christmas Day 1873, Piette envisions aspects that Pissarro would find pictorially rewarding only a few months later: "When I am by myself in a wood, contemplating nature [again see fig. 145], I regain all the strengths that worldly events take away from me; I would like to paint all that is beautiful that I see around me, and you know better than I that winter is full of exhilaration for a painter."[15]

Pissarro's response to the exhilaration of winter took a monumental shape with *Winter at Montfoucault, Snow Effect* (fig. 155)—a very large, almost square painting, probably partly executed or finished in Pontoise after the oil sketch *The Montfoucault Pond, Winter Effect* (PV 275, not illustrated).

The former can be seen as bringing together, climactically, lessons learned from Cézanne and Courbet, as well as displaying a unique approach to subject matter and composition. An extremely cohesive, chromatic harmony of the cold, rich surface of icy blues and greens is toned down with white, which unifies everything. The three elements seem to have fused into one: there is a daunting sense of continuity among the snow-covered earth, the frozen pond, and the heavily loaded sky heralding a further cover of snow. This cycle can even be read as a metaphor for the making of this picture—the canvas having been repeatedly covered with new layers of paint.

Two elements disturb this almost perfect harmony while bringing diversity and animation to the work. The solitary cowgirl on the far side of the pond tends three cows, including a red one, which carries the only note of warmth in the entire chromatic scale of the work, excluding the red of the artist's signature. The tree in the foreground also plays a double role in the organization of the painting. It encompasses, within the intertwined pattern of its branches, the bank on which the artist's easel is set, the frozen pond, the far bank, and the sky. However, concurrently, the tree seems to be running counter to the overall spatial organization of the painting, and its ascendant movement contradicts the horizontal or oblique succession of static planes of color. The complex movement of its entangled branches adds a touch of chaos, lyricism, even madness, to this otherwise impeccably silent, well-ordered composition. The branches are in disarray, pointing in different directions. The two lower right branches cross or bar the group of cows and the figure, reducing the sentimental or narrative element that could be associated with these figures. We see, consequently, that the subject matter of this picture is not just cows drinking in a frozen pond where the ice is broken, nor is it a tree; rather it is a complex ensemble in which all the elements either interact with or counteract each other.

This intricate ensemble is substantiated by paint alone. Here two features mark the significance of the collaboration with Cézanne: the alternating use of both brush and palette knife, partly suggesting the contrast between the frozen solid mass of ice

and the fluffy accumulation of snow, and the fact that, as can clearly be observed here in the treatment of the tree in the foreground, the delineation of objects is sustained by empty contours. Instead of drawing or emphasizing the outlines of objects, as in traditional practice, Pissarro leaves a tiny, barely visible furrow of unpainted canvas between the juxtaposed masses of paint, thus subtly enhancing the presence and volume of the tree and sustaining the impression of limpid clarity which prevails throughout this picture.[16]

Winter at Montfoucault, Snow Effect (fig. 155) and *The Montfoucault Pond, Winter Effect* (PV 275, not illustrated) form a cyclical ensemble together with *L'Abreuvoir de Montfoucault* (fig. 153) and *Autumn: Montfoucault Pond* (fig. 154). *Winter at Montfoucault, Snow Effect* and *Autumn: Montfoucault Pond*, of identical format, were both commissioned by the artist's cousin.[17]

Autumn: Montfoucault Pond, executed after *L'Abreuvoir de Montfoucault* (fig. 153), itself executed after the drawing of the same subject (fig. 152), illustrates the phenomenal flexibility and inventiveness of Pissarro's working methods as he was transposing the motif from a rectangular format (28¾ x 36¼") onto a nearly square canvas of larger and quite different proportions (44½ x 43"), which meant that he was both contracting and expanding his original. In his translation, Pissarro gave more room to the left and right banks, therefore feeling the need to introduce an extra figure seated next to the standing cowgirl to fill in this extra pictorial space. At the same time, he emphasized the entrance gap to the pond (where the cows are led to quench their thirst) by reducing the number of cows from five (in fig. 153) to four (in fig. 154). Instead of unfolding the cows' presence in a tangled oblique **MV** configuration, the cowgirl's stick, dipped diagonally in the pond, echoes the diagonal line of the neck of the right cow in fig. 153. In fig. 154, the cowgirl holds her stick parallel to her vertical body line, detaching herself distinctly from the herd and framing the cows on the right, while the tall, silvery tree on the other side forms a second frame.

The tree in question has gained in height, with more branches visible, and in breadth, now covering more than half of the upper width of the picture. Part of the lateral expanse of sky and landscape has gone in this work, making the picture more compact and more unified—a need felt by Pissarro previously in *L'Abreuvoir de Montfoucault* (fig. 153), when he decided to prolong arbitrarily and unrealistically the reflection of the right-hand tree throughout the whole surface of the pond. The passage from these two paintings reveals nothing short of a tour de force. Both groupings of paintings—*L'Abreuvoir de Montfoucault* and *Autumn: Montfoucault Pond* and the latter painting and *Winter at Montfoucault, Snow Effect*—form extraordinarily coherent and forceful pictorial couples. They display, both independently and together, an astonishing vitality and an autonomy which makes the Montfoucault period decidedly worthy of renewed attention.

It is important to remember, however, that Montfoucault with the richness and density of the pictorial output that characterized the months spent there, in no way terminated Pissarro's Pontoise period but, rather, was an intermezzo within the Pontoise years. From Montfoucault, Pissarro returned to Pontoise, ready to tackle new problems.

Figures, Harvests, Market Scenes

F *igures*

Pissarro and his family left Pontoise finally on December 1, 1882. Initially, they settled in a small village called Osny, a few miles from Pontoise, before leaving for Eragny, where Pissarro lived until his death in 1903. Though Osny was very close to Pontoise, the move was significant: Pissarro, after ten years in Pontoise, had obviously formed a strong attachment for the town and did not leave without some regret. Only two months before, in a somewhat passionate letter to his friend Monet, who himself was moving from Vétheuil and contemplating settling in Pontoise, Pissarro gave one of the most poignant descriptions of what the town had meant to him as a painter: "I have to leave Pontoise much to my regret, as I cannot find a house there that is well located and reasonably priced. It is much to my regret, because it seemed to me that Pontoise suited me from every point of view; but I think that you will manage to find what you are looking for better than I, since you can afford a higher rent."[1] Pissarro then described a couple of houses that probably seemed ideal to him: "On the Côte du Jallais, in the town itself, but only two steps away from the fields, there are one or two houses with gardens for rent."[2]

As we have seen, the majority of works executed in Pontoise represent this ambiguity and ubiquity marvelously: the world of suburbia and its elusive, clashing forces of transformation within the real and the imaginary: industry and leisure, town and country, old and new, movement and stillness, all of which Pissarro transposed into an ever evolving pictorial system.

In a subsequent letter to Duret, written September 28, 1882, Pissarro now expressed his frustration at having to stay in Pontoise, which he referred to as his "hole." He explained that as he had not yet found another house, he and his family might go back to stay with Madame Piette in Montfoucault, because the cold and dampness in the Pontoise house was unendurable in winter, and because there he hoped he would find less costly peasant models for his figure paintings.[3]

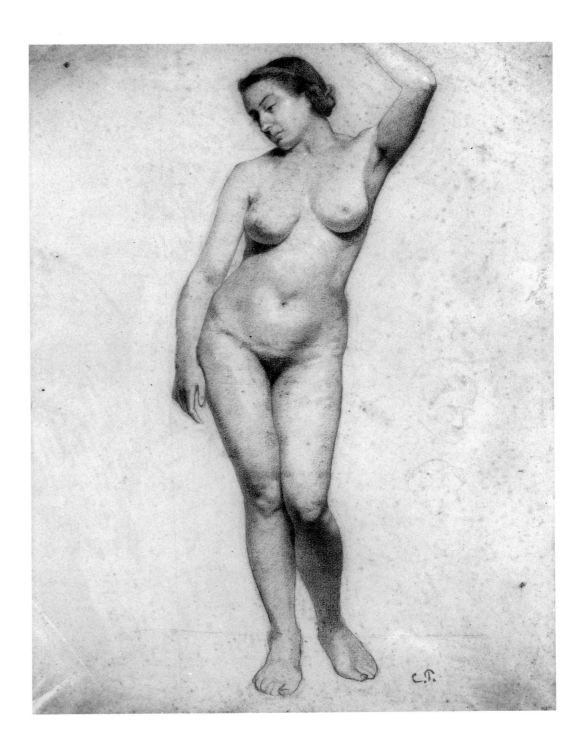

156

Nude. c.1855

Pencil. 17½ x 23½" (45 x 60 cm)
Private collection

His interest in figures had been demonstrated as early as the Saint Thomas period; then, of course, it was more thoroughly developed in Paris at the Académie Suisse, where *Nude* (fig. 156) was probably executed.

At the end of the 1870s, figures had just started to reach the forefront of Camille Pissarro's pictorial considerations, thus coinciding approximately with the end of his Pontoise period. In 1879, for the first time he executed two paintings representing a male peasant, in large scale, engaged in his daily chores, sawing—*Le Père Melon Sawing Wood* (fig. 157), which belonged to Gauguin—and at his ease—*Le Père Melon Resting* (fig. 158). What distinguishes both these works was that in each, the landscape was reduced to a background or backdrop. In this sense, the latter painting could almost be regarded as a portrait of Père Melon (nicknamed after his bowler hat—*chapeau melon*), although really he is not posing (as in a portrait) but

resting—having a break from his work. *Le Père Melon Sawing Wood* represents an extraordinary pictorial spectacle: different angles and forces form an ensemble of orthogonal lines and infuse the work with an inner dynamism. Père Melon is seen sawing a branch of a tree on an **X**-shaped log rest; the movement of the saw is exactly parallel to the two left legs of the log rest. The whole system of this picture is articulated around four main forces: the living tree (pushing upward, cropped by the upper edge of the picture), the dead wood, lying at the foot of the tree, perpendicular to it, the manufactured wood, turned into utensils (saw, log rest) and, finally, Père Melon, who articulates the living-working tensions between all these elements, having selected the combustible dead wood from the green wood, and using his own energy to saw it.

All this is set simply against a backdrop of greens—a ditch covered with intricately interwoven blades of grass, which blocks the horizon (unusual for a painting executed in Pontoise) and acts as a tapestry made up of myriad comma-like touches; this is perhaps one of the first signs announcing Pissarro's future active interest in divisionism.

This picture, which consists of a whole web of forces set in opposition to or equilibrium with each other to create a dynamic scenography of animated forces, is to be seen in contrast with its pendant, *Le Père Melon Resting*. The two utensils to the right of the picture, a hand fork and basket, inform the viewer that his work, which has ceased temporarily, was most likely weeding and earth scratching. Melon sits with his hands crossed, turning his half-smiling, ruddy, round-cheeked, ugly face toward the painter. What is going on? Who is he? The painter? Why does he want to paint me? Melon's gaze calmly seems to question the painter's presence and intention, establishing a dialogue with the painter where connivance and confidence interact with misunderstanding, questioning, and derision.

In order to visualize how radically Pissarro evolved the problematics of his figure paintings, one can set this work against Renoir's portrait of *Madame Charpentier and Her Children*, 1878 (Metropolitan Museum of Art, New York), shown at the Salon of 1879 (the same year that *Le Père Melon Resting* and *Le Père Melon Sawing Wood* were painted). The contrast is not only between the different classes, bourgeoisie and peasantry, or between divergent characters and manners, sophistication and simplicity, a ditch and a bourgeois salon, nature and culture—these works also reflect the chasm between two *Weltanschauungen* and between two totally separate forms of imagination. One is kindled by black silk, the other by rough blue working cloth; one is impressed by a superbly composed still life, the other by untidy nature.

As Mallarmé wrote, "The remarkable thing is that for the first time . . . while orthodoxy praises itself on the hallowed grand organs, anybody, through his individual playing and his ear, can make an instrument for himself; as soon as he learns how to blow on it or caress it or strike it, he can use it for himself, or devote it to language."[4] This is perhaps the most eloquent and succinct way to summarize the importance of these two representations of Père Melon, in contrast to the "grand organs" of Renoir's representation of Madame Charpentier. Père Melon, in these works, is not portrayed through an acceptable, tempered, vaguely sentimental vocabulary, nor is he set on some pedestal, against an artfully composed high horizon line. There is throughout Pissarro's figure compositions, and in particular during the

157

Le Père Melon Sawing Wood. 1879

Oil on canvas, 35¼ x 45⅝" (89 x 117 cm)
The Robert Holmes à Court Collection,
Perth, Western Australia (PV499)

158

Le Père Melon Resting. 1879

Oil on canvas, 21 x 25¼" (54 x 65 cm)
Private collection, New York (PV498)

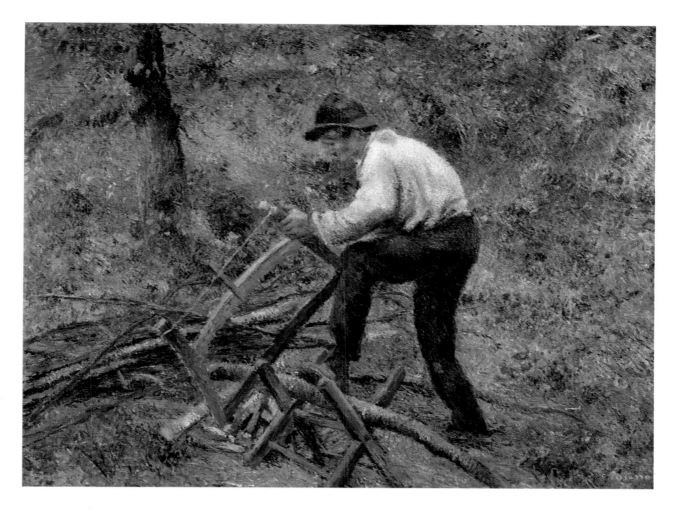

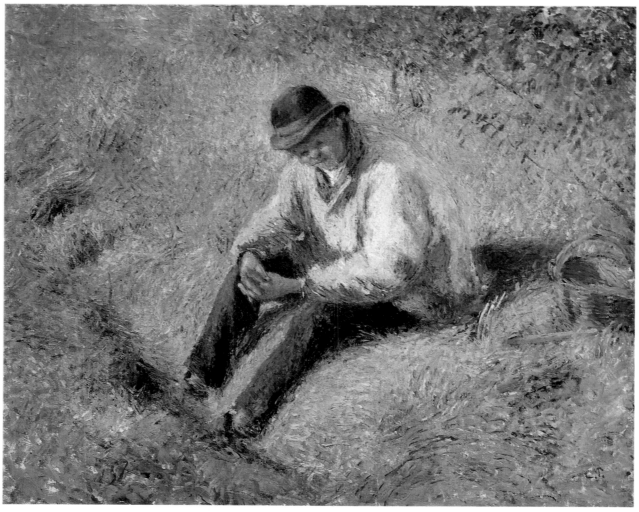

1880s, a paradoxical striving for simplicity, "But don't forget that one must only be oneself. But you will have to work at it!"[5]

Pissarro's ambition—as the Père Melon pictures illustrate and *Girl Tending a Cow in a Pasture* (fig. 126), as well as the peasant paintings (figs. 159–63)—was to develop a pictorial account of people as his gaze lighted on them, without any contortion, distortion, emphasis, or embellishment. The pencil study for *Café au Lait* (fig. 159) clearly demonstrates the artist's immediate response to his model's features.

Critics who reviewed the fifth Impressionist exhibition of 1880, where *Le Père Melon Sawing Wood* was exhibited, raised this very point: "Pissaro [*sic*] is becoming simpler. His *Scieur de bois* [fig. 157] is a rather pretty landscape . . . [where] Pissarro seems to be reforming."[6] Here in a negative judgment: "In his rustic scenes, notably his paintings *Scieur de bois* and *Récolte de petits pois* [*Picking Peas* (fig. 161)], Pisaro [*sic*] unsuccessfully tries to attain the rough, male simplicity of the master Millet."[7]

Despite his derogatory value judgment, the critic, Gustave Goetschy, hinted at an antinomy that is central to practically all of Pissarro's figure paintings. His simplicity of vision in these figures was, paradoxically, the result of a complex and meticulously thought-out endeavor, as Goetschy suggested in juxtaposing the terms "try," "attain," and "simplicity." However, his criticism implies that there is a "good" simplicity and a "bad" simplicity; Millet's is good, Pissarro's is bad.

Similar comments appeared in the reviews of the seventh Impressionist exhibition (1882), where *Young Peasant with Straw Hat* (PV 548, not illustrated), *Café au Lait* (fig. 160), *La Mère Larchevêque* (PV 513, not illustrated), and *Peasants Resting* (fig. 162) were shown; even the rather more sympathetic Armand Silvestre emphasized the kinship between Millet and Pissarro: "If the influence of Corot is manifest in the work of Monet, that of Millet is no less so in the work of Pissaro [*sic*]. And this is in no way a criticism."

Silvestre wrote, as though this relationship needed clarification:

> Whatever one may do, one is always someone's son. And besides, here it is not a question of paternity, but merely of the kinship of souls, and a distant one at that. All in all, to recall great models is in itself glorious. I very much like Pissar[r]o's large figures, permeated with rustic charm. They have a very different kind of truth than that found in Bastien Lepage's peasant women.[8]

Likewise Ernest Chesneau, in *Paris-Journal*, emphasized Pissarro's "difference" and yet concluded with these words, "Since Millet, no one has observed and depicted the peasant with such powerful vigor and with such accurate and personal vision."[9]

What is interesting in this brief note by Chesneau is his pairing two apparently contradictory adjectives, "accurate" and "personal," of the objective and the subjective. This antinomy is central to the famous Impressionist *sensation*. From the intricate and fragile equilibrium between the accurate and the personal, the simple and the complex, the spontaneous and the reflective, the real and the symbolic resulted the forceful and exquisite grandeur of Pissarro's figures.

One may wonder, however, about the relevance of the comparison (almost universal) between Pissarro's figures and those of Millet. The claim that Pissarro's figure paintings emanate directly from Millet has survived a long time. Even a hundred years

after the Impressionist reviews, the comparison could still find an uncritical echo: "in Millet and Breton, Pissarro had two immediate predecessors among painters of peasant subjects."[10]

A notable dissent to this emphasis on the Millet/Pissarro association was made by Huysmans in his review of the seventh Impressionist exhibition: "Pissarro exhibits an entire series of peasant men and women,[11] and once again this painter shows himself to us in a new light. . . . The human figure often takes on a biblical air in his work. But not any more. Pissarro has entirely detached himself from Millet's memory. He paints his country people without false grandeur, simply as he sees them. His delicious little girls in their red stockings, his old woman wearing a kerchief, his shepherdesses and laundresses, his peasant girls cutting hay or eating, are all true small masterpieces."[12] Huysmans singled out *Jeune Fille à la baguette, paysanne assise* (fig. 163), *Two Young Peasants Chatting Under the Trees, Pontoise* (fig. 164), and *Peasants Resting* (fig. 162).

No brief or simplistic account can properly circumscribe the rich and varied complexity of these paintings of figures; they do not fall within any ready-made or monolithic categories. Certainly, Millet in no way "explains" Pissarro. To all the critics who made these remarks on his debt to Millet, Pissarro replied in a letter to his son Lucien, "It is the same for my peasants, which people used to say are done *à la* Millet; people have since realized their mistake: it is too full of sensation not to be obvious; only superficial people can confuse black and white."[13]

Huysmans's notion of the former "biblical" quality in Pissarro and its rejection is central to Pissarro's figure paintings and by extension to Pissarro's aesthetics. Here "biblical" stands for a sign (gesture, mood, expression, etc.) which refers to an ethereal, religious, or mythical content or which hints of some form of "beyond"—be it an ideal, a lost paradise, a longing for happiness, or a striving for something other than the present conditions. None of this exists in Pissarro's figures. They do not carry a message with a lofty content, any ideal. In this again, Pissarro is very close to Flaubert, who wrote, "An ideal is like the sun, it sucks up all the dirt from the earth to itself."[14]

In fact, it is in precisely this that one sees the distance between his figures and those of Millet. But it is the myths and ideals that, according to Pissarro, prevail at all the Salon exhibits of official art and Symbolism, including Gauguin's work, from the 1890s onwards. These trends receive different derogatory labels in Pissarro's letters: "biblical," "literary," "mystical," "anecdotal," "religious," "sentimental."

Pissarro's figures, however, do not purport to convey an exact account of what female and male peasants actually looked like in northern France during the last two decades of the nineteenth century. While they are not allegories, neither are they sociological documents. From this difficulty, which is both essential and highly characteristic of Pissarro's figure paintings—i.e., the fact that they are resistant to conveying any message and to being "read" as sociological or anthropological witnesses of the raw facts—the manifold interpretations of Camille Pissarro's work have arisen.

Pissarro wrote two very interesting letters, about the nature of the problems he encountered in painting figures. The first letter is addressed to Octave Mirbeau and dated November 22, 1891. Referring to *The Cowgirl* (PV 823, not illustrated), Pissarro wrote: "I would so much like to show you my cowgirl, whom I have worked very

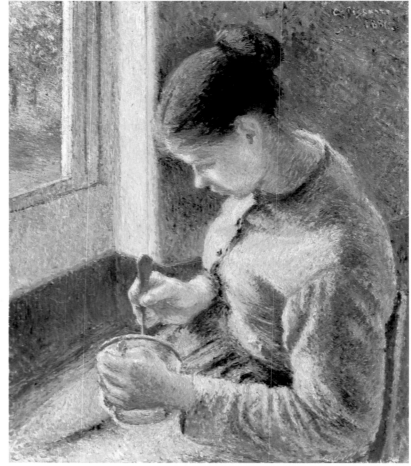

159

Study for *Café au Lait*. 1881

Black chalk, 23 x 17¼" (59.5 x 44 cm)
Private collection

160

Café au Lait. 1881

Oil on canvas, 25½ x 21⅜"
(65.3 x 54.8 cm)
The Art Institute of Chicago
Potter Palmer Collection, 1922436
(PV549)

161

Picking Peas. 1880

Oil on canvas, 23¼ x 28¾" (60 x 73 cm)
Private collection (PV519)

162

Peasants Resting. 1881

Oil on canvas, 32 x 25¼" (82 x 66 cm)
The Toledo Museum of Art, Toledo, Ohio
Gift of Edward Drummond Libbey (PV542)

163

Jeune Fille à la baguette, paysanne assise
(Country Girl with a Stick, Seated Peasant). 1881

Oil on canvas, 31½ x 25¼" (81 x 65 cm)
Musée d'Orsay, Paris (PV540)

164

Two Young Peasants Chatting Under the Trees,
Pontoise. 1881

Oil on canvas, 31½ x 25¼" (81 x 65 cm)
Galerie Abels, Cologne (PV541)

hard on. She is not yet finished, but I believe she is on the right track, until the moment of disenchantment that follows the final brushstroke—a solemn occasion."[15] He then mentioned *Seated Peasant, Sunset* (fig. 165), emphasizing the subject matter: "And my dreaming peasant woman, seated on a hummock, with a field behind, the sun is setting, she has just been gathering grass, she is sad, very sad, our Mirbeau . . . the real problem is that it must not suffer from mediocrity; otherwise it will become a romance. . . . I hate romance!—how can one avoid this crime?"[16]

It is instructive to observe that during the construction of this painting, involving *Seated Shepherdess (Sketch)* (fig. 166), and Study for *Seated Shepherdess* (fig. 167), there had been a flock of sheep which was eliminated in the final work in oils—leaving the figure alone in her reverie, free of any reference to her work, except for cutting grass, as the basket on the ground indicates.

The problems Pissarro described to Mirbeau are also specific to a group of works representing figures in various states of reverie, such as *The Nap, Peasant Lying in the Grass, Pontoise* (fig. 168) and its study (fig. 169), or *The Siesta, Eragny* (fig. 3), where the model's reverie is transformed into actual dream, or *Seated Peasant Woman* (fig. 170). The problem (the "crime") to avoid is romance—any signs, expressions, or gestures that could suggest sentimental narration or, more generally, anything emotional, religious, imaginative, visionary that would assign some precise content to these young female peasants' daydreams. Following Pissarro's advice, one must not to attempt to impose a meaning on their reveries; "She is sad," Pissarro informs us, but he is immediately careful not to reveal what it is that makes his model "sad"; otherwise, this would have become a "romance," an illustration of the "idiotic sentimentalism," which Pissarro saw in Millet's *Angelus*.[17] In fact, to describe what most satisfied him in his landscapes, Pissarro used adjectives which could aptly describe *Seated Peasant, Sunset* (fig. 165): "calm, simple, seated"[18]—qualities that he contrasted to his own occasional "disheveled romanticism," as in his *Cowgirl at Eragny* (fig. 171). But in this work, as in the two preparatory works that accompany it, *Landscape with Cowgirl and Cows* (fig. 172) and Study for *Cowgirl at Eragny* (fig. 174), one is at pains at first to find any signs of this "dishevelment," or what he called, more specifically, "the madness of his execution."

Pissarro was eminently aware of the price he had to pay for his stubbornly individualistic outlook; "too serious to appeal to the masses and not enough exotic tradition to be understood by the dilettante,"[19] was his shrewd observation. Writing with profound admiration about the Bing exhibition of Japanese decorative art in Paris in 1890—which certainly impressed him in his subsequent work—he commented in a similar vein: "it is not nature for the sake of nature, stupidly done, and yet, it is nature to the utmost."[20]

If anarchy has anything to do with Pissarro's art, it is not in his subject matter, since his figures have essentially no message, or little message, to deliver. It is precisely in a new approach to art, in a new task assigned to artists and their public that, in Pissarro's words, the value of art should perhaps be found. In a revealing letter to Lucien, Pissarro appeared flustered at what he called a "sentimental and Christian tendency" which he observed in his son's work *Figure couronée (Crowned Figure)*. Pissarro explained that the problem in his son's *Figure* was not in the drawing, the character, the expression, or the features of the figure, but in the idea.[21] Any art

whose function is to deliver a message, to render or express an idea, to arouse a sentiment, or to tell a story, is abhorred by Pissarro. This wrong tack, according to him, was incarnate in the work of Gauguin. Georges-Albert Aurier labeled Gauguin's art "ideist" (*idéiste*),[22] i.e., an art that suggests a higher content, a "beyond," some transcendent or exotic referentials.

Is this to say, as Aurier suggested,[23] that Pissarro's figures evoke no ideas? Definitely not, answered Pissarro, "but the idea, my dear, there is plenty of it in your other woodblocks, the only thing is that they are ideas of your own, you an anarchist, you who love nature and reserve great art for a better time when man, having attained a different way of life, will achieve a different way of understanding the beautiful."[24]

Pissarro here equates anarchy, great art, love of nature, a new mode of living, and a new understanding of the beautiful. This new understanding will be neither idealistic, nor materialistic; neither religious, nor socialistic;[25] neither literary, nor factual; neither symbolist nor realist. No representational or illustrative program at all was acceptable to Pissarro; this was the surest way to hobble his constant pictorial search, by circumscribing his *sensation*.

Pissarro intended to forge a new ideal and to pave the way towards a radical aesthetic whereby art would be stripped of all its canons and literary ambitions, and not have to express any particular message—be it in order to win an award at the Salon or to express spiritual or mystical feelings.

The abundance of subjects among Pissarro's figures seems to defy any attempt to classify or to draw simple generalizations about his work. His figures may be seen knitting outdoors, sewing, watching geese or children, tending cows, sheep, goats, or turkeys, lighting a fire, lying or resting, about to water the garden, digging a plot of land, picking or cutting cabbages, carrying pails, pushing a wheelbarrow, bathing in a stream, gathering grass, enjoying an idyll, or dancing—or they may be models in related poses performing the gestures without performing the tasks (figs. 174–208; see especially figs. 196 and 206).

This profuse diversity of figures involved in the dynamics of everyday chores, breathes simplicity—unadorned simplicity—a quality in art that Pissarro consciously developed and prized, in pictorial, literary, or even theatrical fields. Commenting on Maeterlinck's play *Les Aveugles*, for instance, he repeatedly emphasized that "what amazes the critics is the apparent simplicity of the material that he uses."[26] He complained in the same letter that the taste of the time seemed to require complication, artifice, elaboration—all displaying a fundamental lack of sincerity. The simplicity consistently sought after by Pissarro was not to be equated with spontaneous immediacy—it was the result of sustained, complex research involving several steps of creation, as can be seen in *Standing Female Nude I* and *II* (figs. 175 and 176), preliminary studies for *Bathers* (fig. 177).

Pissarro's figures are simple ("apparently") and sincere. They are not on show and no pretense of any sort animates their action or their pictorial representation. They have nothing to say; they are withdrawn or absorbed by their reverie or their chores. Even in groups, there seems to be a conspicuous lack of dialogue or narration—the painter seems to be depicting moments of silence as well as the lack of communication among the artist's models. It is all the more surprising that greater

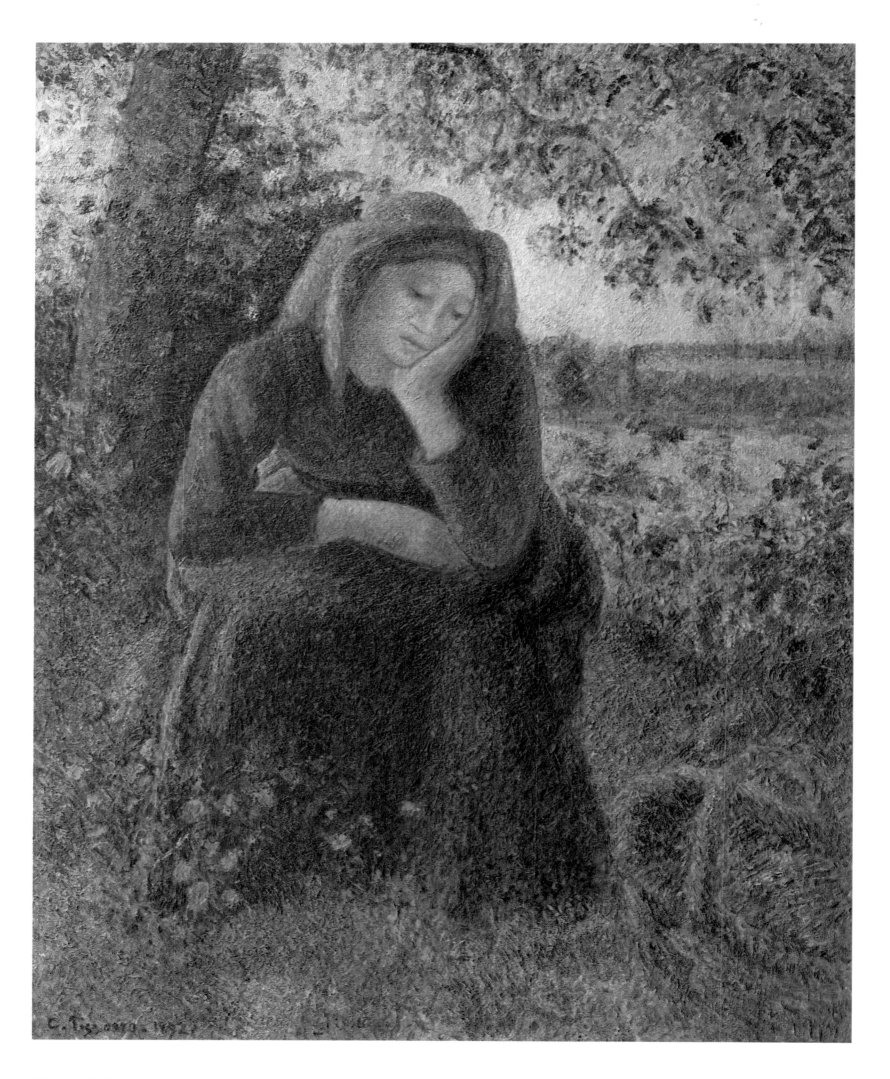

Opposite:

165

Seated Peasant, Sunset. 1892

Oil on canvas, 31½ x 25¼" (81 x 65 cm)
Private collection (PV824)

166

Seated Shepherdess (Sketch). c. 1892

Tempera, 31½ x 25¼" (81 x 65 cm)
Private collection (PV 1468)

167

Study for *Seated Shepherdess.* c. 1892

Crayon, ink wash on pencil grid,
6¼ x 4⅞" (16 x 12.4 cm)
Öffentliche Kunstsammlung,
Kupferstichkabinett, Basel

attention was not given to the daydreaming activity of many of Pissarro's figures, since dream is a notion to which Pissarro gave repeated voice: "I believe that there will be another generation who will be more sincere, more studious, and less malign, who will achieve the dream."[27]

According to Pissarro's aesthetics and ethics, this generation would possess the virtues necessary to realize the dream: sincerity, conscientiousnesss, and probity (essentially ethical values which Pissarro saw as conspicuously lacking in Symbolism —as exemplified by Gauguin).

Commenting on Prince Kropotkin's book *La Conquête du Pain*, Pissarro also mentioned the importance of the dream in anarchist thinking: "It must be said that even though it is utopian, it is at any rate a beautiful dream and we often have examples of utopias that have turned real, nothing stops us from believing that one day this will be possible, unless man sinks and returns to total barbarity."[28]

Of course, this is not to suggest that Pissarro's figures might be dreaming about utopias—what they are dreaming about is of no concern whatsoever to the painter. What is relevant, however, is that they are engaged in their reveries irrespective of the content. What interested Pissarro in his figures' reveries is that they are unfathomable; fundamentally these dreamers resort to what he called "ABSOLUTE LIBERTY."[29] Furthermore, this activity is most pertinent to the crucial artistic individual factor—the *sensation*.

Opposite:

168

The Nap, Peasant Lying in the Grass, Pontoise.
1882

Oil on canvas, 24¼ x 30½" (63 x 78 cm)
Kunsthalle, Bremen (PV565)

169

Studies of a Peasant Woman I. c.1884

Pencil, 11¾ x 14½" (30 x 37 cm)
Private collection

170

Seated Peasant Woman. 1885

Oil on canvas, 28¼ x 23" (724 x 59 cm)
Yale University Art Gallery. Gift of Mr. and Mrs.
Paul Mellon, B.A. 1929 (PV676)

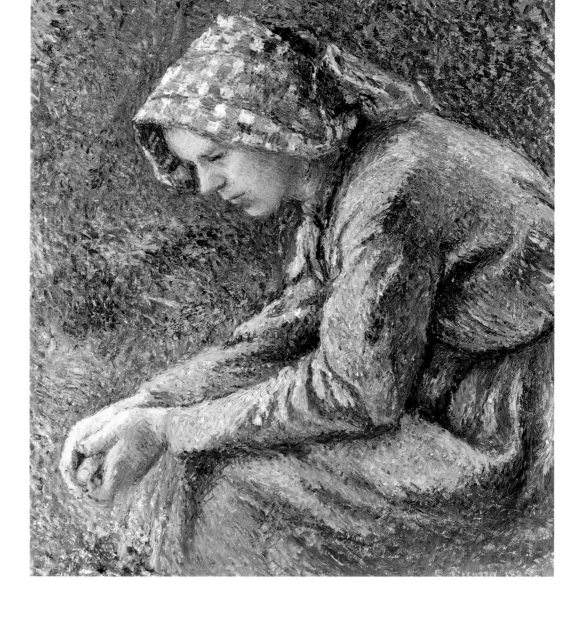

When Pissarro finally expressed some satisfaction to Lucien at having completed *Seated Peasant, Sunset* (fig. 165), he explained, "I believe that these paintings have gained a lot in respect to unity; what a difference from the studies!" (figs. 166 and 167). He then defined his new method: "I stand more than ever for the impression from memory; you get less the thing itself, but vulgarity goes also, to let the truth, half seen and felt, emerge."[30] Reverie, sensation, memory, then, form a kind of homogeneous chain which enables the artist to re-create the truth.

Pissarro's truth has to be constructed through a distancing from the first notes taken from nature. It resorts more to memory than to direct observation. In the same way as his figures tend to be absent-minded, Pissarro in his constructions becomes oblivious to his first perceptions of nature. This process, however, is nurtured by numerous studies directly observed. In this process, in all his figure paintings, Pissarro remained faithful to the clear and succinct definition of Impressionism he gave in 1883: "Really Impressionism was nothing but a pure theory of observation, without losing hold of fantasy, liberty, or grandeur—in a word, of all that makes an art great."[31]

Opposite:

171

Cowgirl at Eragny. 1884

Oil on canvas, 23¼ x 28⅝" (59.7 x 73.4 cm)
The Museum of Modern Art, Saitama (PV701)

172

Landscape with Cowgirl and Cows. 1884

Pen and ink on paper, 6 x 5¼" (15.6 x 13.4 cm)
The Langmatt Foundation, Sidney and Jenny
Brown, Baden, Switzerland (study for PV701)

173

Shepherdess. c. 1887

Tempera and gouache, 24¾ x 18¾" (63 x 48 cm)
Matsuoka Museum, Tokyo (PV1418)

174

Study for *Cowgirl at Eragny.* 1884

Watercolor, 16⅛ x 20½" (41 x 52 cm)
Private collection

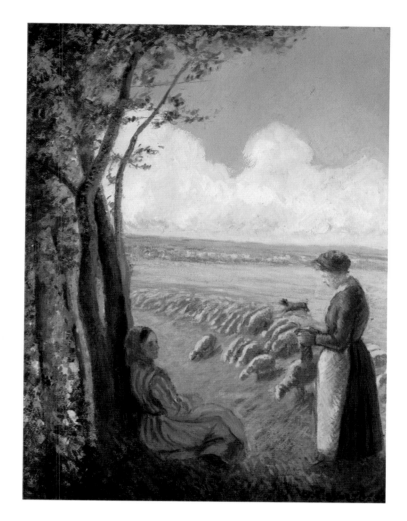

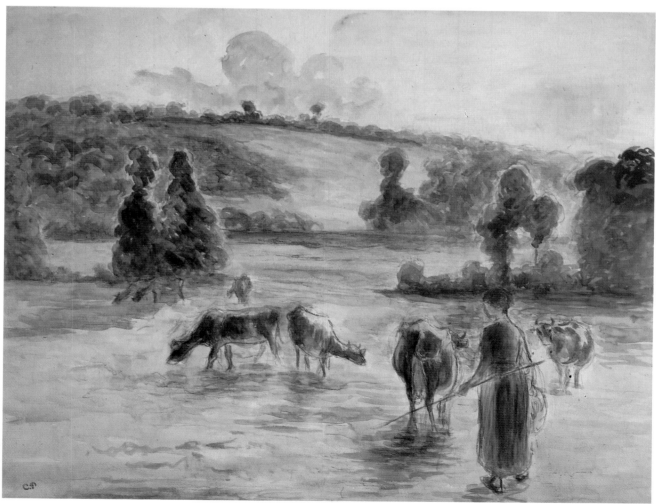

175

Standing Female Nude I. 1896

Pastel and black chalk on blue paper.
22 x 15¼" (56.5 x 39.5 cm)
Private collection (study for PV940,
PV938)

176

Standing Female Nude II. 1896

Red and black chalk on buff paper.
22⅞ x 16⅜" (58.7 x 42 cm)
Private collection (study for PV940,
PV938)

177

Bathers. 1896

Oil on canvas. 28¾ x 36" (73 x 92 cm)
Private collection (PV940)

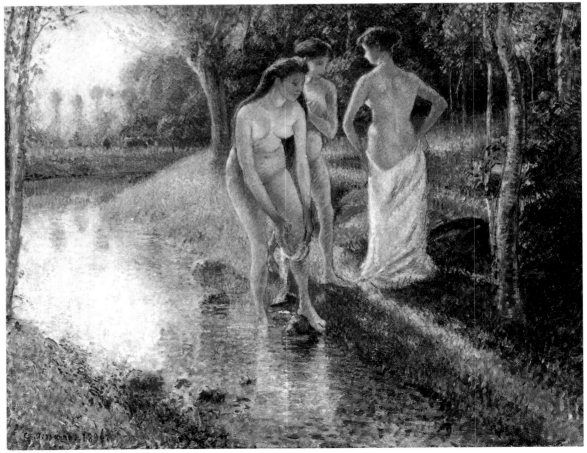

178

Woman Sewing. 1881

Gouache, 9¾ x 7⅜" (25 x 19 cm)
Private collection (PV 1356)

179

Girl Sewing. 1895

Oil on canvas, 25½ x 21¼" (654 x 544 cm)
The Art Institute of Chicago. Gift of Mrs. Leigh
B. Block, 1959.636 (PV 934)

180

Seated Goosegirl. 1891

Oil on canvas, 21 x 25¼" (54 x 65 cm)
Private collection (PV 770)

181

The Foot Bath. 1895

Oil on canvas, 28¼ x 36" (73 x 92 cm)
Collection Sara Lee Corporation,
Chicago (PV903)

182

Bather in the Woods. 1895

Oil on canvas, 23¼ x 28¼" (61 x 73 cm)
The Metropolitan Museum of Art,
New York. Bequest of Mrs. H. O.
Havemeyer, 1929 (PV904)

183

Cowgirl, Pontoise. 1880

Gouache, 13¼ x 18¾" (34 x 48 cm)
Private collection, New York (PV 1329)

184

Frost, Young Peasant Making a Fire. 1888

Oil on canvas, 36¼ x 36¼" (93 x 93 cm)
Sotheby's, New York (PV 722)

185

Woman Breaking Wood. c. 1890

Gouache, 23 x 18" (59 x 46 cm)
Sotheby's, New York (PV 1455)

186

Woman Breaking Wood. 1890

Oil on canvas, 49¼ x 48¾" (126 x 125 cm)
Kowa Company, Ltd. (PV 757)

187

Woman and Child at the Well. 1882

Oil on canvas. 31¼ x 25⅞" (81.5 x 664 cm)
The Art Institute of Chicago. Potter Palmer
Collection. 1922436 (PV574)

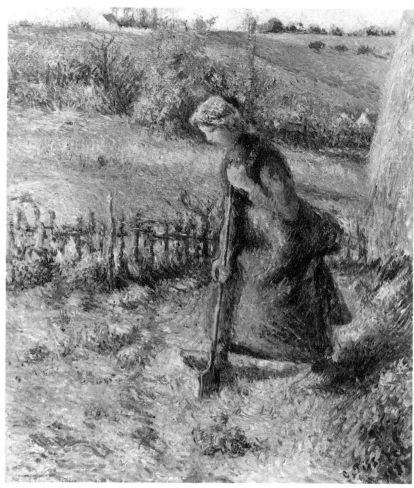

188

Kneeling Woman. c. 1881

Charcoal on paper, 23½ x 17⅜" (60 x 44.5 cm)
Reproduced courtesy of J.P.L. Fine Arts. London

189

Woman Digging. 1883

Oil on canvas, 18 x 15" (46 x 38 cm)
Collection Janice H. Levin (PV618)

190

Women Pulling Up Grass. c. 1879-80

Gouache on silk, 5⅞ x 21½" (15 x 55 cm)
Whereabouts unknown (PV 1612)

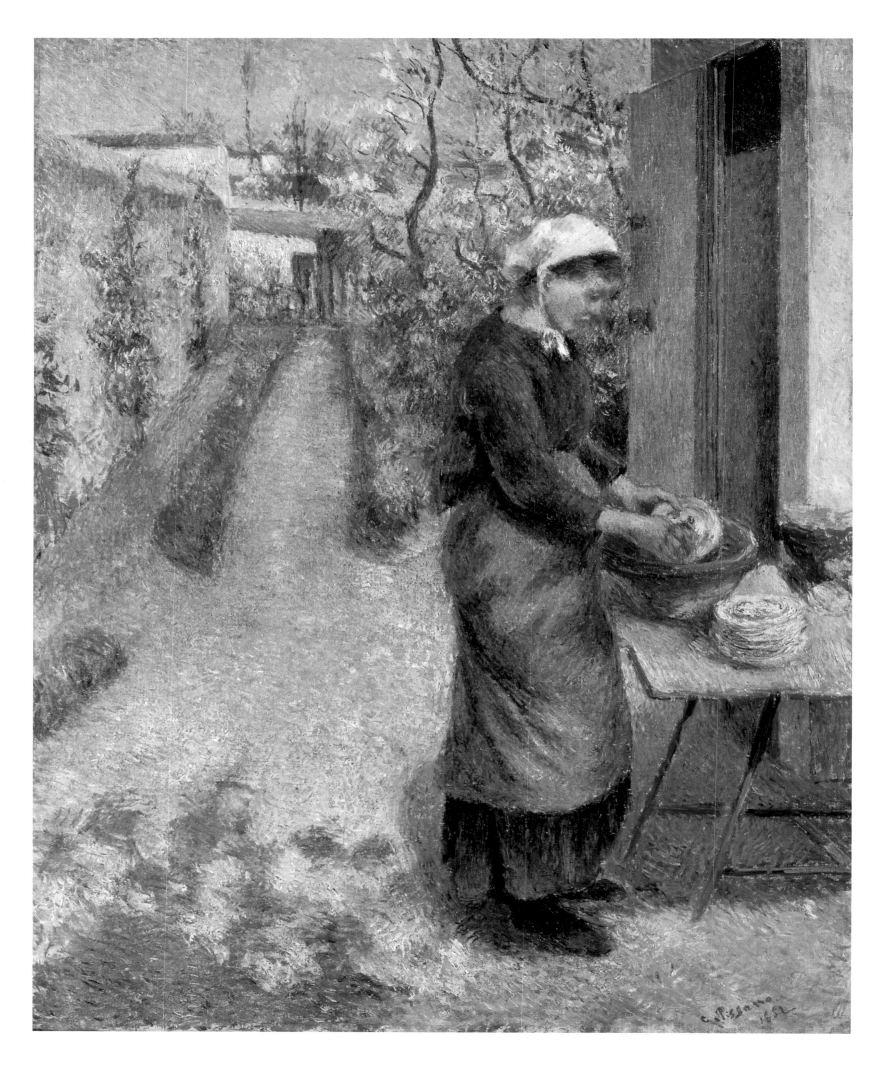

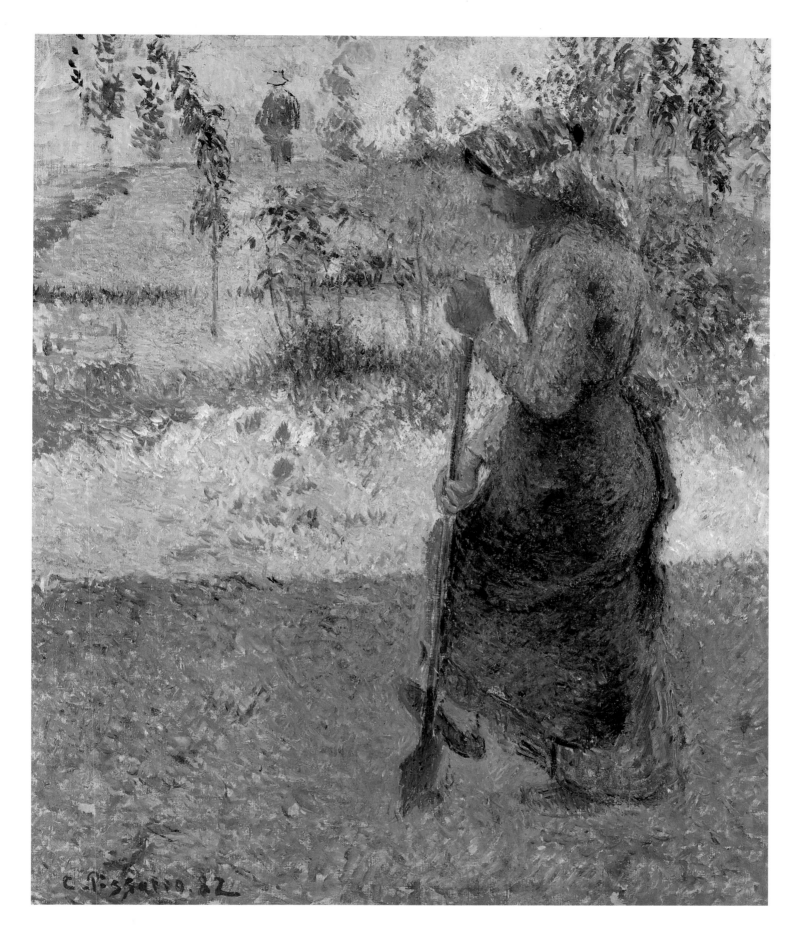

191

Girl Washing Plates. c.1882

Oil on canvas, 33¼ x 25⅝" (85 x 65.7 cm)
Fitzwilliam Museum, Cambridge, England
(PV 579)

192

*Study of a Peasant in Open Air
(Peasant Digging).* 1882

Oil on canvas, 25¼ x 21" (65 x 54 cm)
Private collection, Switzerland (PV 577)

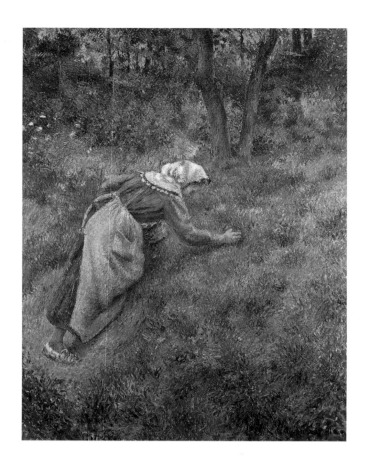

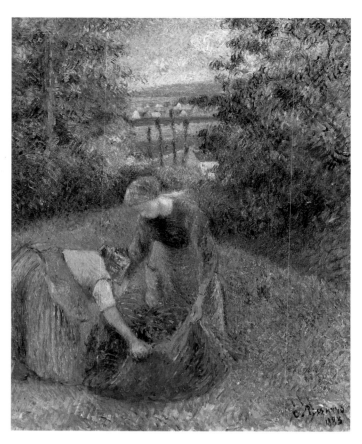

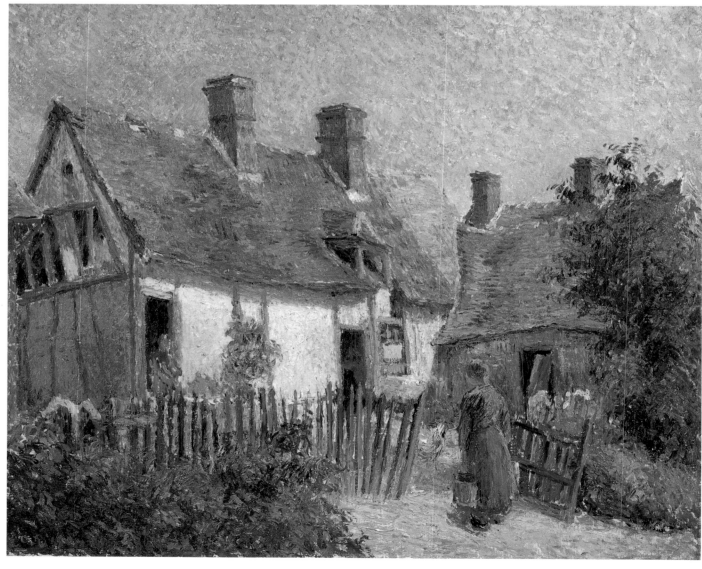

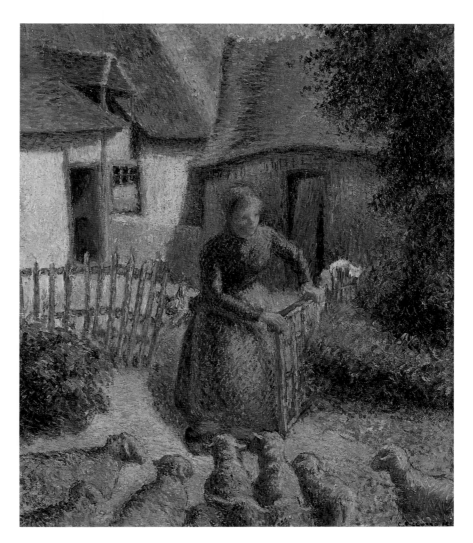

Opposite:

193

Peasant Gathering Grass. 1881

Oil on canvas, 45¼ x 35" (116 x 90 cm)
Private collection, France (PV543)

194

Women Gathering Grass. 1883

Oil on canvas, 25¼ x 21" (65 x 54 cm)
Private collection (PV616)

195

Old Houses at Eragny. c. 1885

Oil on canvas, 18 x 21" (46 x 54 cm)
Zen International Fine Art, Tokyo (PV682)

196

Shepherdess Bringing in the Sheep. 1886

Oil on canvas, 18 x 15" (46 x 38 cm)
Private collection (PV692)

197

Study for *Peasants Chatting in the Farmyard.
Eragny.* 1895

Charcoal and wash heightened with white
gouache, 11⅜ x 9" (29 x 23 cm)
Private collection, France

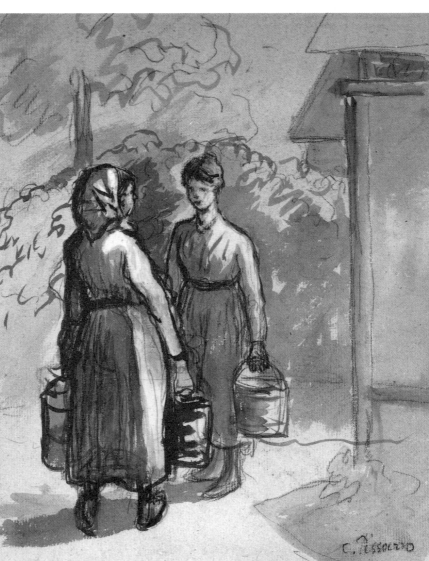

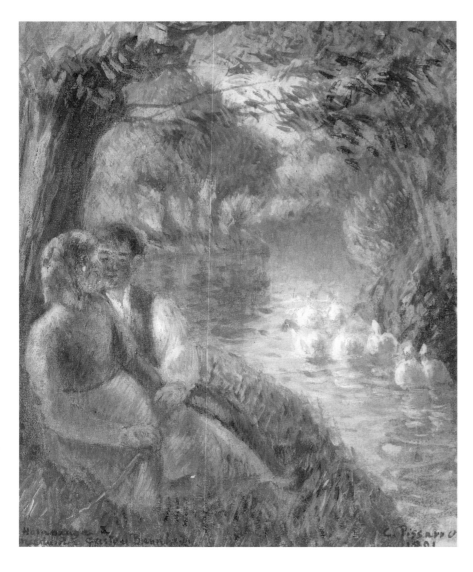

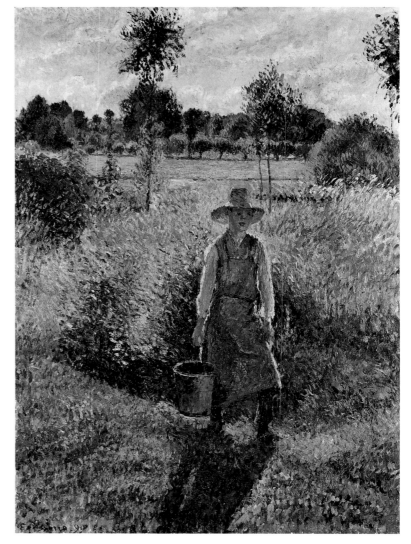

198

Lovers Seated at the Foot of a Willow Tree. 1901

Gouache. 8⅛ x 6⅝" (21 x 17 cm)
Private collection (PV 1498)

199

The Gardener, Afternoon Sun, Eragny. 1899

Oil on canvas, 36 x 25¼" (92 x 65 cm)
Staatsgalerie, Stuttgart (PV 1079)

200

Two Girls. c. 1895

Black chalk and pastel on pink paper.
17⅝ x 17" (45.7 x 43.8 cm)
National Museum of Wales, Cardiff

Opposite:

201

Peasants Chatting in the Farmyard. Eragny.
1895-1902

Oil on canvas, 31½ x 25¼" (81 x 65 cm)
Private collection, France (PV 1272)

202

The Flock of Sheep. Eragny. 1888

Oil on canvas, 18 x 21½" (46 x 55 cm)
Private collection, Paris (PV723)

203

Girl in a Field with Turkeys. 1885

Gouache on fabric mounted on paper,
8³⁄₁₆ x 25⅝" (20.7 x 65.1 cm)
The Brooklyn Museum, 59.28. Gift of Edwin C. Vogel

204

Woman with a Goat. 1881

Oil on canvas, 32 x 25¼" (82 x 65 cm)
Private collection (PV546)

205

The Gardener (Old Peasant with Cabbage).
1883–95

Oil on canvas, 31½ x 25¼" (81 x 65 cm)
Collection Mr. and Mrs. Paul Mellon, Upperville,
Virginia (PV617)

206

Peasant Woman at Gate. 1886

Chalk, 9¾ x 7⅝" (25 x 19.6 cm.)
Philadelphia Museum of Art

207

Studies of a Peasant Woman II.
c. 1882–85

Gouache and ink over pencil,
12½ x 8" (32 x 20 cm)
Private collection

208

Shepherdess and Sheep in Landscape. c. 1859

Pen and ink, dimensions unknown
Private collection, Switzerland

Harvests

Pissarro's figure paintings show the individual peasant at work or rest. However, his compositional genius was extended perhaps more fully in his harvest and market scenes, in which groups of peasants worked together or met in social and commercial exchanges. It is these scenes that mark one of the major differences between Pissarro's figures and those of Degas or Toulouse-Lautrec—all three among the most important figure painters of the Impressionist and Post-Impressionist era: with a few exceptions, such as *The Little Country Maid* (fig. 209), Pissarro's figures tend to work outdoors. The air that circulates through these representations of workers in country fields is the substance of liberty—a notion absolutely central to Pissarro's pictorial, poetical, and political program. Between the quality of Pissarro's air, on the one hand, and the air of Degas and Toulouse-Lautrec, on the other, lies a clear chasm.

In Degas's rehearsal rooms the air is tainted, musty, acid, heavy; his dancers sweat; their bodies cave in under effort and pain. Occasionally watering cans are used to try to keep the dust down and to cool the air. The air in Toulouse-Lautrec's brothels is acrid, insalubrious, in short supply; windows and shutters are often closed.

The air in Pissarro's fields carries totally different contextual odors: freshly cut grass, hay, fruit, wheat, animals. In his paintings of solitary figures, or of his figures at rest, the air is still. The air is a strange substance—a substance with no substantial qualities. It brings nothing, carries nothing—and as such, is most appropriate to be the material element suggesting the freedom of these figures—whether dreamt or real.

In Pissarro's harvest pictures, where peasants are reaping, picking, cutting, the air is full of noise. A sharply different situation prevails in *Frost, Young Peasant Making a Fire* (fig. 184) and *Woman Breaking Wood* (fig. 186), where the crisp, biting winter air was set in dynamic opposition to the crackling fire darting its flames upward (a truly Nietzschean image). Harvesting (be it wheat, apples, potatoes, peas, etc.) is a collective effort, emphasizing the communal and cooperative structure of land farming, rather than the solitary, meditative aspect of figures resting, working, or herding on their own. These joint actions are staged in various settings, particularly evident in certain works such as a group concerned with planting and picking peas (figs. 210–13), or *Haymaking at Eragny* (fig. 214), where the parallel angles of the arms and pitchforks create a rhythm of their own. The crops can hardly wait; when the crop is mature, it calls for action. The threat from procrastination is manifold: rot, waste, animal destruction, bad weather—all of which may reduce months of effort to nothing.

These reaping scenes underscore two themes which find resounding evocations in the last two decades of Pissarro's work: plenitude or abundance and a certain satisfaction, both themes being intimately connected semantically with Pissarro's personal work ethic. Plenty of work, abundant crops of drawings, intensity, and satisfaction are concepts that can aptly describe Pissarro's own working methods. This is not to suggest that his many harvest scenes should be regarded as metaphors for his own work, although the idea is not without interest. More to the point, however, these figures display values that function analogously within Pissarro's career.

Pissarro was fanatical about work; his letters to his sons communicate this ardor and passion for his profession, as well as for the strenuousness of its physical and

209

The Little Country Maid. 1882

Oil on canvas. 25¼ x 21" (65 x 54 cm)
The Tate Gallery London (PV575)

210

Planting Peas. 1890

Gouache and black chalk. 16 x 25¼"
(40.7 x 64.1 cm)
Ashmolean Museum, Oxford (PV1652)

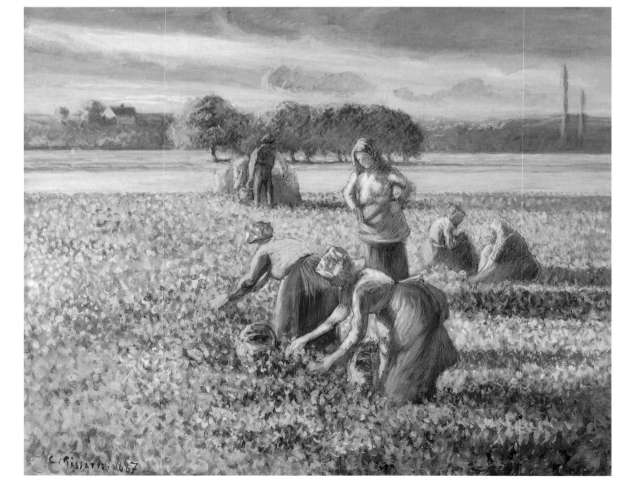

211

Picking Peas. 1887

Gouache. 20¾ x 24¾" (52 x 63 cm)
Private collection (PV1408)

212

The Pea Harvest. c. 1885

Watercolor and charcoal, 9 x 11" (22.8 x 27.9 cm)
The Armand Hammer Collection. On long-term
loan to the National Gallery of Art, Washington,
D.C. (recto)

213

The Pea Harvest. c. 1880

Pencil, 7¾ x 12" (19.9 x 31 cm)
Lowe Art Museum, University of Miami, Museum
Purchase through funds from the Wilder
Foundation and Friends of Art, 1982

214

Haymaking at Eragny. 1901

Oil on canvas, 21 x 25¼" (54 x 65 cm)
Ottawa Art Gallery (PV 1207)

mental demands. One can scarcely find a letter from Pissarro to Lucien in which the advice to work and work harder is not put forward: "The only thing is that you have to draw, draw a lot."[32] Or again: "Draw a lot, always from nature, and as often as you can. . . . If only you could be persuaded that this is the most intelligent and the most enjoyable activity! It would be perfect if you would become passionate about art; Sundays and holidays would then become days of happiness, eagerly awaited; this is not given, it must be felt!"[33]

Pissarro also understood a necessary virtue that fuels arduous work, willpower. He wrote to Lucien: "Remember that this is the basis for everything, you need it and a lot of it. The willpower to get up early in the morning, to run to one's work, to withdraw into it, to create a whole world that only oneself can understand, though even this is not enough, the willpower to create a work that others must understand."[34] Again, "While you have time, draw a lot, do not waste time, this will help you more than you think. . . . All you need is your own willpower."[35]

In case his son might forget, Pissarro went on: "Paper and pencil, this is the main thing; you must draw seriously, as I have told you; you should draw heads and portraits and do them from memory . . . trees as well, but seriously executed, this will do you a lot of good."[36]

There are several parallels to be drawn between the field activities represented in Pissarro's rural scenes and his own conception of work. Liberty is inconceivable in Pissarro's work without action and hard work. Liberty and hard work are connected in his ethical concepts through self-discipline or determination. Both art and rural work require an iron will (which, incidentally, Pissarro also recognized and praised in Degas).[37] Like Impressionism, rural work does not follow any preestablished rule—the day the harvests start is never the same every year, it depends partly on nature and partly on a communal decision as to the right time. Communal participation plays an important role in rural work—as indeed interaction does throughout Impressionism, particularly for Pissarro, who devoted much attention and care to his role of art tutor to his five sons. He was always careful to encourage them to develop plastic qualities of their own, under his guidance, without impinging upon their own freedom, or *sensation*: "When one feels, that is the difficult thing, the rest comes by itself."[38]

Furthermore, just as when the crops are ready to be reaped, one has to work unflaggingly, an analogous sense of urgency seizes Pissarro when he feels his *sensation*. In a letter to two of his sons, Lucien and Georges, he gives this emphatic advice: "I have experienced it, follow it! When you feel a certain thing, you have to do it at whatever cost . . . you can be sure that you will reap the rewards." Then follows a description of the dialectic of freedom and necessity not dissimilar to the practice of rural work: "It is so rare to want to do something that you really have to do it; you must even hurry, for it will just go away if you wait . . . now, go on, believe me, go on! . . . *it is also the most practical thing to do!*"[39]

In this wise, heartfelt letter, Pissarro evokes the themes that characterize his conception of work and, in addition, codify the practice of the rural workers that he represented. Experience is of determining importance in tackling one's work; as soon as the *sensation* or the crops are ripe, one must not delay setting off to work; otherwise, all may be lost. No exertion or pain should be spared; anyone who has ever taken part in a harvest will know how true this is. The yield is worth the effort: a

215

Two Peasant Men Working. c. 1890

Wash over charcoal, 6 x 8¾" (154 x 224 cm)
Private collection

216

Peasants in the Fields, Eragny. 1890

Oil on canvas, 25⅛ x 31⅝" (65 x 81 cm)
Albright-Knox Art Gallery, Buffalo, N.Y.
Gift of A. Conger Goodyear, 1940 (PV755)

217

Picking Peas. Eragny. c. 1893

Oil on canvas. 18 x 21½" (46 x 55 cm)
The Langmatt Foundation, Sidney and Jenny
Brown, Baden, Switzerland (PV857)

218

The Picnic. c. 1891

Watercolor and charcoal. 11 x 21⅝" (28 x 55.5 cm)
Private collection, c/o Legatt Brothers, London

219

Haymakers Resting. 1891

Oil on canvas. 25¾ x 32" (66 x 82 cm)
Marion Koogler McNay Art Museum, San
Antonio, Texas. Bequest of Marion Koogler McNay

harvest of drawings, prints, and paintings result from urgent, hard work. In *Picking Peas* (fig. 211) and *Two Peasant Men Working* (fig. 215), Pissarro depicts this kind of repetitive, numbing work, that must be carried on unrelentingly until the harvest is over.

It is more than doubtful, of course, that the field workers depicted by Pissarro could always—or ever—be happy in their work, but then a glance at Pissarro's letters indicates that he himself seldom was. What matters here is Pissarro's own choice to represent these figures as seeming to be at one with nature and in harmony with each other, as in *Peasants in the Fields, Eragny* (fig. 216), or *Picking Peas, Eragny* (fig. 217). Certain paintings represent these workers having a break—a theme that echoes the depictions of Père Melon and others in the previous chapter. However, in those paintings, the tranquillity of the landscape was emphasized and the work involved (if any) was minimized. In contrast, *Haymakers Resting* (fig. 219) focuses on the massive stack of hay in which and against which these three female workers are briefly resting.

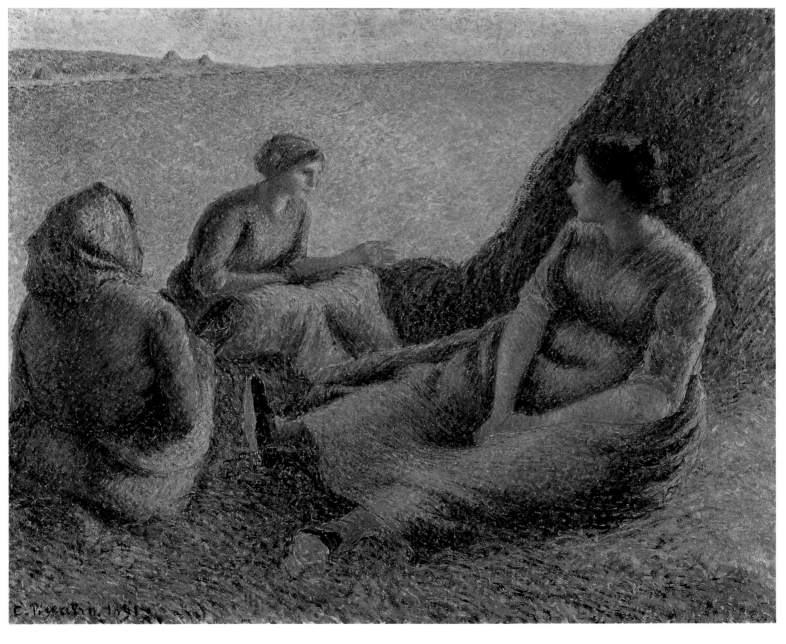

This high, dense stack and its shadow occupy over half the space of the picture plane; its vertical slanted mass is set off by the horizontal, slightly rounded vast empty field nearby, suggesting that these haymakers have gathered all the hay from the field into this stack. Two of the women wear a scarf protecting them from the sun and dust; the third, really a girl, seated right, is bareheaded, letting the light from the sunset gently caress the crest of her hair and run along the edge of her shoulder and arm. The paint surface is animated with long, thin strokes of paint that tend to imitate through their own shape the very shape of the blades of hay that make up the stack.

In *The Picnic* (fig. 218), although without any indication of what work the men were up to, it appears doubtful that this is a weekend family picnic. Rather, these people are having their meal at work. As in *Haymakers Resting*, the upper left of the picture depicts an empty sun-drenched field, while the figures, displaced to the right, enjoy the shade of the foliage. Indeed, in the fields, the cycles of nature and work hardly ever stop; the work carried out in a studio or outdoors by a painter like Pissarro responded to similar stimuli.

Usually shortly after the harvest, field workers come to a halt—usually for a celebration: *la fête du village*, as in *The Carousel* (fig. 220). Pissarro saw there a source of imagery for caricatures that bring to mind some of Flaubert's descriptions of rural fairs and landowners' meetings. This is perhaps where the line should be drawn between painterly work and rural work. In Pissarro's work ethic, at least, the notion of "holidays" or, even worse, "entertainments" was a sheer absurdity. Pissarro probably never took a holiday in his life; whenever he traveled from his home and studio, it was because he was either house hunting, or visiting his relatives or his wife's. Even when he visited his wife's countryside in Burgundy in 1882, he wrote to Duret, "I saw the most astonishing things to paint. The town of Troyes seemed to me to be made for painting, mat and clear . . . certain landscapes with old towers, churches, houses, having a romantic air, would be odd to do with our modern eye."[40]

The Carousel, set in Osny, is one of the rare works in his *oeuvre* that shows a scene of entertainment. In this work, the wooden horse of the merry-go-round seems to be merrier than any of the figures—underscoring the comical aspect of this scene. A moment of celebration at the end of the harvest is depicted in *La Ronde* (figs. 221 and 222), which can now be precisely dated 1892,[41] in the light of a letter from Pissarro to his second son, Georges, in which there is a clear reference to this work:

> After having searched quite hard and made many attempts, I have finally managed to find my composition for my female villagers' dance; the young women turn from right to left; they extend nearly the whole height of the canvas; just above their heads, groups of horses tied to the main beam of a mechanical wheat thresher also walk in a circle. The whole thing moves between the dancers' heads. A few more male and female peasants, busy with some harvest work, complete the composition. This will be a time-consuming task. I do not dare yet tackle it. I will need a few studies of movement; I do not know where to get them.[42]

This letter reveals several components of Pissarro's work and approach. In fact, it describes the watercolor study for *La Ronde* (fig. 221), after which Pissarro anticipated executing a canvas. Indeed, the dancing figures here occupy virtually the entire height of the work, and the central, slightly bent, beam of the thresher is prominently displayed on the top edge of the watercolor. Thus, the watercolor emphasizes

220

The Carousel. c.1883

Pastel on paper, 25⅛ x 31⅛" (64.4 x 79.8 cm)
Albright-Knox Art Gallery, Buffalo, N.Y. Bequest
of A. Conger Goodyear, 1966 (PV 1567)

circularity—the dancers in the foreground and the horses in the background all turning around clockwise. The tempera version (fig. 222), on the other hand, appears both more simple and more complex than the preparatory gouache. Pissarro had apparently decided to do away with the thresher, leaving the horses without a function in the tempera. Emphasis has been shifted instead to the dancers, and their movements—a proclaimed subject of concern in Pissarro's letter. The artist's vantage point is now slightly farther away from the dancers, giving the group more unity and cohesion: a figure has been brought in at the left, completing the circle and closing the dance. This is now a more synoptic view of this awkwardly lyrical scene.

More important, everything in the tempera echoes the shift of emphasis from the circular movement of the dance to the composition itself. The buzz of the figures in the watercolor "busy with some harvest work" has turned into a group of male peasants gazing at the dancers, and offering a mirror reflection of our own gaze; thus suggesting another model of circularity: the circular exchange of two gazes, one internal, the other external to the representation; one the object and the other the subject of the representation, both of which meet around the dancing figures.

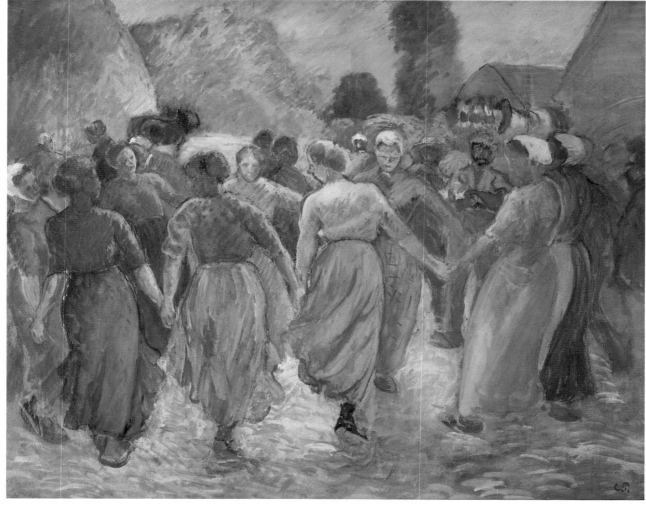

Opposite:

221

La Ronde. 1892

Watercolor over black chalk on pink paper.
18 x 23½" (46 x 60 cm)
Courtesy of Christie's, London (PV 1392)

222

La Ronde. 1892

Tempera. 25¼ x 31½" (65 x 81 cm)
Collection Adele and Herbert Klapper (PV 1393)

223

*Flock of Sheep in a Field After the Harvest.
Eragny.* 1889

Oil on canvas. 25¼ x 31½" (65 x 81 cm)
Private collection (PV 736)

224

The Harvest. 1882

Tempera. 26 x 46⅞" (67 x 120 cm)
The National Museum of Western Art, Tokyo
(PV 1358)

225

Sheaves of Wheat. 1889

Black chalk, 8½ x 15¼" (22 x 39 cm)
Private collection (study for PV730)

The obvious presence behind this composition is Degas. Of course, here, Pissarro's village dancers are nonprofessional; they are celebrating the end of a tough harvest, rather than earning a living by dancing, or training for a career in dance; and they are outdoors rather than indoors. But the importance of Degas's role here is more in the technique to which Pissarro resorted than in the subject matter. The key concepts in Pissarro's method are memory and reflection. As Pissarro wrote to Lucien in that same letter, "Nothing can be worth a picture done from memory."[43]

A day later, when he confirmed and developed the same idea in a second letter, he voiced his astonishment that many of his colleagues were blind to this perception about the importance of memory in refining and fixing visual images: "When you think that this is not even understood!"[44]

Pissarro's letters, together with the abundant visual evidence that sustains them, clearly contradict the notion that Impressionism consisted of the direct recording of pure sensations. Nevertheless, such a noted historian as Pierre Francastel asserted, "For Monet, Pissarro, and their contemporaries, nature serves not so much as a theme for reflection, but as an immediate source of pure sensations." He went on to define Impressionism as "an effort to capture the pure data of the senses—or more accurately of the optical sense."[45]

Any number of scenes by Pissarro demonstrate that this is a reductive and inaccurate view of Impressionism. Harvests painted in the 1880s, for instance, together with their numerous directly or indirectly related studies (figs. 223–34), testify to the contrary; these representations of peasant field workers plainly draw on reality as a source of reflection. The very definition of his *sensation* is rooted in this intermediary process of construction, several steps removed from sensory perception of reality. Hence, as Pissarro put it, reality, "the truth," is "half seen" and "felt" as such. His field compositions are made out of mediations, intervals; the result is, just like that of building a haystack, the product of several intermediary steps, as in *Flock of Sheep in a Field After the Harvest, Eragny* (fig. 223), *The Harvest* (fig. 224), *Les Glaneuses* (fig. 226), and *The Hay Harvest, Eragny* (fig. 227). Why is Degas's role significant in this particular method of composition, despite the irrelevance here of his ballet world? Because Pissarro proceeded here according to a countermethod suggested by Degas, in which observation from nature was merely a preliminary step. He was convinced so completely that he passed it on to Lucien:

> I have spoken to Degas of your project to go and take Legros's drawing course. Degas said to me that there is a very simple way to avoid the influence of that artist: this is very simple; what you have to do is to reproduce the work you did in class, once you are at home, from memory. . . . You will find it difficult, but there will come a time when you will be surprised how easily you remember forms, and curiously, the studies that you will make from memory will be far more powerful and original than those made after nature; the result will be that your drawing will be artistic, it will be a drawing by yourself. This is a good way to avoid slavish imitation.[46]

226

Les Glaneuses (The Gleaners). 1889

Oil on canvas, 25¼ x 31½" (65 x 81 cm)
Kunstmuseum, Basel, Öffentliche Kunstsammlung,
Dr. Emile Dreyfus Foundation (PV730)

227

The Hay Harvest, Eragny. 1887

Oil on canvas, 19½ x 25¾" (50 x 66 cm)
Photograph courtesy of Gallery Urban (PV713)

In their own ways, Pissarro and Degas had experienced together the fact that complete fidelity to the motif was never quite possible. They found it was well-nigh impossible to bridge the gap between their immediate perceptions of a landscape and their representations of it, on the one hand; and on the other hand, the various

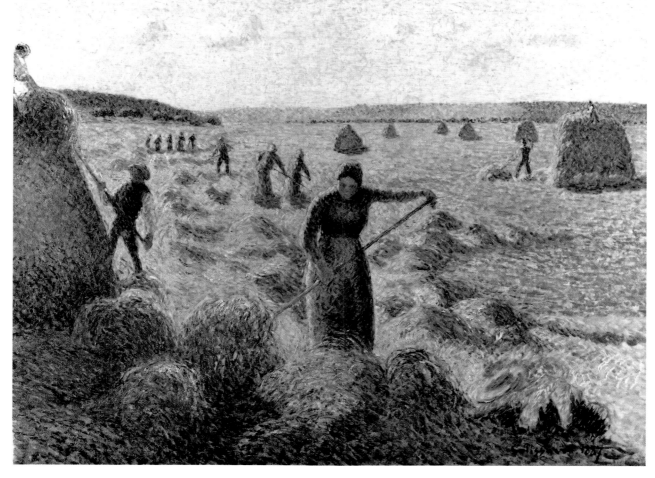

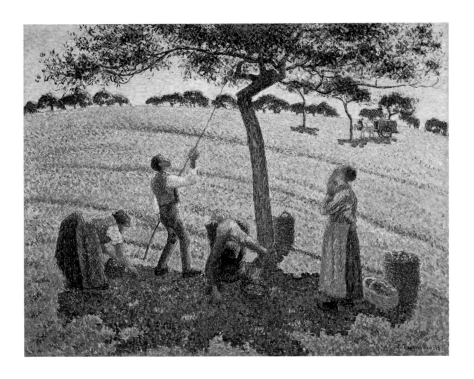

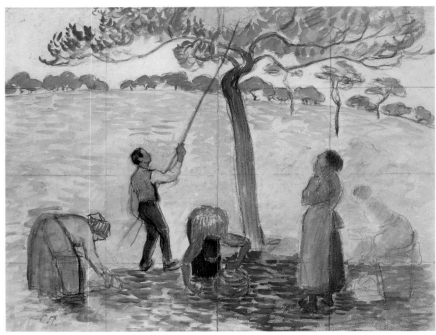

228

Apple Picking at Eragny. 1888

Oil on canvas, 23 x 28½" (59 x 724 cm)
Dallas Museum of Art, Munger Fund (PV726)

229

Picking Apples, Eragny. c. 1888

Gouache, 18 x 23" (46 x 59 cm)
Collection William Kelly Simpson, New York (PV1423)

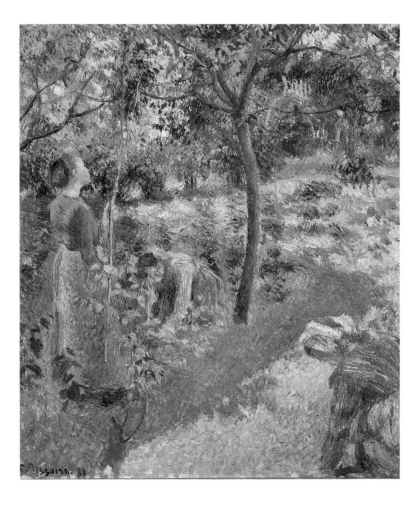

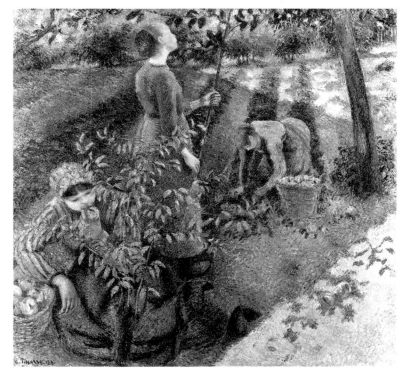

231

Picking Apples. 1886

Oil on canvas, 50 x 50" (128 x 128 cm)
Ohara Museum of Art, Kurashiki, Japan (PV695)

230

Picking Apples. 1881

Oil on canvas, 25¼ x 21" (65 x 54 cm)
Collection Evelyn A. J. Hall (PV545)

232

Letter to Georges Viau. October 11, 1893

The Langmatt Foundation, Sidney and Jenny Brown, Baden, Switzerland

233

Man with a Stick. c.1888

Charcoal on paper. 16¾ x 10¼" (43 x 26.5 cm)
Collection William Kelly Simpson, New York
(study for PV1423)

234

Peasant Girl with a Stick. 1885-86

Pastel, 23⅞ x 18¼" (61.2 x 47 cm)
Musée du Louvre, Cabinet des Dessins
(Fonds du Musée d'Orsay)

stages of studies and preparations integral to their dense, rich work could never be seen as a coherent whole either.

It is perhaps their strength that both artists pushed the graphic mediums—traditionally regarded as intermediary and inferior steps—to new achievements, thereby conferring renewed autonomy on them. An excellent example of this can be found in their exploration of the technique they called "dessin imprimé" ("printed drawing"), known today as "monotype."

Just like harvesters, they also accumulated piles of visual data concerning two phenomena: memory and movement. Contrary to a cliché which has long persisted, Pissarro, largely following Degas's impulse, cultivated the changed effect produced by memory, i.e., he let time elapse before he returned to his records of his immediate visual perceptions. The result for both artists was that they were working further from the objective truth but closer to truth of their own *sensations*.

A second aspect of Degas and Pissarro's association is that both were interested in studying figures in ceaseless movement. This resulted from the original concern which prompted them to rely on memory: their resolve to distance themselves from objective, static, seemingly congealed reality, because reality does not work like an immaculately depicted flight of angels frozen onto the surface of a canvas. To both artists, movement is essential and inherent in pictorial practice. In this, their approach was possibly closer to that of a musician than to that of their colleagues from the Salons. One might even say that a grasp of symphonic rhythm is esssential to understand both Pissarro's haymakers and Degas's dancers.

The lesson of the harvest—itself a rhythmic rite—does not end there when the hay or the corn has been gathered into a stack. Once the harvest is over, there come the gleaners to pick up the rest—the leftovers. Then again come the sheep and the cows to graze—as in *Flock of Sheep in a Field After the Harvest, Eragny* (fig. 223)—before another cycle or another season starts.

Market Scenes

Pissarro's market scenes offer perhaps the most revealing glimpse into his creative process. These paintings powerfully evoke the bustling dynamics of his imagination and of his compositional methods.

Apart from a few tentative studies in Venezuela, he painted his first market scenes in 1881[47] and executed the majority of them by the mid-1890s. For them he essentially resorted to a considerable variety of techniques, among which oil painting is not predominant. They suggest the continuum of the ebbing fluxes of crowds gathering weekly, actively engaged in intense exchanges: buying, selling, bartering, testing, conversing, swearing, communicating, shouting, daydreaming, laughing, etc. The spaces depicted (the marketplaces) are bulging with people, wares, stalls, carts, scarves, aprons, and all sorts of staples: the density and variety of objects, people, architecture, and movement represented per square inch is phenomenal. In tempo these scenes contrast strongly with Pissarro's depictions of peasant figures, which he shows alone or in groups of no more than two or three, seen in their own reverie or in desultory conversations, and with his harvest scenes, in which emphasis is placed on communal work—on the lyrical rhythm of collaborative gestures and on the plastic and imaginary kinships suggested by the rotund curves of the horizon lines,

haystacks, and female bodies, as in *Les Glaneuses* (fig. 226). A totally different world is evoked in his market scenes, which present a full microcosm of the rural society whose members are here intertwined. The activity in these scenes hints at the bustling plastic and compositional activity involved in depicting them.

To read into Pissarro's market scenes a representation of "polarized classes," or as recently suggested, to interpret them as an adaptation of "a stereotype to suit his own ideology,"[48] is misleading and requires some clarification. At the outset, to equate the existence of these markets in Pontoise or Gisors with the Marxian theory of labor capitalism and of class struggle[49] creates confusion. Indeed, even in Marx's own terms, these provincial markets were the effect, not so much of a capitalistic structure of exchange, as of a precapitalistic society where producers and consumers would meet and exchange their products directly. The producers, not having been spoiled or alienated from the product of their labor by the owners of the means of production, directly "profit" from the results of their labor through this market exchange.

Further, to confuse Pissarro's "ideology" with "Socialism" is itself evidence of profound misunderstanding.[50] Pissarro was an out-and-out anarchist who had persistently voiced contempt for Socialism: "The Socialist congress happens to be little more than a bourgeois party . . . more advanced, but with the same prejudices."[51]

In the same letter, Pissarro protested against the English Socialists for not having opposed the violence inflicted on certain anarchists "in order to stop them from saying out in the open what they thought was the truth."[52]

Pissarro rejected both nineteenth-century capitalism and budding Socialism; both, in his eyes, constituted a common ground for various forms of reactionary politics and aesthetics inherently tied to the overall rule of some state authority—be it that of Salon art or the resurgences of official taste in late nineteenth-century France, or that to come, as Pissarro had foreseen (only a couple of decades later), of "Socialist realism." Both forms of art tended to annihilate individual *sensation*. Indeed, Pissarro detected very shrewdly in Socialism a propensity to utilize myths and cultures akin to kitsch, which nurtured the socialization of the hero, the foundation of a new religiosity, and the transformation of history into hagiography. Stalinist artists, for instance, produced an imagery not all that distant from Salon artists such as Christian Symbolists like Ernest Duez and Paul-Albert Bernard, and other artists of the Rose + Croix, against whom Pissarro vituperated: "All these folks are nothing but miserable materialists who see nothing but the subject and who have none of the *sensations* that emanate from a work of art."[53]

In contradistinction, Pissarro, following Proudhon, placed the highest value on *love of the earth*, which Proudhon connected with the revolution and which Pissarro linked "consequently with the artistic ideal."[54] To him, anarchism, love of nature, and conserving great art for a better time were the three essential components of this new ideal. This implied that an artist should "find his own style and impose it and demonstrate that he knows why he does it; this will require a certain authority."[55] Next to himself, the first example of an artist who could vie with such an authority against kitsch and sentimentality and who had found a style of his own was Degas. "We are the true, logical path that will lead us to the ideal."[56] At the opposite end of this ideal or of the "true, logical path," Pissarro listed "those who follow the new trend," who "are influenced by the bourgeois reaction." He went on:

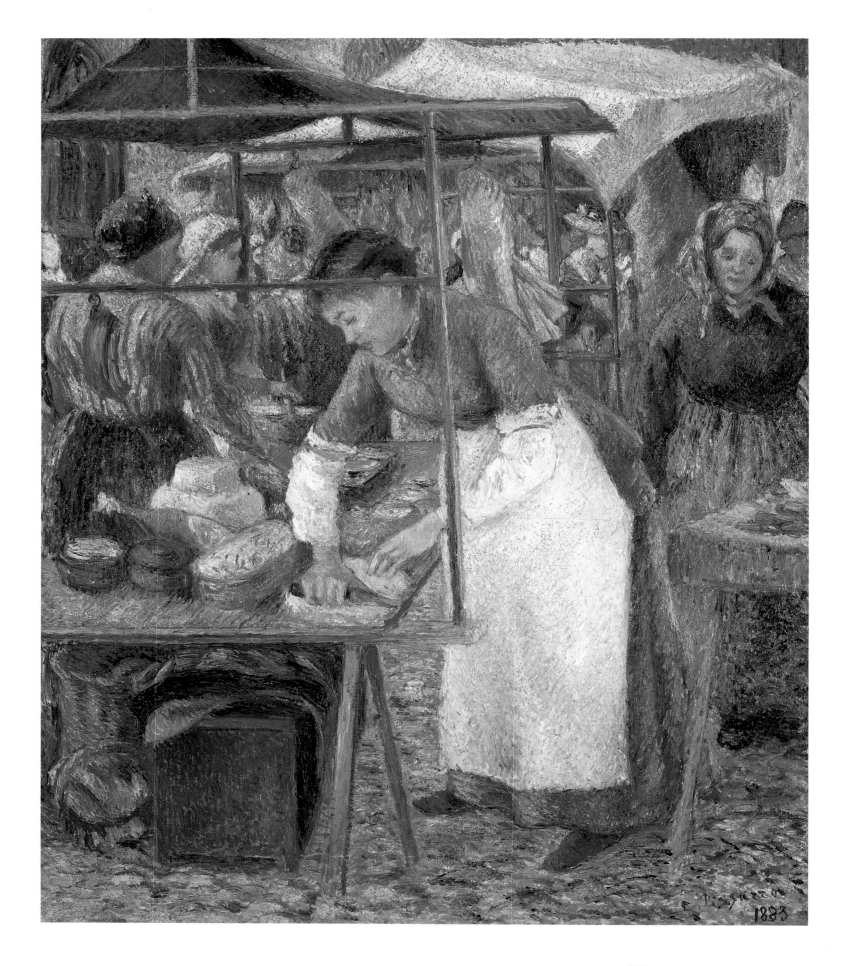

235

The Butcher. 1883

Oil on canvas. 25¾ x 21¼" (66 x 54 cm)
The Tate Gallery, London (PV615)

236

The Poultry Market, Gisors. 1885

Gouache and black chalk on paper mounted on
canvas, 32⅛ x 32⅛" (82.2 x 82.2 cm)
Courtesy, Museum of Fine Arts, Boston. Bequest
of John T. Spaulding (PV 1400)

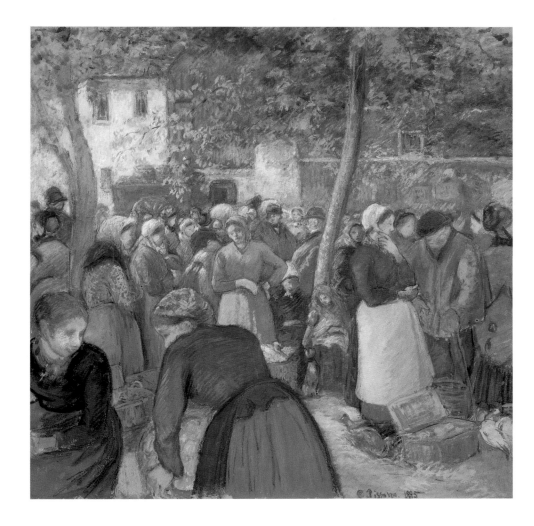

237

The Gisors Market. 1887

Gouache, 12 x 9½" (31 x 24 cm)
Columbus Museum of Art. Gift of Howard D. and
Babette L. Sirak, the Donors to the Campaign for
Enduring Excellence, and Derby Fund (PV 1413)

238

Compositional Study for *The Gisors Market.* 1885

Brush drawing in gray wash,
10⅜ x 8¼" (26.6 x 20.5 cm)
Ashmolean Museum, Oxford

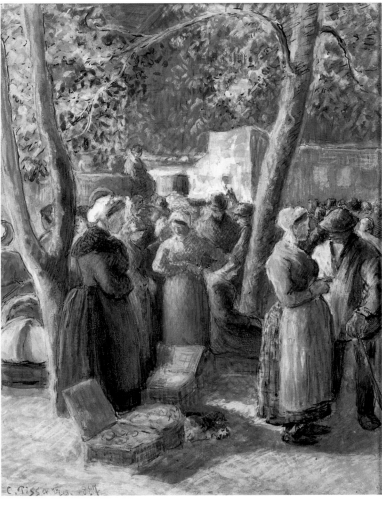

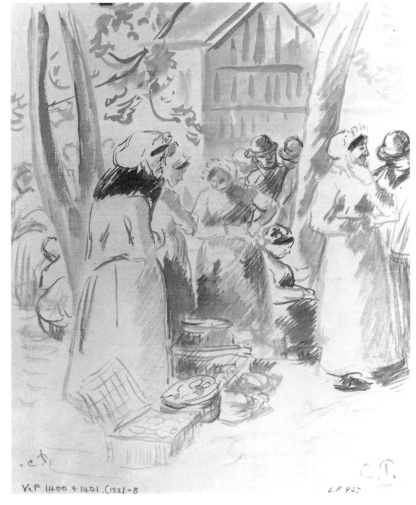

Just see how bourgeois society is proving that it is loving and tender towards the workers; isn't everybody a socialist? Hasn't the Pope himself launched such a campaign? . . . Reaction! . . . All this, my dear, is designed only to hinder the continuing movement. We should, therefore, be wary of all those who, under the pretense of Socialism, idealistic art, pure art, etc., etc. . . . follow indeed a certain movement—but a false, tremendously false movement. . . . A certain kind of people may well have to feed on this sort of thing, but this is not for us who have a totally different ideal to create.[57]

Pissarro described this ideal again with the same terms—"true and logical"—in another letter,[58] as though the form of art he is referring to possessed its own inner structure for verification, like a logical or mathematical system. What this ideal meant to him was "absolute liberty" and guarantees against imprisonment or death—two requirements which, concisely put, define the antithesis of bourgeois censorship and the oppressive French political and cultural system of the nineteenth century, as well as the antithesis of the dictatorial "Socialist" alternatives to come. One could almost be tempted to coin a phrase for Pissarro, calling him an "anartist," for, in his eye, his art and anarchy were inherently bound together, knocking down all the pontificating clichés, idols, and principles regulating the official art world, past and future. Pissarro thus concluded his letter on anarchism (explaining to Mirbeau that he was incapable of writing an article on his thoughts on the subject) with these words: "One will become an artist when one knows what is needed to make art."[59] The simple, yet difficult to obtain ingredient needed to make art is the famous *sensation libre*: "What you need is persistence, willpower, and free sensations—stripped of everything other than one's own sensation."[60]

Perhaps this helps us to better understand the often quoted statement by Pissarro, "I firmly believe that our ideas, impregnated with anarchistic philosophy, rub off on our work."[61] To the extent that his free sensations (at the core of his anarchistic sensibility) can be observed at work through his market scenes, they reveal an important link between his politics and his aesthetics. These representations of provincial markets, as in *The Butcher* (fig. 235), or one of his scenes of an urban market, such as *A Corner of Les Halles* (fig. 241), can rightly be considered among Pissarro's major contributions to the web of Impressionist imagery.

The place occupied within Impressionism by Pissarro's market scenes can then be compared to Degas's dance rehearsals or Renoir's, Degas's, and Toulouse-Lautrec's theater scenes. This comparison will in turn help us to appreciate their originality. The latter celebrate the pleasures (from the spectator's point of view) or the labors (from the actor's point of view) of leisurely urban society. They are representations of nighttime performances, riveted to the framework of institutional decor and decorum (a theater, a cabaret, a bordello, etc.).

These works, and particularly those by Toulouse-Lautrec, enhance the duality and the distance between spectators and actors. Pissarro's market scenes are daily pictures. Everybody intermingles there—all ages, classes, and sexes. The "roles" of the "actors" there are interchangeable: those who sell may have something to buy, and equally, those who buy may have sold something. The markets are their own stages. Gazers are being gazed at and vice versa—a wide array of interests organizes the intricate exchanges of gazes and the network of communication. Producers, consumers, and chatters are not always easy to distinguish from each other, nor is it easy

to identify precisely the object of interest: is the male gazer in the right corner of *The Poultry Market, Gisors* (fig. 236) bargaining over what he must pay for the eggs and hens, or is he selling them? Or is he indulging his libidinal urgings by peeping sideways at the young maid's breast?

The passage from *The Poultry Market, Gisors* to *The Gisors Market* (fig. 237) is most telling. Although the latter is much smaller than the former, it was executed subsequently, and curiously, originally given a different location in the title: Pontoise instead of Gisors. The smaller work represents the couple (the older man and the maid) on the right in further isolation, whereas in the former, they are surrounded by an elegantly dressed female figure showing her back (at the right-hand edge), a female head that can be seen between the man's and the young woman's heads, together with a head behind the young woman's neck and children behind her.

In *The Gisors Market*, on the other hand, while they are physically set at some distance from the rest of the crowd, they also lose the object of their conversation—baskets of eggs and chickens—which have been transferred to the lower center of the composition. The man and woman to the right are in a sense left to themselves; the ambiguity of their exchange is all the greater. At the same time, their uncouth magnified features display Pissarro's interest in caricature, which is all-pervasive throughout his market scenes and quite evidently displayed in the intermediary works between *The Poultry Market, Gisors* and *The Gisors Market*. An example of this is a wash, Compositional Study for *The Gisors Market* (fig. 238), where the right-hand female figure is seen still resting her chin on her left hand and wearing a bonnet with a comb that gives her a distinct resemblance to a rooster, well in keeping with the context of a poultry market.

In fact, Pissarro regularly resorted to caricature and various forms of comic notations within his market scenes, perhaps as a result of his purchase of Champfleury's *Histoire de la Caricature* in 1883. One of Pissarro's favored devices—as seen in the wash mentioned above—consisted of placing emphasis on one particular part of his character's garments, instruments, or facial features, which became either prevailing or at least conferred a certain overall connotation on the whole character: the comb bonnet linking the market shrews to fowls; the rotundity and noise of the musical instruments in *Woman Playing a Musical Instrument* (fig. 242) filling out the two female players; or the massive stout build and chubby rotund cheeks of ox buyers in *Calf Market at Gisors* (fig. 243) visually associate them with the objects of their interest. In this, it is easy to detect a procedure exploited by Flaubert in his novels and by Daumier in his graphic art; both artists were greatly and consistently admired by Pissarro.[62]

Another device to which he resorted was the use of similar formal, plastic materials (lines, shapes, colors) to depict disparate objects. The formal closeness of the two creates a new effect (of resemblance or of opposition) between them,[63] whose unexpected juxtaposition makes us laugh! Examples of this abound in the market scenes: the thick, rough, shapeless, baggy skirts of the seated female figures, as seen in the foreground of *Grain Market at Pontoise* (fig. 244) are closely associated with the bags of wheat they are selling and by which they are seated. There is a similar effect in *Potato Market, Boulevard des Fossés, Pontoise* (fig. 239), plus the fact that here the depiction of this group of figures is articulated by various parts of

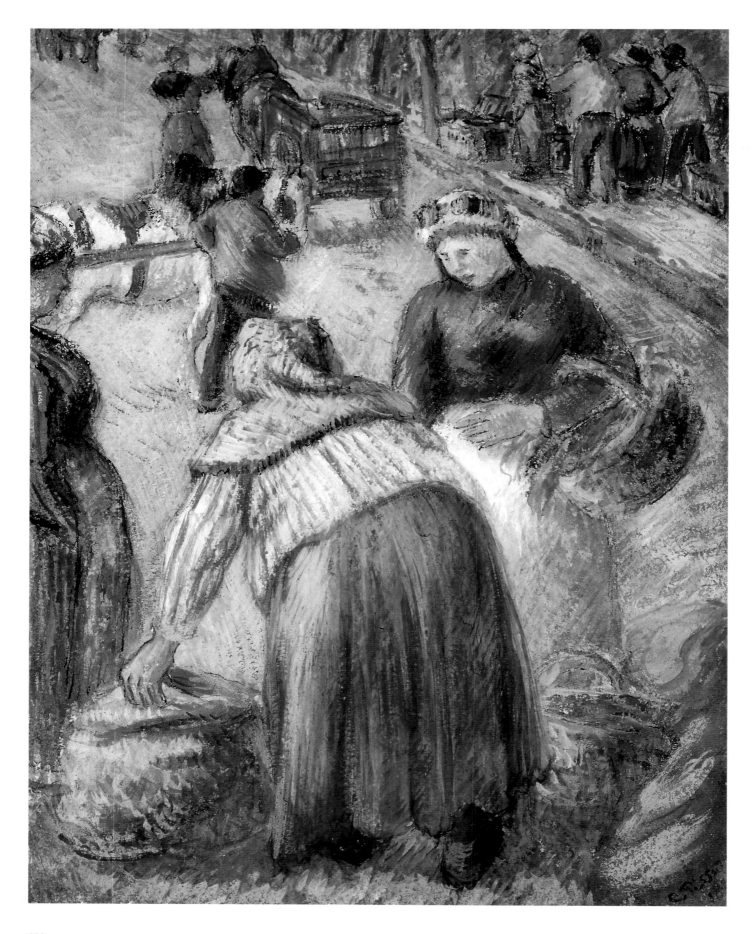

239

Potato Market, Boulevard des Fossés,
Pontoise. 1882

Gouache. 10 x 8" (26 x 20 cm)
Private collection (PV 1365)

240

Poultry Market at Gisors. 1889

Gouache and tempera. 18 x 15" (46 x 38 cm)
Private collection, New York (PV 1453)

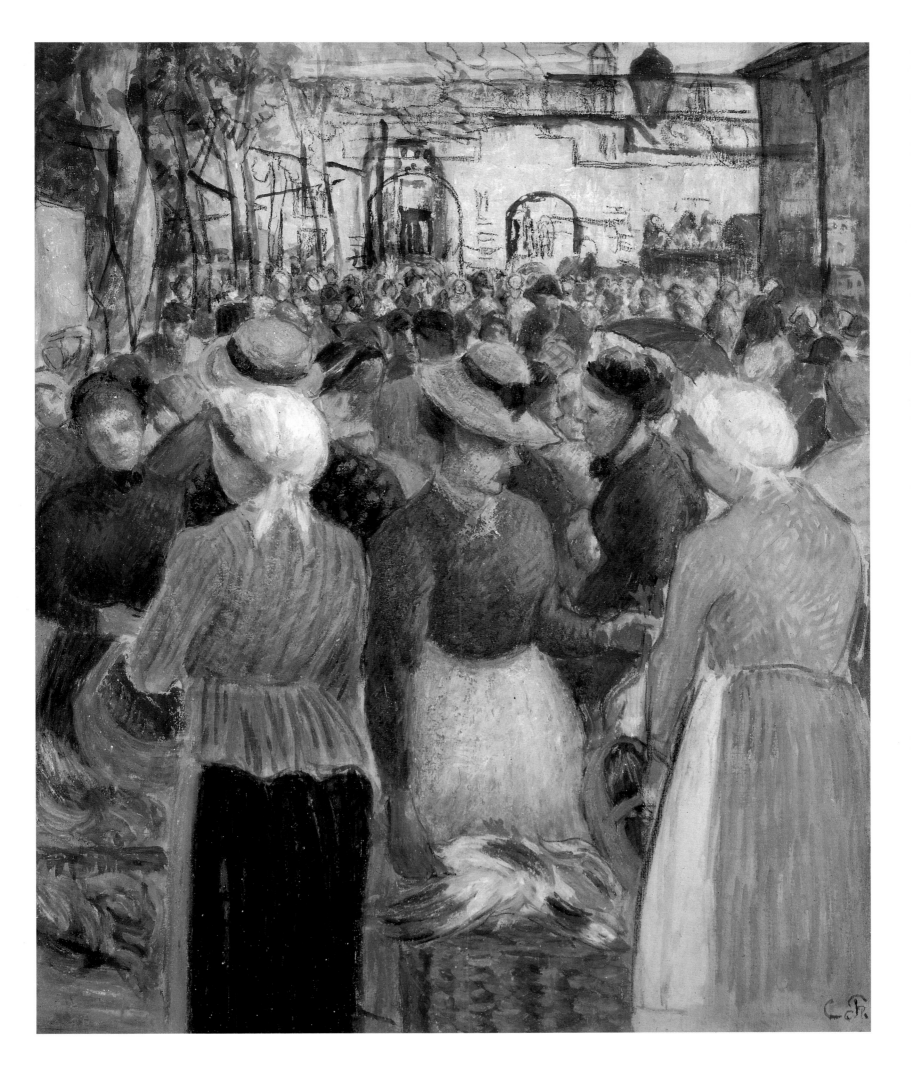

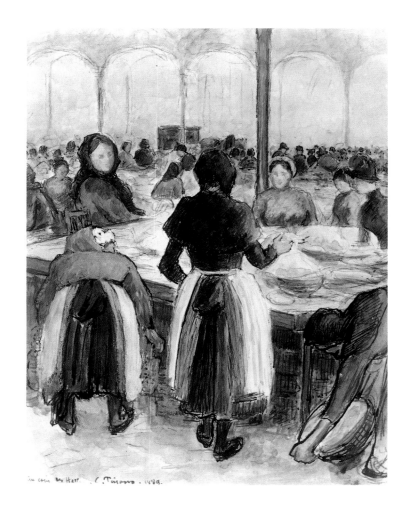

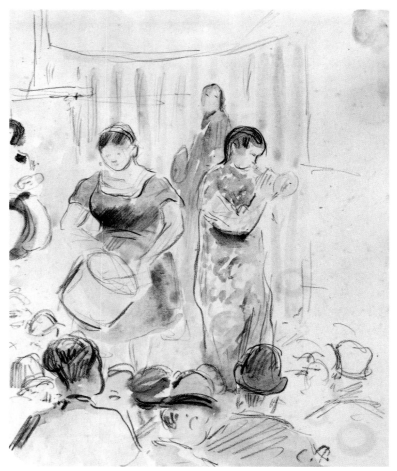

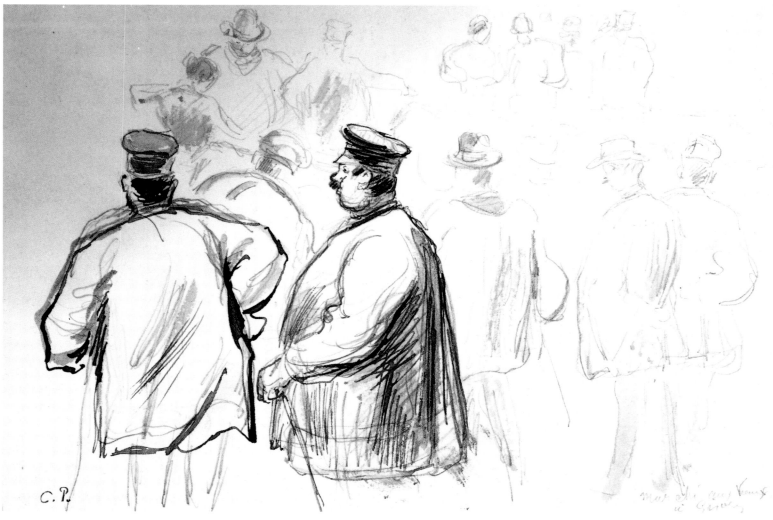

Opposite:

241

A Corner of Les Halles. 1889

Black chalk, watercolor, pen and ink.
11¾ x 9" (29.5 x 22.8 cm)
Fogg Art Museum, Harvard University, Cambridge

242

Woman Playing a Musical Instrument. c. 1883

Watercolor over pencil and charcoal.
6½ x 8¼" (16.7 x 20.5 cm)
Private collection

243

Calf Market at Gisors. 1885-90

India ink and wash over pencil,
dimensions unknown
Private collection

244

Grain Market at Pontoise. 1893

Oil on canvas. 18 x 15" (46 x 38 cm)
Private collection (PV862)

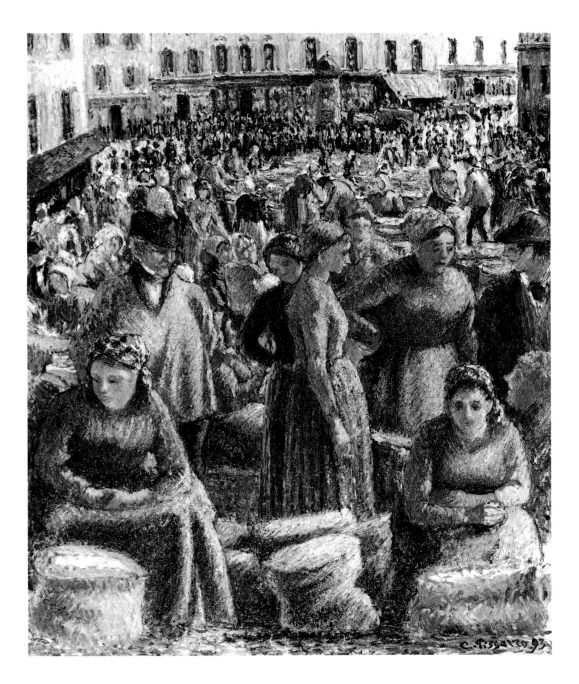

the canvas that bond together scarves, breast (in profile, left), buttocks, baskets, and bags in a fluid, swinging rhythm of long rounded strokes of gouache. In *Poultry Market at Gisors* (fig. 240), there is also the recurrent use of a detail: a protruding beaklike shape (pointing from left to right) which depicts the edge of a yellow hat, the nose of the face under the hat, and the beak of the dead duck being held by the woman. In the same work there is a plethora of repetitious curves depicting the abundance of hats and which are echoed by the curves of an umbrella, a streetlamp (upper edge of the picture), porches in the background, or when inverted, the baskets held by the women in the foreground. Incidentally, none of these formal kinships can be observed in the study for this work in the Ashmolean Museum, suggesting that Pissarro deliberately composed his picture and knew full well what he was doing.

In *Female Figure in a Hat Holding a Fowl, with a Study of Her Head in Profile* (fig. 245), uniformly thick pencil lines flow down along the right arm of the standing female and the goose. The same rhythm of audacious and substantial lines represents

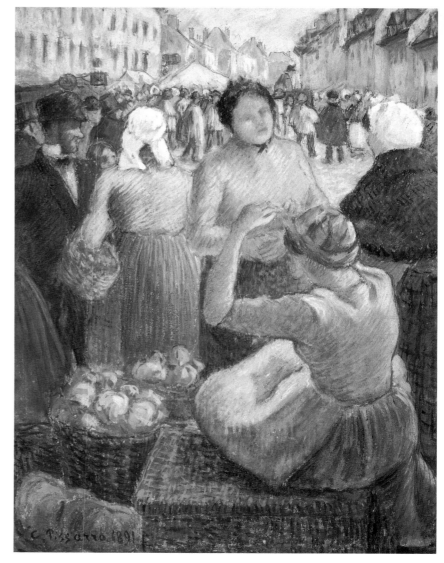

245

Female Figure in a Hat Holding a Fowl.
with a Study of Her Head in Profile. c.1895-90

Black chalk on smooth paper.
8 x 6" (20.1 x 15.8 cm)
The Art Museum, Princeton University

246

Marketplace, Gisors. 1891

Gouache. 13⅝ x 10¼" (35 x 26.3 cm)
Philadelphia Museum of Art. Louise E. Stern
Collection (PV 1465)

247

The Poultry Market at Pontoise. 1882

Oil on canvas. 31⅞ x 25⅝" (81.7 x 65.7 cm)
Norton Simon Art Foundation (PV 576)

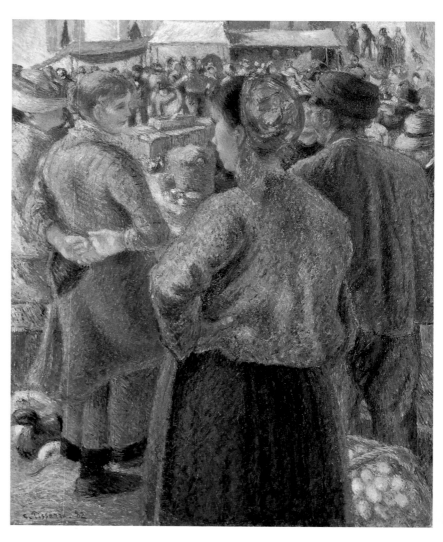

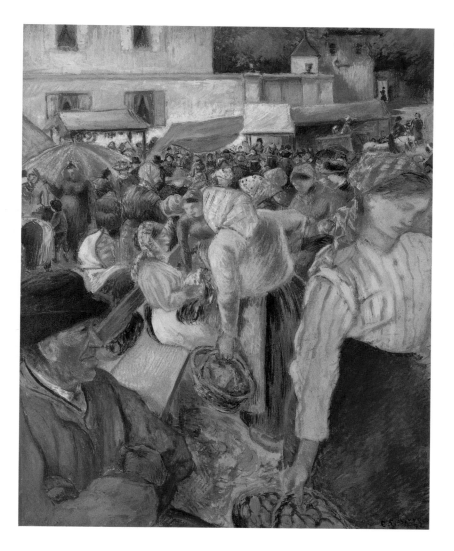

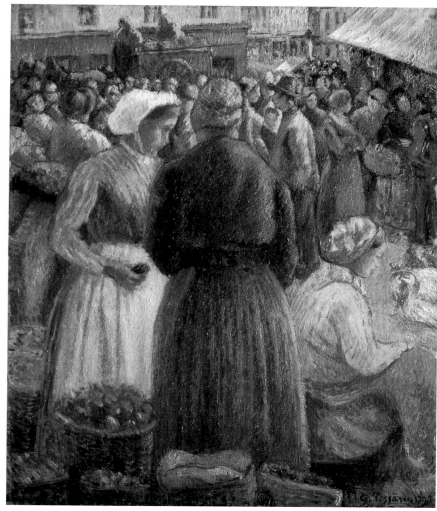

248

Poultry Market, Pontoise, 1882

Tempera and pastel, 31½ x 25¼" (81 x 65 cm)
Private collection, United States (PV1361)

249

Market at Pontoise, 1895

Oil on canvas, 18¼ x 15⅛" (46.3 x 38.3 cm)
The Nelson-Atkins Museum of Art, Kansas City,
Missouri. Nelson Fund, 33-150 (PV932)

arm and goose within a single round of movements, suggesting some resemblance (or kinship) between the holder and what she holds. The detail of the head—seen at a different angle and in isolation—is highly typical of Pissarro's late drawing procedures: the hat does not so much stand on the female's head as it stands for her head. The facial features are reduced to virtually nothing: a few tiny, light pencil strokes.

In *Marketplace, Gisors* (fig. 246), Pissarro depicted the orange scarf being tied up by the seated woman in the foreground (with her back to us) with the same size, shape, colors, and brushstrokes as he used to depict the pumpkins sitting on the ground in the lower left corner, creating here again, an obvious comic *rapprochement*.

The recourse to puns and caricature is no more systematic than any other compositional procedure throughout Pissarro's *oeuvre*. Pictorial puns are often found next to prosaic and "serious" representations, as are caricatures next to objective depictions of figures: see the gendarme (who looks like a marionette straight out of a Punch and Judy theater) peeping out on the left of an otherwise straightforward market scene such as *The Market at Gisors* (fig. 5), or the duck tucked away in the corner of *The Poultry Market at Pontoise* (fig. 247).

Laughter is contiguous to seriousness, jokes to inner meditation, for example, in *Poultry Market, Pontoise* (fig. 248), where the two foreground figures, each in his/her own world, are set against the group of three or four ladies joking around a rooster.

250

Two Studies of Female Figure with Head Turned, Right Hand on Hip. c. 1885-90

Black chalk, the nearer figure redrawn in pen and dark ink on smooth paper.
7½ x 6¼" (19.4 x 16 cm)
The Art Museum, Princeton University

Fun and business are provokingly intermingled. These market scenes exploit popular culture through all sorts of disjunctions. Analogous to Rabelais, who made use in his novels of old dialects, proverbs, student jokes, and farcical pranks, Pissarro made use of simple, unorthodox compositional, pictorial, or graphic devices. He did not manifest his radical opposition to Salon art by choosing market scenes as a subject, for they were a familiar Salon subject.[64] Instead, he deliberately rejected the whole mixed bag of traditional, documentary, patronizing, sentimental, well-polished, and utterly dull treatments of the market to be seen throughout Salon imagery. But in his markets he integrated forms of lower art: puns, jokes, and caricatures of various sorts. Also, in a Degas-like manner, he compressed and condensed or exaggerated these perspectival systems so that close-up figures in the foreground are often seen detached against a crowded background with very few intermediary figures, truncating the intermediary space: see figs. 246–49, as well as *Poultry Market at Gisors* (fig. 240) or even *The Butcher* (fig. 235) or *The Market at Gisors* (fig. 5).

Technically and compositionally, Pissarro was more audacious and adventurous with his market scenes than perhaps with any other field he explored at any other period of his career—although one can find similar compositional procedures in some harvest scenes, such as the magnificent *The Harvest* (PV 1462, not illustrated). He experimented with virtually every medium imaginable—from single pencil sketches to oil paintings, via watercolors, gouaches, tempera, mixed media, etchings, woodblocks, hand-colored etchings, and also combinations of all these.[65] He played with his market

figures in the way a child plays with dolls—placing, displacing, replacing them from one composition to the next and repeating them—as in *Two Studies of Female Figure with Head Turned, Right Hand on Hip* (fig. 250); working them out and reworking them in a different position—as in *The Butcher*.[66] The overwhelming energy and activity expressed throughout Pissarro's market scenes "motivate" the phenomenally complex and diverse array of compositional and technical methods he employed in them.

Unlike the scenes of theater painted by Degas, Toulouse-Lautrec, and Renoir, the market and fair scenes by Pissarro mingle the spectators with the spectacle. They share with the carnivals in Dostoyevsky's and Rabelais's novels the "abolition of distance and establishment of free and familiar contact and exchange." And in them all, "age, social status, rank lose their powers, have no place; familiarity of exchange is heightened."[67]

In this, Pissarro could be seen prolonging and enriching a multicultural tradition. He could thus be described as one of the most democratic figures in Impressionism.[68] This is especially fitting in the case of Pissarro insofar as the multifarious world of forms and manifestations of his rural markets and yearly fairs stood at the antipode of the serious and stiff tone of official culture. Nothing *recherché* is to be found about Pissarro's market figures. Instead, one sees at work there "a sort of indestructible, categorical, unofficial character, so that no dogmatism, no authority, no unchallengeable pomposity can fit comfortably alongside [Rabelais's and Pissarro's] images, which stand unyielding against any permanent achievement, anything stable, anything narrow-mindedly serious, any eternal, permanent limitation or definitive decision in the conception of the world."[69]

In the same vein, Pissarro's market scenes find an extraordinary echo in Rousseau's *Lettre à d'Alembert*, where the eighteenth-century philosopher identified two forms of entertainment, or spectacles: fairs or markets and theaters. While the theater reinforces monarchical distance, Rousseau sees the *fête* as the symbol of democracy. The *fête* relies upon direct communication. The spectators' gazes are not focused on an exterior center of interest (a stage)—instead, they are a spectacle for themselves.

Although there is no firm proof of this, it is difficult not to assume that Pissarro, with his vast knowledge of politics and philosophy, was familiar with this well-known text, which exactly summarizes what is at stake in Pissarro's scenes:

> No, happy people, these are no "fêtes" of yours! It is outdoors, under the sky that you should gather and give way to the sweet feeling of your happiness. . . . But what will then be the themes of these shows? What will be shown there? *Nothing, if you please.* Alongside freedom, wherever a throng prevails, there, well-being prevails too. Stick a pole crowned with flowers in the middle of a square; gather people there; and you will have a "fête." Do even better: make a spectacle of the spectators; turn them into actors themselves. Make sure that everybody sees and loves oneself through the others, so that all of them may be the better united.[70]

Neo-Impressionism

P issarro was not a simple artist. His career through the 1880s and early 1890s was characterized by intense pictorial efforts developing representations of figures—in different settings, contexts, mediums, and with different implications. Parallel to this course, Pissarro seems to have been preoccupied with various formal problems—or as he would put it himself, he enjoyed reflecting on his "execution."[1] As he declared to the dealer Durand-Ruel in 1885, a year before the Neo-Impressionist exhibition at the Salon des Indépendants, "I am in a process of transformation."[2]

This process is most clearly highlighted by the last three or four years of his work in the 1880s. During this time, Pissarro, more than any of his Impressionist colleagues, radically questioned his techniques and methods and adopted—for a while—new procedures: Pointillism or Neo-Impressionism. To him it represented "a new phase in the logical march of Impressionism."[3] This new direction had serious consequences for his working life. In essence, he severed his ties with his old colleagues Monet and Degas. He exhibited at the last Impressionist exhibition in 1886 no longer as an Impressionist but as a Neo-Impressionist. This also meant that Pissarro, the oldest of the Impressionists (two years older than Degas and Manet and ten years older than Monet), was now exhibiting in the same room as artists who were his sons' ages. It took nothing short of a vast period of reflection and a bold commitment to self-criticism to lead him to this hazardous initiative: the artist was then in his mid-fifties, with six children, still striving to obtain some recognition and sell enough works to pay the bills.

Pissarro's work never ceased to transform itself. This process of self-cancellation or self-transformation is, as we have seen, at the very core of Pissarro's Impressionism. This continual self-transformation—or reflexive stance—ensured that, for him, Impressionism would never congeal into a set of encapsulated formulas (unlike academic art), and that individual innovations and intersubjective responses to other

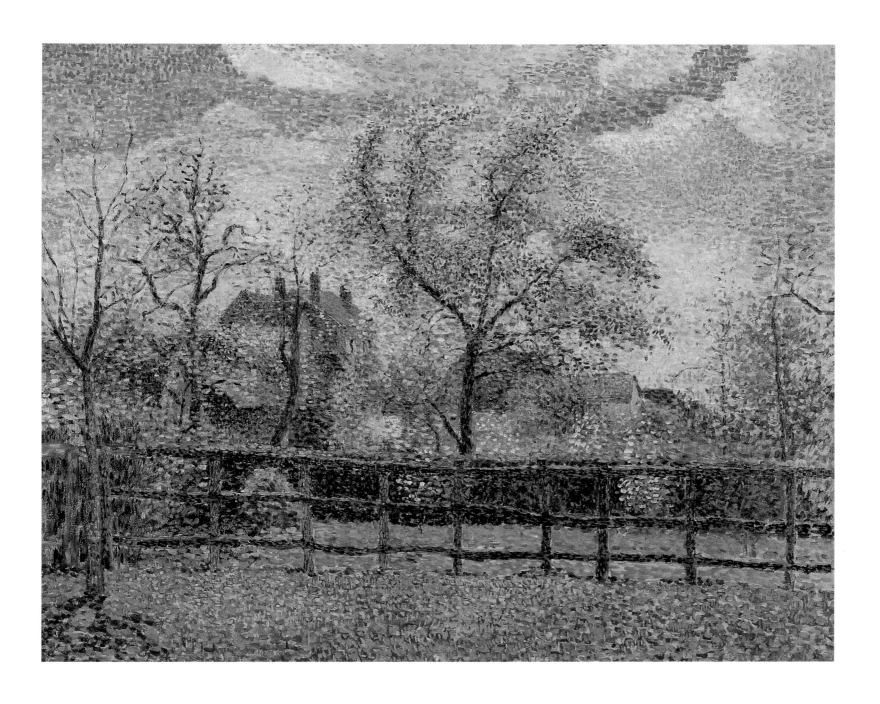

251

Pear Trees in Bloom at Eragny, Morning. 1886

Oil on canvas, 21 x 25¼" (54x65 cm)
Isetan Museum, Tokyo (PV697)

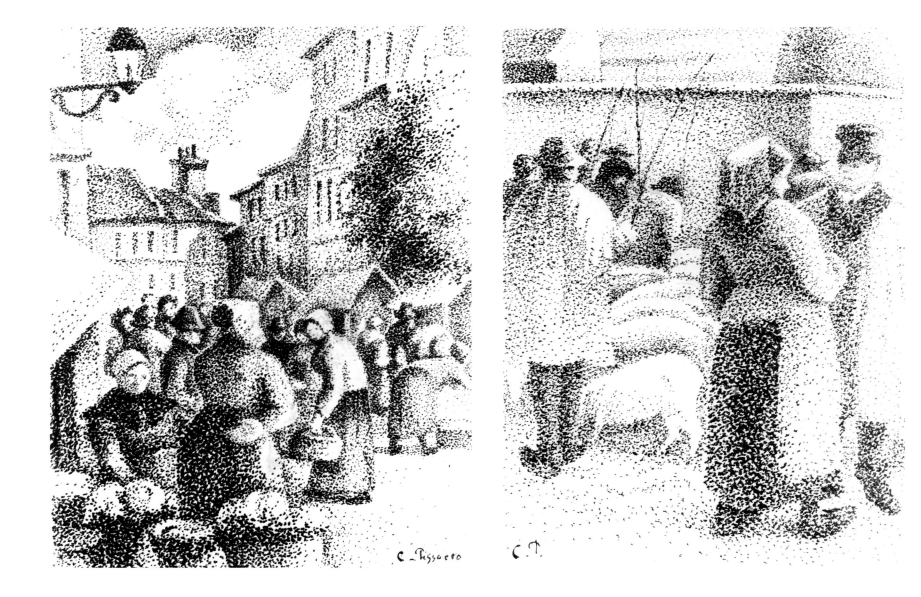

252

Market at Pontoise. 1886

Pen and ink, 6½ x 5" (16.8 x 12.7 cm)
The Metropolitan Museum of Art, New York

253

_Le Marché aux cochons, foire de la Saint-Martin,
Pontoise (Pig Market, Saint-Martin Fair,
Pontoise)._ 1886

Pen and ink, 6⅞ x 5" (17.5 x 12.7 cm)
Musée du Louvre, Cabinet des Dessins
(Fonds du Musée d'Orsay)

artists' transformations would find a considerable scope of action among its adherents.
Finally, it ensured that the process of production—the modes and methods of artistic
creation—were given more emphasis than the actual product; the end result—the
work of art—mattered only insofar as it was a link in a continual process of plastic
exploration.

We have seen how this process of production was put to the test in some of
Pissarro's figure paintings. These figures have no message to deliver. They are utterly
antiallegorical. To read into their "expression" a deep concern for the plight of
mankind or a relish of the idylls of the countryside reveals more about the authors
of such suggestions than about Pissarro or his figures. These figures, together with
the whole cycle of life, work, and exchange that determine the rural conditions of
existence, as represented by Pissarro, are autonomous. This autonomy of presence,
of thoughts (as well as of their economic and material status, as represented by
Pissarro) may call for an autonomous way of looking at the internal process of trans-
formation in his work of the 1880s. Just as these figures embody the deprecation
with which he viewed the narrative Salon tradition, his Neo-Impressionist work of
the late eighties (with a whole diverse gamut of subjects) emphatically displays a
scattered, fragmented, painterly surface. Just as Pissarro's figures commanded patient

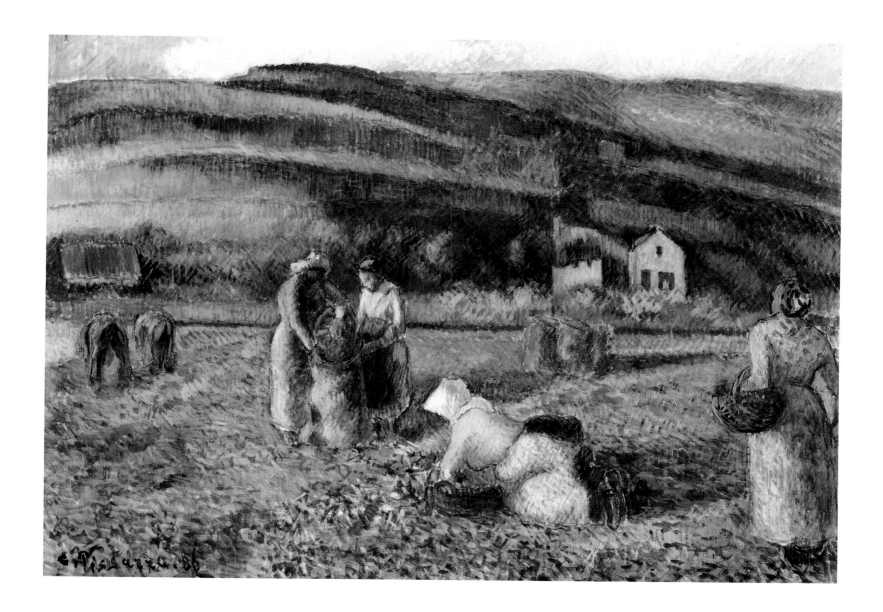

254

The Potato Harvest. 1886

Gouache, 10½ x 15¼" (27 x 39 cm)
Private collection (PV 1405)

interpretation, this later work demanded patient observation due to its painstakingly detailed surface.

As Pissarro was preparing for his most important Neo-Impressionist show at Theo van Gogh's gallery, he described himself as entering upon an intense meditation: this preparation "demands a considerable tension of mind and a lot of work, I have to go into retreat within myself like the monks of the past, and quietly, patiently elaborate the *oeuvre*."[4] Patient execution requires patient observation. Pissarro's Neo-Impressionist art is not meaningful to those in a hurry: it yields little aesthetic surplus-value in the short term. Pissarro pointed this out at the onset of his Neo-Impressionist phase in a remarkable and little-understood letter. Observing ironically that two of his most successful and finished paintings—*Café au Lait* (fig. 160) and *Jeune Fille à la baguette, paysanne assise* (fig. 163)—had been snubbed in London, he explained to his son Lucien, "Remember that I am of a rustic, melancholic temperament, with a rough and wild appearance; it is only after a long while that I may please, and then only if those looking at me have a grain of indulgence; but as for the passerby, a mere glance is too hasty, he can only see the surface; whoever is in a hurry will not stop for me!"[5]

Pissarro's Neo-Impressionistic works, by emphatically displaying their technicality and their fractured brushwork, call renewed attention to the dialectical exchange

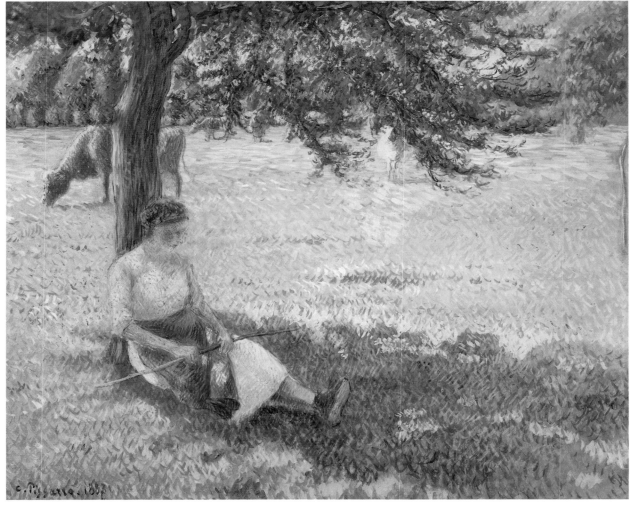

between painter and spectator. The astonishing degree of the grinding of the palette colors into myriad touches on the canvas—as in *Pear Trees in Bloom at Eragny, Morning* (fig. 251)—necessarily directs the observer's gaze and his mind toward the technical conditions of the production of such a painting. In this canvas, the ultimate highly fragmented touches are not called for or motivated all the way by the representational content of the work. The tiny units of divided color applied to the canvas function better as representational devices in some parts than they do in others: the tiny fragmented brushstrokes carry more formal kinship and, therefore, are more convincing signifiers when used to depict freckling leaves of trees or grass rather than tree trunks, a gate, or a path.

A glance at Pissarro's Neo-Impressionist works is enough to convince one of the enormous variety of treatment used throughout. Among the mediums was pen and ink, exemplified in the two market scenes of 1886, *Market at Pontoise* (fig. 252) and *Le Marché aux cochons, foire de la Saint-Martin, Pontoise* (fig. 253),[6] where myriad ink dots have been applied on the paper sheet around and within a scaffolded structure of pencil lines. Pissarro also occasionally resorted to watercolor as in the remarkably sober *Paysage d'Eragny* (fig. 255), where tiny parsimonious strokes create configurations of colored dots that evoke a few trees, a couple of roofs, and a hill. Its remarkable display of economy of plastic means is in keeping with the bare, restrained simplicity of the subject matter. A few strokes were applied from the tip of the brush—in some areas there are so few that one can almost count them—after being dipped into a very limited range of colors: a couple of yellows, a vermilion, an orange, a couple of blues, and a couple of greens.

Pissarro also employed gouache, as in *The Potato Harvest* (fig. 254), *Picking Peas* (fig. 211), *Cowgirl, Eragny* (fig. 256), and *Woman in Front of a Mirror* (fig. 257). These works—the first executed in 1886 and the rest a year later—emblematically show the ample diversity of Neo-Impressionist techniques that Pissarro could imagine. In *The Potato Harvest*, which emphasizes a few important points, Pissarro repeated a motif painted in oil in Pontoise in 1874, with the same name (fig. 127).[7] There are several other instances where he reinterpreted a previous motif in the Neo-Impressionist method: *The Brickyard at Eragny* (fig. 258) is a Neo-Impressionist replica of the same subject done three years earlier (fig. 259); *Shepherdess Bringing in the Sheep* (fig. 196) is a variation of a similar theme in *Old Houses at Eragny* (fig. 195), executed a year previously; *Woman Breaking Wood* (fig. 186) is a replica of *Frost, Young Peasant Making a Fire* (fig. 184), and *Picking Apples* (fig. 230) is a replica with variations of *Picking Apples* (fig. 229).

Through its motif and technique, *The Potato Harvest* of 1886 points to the indirect importance of Cézanne in the development of Pissarro's Neo-Impressionist idiom. This certainly does not diminish the crucial influence exerted on Pissarro by Signac, whom he met at the studio of Armand Guillaumin in 1885 and, more so, by Seurat, introduced to Pissarro by Signac in the same year. The two main concepts Pissarro imported from Signac and Seurat were the division of the paint into tiny brushstrokes and the use of contrasts based on pure hues and complementary colors.[8] The treatment of the gouache in *The Potato Harvest*—and this is also true of *Picking Peas* (fig. 211) and *Woman in Front of a Mirror* (fig. 257)—is in some parts dependent on the lesson taught by Seurat and Signac, but not solely. The rather dense, thick,

255
—————

Paysage d'Eragny, c. 1886
—————

Watercolor, 4¾ x 8" (12.3 x 20.5 cm)
Courtesy of the Pierpont Morgan Library,
New York. The Thaw Collection

256
—————

Cowgirl, Eragny, 1887
—————

Tempera, 21 x 25¼" (54 x 65 cm)
Collection Sara Lee Corporation, Chicago
(PV 1416)

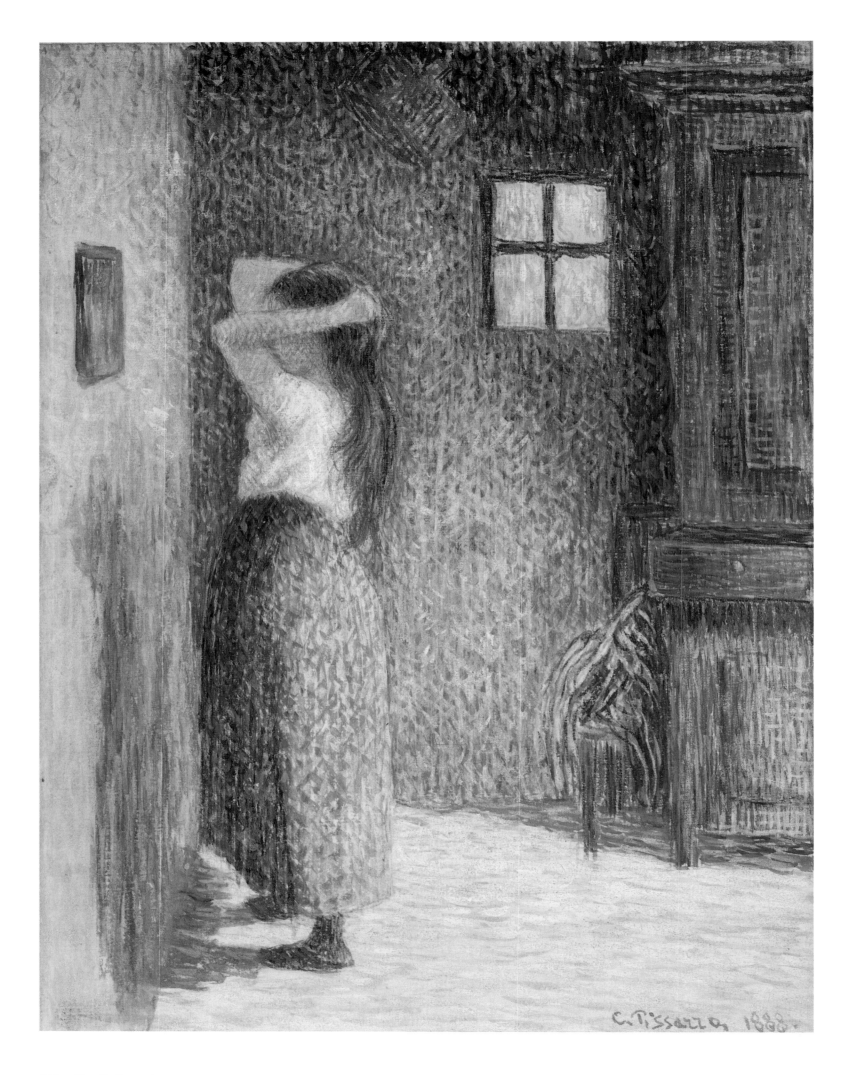

258

The Brickyard at Eragny. 1888

Oil on canvas. 23½ x 28¾" (60 x 73 cm)
Courtesy of Gallery Urban (PV724)

257

Woman in Front of a Mirror. 1887

Gouache. 12½ x 9½" (32 x 24 cm)
Private collection, United States (PV1421)

259

The Brickyard at Eragny. Sunset. 1885

Oil on canvas, 23 x 28¼" (59 x 73 cm)
Collection Mr. and Mrs. Joseph L. Mailman
(PV679)

parallel vertical strokes of the background hill are as reminiscent of Cézanne's "constructive stroke" as of Seurat's divisionism.[9] Pissarro, like Signac, had acquired several studies by Cézanne, which evoked this passage in a letter to Lucien: "If you are too close to something, you cannot see anything—it is just like a painting by Cézanne that you would stick under your nose. Speaking of which, I have just bought four of his studies, very curious."[10]

In 1885, the year he met Signac and Seurat, Pissarro was already applying diagonal parallel brushstrokes to his work, as in *Gisors, New Section* (see fig. 91). This suggests that his own observations of Cézanne's work had made him pictorially ready to meet Signac and Seurat and to make full use of their technique. As demonstrated by *The Potato Harvest*, however, Pissarro paraphrased neither Cézanne nor Seurat and Signac. By integrating some of their procedures within his own idiom, he created a third highly innovative solution—altogether complex, provocative, and heterodox. This canvas succeeds in amalgamating chaos and order. In the foreground, the earth is furrowed by a milling variety of uncoordinated strokes (curves, accents, crosses, hieroglyphics), offset by the neat regularity of parallel verticals scanning the back-ground. In the intermediate space, a whole gamut of other possibilities was put into use: crisscrossing strokes (aprons), comma-like strokes (basket), parallel diagonals, etc.

The recipe differs in all other works. The group of gouaches just referred to attest that Pissarro's interpretation of Neo-Impressionism was anything but formulaic.

He instilled a sense of jazziness and of ceaseless improvisation within the tenets of Neo-Impressionism: *Cowgirl, Eragny* (fig. 256), developing a frequent theme in Pissarro's *oeuvre*, heightens the awareness of color contrasts; along with *Picking Peas* and *Woman in Front of a Mirror*, its luminosity reveals the impact of contemporary scientific discoveries on the composition of light.

Pissarro avidly read Eugène Chevreul on the prismatic separation of colors and the American Ogden Rood's *Theory of Colors*,[11] a crucial text for Pissarro that scientifically established the difference between light-colors (spectrum colors) and matter-colors (or pigments), and pointed out that matter-colors could never match or serve as the equivalents of light-colors. In other words, in order to create contrasts of colors in paint that would carry the same vibrancy as light-color contrasts, one would have to resort to different color complementaries than those observed in nature. Rood suggested using complementaries such as purple/green rather than the traditional red/green, for instance.

The color contrasts with which Pissarro experimented during these few years of Neo-Impressionism were probably the most important legacy of his Neo-Impressionist phase; after he became tired of its rigorous methods, he retained, for several more years, analogous and luminous color contrasts.

Even at the height of his Neo-Impressionist period, Pissarro took definite liberties with the "scientific" rigor of the theories in which he, Seurat, and Signac shared a passionate interest. He instilled an unmistakable sense of poetry into several major works of this period. This clearly is the case with *Cowgirl, Eragny* as well as *Railroad to Dieppe* (fig. 260), *View From My Window, Eragny* (fig. 261), *Frost, Young Peasant Making a Fire* (fig. 184), and *Woman Breaking Wood* (fig. 186), in particular. This ambivalent attitude, quite characteristic of Pissarro's art, balancing, in a constant tension, rigor and improvisation, system and individual freedom, science and poetry, seems to echo one of Friedrich von Schlegel's mottoes: "Physics is nothing but the source of poetry and the only visual stimulant of visions."[12] In that, Pissarro was not that far from Seurat, who also can be seen both as a poet and a technician.[13] But the specificity of Pissarro's poetics is the fundamental lesson taught by his Neo-Impressionist achievement. The fragmentation of brushwork (divisionism) brought up the particulars of his pictorial touch, calling for fresh attention to the complicated processes of creation involved.[14]

But whereas Seurat's repetitions and variations of similar themes and motifs, following a pyramidal or hierarchical structure, contribute to a unique final masterwork, Pissarro, on the other hand, follows a more circular model, whereby the end of a chain of related works is not just one single masterpiece, but two (or occasionally several), as demonstrated by the two monumental achievements *Frost, Young Peasant Making a Fire* and *Woman Breaking Wood*, dated 1888 and 1890. These two works need to be seen side by side, since they corroborate and complement each other through their technical, compositional, and representational specifics, creating a fascinating dialogue whose interplay the viewer can freely observe, back and forth. This confrontation also reveals the modifications brought by Pissarro into Neo-Impressionism within the short span of two years. Like *Woman Breaking Wood*, *Haymakers at Eragny* (fig. 262) emphatically embodies the time-consuming limitations that Pissarro felt were imposed by Neo-Impressionism.

260

Railroad to Dieppe. 1886

Oil on canvas, 21¼ x 25¾" (54.5 x 66 cm)
Private collection (PV694)

261

View from My Window, Eragny. 1888

Oil on canvas, 25⅝ x 31⅞" (65.7 x 81.7 cm)
Ashmolean Museum, Oxford (PV721)

262

Haymakers at Eragny. 1889

Oil on canvas, 28¾ x 23½" (73 x 60 cm)
Private collection (PV729)

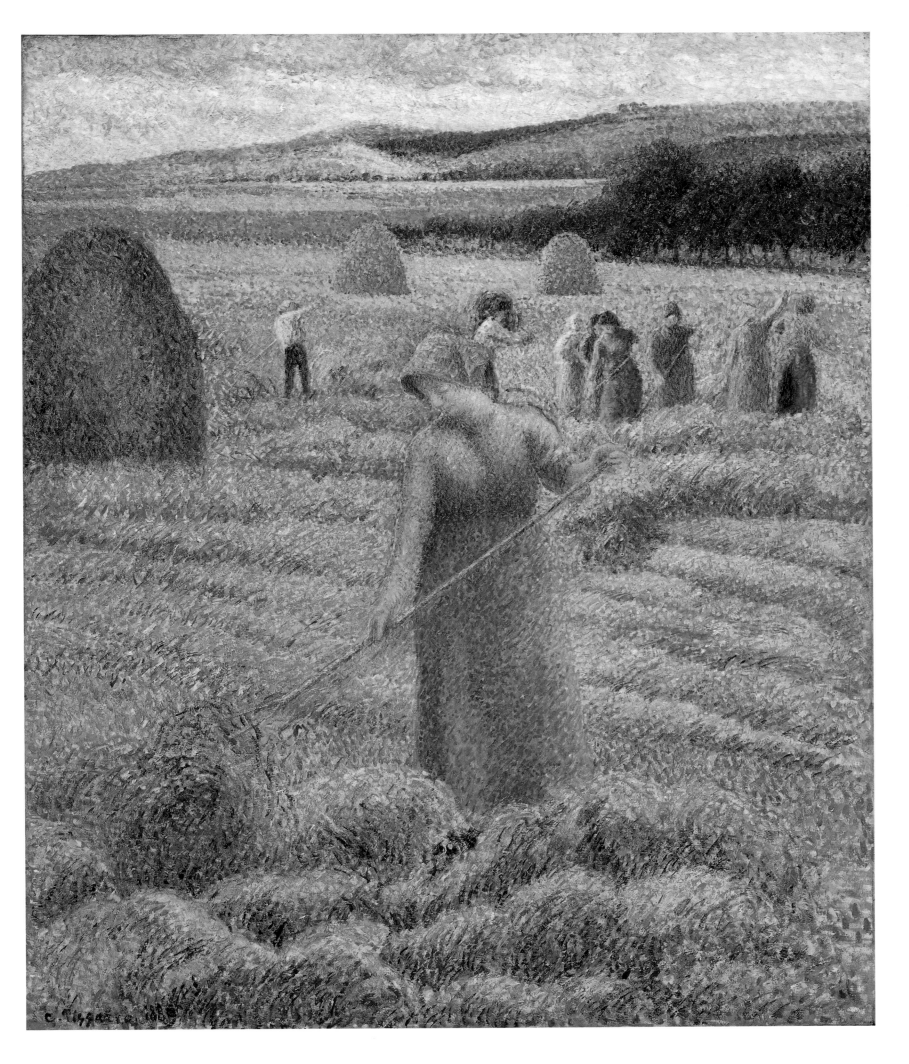

Late Landscapes

*I*n the few years of his experimentation with Neo-Impressionism, Pissarro was intent on "acquiring science" without losing sight of the "feeling for nature" or of his own *sensation*. Thus he felt relatively free to improvise, or at least to modulate and diversify the main tenets of its theoretical framework.[1] Despite this, the formulaic and somewhat constructive aspect of Neo-Impressionism soon began to lose its appeal for him. The Neo-Impressionist technique, even though he adapted it with some freedom, was both painstaking and arduous. The number of paintings listed in the *catalogue raisonné* for this period is revealing: In 1885, the year before he launched seriously into Neo-Impressionism, he painted thirty-five works; in 1886, the year in which he participated in the last Impressionist exhibition, he executed only seventeen; in 1887, however, ten; in 1888, only nine; and in 1889, ten. In 1890, when he started to look towards different pictorial horizons, his output rose to twenty-four works.[2]

Pissarro complained in no uncertain terms about the time this technique entailed: "These pictures are awfully time-consuming, and when you think we are reproached chiefly for not finishing our work!"[3]

In addition, because of the painstaking technique involved, these paintings were executed mainly at the studio, from tiny oil sketches or watercolor notes made on the spot. As a result, Pissarro lost direct contact with nature—compounded by the fact that in the late eighties, he contracted an inflammation of the tear glands, which prevented him from working outdoors.

With the end of his Neo-Impressionist phase and his convalescence, Pissarro expressed to Monet his joy in leaving the confines of the studio: "It seemed so good to me to work outside, it had been two years since I last dared to attempt the adventure!"[4]

Severing his ties with Neo-Impressionism also made it possible for Pissarro to resume his friendship with his old friends, namely Monet and Degas, whom he had

castigated as "Romantic Impressionists"[5] and from whom he had maintained his distance. Even though it required patience and perseverance in order to transfer his *sensation* onto his canvas, Neo-Impressionism placed just too much emphasis on the technical "rendering" of his sensations, thus whittling away or congealing those sensations, and tilting the balance between observation and expression. This soon led Pissarro to raise serious questions as to the sustaining validity of the "monolithic and rigid technique of the dot."[6]

More fundamentally, Pissarro constantly questioned his own working process. Even at the peak of his Neo-Impressionist phase, he was able to be self-critical: "It is really taking too long. More than ever I am going to make some gouaches, for I cannot see a way to paint figures that will sell. I might have to go back to my old style? This is quite embarrassing! . . . At least, it will have helped me to do more precise work."[7]

There is probably no better way to observe the manifestations of these transitional tensions, innovations, hesitations, backward steps, transformations, pictorial gains and losses than to look at Pissarro's landscape paintings during the last twenty years of his life. This is the period of his move from Pontoise (1882) and his settling in Eragny (1884), with a one-year intermezzo in Osny, just outside Pontoise (1883); see *View of Osny near Pontoise* (fig. 132) or *La Route d'Osny* (fig. 140). Eragny-sur-Epte was (and still is) a tiny village about sixty miles from Paris on the border between Vexin Français and Vexin Normand, and very close to Normandy. It consists of a few houses set in a row on either side of the main road through the village, as aptly illustrated by *Entering the Village of Eragny* (fig. 266) It is separated from another small village, Bazincourt, by the Epte—a small river which also crosses Giverny, Monet's village, about thirty or forty miles downstream. Bazincourt's houses were built on the hillside on the opposite bank of the Epte and are invisible from Eragny, less than two miles away; its church spire is easily recognizable through the groves of trees covering the hill.

Unlike Pontoise, whose tensions were those of a suburban town, semirural and semiurban, in Eragny, no signs of industry could be observed for miles. Varied expanses of pasture and cultivated land complete the visual field. However, Eragny's earthly space is not banal. For twenty years Pissarro concentrated on this very confined area, on the visual material offered by the stretch of meadows lying in front of him, informed by poplars, gates, the river, and produced over two hundred paintings of these motifs. His representations of these fields and gardens constitute the most spectacularly intense pictorial effort to "cover" a particular given space in his career. Added to these two hundred paintings are hundreds of drawings and watercolors. In 1891, Pissarro counted one hundred sixty-one watercolors, mainly of Eragny, which he arranged in series within portfolios,[8] for example, *Eragny* (fig. 263), *Twilight, Eragny* (fig. 264), and *Eragny, Twilight* (fig. 265).

The variety and richness of plastic possibilities that Pissarro examined through-out his twenty-year sojourn in this tiny area can be seen in the developments that his work underwent during this period. Signs of his approaching Neo-Impressionism can be observed in the detached, slightly fragmented brushwork of paintings executed in 1885, such as *Fields at Eragny* (fig. 267), while by the early 1890s his work was edging away from pointillism, as evidenced by paintings such as *Sunset*

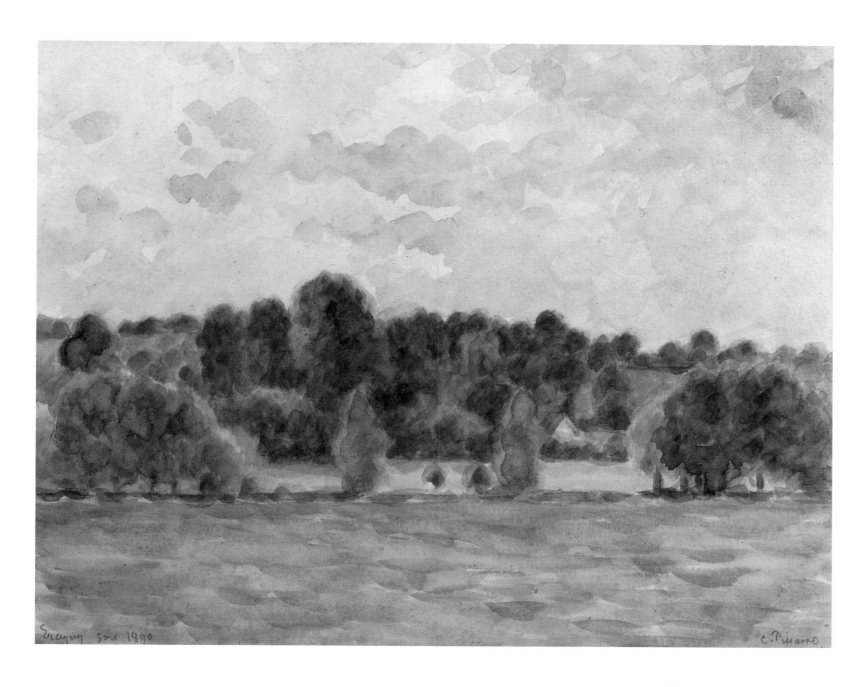

Eragny, soir 1890 C. Pissarro

265

Eragny, Twilight. 1890

Watercolor, 8¾ x 11" (22.4 x 28.2 cm)
Private collection

263

Eragny. 1890

Watercolor, 6½ x 9½" (16.5 x 24 cm)
Reproduced courtesy of J.P.L. Fine Arts, London

264

Twilight, Eragny. 1889

Watercolor, 8¾ x 11" (22.4 x 28.2 cm)
Private collection

266

Entering the Village of Eragny. 1884

Oil on canvas, 17½ x 21" (45 x 54 cm)
Photograph courtesy of Wildenstein & Co.,
New York (PV636)

267

Fields at Eragny. c. 1885

Oil on canvas, 21 x 25" (54 x 64 cm)
Private collection (PV664)

at Eragny (fig. 272), depicting a narrow stretch of land with a sunset effect, or as in *Pasture, Sunset, Eragny* (fig. 273), where some scattered traces of his Neo-Impressionist period are integrated into the larger tapestry of bright sunset hues.

It is possible to distinguish certain classifications of compositional organization in these two hundred paintings of the same single square mile of landscape. Pissarro favored certain motifs—for example, the skirt of the wooded hill of Bazincourt, which itself (when seen as a whole) forms a recognizable pattern, something like an S and Z joined together at the top. This motif is more or less readable in *Sunset at Eragny* (fig. 268) and *The Meadow at Eragny* (fig. 269). (The latter painting is one of the few examples of an Eragny landscape in which a human figure is to be found.) Pissarro also fragmented this whole motif and looked more to his left while he was facing Bazincourt and its church spire, as in *View of Bazincourt, Sunset* (fig. 270), in which we see the S curve; or equally he could turn more to his right, as in the astonishing sunset version, *Red Sky, Bazincourt* (fig. 274) or *Frost, View from Bazincourt* (fig. 271), and focus more on the Z shape.

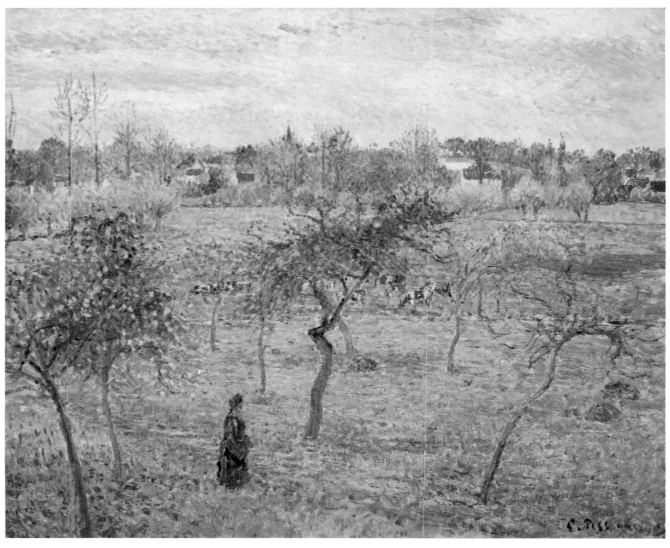

Opposite:

268

Sunset at Eragny. 1894

Oil on canvas, 21 x 25¼" (54 x 65 cm)
Private collection (PV873)

269

The Meadow at Eragny. 1894

Oil on canvas, 25¼ x 31" (65 x 80 cm)
Private collection (PV899)

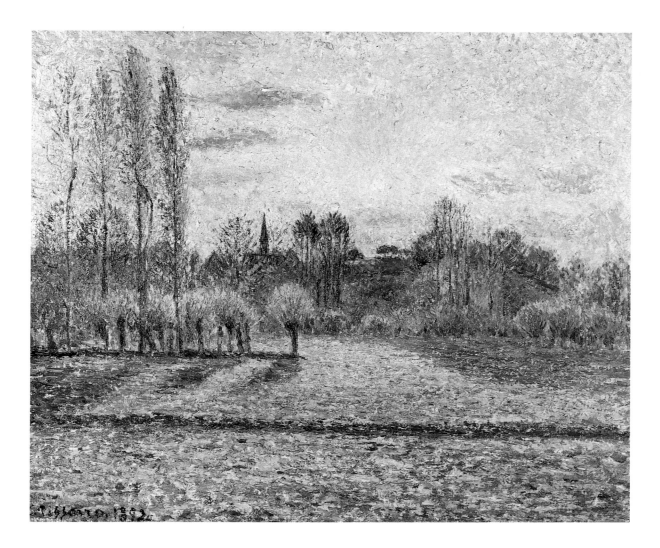

270

View of Bazincourt, Sunset. 1892

Oil on canvas, 18 x 21½" (46 x 55 cm)
Private collection (PV812)

271

Frost, View from Bazincourt. 1891

Oil on canvas, 15 x 18" (38 x 46 cm)
Private collection (PV763)

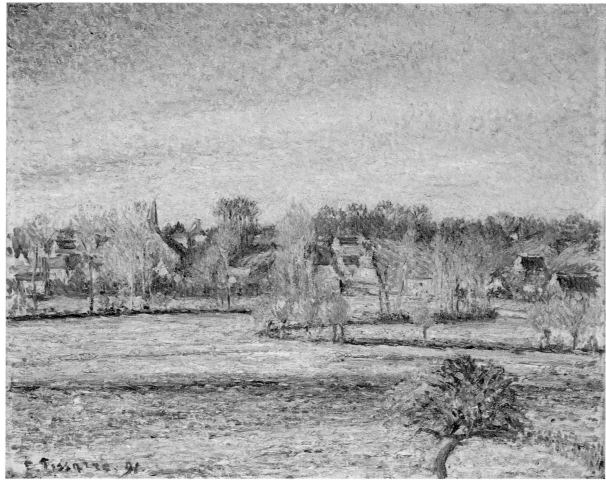

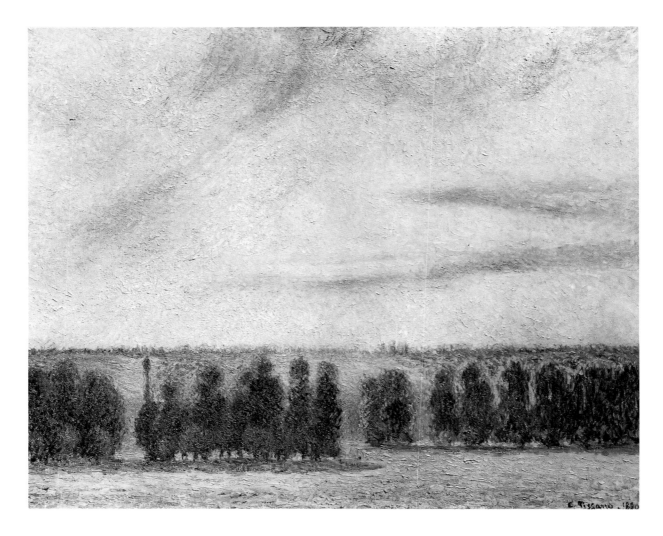

274

Red Sky, Bazincourt. 1893

Oil on canvas, 18 x 21½" (46 x 55 cm)
Private collection (PV840)

272

Sunset at Eragny. 1890

Oil on canvas, 32¼ x 25¾" (82.7 x 66 cm)
Private collection (PV751)

273

Pasture, Sunset, Eragny. 1890

Oil on canvas, 15 x 18" (38 x 46 cm)
Private collection (PV753)

The variations on this single motif, which was only one of Pisarro's favorite
Eragny motifs, proved to be infinite: *Flood, Twilight Effect, Eragny* (fig. 275), which
was executed from a vantage point slightly to the right of *Red Sky, Bazincourt* (and
in which, therefore, Bazincourt is pushed to the left of the canvas) introduced a
downward vantage point onto the fields. This angle was visible from an elevated
studio which Pissarro had specially made in 1893;[9] hence, the segments of the walls
and the rabbit holes included in the picture. This painting also shows the
transformation of the landscape resulting from a recent flood of the River Epte—a
river usually discreet to the point of invisibility. The vertical format of this picture
heightens the difference in the vantage points between the two paintings.

In addition, Pissarro was also able to stand at the exact antipodes of *Flood,
Twilight Effect, Eragny*, as may be seen in *Apple Trees in a Field* (fig. 276), in which
the artist is seated at his easel at ground level. The river is here only alluded to,
through the horizontal row of short willows and few poplars that cut horizontally
across the picture plane. In this painting the artist focuses more closely on the skirt of

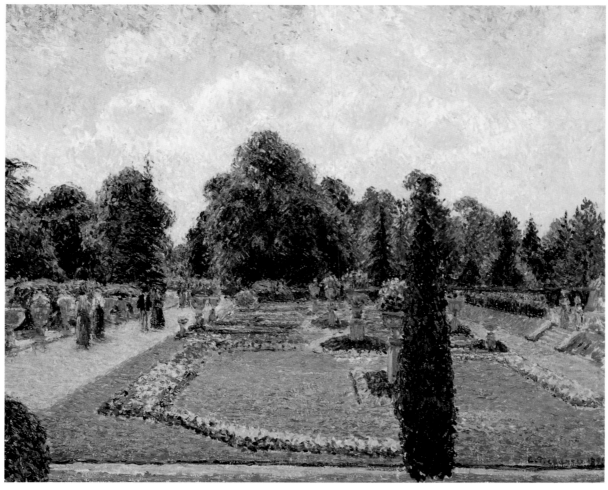

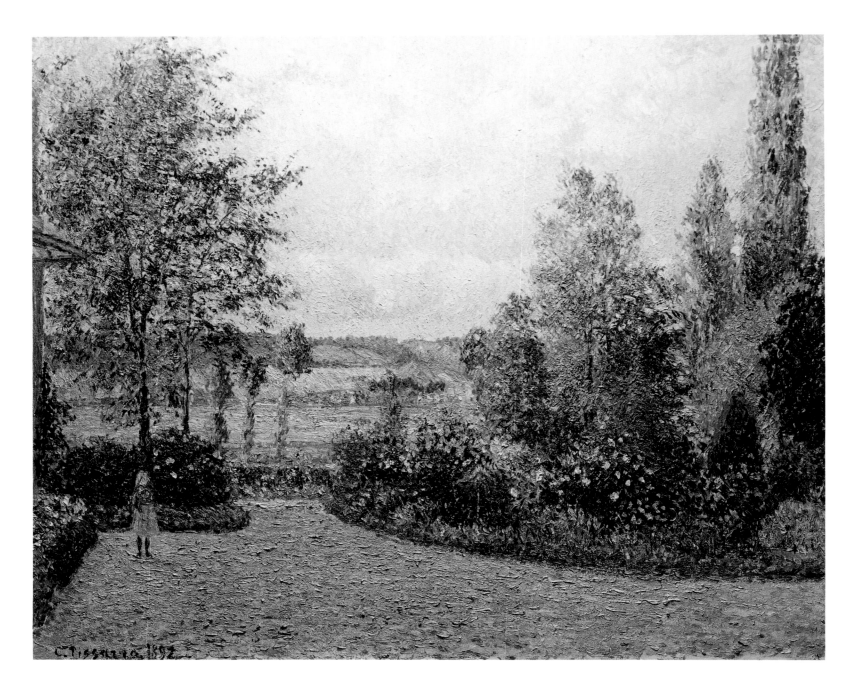

278

Mirbeau's Garden, the Terrace, Les Damps (Eure), c. 1892

Oil on canvas, 28¼ x 36" (73 x 92 cm)
Collection Robert B. Mayer Family, Chicago
(PV807)

the Bazincourt hill, and the church spire has been obliterated from view, as he has shifted his vantage point to the left of the church. The picture is about a certain orderly asymmetry: parallels that in fact meet somewhere, a group of tall poplars that disrupt (right) the otherwise regular and well-formed row of willows: three trees on each side, suggesting a short-range perspectival axis; but these trees are not quite centered, nor are they the same height, and the woman on her knees is represented ignoring all this and concentrating on her chore of feeding the rabbits. The cycle of colors used in this work is important as it is emblematic of the palette used by the artist from around 1892 to 1894. There are echoes of the same palette in his scenes of Kew Gardens of 1892—for example, *Kew Gardens: Path Between the Pond and the Palm House* (fig. 277)—and in figs. 268, 270, and 278. This basic palette, which he would often mix with other pigments, as in *Mirbeau's Garden, the Terrace, Les Damps (Eure)* (fig. 278), consisted of several principal hues: light green, chrome yellow, crimson, purple, pink, and ultramarine. Yet within this regular system, a painting such as *Red Sky, Bazincourt* (fig. 274), one of his most spectacular late

landscapes, escapes any technical formula. It is breathtakingly painterly, the result of an incredibly multifarious technique, alternating between a thick impasto composed of several underlayers of paint, and tiny fragmented purple strokes, as in the foliage of the trees on the hill, revealing Pissarro's supple and confident hand. There is something almost culinary about the way the material of the paint has been applied and manipulated on the surface of this work. It is all the more surprising a painting in that it was executed three years after Pissarro's flirtation with Neo-Impressionism; if the chromatic scale retains elements of Neo-Impressionist contrasts, the technique has become increasingly audacious, and at the same time remarkably assured, serene, and cohesive.

Other motifs centered on the land around Pissarro's house. One of them was the visual dialogue established among trees, gates, fences, or land of different heights. Trees emphasize the verticality of the rural space; conversely, fences run across the fields, defining the horizontal limits of the land. Another important idiosyncrasy of Pissarro's Eragny pictures—which indeed only find an equivalent in Monet's studies of Giverny and Cézanne's of Mont Sainte-Victoire—is that once Pissarro chose a motif, he would record not only the seasonal, atmospheric, climatic changes, and their impact on the landscape, but also the changes experienced by a piece of land or a tree throughout the years. A seven-year span separates *The Big Walnut Tree at Eragny* (fig. 279) and *Landscape—Fields, Eragny* (fig. 280).[10] Both pictures depict a tall walnut tree, legendary among the children of Eragny at the time for its huge size. In 1885, as one can see in *Landscape—Fields, Eragny*, four saplings had been planted between the walnut and the apple tree. In 1892 (according to *The Big Walnut Tree at Eragny*), only one of the new trees seems to have survived, while another has been planted to the right of the walnut, where the stump of a huge tree had been in 1885.

More interesting perhaps than the recorded transformations of nature, is the fact that these changes constitute the support of the artist's imagination, his *sensations*, his techniques. How pink or red had the bank of lush green land in *Landscape—Fields, Eragny* really become, as seen in *The Big Walnut Tree at Eragny?* It matters relatively little to know the answer (the factual circumstance of the autumnal plowing of the land provides an inadequate or oversimplistic answer). The point here is that nature and imagination, the real and the pictorial follow intertwined courses. This pair of works reminds us that the two cannot be dissociated. One might also consult the follow-up work *The Walnut and Apple Trees in Bloom at Eragny* (fig. 281).

Towards the end of his life, Pissarro gradually reintroduced figures into his landscapes, which had previously consisted solely of scenographic arrangements in which trees were the primary protagonists. Both *Landscape, Gray Weather at Eragny* (fig. 282) and *Apple Trees, Sunset, Eragny* (fig. 283) offer magnificent examples of transformed plastic issues. In the former there is no panoramic aerial vista of plain fields between two villages. This is a garden landscape, reminiscent of some of Pissarro's paintings of Pontoise kitchen gardens. The perspective in *Landscape, Gray Weather at Eragny* is abruptly cut by tall trees, whose own height is highlighted by the relative height of the fence and of the human figures. The fence reintroduces a shortened and effective perspective, directing the viewer's gaze into the garden and arresting his/her attention to the two workers. This circumstantial scene occupies less than a quarter of the painting's surface. This picture is about the opposition and complementaries of green and gray—between the myriad different shades of greens

279

The Big Walnut Tree at Eragny. 1892

Oil on canvas, 24 x 29" (61.5 x 74.4 cm)
Collection Samuel LeFrak (PV781)

280

Landscape—Fields, Eragny. 1885

Oil on canvas, 29 x 23⅝" (74.4 x 60.6 cm)
Philadelphia Museum of Art,
W. P. Wilstach Collection (PV658)

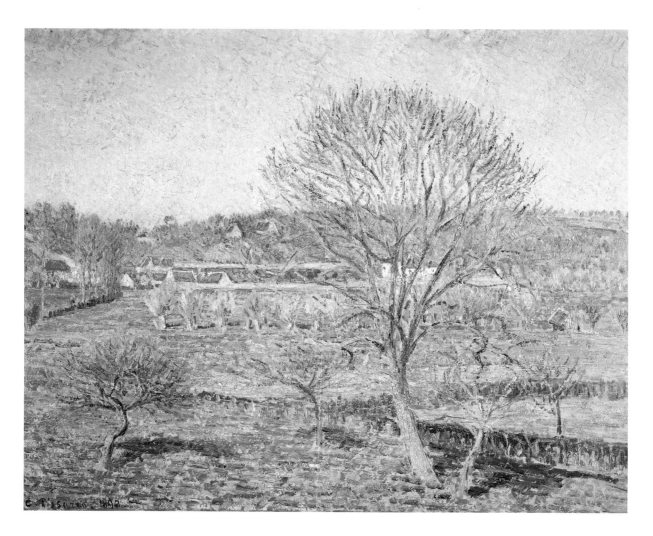

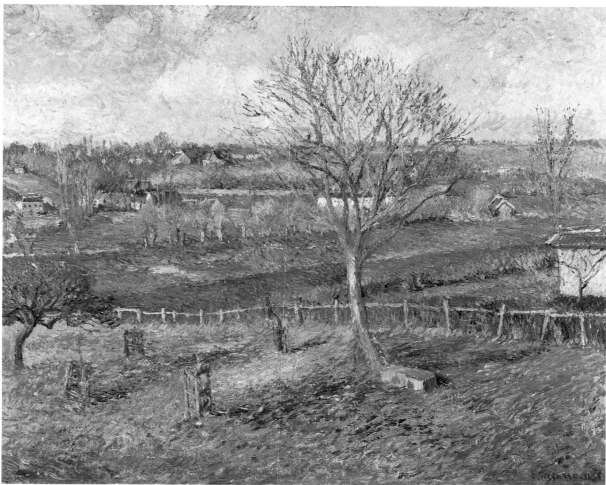

Opposite:

281

*The Walnut and Apple Trees in Bloom
at Eragny.* 1895

Oil on canvas, 18 x 15" (46 x 38 cm)
Private collection (PV916)

282

Landscape, Gray Weather at Eragny. 1899

Oil on canvas, 25¼ x 31½" (65 x 81 cm)
Private collection (PV 1082)

283

Apple Trees, Sunset, Eragny. 1896

Oil on canvas, 25¾ x 31½" (66 x 81 cm)
Private collection, Japan (PV 977)

284

The Fields at Berneval. Morning. 1900

Oil on canvas. 25¼ x 31½" (65 x 81 cm)
Collection the Wohl Family (PV 1145)

representing this ceaselessly animated corner of vertical nature and the light mauve shades that serve as counterpoint to these lavish pigments.

Pissarro could never get enough of Eragny. His infrequent travels—to Berneval, for instance: see *The Fields at Berneval. Morning* (fig. 284)—always brought him back to Eragny with renewed resources, fresh ideas, and an eagerness to paint the same and yet ever different locations once again. The nineteen years that he spent in Eragny undeniably constitute a significant episode in the history of late Impressionism. The images resulting from these two decades of intense reflection and work have paradoxically remained the least studied in Pissarro's *oeuvre*.

Travels and Series Campaigns

*T*hroughout the 1890s, as he was exploring an array of pictorial methods subsequent to his short-lived Neo-Impressionist phase, Pissarro alternated his search for motifs between town and country; more precisely, between the four towns where he evolved his series of cityscapes and the tiny village of Eragny, where he produced many landscapes, all rooted topographically within a few acres of the fields and trees expanding in front of his window. He also made successive short, though fecund, trips to London and Belgium.

England—Belgium

Unlike Renoir or Monet, Pissarro never showed interest in the south of France or the Mediterranean. One more paradox is that, born in the tropics, Pissarro was fundamentally a painter of the north—of the Seine and of the Thames, of fogs and puffs of steam, of parks, lakes, and bridges, as in his London paintings of Hyde Park (fig. 285), Stamford Brook Common (fig. 286), Charing Cross and Chelsea bridges (figs. 287 and 288), Hampton Court Green (fig. 289), Kew and Kensington gardens (figs. 290 and 291). Another characteristic of these few trips is that they were always motivated by some practical, rather than pictorial, reason. Pissarro had nieces in London; his eldest son, Lucien, himself an artist, also lived in London, where he settled in 1883. From then on, father and son corresponded with amazing regularity and thus forged a major cornerstone of epistolary art literature in the nineteenth century. Pissarro's three older sons all spent prolonged periods in London; two of them married English women. In 1893, his first two grandchildren were born, in England.[1] His successive visits to England in 1890, 1892, and 1897 were certainly prompted by his family, but his visit to Belgium in 1894 was politically motivated. The 1890s, and 1894 in particular, were agitated years in France. Several bomb explosions occurred. The anarchistic militant Auguste Vaillant was sentenced to death and

285

The Serpentine, Hyde Park, Fog Effect. 1890

Oil on canvas, 21 x 28¾" (54 x 73 cm)
Private collection, Paris (PV744)

286

View Across Stamford Brook Common
(formerly known as *Bedford Park*). 1897

Oil on canvas, 21¾ x 25⅝" (54.8 x 65.7 cm)
Private collection

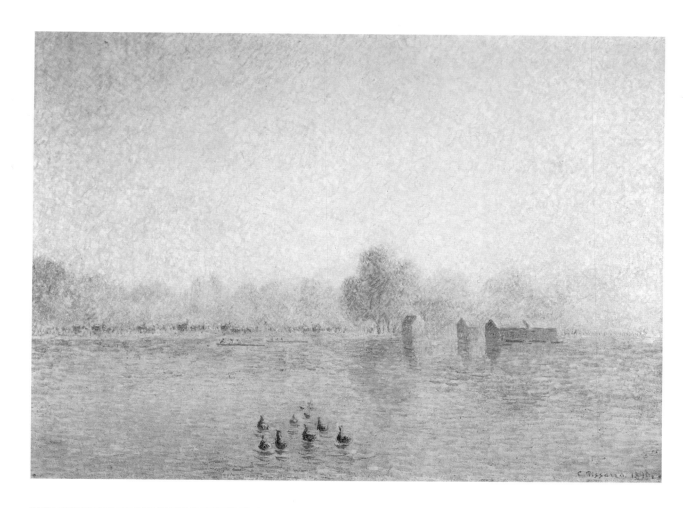

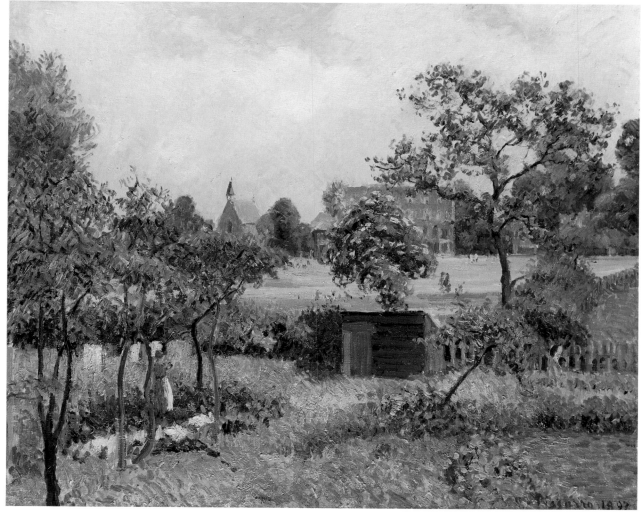

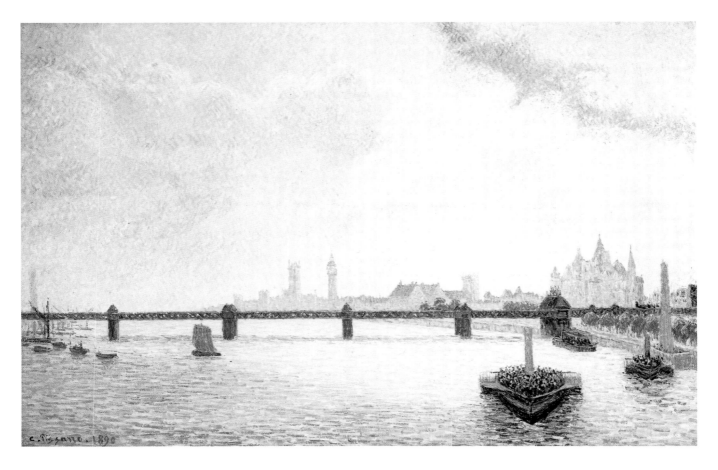

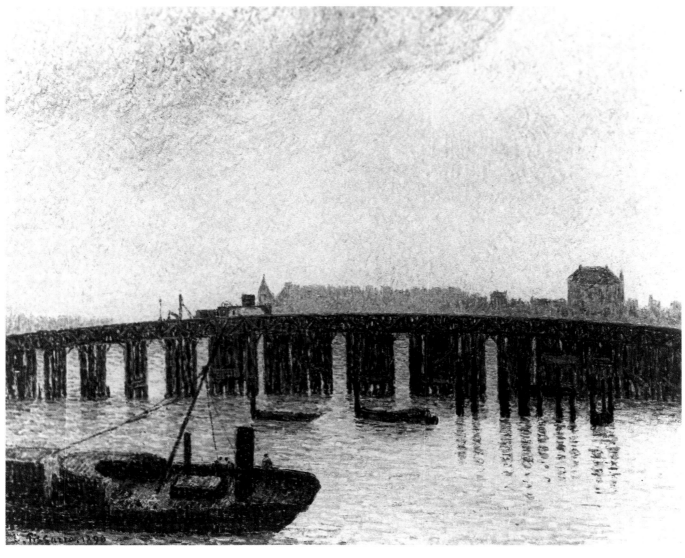

289

Hampton Court Green. 1891

Oil on canvas, 21⅛ x 28¾" (54.3 x 73 cm)
National Gallery of Art, Washington, D.C.
Ailsa Mellon Bruce Collection (PV746)

287

Charing Cross Bridge, London. 1890

Oil on canvas, 23⅝ x 36⅜" (60.6 x 93.3 cm)
National Gallery of Art, Washington, D.C.
Collection of Mr. and Mrs. Paul Mellon (PV745)

288

Chelsea Bridge. 1890

Oil on canvas, 23½ x 28½" (60.3 x 73.1 cm)
Private collection

292
—————
The Knocke Windmill, Belgium. 1894-1902

Oil on canvas, 25¼ x 31½" (65 x 81 cm)
Private collection, New York (PV883)

290
—————
Kew Green. 1892

Oil on canvas, 18 x 21½" (46 x 55 cm)
Musée de Lyons (PV799)

291
—————
Kensington Gardens, London. 1890

Oil on canvas, 21 x 28¾" (54 x 73 cm)
Private collection (PV747)

executed; this in turn unleashed a series of terrorist attacks. An infernal concatenation of reprisals and counterreprisals followed. Searches were carried out in the premises of anarchists or their sympathizers. A series of infamous antiterrorist laws (*lois scélérates*) were passed. Most anarchist newspapers (including *Le Père Peinard* and *La Révolte*, to which Pissarro subscribed) were suspended or heavily censored. These measures failed, however, to deflate the increasing tensions. On June 24, 1894, the president of the republic, Sadi Carnot, was murdered. Though an anarchist sympathizer, Pissarro strongly opposed the recourse to violence. In spite of this, he was listed as one of hundreds of suspects. He, his wife, and their son Félix left for Belgium the next day. There he produced an extraordinary group of pictures almost as if evoking Don Quixote's vision of windmills. Outstanding among them is the exquisitely lush and subtly painted *The Knocke Windmill, Belgium* (fig. 292).

In the case of Pissarro's 1892 visit to London, he was impelled by a religious—or rather antireligious—reason. His atheism and profound opposition to all religions was in direct echo of Proudhon's famous saying: "Man is destined to live without religion." In 1871 Pissarro had married his long-time companion, Julie, who had been a Catholic, at the City Hall of Croydon.[2] All their children were brought up as atheists.

Pissarro's opposition to religion reached a climax twenty years later, in 1892, when Lucien decided to marry Esther Bensusan, the daughter of an Orthodox Jew. Her family asked Lucien, an atheist and anarchist himself, to be circumcised and to convert to Judaism. Lucien called upon his father for help; Pissarro offered to go to London to resolve "this complicated matter of religious foolishness."[3] Pissarro had warned Lucien in an earlier letter that he feared that Bensusan's father would demand "that you be baptized or, rather, be initiated into the Jewish religion."[4] Thus, Pissarro here linked Christianity and Judaism, with equal contempt. In another letter, Pissarro is even more vehement: "What can one do, for I do not think that you will accept such a stupid and false arrangement? . . . It seems to me that this is impossible; he is the one who has to give in. This is too stupid."[5] Lucien and Esther were married finally without her father's blessing, though ultimately he was reconciled with them. Pissarro's undying opposition to any form of religion was rooted in his belief that religion consisted of a stultifying mass of myths and illusions destined to lead people's minds away from the real questions—whether ethical, political, or aesthetic.

Pissarro led his life, on all counts (personal, political, ideological, religious) with the same passionate distaste for conventions and dogmas as he followed in his art. "I shock people too much, I break with all ingrained habits,"[6] Pissarro wrote. In all his actions Pissarro showed a sustained strength of opposition to every sort of conformism and received ideas.

Yet one would be foolish to attempt to read his art as an illustration of or documentary testimony to his convictions. His art proceeded autonomously from his life, and one cannot discern any echo or trace of his antireligious radicalism or of his anarchism in the well-ordered, immaculately luminous, thickly impastoed composition *Kew Gardens: Path Between the Pond and the Palm House* (fig. 277), for instance—or indeed in any of his other London compositions throughout the 1890s. But examining Pissarro's London works in particular should enable one to discern the mode of existence of a different type of truth—not ordinary logical truth, a truth to reality, a truth to one's feelings or ideas, for instance, whereby the reality depicted

permeates by means of a given language, unhindered. Instead, the sort of truth that animates Pissarro's London work is of a poetical order; it cannot be said to be false or inaccurate, because it is total.[7] It involves a whole different array of concerns which he experiments with in fresh ways. They have to do with oscillations between intention and reflection, visual sensation and memory, presence and absence, thought and touch, eye and hand, chance and method.

Kensington Gardens, London (fig. 291) embodies these paradoxes. It depicts a precisely identifiable scene in London, the east facade of Kensington Palace (the old iron park bench on which two ladies are seated has since been replaced by a modern one); the spire seen at left is of Saint Mary Abbots Church, at a distance on Kensington Church Street. The place where Pissarro sat can be located exactly.[8] Yet this topographical precision does not begin to account for what goes on in this work. One vividly senses Pissarro's fresh memories of Seurat's work behind all—in particular, in the chromatic opposition between the yellow-green and crimson-mauve-purple that dictated the basis of Pissarro's palette harmonies and contrasts until 1893. Yet again, there is a great deal more to this work; hesitations, *pentimenti, repentirs*, lines over paint, paint over lines, and an unbelievable accumulation of heterogeneous touches and dots form this work fundamentally resistant to any given formula. How to interpret the ghostly spire of Saint Mary Abbots, inserted within the trembling crust of chalklike paint that forms the sky? What is striking and strange within this work is the uncoordinated disunited complexion of the painterly surface. The sense of oddity is reinforced by the unrelated, unresolved proportions of the figures, seen in perspective. This painting—executed probably after a preparatory watercolor— escapes all categorization. Neither a cityscape, nor a landscape, neither a painting of figures, nor a painting without figures, neither a Neo-Impressionist painting, nor a painting that has lost all traces of Neo-Impressionism, it reveals perhaps best the plastic virtualities that the artist set in front of himself and with which he played.

These London paintings in fact have an important place within Pissarro's development in the 1890s. They occur at the confluence of the various imaginary and plastic forces evident throughout this decade. To gauge the sheer technical transformations his work experienced, juxtapose, for instance, a canvas of 1890, such as *Kensington Gardens, London* (fig. 291)—or even more tellingly *The Serpentine, Hyde Park, Fog Effect* (fig. 285), more tributary to the Neo-Impressionist phase—with a work of 1892, such as *Kew Gardens: Path Between the Pond and the Palm House* (fig. 277), and a work of 1897, such as *View Across Stamford Brook Common* (fig. 286). Of course, it is noteworthy too that Pissarro's sustained interest in representations of bridges developed in London; both *Chelsea Bridge* (fig. 288) and *Charing Cross Bridge, London* (fig. 287) date from 1890. This had important echoes within his depictions of France—some of his most impressive series focus on the bridges of Rouen or those of Paris. And Monet by 1899 had tackled a series of London bridges that in some ways is reminiscent of Pissarro's work in that city ten years previous.

Rouen, Paris, Dieppe, Le Havre

The paintings that resulted from Pissarro's short succession of London sojourns in the early 1890s and his earlier visit to Rouen, in the autumn of 1883, provided

293

Vue de Rouen—Route de Bon Secours. 1883

Pencil and charcoal, 8⅞ x 11¼" (22.7 x 28.7 cm)
Musée du Louvre, Cabinet des Dessins
(Fonds du Musée d'Orsay)

294

L'Ile Lacroix in Rouen. 1883

Oil on canvas, 21 x 25¾" (54 x 66 cm)
Private collection (PV607)

Opposite:

295

Georges Seurat
La Maria, Honfleur. 1886

Oil on canvas, 20½ x 24¼" (52.5 x 63.5 cm)
Národni Galeri, Prague

296

The Quays at Rouen. 1883

Oil on canvas, 19⅝ x 25¼" (50.3 x 64.7 cm)
Courtauld Institute Galleries, London
(Courtauld Collection) (PV601)

250 · *Camille Pissarro*

strong indications that his interests were shifting towards a broader, more complex apprehension of the city and the rural world alike. In the event, these altered interests developed into his most systematic treatment of either world through the rigorous framework of a pictorial series.

The premises of Pissarro's visual and pictorial interest in Rouen as a source of motifs can be seen in a rather large charcoal drawing, inscribed "Vue de Rouen— Route de Bon Secours" (fig. 293). Rouen, a major Gothic city, with its many church spires and amazing architecture, had long attracted numerous artists—including the Englishmen Richard Parks Bonington and J. M. W. Turner. Pissarro shared his appreciation of the city's visual wealth with Monet, who had a brother living near Rouen, and who himself had executed a group of views of Rouen as early as 1872.[9] In a letter written to Lucien, October 22, 1883, Pissarro expressed the fascination exerted by Rouen on himself and Monet: "Yesterday I was paid a visit by Monet, his brother and his son, Durand-Ruel and his son. We spent the day together in Déville, on a high hill. There we saw the most splendid landscape that a painter could ever dream of: a view of Rouen, in the distance, with the Seine flowing, unfolding, as calm as a mirror, sunny slopes, splendid foregrounds: it was magical. No doubt, I will go back to this village to paint there: it is marvellous."[10]

There is no record showing that Pissarro ever painted in Déville. However, he brought back from Rouen two sets of works that can rightly be considered direct precedents for his series to come. The first set consisted of thirteen oil paintings, including: *L'Ile Lacroix in Rouen* (fig. 294); two paintings of the quays of the harbor; two paintings of the Cours-la-Reine,[11] which in turn most certainly had some impact on Seurat a couple of years later, as in his *La Maria, Honfleur* (fig. 295); three paintings of a street and bridge junction near the Seine, among them *The Quays at Rouen* (fig. 296). The second set consisted of prints depicting through various states the banks of the Seine and the narrow medieval streets of the old district of the city, for example, *Le Port près de la Douane, à Rouen* (fig. 297) and *View of Rouen (Cours-la-Reine)* (fig. 298). In other words, with the exception of one painting showing the cathedral at a distance, Pissarro executed works that all related to other works with regard to the motif: the concept of the series was being born. A letter Pissarro wrote to his son Lucien offers a clear image of what this concept involves technically and practically:

> I know myself the difficulty or rather the difficulties that beset one unexpectedly when working outdoors. Here the weather is always changing, it is very discouraging. I have started work on nine canvases, all more or less advanced. The day after your departure I started on a new painting at Le-Cours-la-Reine [*View of Rouen (Cours-la-Reine)* (fig. 298)], in the afternoon in a glow of sun, and another in the morning by the water by Saint-Paul's Church. These two canvases are fairly well advanced, but I still need one session in fine weather without too much mist to give them a little firmness. Until now I have not been able to find the effect I want. I have even been forced to change the effect of fog, another, same effect, from my window, the same motif in the rain [*Place de la République in Rouen* (PV 608, not illustrated)], several sketches in oils done on quays near the boats; the next day it was impossible to go on, everything was confused, the motifs no longer existed; one has to realize them in a single session. . . . I work at my windows on rainy days; these may well turn out to be my best pictures. With all of this no sale so far. It is starting to rain, I run to my window.[12]

The specific components of Pissarro's later series are here succinctly couched on paper; they were subsequently developed into more systematic, cohesive, intense groups of works. When he returned to Rouen thirteen years later, twice in 1896, and again in 1898, with clear intention of developing new series, he reduced the number of motifs to two: the bridges and the harbors (and the cathedral, of which he painted three canvases). Reducing the number of subjects gave him far more scope for play within each canvas. This is illustrated stunningly when one views in juxtaposition *The Boïeldieu Bridge at Rouen, Misty Weather* (fig. 299), *The Boïeldieu Bridge at Rouen, Sunset* (fig. 300), and *View of Rouen, Saint-Sever, Morning* (fig. 301). In the first two, among sixteen works focusing on the Rouen bridges, Pissarro did not depict anything particular; rather, each picture contains a configuration of several themes that are given more or less emphasis in the various works. Selected compositional procedures reinforce a given aspect. The differing factors are the time and weather (which are the absolute core principle of Impressionist series works). *The Boïeldieu Bridge at Rouen, Misty Weather* represents an effect after rain. What matters is not so much the sky as the wetness of fallen rain, which he rendered by painting wet on wet so that colors dissolve into each other, losing their distinction and tending to reflect or overlap. In *The Boïeldieu Bridge at Rouen, Sunset* the sky/sunset effect matters most; its coloring transfuses the whole reality. Inevitably, the Seine plays the part of a distorting, slowly moving, and fragmented mirror, an indicator of the surrounding atmosphere and the sky.

The spectacular structure sky-atmosphere-river is a constant within all the Rouen series, and directly recalls the sentence written by Pissarro in 1883 describing the Seine as "unfolding, as calm as a mirror." This peculiar reflexive structure is then combined with another system of forces that are powerfully integrated within the

Opposite:

298

View of Rouen (Cours-la-Reine). 1883

Oil on canvas, 21½ x 25¼" (55 x 65 cm)
Private collection (PV602)

299

The Boïeldieu Bridge at Rouen. Misty Weather.
1896

Oil on canvas, 28¼ x 35⅝" (73.7 x 91.4 cm)
Art Gallery of Ontario. Toronto. Gift of Reuben
Wells Leonard Estate, 1937 (PV948)

300

The Boïeldieu Bridge at Rouen. Sunset. 1896

Oil on canvas, 28½ x 36" (73.1 x 92 cm)
By permission of the Birmingham Museums and
Art Gallery. England (PV952)

301

View of Rouen. Saint-Sever. Morning. 1898

Oil on canvas, 25 x 31¼" (63.5 x 79.4 cm)
Honolulu Academy of Arts, Gift of Mrs. Charles
M. Cooke (4110) (PV1049)

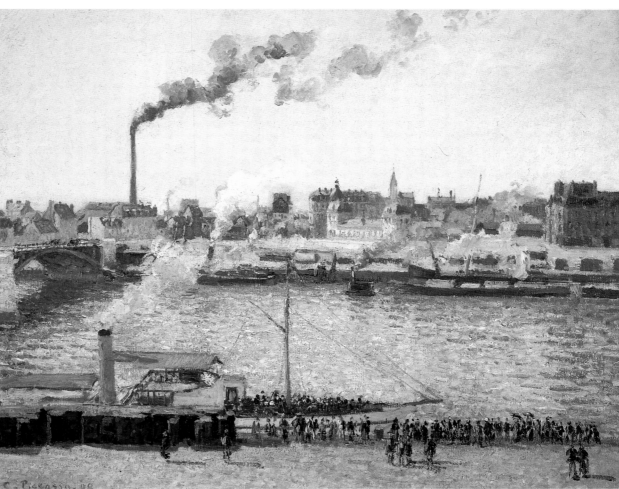

whole to produce a distinct poem, or canvas: the bridge, which cuts across the Seine diagonally, forming an **X** with the river; the architecture, seen on either or both banks (in the sunset painting, the near bank, where the artist had placed himself, has been omitted); the human and horsecarriage traffic filling the bridge; the boat traffic, its loading and unloading (absent also from the sunset picture) are parallel to the bank and crossing under the bridge; the smokestacks of boats and trains poking into the sky and spurting out their puffs of smoke or rolls of steam, interfering with and dissolving into the atmosphere.

There is something colossal and ample, and at the same time, fine and almost fragile about these Rouen series works. They bring to mind the definition Flaubert, who was born in Rouen, once gave of "the great, the rare, the true artists": those who "summarize humanity; with no concern for themselves, or for their own passions, discarding their personality in order to absorb themselves into the others: they reproduce the universe which reflects itself in their works, glittering, varied, manifold, as a whole sky which casts its reflection in the sea with all its stars and all its azure."[13]

Another aspect of Pissarro's series work recalls even more essentially his undying admiration for Flaubert: his deliberate choice of "simple," inconspicuous, and unconventional subject matter. As Flaubert wrote to Huysmans in 1874: "Art is not reality. Whatever one does, one immediately has to select among the elements that it provides."[14] Pissarro's series paintings follow this principle to the extreme. If one looks at the passage from the misty weather scene to the sunset, and then to *View of Rouen, Saint-Sever, Morning* (fig. 301), painted two years later, what seems to matter most is not that all three paintings represent the Gare d'Orléans seen across the Seine, but more poignantly the shift from sunset/mist/industrial smoke to a "wet weather" effect, duplicating the mirroring effect in the later work. Furthermore, what matters is not so much the station itself as the system in which it functions, of which it is inextricably part.

Analogously, almost every component of each series painting seems to be called for by an inner necessity. The pictorial cohesion is so intense and so solid that it is unimaginable to withdraw any of the components (be it frail horizontal shadows of the few individuals in the foreground of *View of Rouen, Saint-Sever, Morning* or the thin threads of cable attached to the mast for the sailboat) as it is to imagine the Boïeldieu Bridge, in reality, without one of its arches. By shifting his vantage point, right, left, center, by focusing his pictorial attention more on the sky, or more on the bridge, on the traffic, on one bank or the opposite or both, Pissarro heightened the importance of the *selecting* process that presides over the making of any work of art, and in turn its importance for his compositional methods. Pissarro's attitude toward his subject matter within the series corroborates the fundamental principle that "art is not reality." His choice of subjects (in three out of four cities) reflects what could be called the dialectic of the wallflower and the rose: in his letter to Huysmans, Flaubert also wrote, "Neither wallflowers nor roses are interesting in themselves. The only interesting thing is the manner of painting them."

Pissarro likewise was highly aware of the "signification"—or of the "connotations"—of choosing to paint a brand-new train station or an industrial zone, with all the jazz of their ceaseless activities and their burning of energy. It was bound to be criticized as vulgar, prosaic, or at best, banal—choosing to describe a wallflower

rather than a rose. Pissarro mocked the art critic Gabriel Mourey in explaining his choice of subject:

> I am working on ten pictures at once . . . every kind of effect. I have a motif which should be the despair of poor Mourey: just conceive the new district of Saint-Sever, right opposite my window, with the ghastly Gare d'Orléans brand new and shiny, and a whole lot of smokestacks, some enormous, some tiny, with a proud parading look. In the foreground, boats and water; to the left of the station, the working-class district which runs along the quays down to the iron bridge, the Boïeldieu Bridge; this is the morning with a delicate, misty sun. Well, then! that fool Mourey is dense to think that this is banal and commonplace, it is as beautiful as Venice, my dear, it has extraordinary character, and truly, it is beautiful! It is art seen through our sensations. There is not only this motif, there are wonderful things left and right.[15]

This letter is crucial for an understanding of Pissarro's own conception of the series. The reference to Flaubert and particularly to the opposition to what Flaubert termed "the aristocracy of the subject matter" is all the more pertinent as, in the same letter, Pissarro cynically refers to the person whom Flaubert wrote in 1874—Huysmans. In Pissarro's own terms, this opposition to grand subjects takes the form within his series of a dialectic between the "ghastly" and the "marvelous," the wallflower and the rose, the ugly and the beautiful. Close reading reveals Pissarro's surreptitious and sudden shift in this revealing letter from a description of what he saw from his window to what he called "art"—art "seen through our *sensations*." And it is that that makes this "ghastly" railway station "beautiful." Pissarro here used the first person plural, not as a regal "we," but because he encompassed Lucien, and others who shared the same aesthetic stance, as artists too.

If Pissarro had looked at the same motif as an object of sociological investigation—and he also happened to be very interested in sociology—it would of course immediately lose its "extraordinary character," its beauty and its art. Pissarro's strength and intelligence was that he was capable of reading sociological treatises at night and of painting by day, and retaining complete autonomy in both activities. Indeed, art is not sociology and sociology is not art. Pissarro carefully distinguished the two, preventing a confusing and confused amalgamation of separate activities. Politicizing of Pissarro's artistic work is therefore inappropriate. His perpetual personal search for freedom—he has stressed that personal *sensations* filter reality before it can come out—is mirrored in his further definition of *sensation* in a letter: "Work, research, and do not look with alien concerns, and it will come. What you need is persistence, will-power, and free sensations—stripped of everything other than one's own sensation."[16]

The definition of the *sensation* leads to a tautology and a paradox: a sensation is by essence free, insofar as it is nothing but itself; however, one does not reach this free *sensation* without effort.[17] It is the result of a long, painful struggle, perseverance, and discipline. It is not the disheveled, trivialized romantic freedom to do anything and feel anything in wild excitement. It is the freedom to impose on oneself one's own law, one's own regulations or limitations, one's own pictorial reflection, and one's own process of selection. This is, strictly speaking, the definition of autonomy (giving oneself one's own law)—a concept absolutely central to anarchy. This makes it possible to understand more fully the dialectics of Pissarro's subject matter. Since his

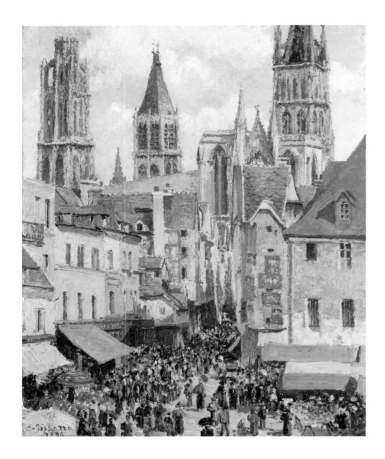

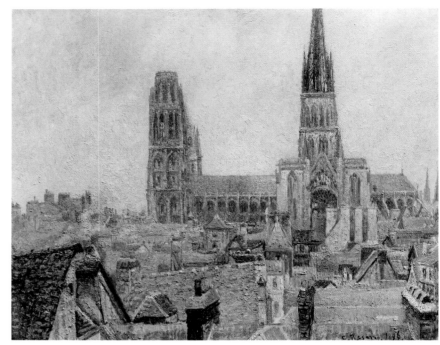

302

La Rue de l'Epicerie, Rouen. 1898

Oil on canvas, 32 x 25⅝" (82 x 65.7 cm)
The Metropolitan Museum of Art, New York.
Purchase. Mr. and Mrs. Richard J. Bernhard
Gift, 1960 (PV 1036)

303

*The Roofs of Old Rouen. Gray Weather
(La Cathédrale).* 1896

Oil on canvas, 28½ x 36" (73.1 x 92 cm)
The Toledo Museum of Art, Toledo, Ohio
Gift of Edward Drummond Libbey (PV973)

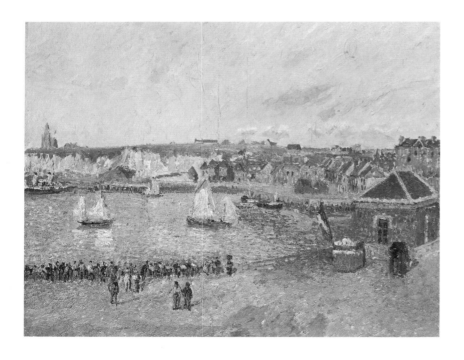

304

*L'Avant-port de Dieppe
(Inner Harbor of Dieppe).* 1902

Oil on canvas, 21 x 25¼" (54 x 65 cm)
Musée de Dieppe (PV 1247)

305

*La Foire autour de l'église Saint-Jacques. Dieppe
(The Fair at the Church of Saint-Jacques. Dieppe).* 1901

Oil on canvas, 28¾ x 36" (73 x 92 cm)
Private collection (PV 1197)

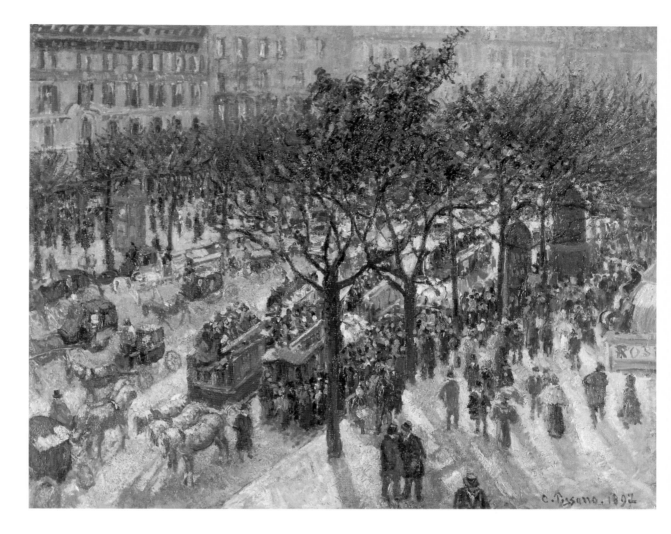

306

Boulevard des Italiens, Afternoon. 1897

Oil on canvas, 28¼ x 36" (73 x 92 cm)
Private collection (PV999)

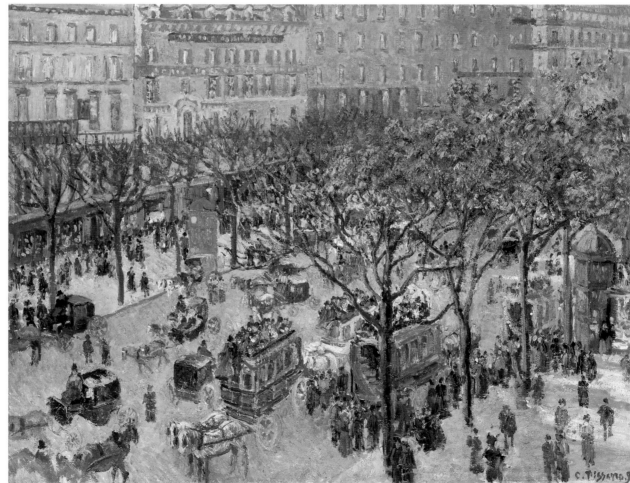

307

Boulevard des Italiens, Morning, Sunlight. 1897

Oil on canvas, 28⅞ x 36¼" (73.2 x 92.1 cm)
National Gallery of Art, Washington, D.C.
Chester Dale Collection (PV1000)

sensations are hindered by no rule but their own, they are "free" to wander from one motif to another, from left to right, from the ghastly to the beautiful, from the banal to the sublime. The free *sensation* can be rightly compared to the nerve center of Pissarro's descriptive system throughout his series. Thus we see various bridges studied from different angles, as the artist shifted his vantage point or shifted from bottom to top of the traditional scale of subject matter. So each series in a way carries elements of this dialectic of the "ghastly" and the "extraordinary," the "banal" and the "beautiful."

In Rouen, as soon as Pissarro turned his attention away from the bridges and harbors, he executed a series of prints of the old Gothic center of Rouen, and painted the cathedral: *La Rue de l'Epicerie, Rouen* (fig. 302) and *The Roofs of Old Rouen, Gray Weather (La Cathédrale)* (fig. 303). Both sources of motifs are regarded as equivalent pictorial subjects; this paradox throughout Pissarro's urban work did not escape contemporary critics' attention. They were certainly far from sympathetic to his raw representation of urban themes. P. G. Hamerton, a critic in England, wrote in 1891 about some of Pissarro's earlier Rouen pictures:

> It seems to me that he admits lines and masses that a stricter taste would alter or avoid, and that he includes objects that a more scrupulous artist would reject. . . . He does not seem to care whether the line of shore is beautiful or not, and he has so little objection to ugly objects that in one of his pictures the tower of a distant cathedral is nearly obliterated by a long chimney and the smoke that issues from it . . . just as they might present themselves in a photograph. By this needless degree of fidelity, M. Pissarro loses one of the great advantages of painting.[18]

Startling contrasts abound in the Rouen work and within individual pieces: Pissarro's cathedrals are rooted in the milling activity of the street market and colorful store canopies, such as are to be seen in *La Rue de l'Epicerie*; or the roof of the cathedral is represented contiguously and in relation to other roofs. How far we are here from Monet's ethereal cathedral, ascending and disappearing into the sky or dissolving into its atmospheric envelope. Here again, Pissarro seemed to know exactly what he was achieving: "Just imagine: the whole of old Rouen seen above roofs, with the cathedral, Saint-Ouen Church, and fantastic gables, really amazing turrets. Can you picture a large canvas filled with ancient, gray, worm-eaten roofs? It is extraordinary."[19] This contrast is unthinkable in Monet's terms.

Further contrasts can be found in the Dieppe series, which date from 1901 and 1902. There Pissarro concentrated his efforts on the one hand on representing the hustle and bustle of the harbor, of which he executed twelve canvases, including *L'Avant-port de Dieppe* (fig. 304), and on the other in representing the church of Saint-Jacques, a series of nine canvases, including *La Foire autour de l'église Saint-Jacques, Dieppe* (fig. 305), which was plotted in the milling crowds of a hectic market day.

Throughout the Paris series analogous contrasts can be observed between the new areas of Paris, recently transformed by the popular boulevards designed by Baron Hausmann, and the landmarks of the city's permanent history, its traditional cultural foundations. For the social and economic new classes, there were *Boulevard Montmartre, Spring* (fig. 308), two canvases of the Boulevard des Italiens (figs. 306

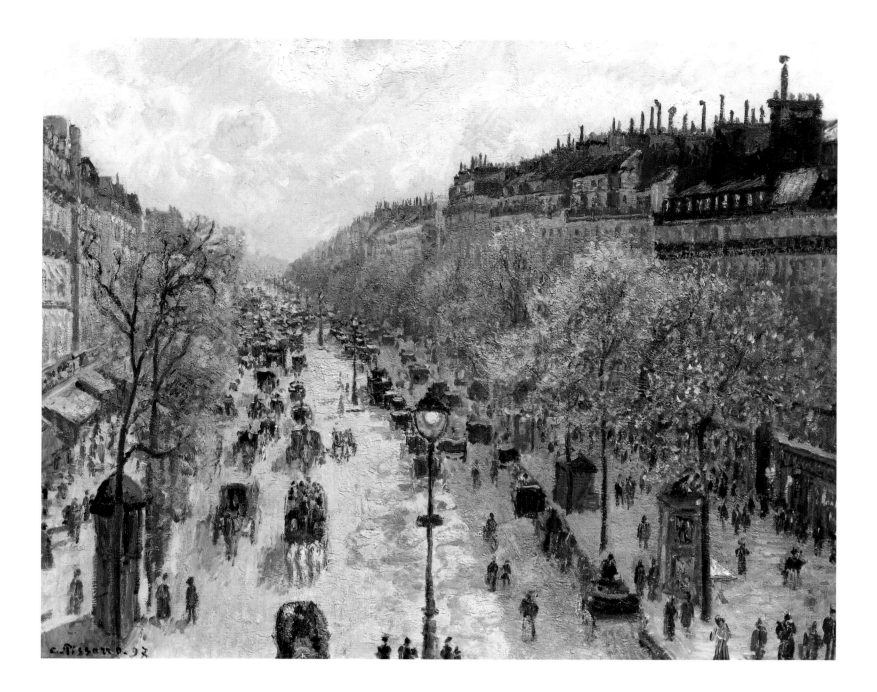

308

Boulevard Montmartre, Spring. 1897

Oil on canvas, 25¼ x 31½" (65 x 81 cm)
Private collection, New York (PV991)

and 307)—which incidentally recall one of Pissarro's earliest views of a Paris boule-
vard, the 1880 *Boulevard de Clichy, Winter, Sunlight Effect* (fig. 309)—and his
Avenue de l'Opéra (fig. 310) and *La Place du Théâtre Français* (fig. 311).[20] Opposing
these emblems of newness were *Jardin du Louvre, Morning, Gray Weather* (fig. 312),
Le Jardin du Carrousel (fig. 313), *The Pont Neuf: A Winter Morning* (fig. 314). In the
Avenue de l'Opéra and the Boulevard Montmartre series, Pissarro chose these
symptoms of the grandiloquence of France's Second Empire as a backdrop to his
study of the weight of the rain on the cobbles, of the various traffic effects, and their
intertwined friezes of motifs.

In a way similar to his treatment of the four seasons, Pissarro here ensured that
his many depictions of a motif would be free of any metaphysical content. Far from
inspiring love, beautiful nature, enchantment, charm, the Good, women, and roses,
Pissarro's views of the Boulevard Montmartre and of the Avenue de l'Opéra harbor
no hint of sentimentality; no trace of any morals, no narratives, no sociological

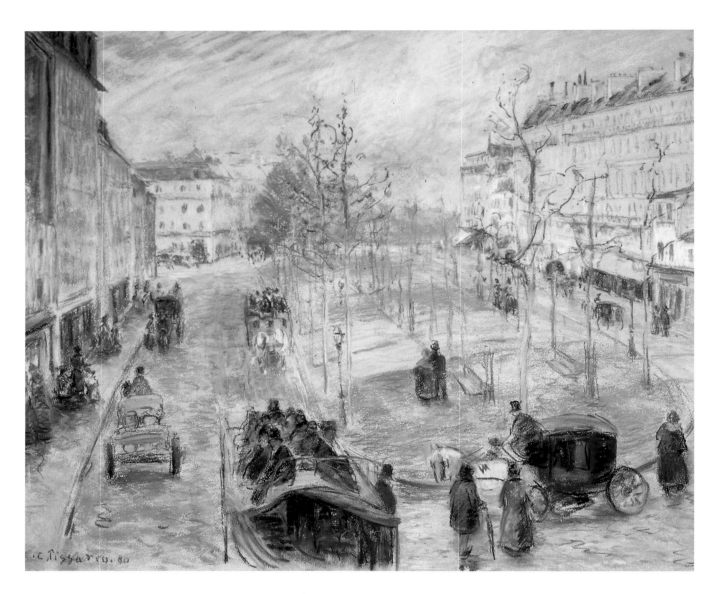

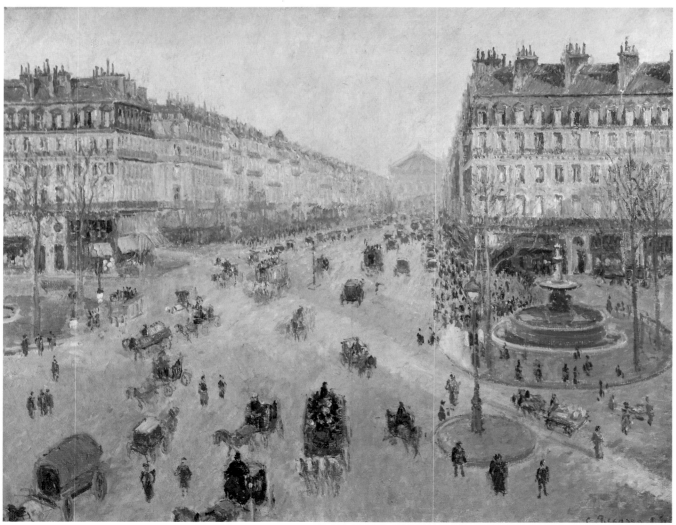

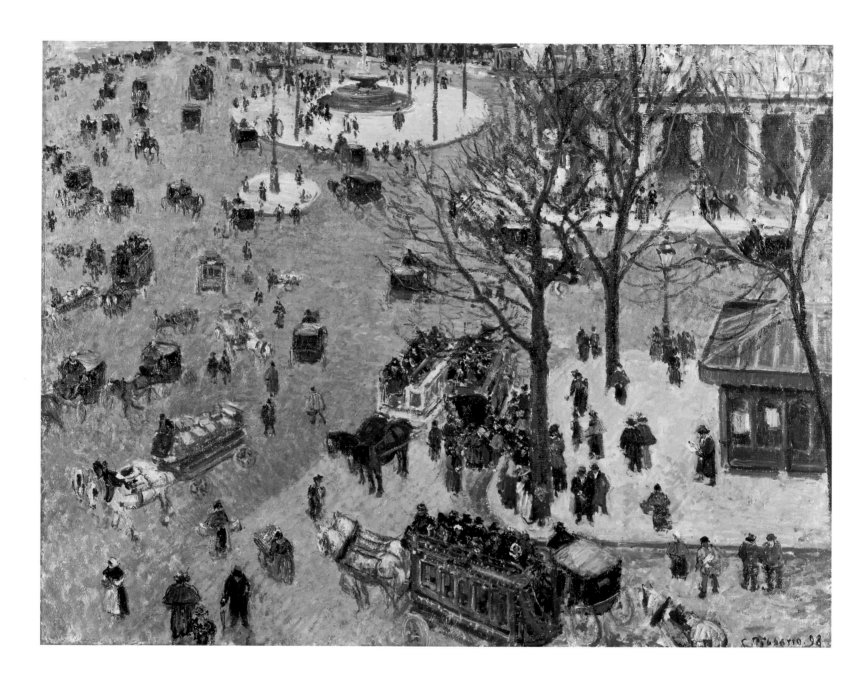

311

La Place du Théâtre Français. 1898

Oil on canvas. 28½ x 36½" (73.1 x 93.6 cm)
Los Angeles County Museum of Art, Mr. and
Mrs. George Gard de Sylva Collection (PV 1031)

309

Boulevard de Clichy. Winter. Sunlight Effect.
1880

Pastel. 23½ x 29½" (60 x 75 cm)
Private collection (PV 1545)

310

L'Avenue de l'Opéra. 1898

Oil on canvas. 25¼ x 31½" (65 x 81 cm)
Musée des Beaux-Arts, Reims (PV 1024)

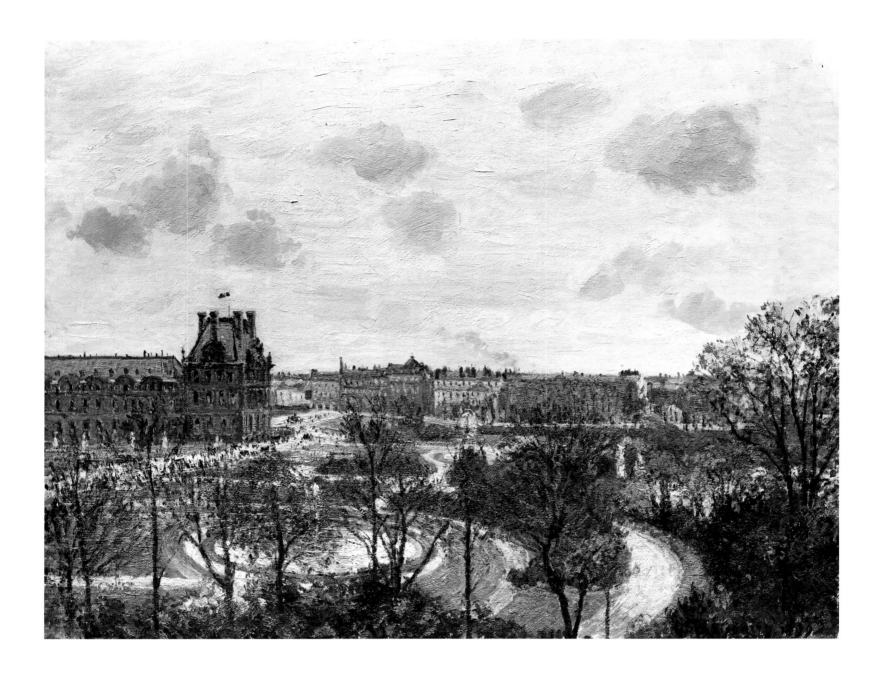

312

Jardin du Louvre, Morning, Gray Weather. 1899

Oil on canvas, 28¾ x 36" (73 x 92 cm)
Private collection, New York (PV 1107)

evidence is to be found there either. Nor any hierarchy of subjects—whether Pissarro sets his mind on depicting the Jardin du Louvre on a morning in gray weather or decides to focus on the extension of the Tuileries Gardens, the Jardin du Carrousel, on an autumn morning, or whether radically shifting his viewpoint, moving his easel to the Ile de la Cité, sitting between the two banks of the Seine, he may either focus on the huge facade of the Louvre seen at a distance alongside the Seine (*The Louvre, Morning, Sun* [PV 1159, not illustrated]), or gently shifting to his left, he may then focus on the statue of Henri IV.

In his Paris series, as almost everywhere else in his pictorial career, Pissarro continually alternated his vantage points, now standing back, looking at the distant Louvre or Institut de France (the bastions and symbols of the perpetuation of art tradition), which he depicted purely as components of a pictorial-descriptive system. In *The Pont Neuf: A Winter Morning* (fig. 314), for instance, the system is constructed around an essentially two-tone opposition between the complementaries orange and blue, which through their many shades, going from a cold pale bluish-gray to fiery

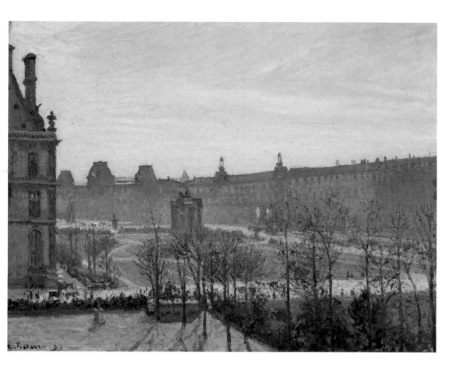

313

Le Jardin du Carrousel. 1899

Oil on canvas, 28¾ x 36" (73 x 92 cm)
Private collection, London (PV 1110)

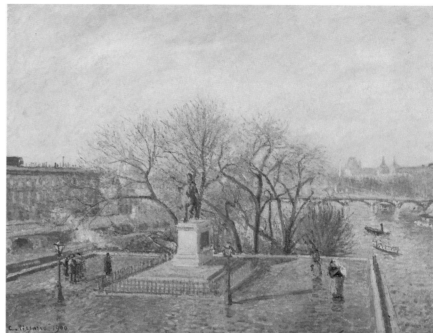

314

The Pont Neuf: A Winter Morning. 1900

Oil on canvas, 28¾ x 36½" (73 x 93.6 cm)
Krannert Art Museum, University of Illinois at
Urbana-Champaign (PV 1155)

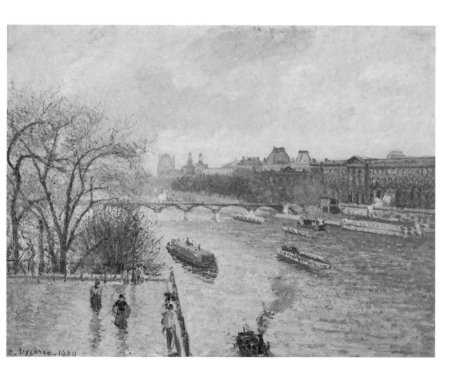

315

The Louvre, Afternoon, Rainy Weather. 1900

Oil on canvas, 25¼ x 31½" (65 x 81 cm)
Corcoran Gallery, Washington, D.C. (PV 1157)

316

*L'Avant-port et Anse des pilotes, Le Havre
(Inner Harbor and Pilots' Jetty, Le Havre).* 1903

Oil on canvas, 6⅝ x 8⅜" (17 x 21 cm)
Gallery Art Point, Tokyo (PV 1313)

siennas, organize the whole picture. This simple opposition conveys several contrasts: between the amber rays of sun on a short mild autumn afternoon[21] and the bluish-gray shadows, between the sun-drenched rust-colored foliage of the trees (center midground and right background and in the row of trees along the Seine) and the colder, vertical surfaces and the slate roofs of the architectural units (the Hôtel des Monnaies and the Institut, left, and the Louvre roofs, right). The sky and the river, as in the Rouen series, tend frequently to echo each other, and both, to various extents, carry the dual contrast of blue and orange, warmth and cold; the colors of the equinox, the transient, fleeting passage between the last warm days of summer and the cold of winter. Even the few human figures and barges seem to echo this two-tone opposition, so that there is no dissonance in this wholly cohesive composition, itself a link within the chain of this series, which contains over forty works.

The Louvre, Afternoon, Rainy Weather (fig. 315), on the other hand, presents a much more homogenized, if complex, palette, made up of very different subtle gradations of muted hues, going from a light mauve-gray to an ocher-red with pink undertones in the foliage. These different shades are for the most part amalgamated or applied over each other as huge slabs of wet-on-wet paint, producing a nearly mauve or ruddy grisaille, as can be observed in the sky and on the water's surface. This·technical solution conveys the pervasive dampness of the air, as well as the heavy wet atmosphere that blurs the definitions of things.

The Le Havre series, executed in 1903, the year of Pissarro's death, demonstrates the extent to which he was capable of experimenting with new pictorial parameters—for instance, although structurally quite close to the Dieppe harbor series, e.g., *L'Avant-port de Dieppe* (fig. 304), *L'Avant-port et Anse des pilotes, Le Havre* (fig. 316) displays remarkable mastery. Composing as if for a piece of scenography (in the way sails are displayed, gliding through the confined water-space stage of the approach), he used the horizontal succession of tall, bizarre sails, floating alongside the jetty, with their lofty fragility, to contrast with the row of human figures—represented here with elementary dots and tiny strokes of paint. Although comma-like brushstrokes in black animate the rhythm of the jetty, they are so minuscule that at first glance one can easily miss them. The composition is about something else. The scene observed is bigger than the observer. It is about this gigantic, yet frail iron lamppost at the center of the composition, among the scanning rhythms of the gliding sails, and countering the advertising kiosk-*pissoir* (a recurrent image within Pissarro's series, see figs. 306–8). Although the Le Havre harbor series appears the least urban of all—no architecture (besides the jetty) is to be seen and the crowd is reduced to a minimal scale—this painting and its counterparts summarize Pissarro's visual and representational experiences of cities in general. In this modestly sized work, the point is the loss of quantifying—humans are represented by a dot while these vast sails, which play the main part within the picture, seem no more than average in size. In comparison to the iron lamppost, they are small; in comparison to the kiosk, they are buoyant. The lofty lamppost, also given prominence in the other works such as *Boulevard Montmartre, Spring* (fig. 308), indicates that movement and time throughout the cities of *fin de siècle* France are ceaseless: one movement is followed by another; one flux of crowds begets another; sailboats queue behind each other; daylight precedes and succeeds electric light. *L'Avant-port et Anse des pilotes,*

like perhaps all Pissarro's series work, is about the organization, the institutions, and the imagination of cities. Everything is in movement; no need to go to the opera, or to the brothel. The cities in Pissarro's series works display themselves as transient spectacles. In this sense, the columnar kiosk acts as a synecdoche for the whole: it indicates what's on now. Tomorrow, next week, different posters will announce new entertainments. The weather, the sea, the crowds, the boats, the light, the vegetation will all have changed too.

Pissarro's series are not only about these changes; they are these changes. These changes—now pictorial or technical, now representational—make these works exist.

Interiors: Still Lifes, Portraits

S *till Lifes*

From the mid-1860s to the early 1880s, Pissarro was interested in the visual tensions and polarities offered by the semirural landscape of Pontoise. From the 1880s onwards his work seemed to follow three main directions: showing a renewed interest in figure paintings and a widening concern with both the imagery of rural land and that of urban districts; all three groups of works were conceived in series.

Still another aspect of Pissarro's work and imagination is that of the intimate Pissarro and his exploration of interior scenes. And within that framework, the still lifes he painted over a period of more than thirty years offer a condensed and evocative vision of the complexity of the issues with which he was dealing. It is difficult to believe that the same artist executed *Still Life* (fig. 318) in 1867, about three to six years later[1] *Bouquet of Flowers: Chrysanthemums in a China Vase* (fig. 317), and *Bouquet of Flowers: Irises, Poppies and Blossoming Cabbage* (fig. 319) in 1898.

Still Life, the 1867 work, was among his first still lifes. Painted a little over a decade after his arrival in France, it indicates the mastery that he had reached as a painter by that time (the same year that, for instance, he executed his phenomenal group of views of L'Hermitage). *Still Life* is about matter. The composition is simple, deliberately frugal, almost austere in its succession of horizontal planes of ocher, siennas, off-white, and black and white. The background is plain and conventional. As matter, the paint, however, is glowing, thick, and succulent, whetting one's visual appetite, and the work bridges the gap between the realms of two senses, the tactile and the gustatory. This painting is about plenitude and simplicity, and it announces an aesthetic, almost ethical problem: Of what does simplicity consist? Pissarro would spend his whole life trying to answer it. The paradox is that the answer is anything but simple.[2] It bears structural analogies with the task of medieval mysticism, which, as defined by Saint John of the Cross, consisted in "ascending the ladder of humility."

317

Bouquet of Flowers: Chrysanthemums in a China Vase. c. 1873

Oil on canvas, 23¾ x 19½" (61 x 50 cm)
The National Gallery of Ireland, Dublin (PV 102)

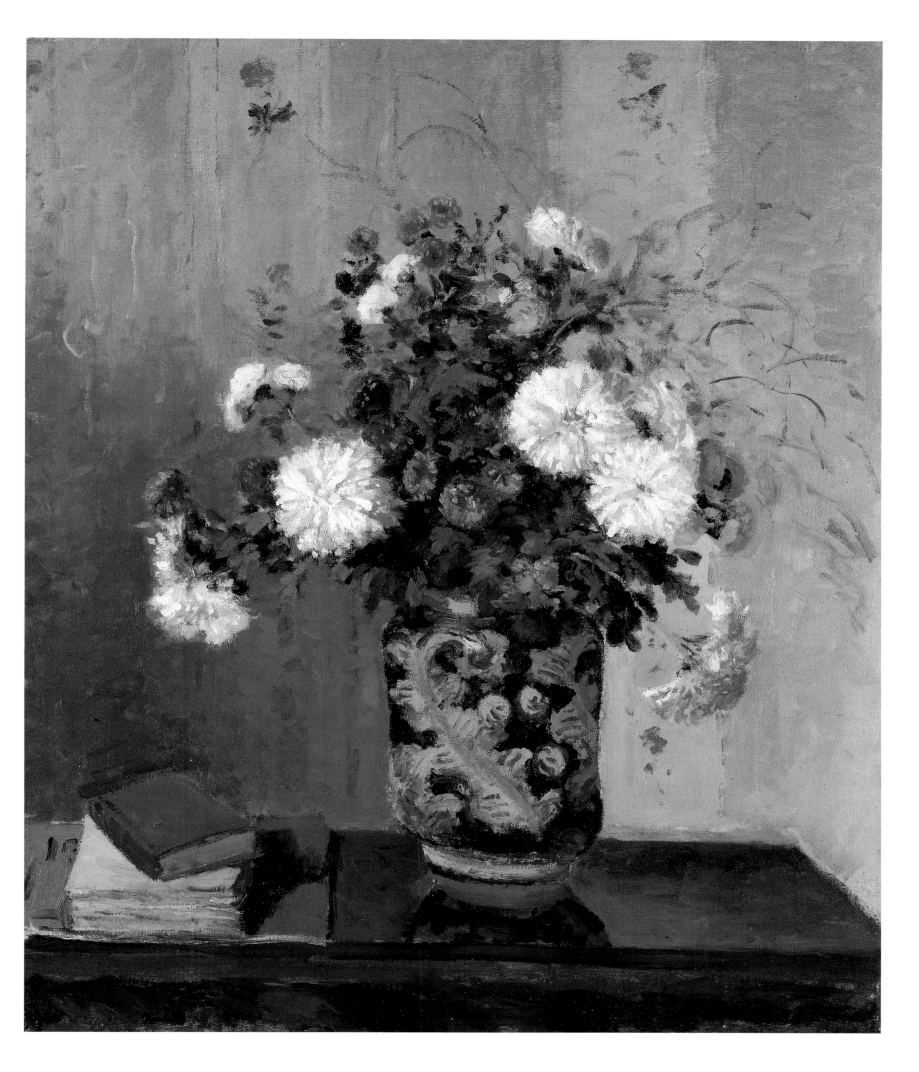

318
———
Still Life. 1867

Oil on canvas, 31⅞ x 39¼" (81.7 x 100.7 cm)
The Toledo Museum of Art, Toledo, Ohio
Gift of Edward Drummond Libbey (PV50)

319
———
Bouquet of Flowers: Irises, Poppies, and Blossoming Cabbage. 1898
———
Oil on canvas, 23¼ x 28¾" (60.3 x 73.7 cm)
Private collection, England (PV1063)

Saint John's problem might be simply put: how not to become proud of being humble? For humility may deliver a certain satisfaction, a certain pride, which is its exact opposite.

Pissarro's dialectic was no less easily resolvable: How to depict simplicity simply? The ordinary, elementary ingredients selected for this still life seem to convey a certain visual asceticism, a nearly monastic deprivation. This parsimony is, however, depicted with the most lavish, unctuous painterly surface. The size is equally impressive, and the way in which the elements are given volume is anything but simple; they are carved into the surface of the paint. Pissarro probably used the tip of the brush to dip into the impasto and form his objects, or he simply left the contours of the objects unpainted.[3]

Chrysanthemums in a China Vase (fig. 317) seems to be almost the exact opposite of *Still Life.* A vertical painting, it is probably one of the most ornate and sophisticated still lifes Pissarro ever painted. The highly polished table surface, the intricate pattern of the vase, the diverse and carefully selected bouquet, as well as the discreetly displayed book make this work an urbane and urban still life. It is in direct contrast not only with the sensual coarseness of the earlier painting but also with the more "simple" unadorned still lifes, executed at the same period. Other paintings display the same wallpaper as *Portrait de C. Pissarro* (fig. 326). Objects there are unglazed, earthy—more elementary. The main contents of the still life have shifted from flowers (an ornament) to fruit (a sustenance). Palette-knife work has been superseded in all three paintings by brushwork that displays suppleness and softly nuanced gradations of tone (what Pissarro called the "qualité grise et fine" [the refined grayness] in referring to some other of his paintings in the same year).[4] In addition, they address such compositional issues as orthogonal oppositions (horizontals-verticals), reinforced by the diagonal of the knife, as in *Still Life with Apples* (fig. 320), and by the sharply ironed folds of the tablecloth, as in *Still Life: Apples and Pears in a Round Basket* (fig. 321). They also have to do with masses, weights (the weights of the pears tilting against the lighter wicker basket), roundness and swelling volumes (natural or handmade), and with the juxtaposition of different types of painted motifs. Three are to be found in the *Still Life with Apples*: the wallpaper motif (flowers) that, although of a lighter shade, picks up the red of the apples; the painted motifs of the vase, a crown of flowers, whose vermilion and gold-yellow pick up the shades of the apples around the neck of the vase; and the abstract friezes on top of the vase and in its center. Paint here imitates paint; this is of course another motif, which unifies the other motifs into a whole painting and holds all the components together around the other, smaller still-life motifs, painted on the vase and the wallpaper and, of course, on the canvas. One cannot help being struck by Pissarro's brushstroke on the upper rim of the vase, which imitates—or stands for—another brushstroke, applied by an anonymous craftsman, on a simple piece of earthenware, with a slightly chipped, worn rim.

Pissarro continued to paint still lifes throughout his life. *Vase of Flowers* (fig. 322) executed around 1877–78, was perhaps done partly in response to Cézanne's first three still lifes exhibited at the Impressionist exhibition of 1877.[5] The earlier complex relationship between background and reality gives way in this painting to an intricate web of fragmented touches of color whose interrelations create organized pictorial chaos. The four elements of this composition—flowers, vase, background,

320

Still Life with Apples. c. 1872

Oil on canvas, 18 x 21⅞" (46 x 56 cm)
The Metropolitan Museum of Art,
New York (PV 195)

321

*Still Life: Apples and Pears in a Round
Basket.* 1872

Oil on canvas, 18 x 21¾" (46.2 x 55.8 cm)
The Henry and Rose Pearlman Foundation,
Inc., on loan to The Art Museum, Princeton
University (PV 194)

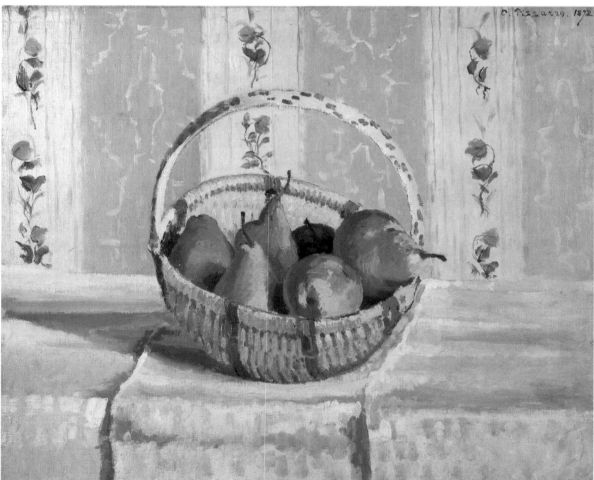

Opposite:

322

Vase of Flowers. c. 1877–78

Oil on canvas, 32 x 25½" (82 x 654 cm)
Collection Sara Lee Corporation,
Chicago (PV 467)

323

Bouquet of Flowers. 1900

Oil on canvas, 21 x 25¼" (54x65 cm)
Collection Mr. and Mrs. Joseph L. Mailman
(PV 1117)

table—all seem to drip onto and stain each other. The purple-blue of the vase is picked up by some flowers or leaves, which seem to leak their color onto the table. The background, with its vibrant fresco of vivid stains, pushes forward, absorbing the flowers, so that it becomes difficult to read which is at the right, for instance.

Toward the end of his life, Pissarro produced a small series of still lifes that to some extent radicalized certain of the concepts that he had experimented with in the 1870s, including *Bouquet of Flowers: Irises, Poppies, and Blossoming Cabbage* (fig. 319), *Still Life with Spanish Peppers* (fig. 325), and *Bouquet of Flowers* (fig. 323). *Still Life with Spanish Peppers* may perhaps be the least audacious of the three works, although the smooth, unctuous oil-paint surface of the green, yellow, and red peppers itself imitates the slick satiny sheen of the fruit. This painting is also about the way a familiar tone of green may suggest different objects (according to their shapes of course, but also according to where and how the reflections are displayed): glazed green pot, green-glass bottle neck, green peppers.

324

Henri Matisse
Red Studio. 1911

Oil on canvas, 71¼ x 86¼" (182.7 x 221.2 cm)
Collection, The Museum of Modern Art, New
York. Mrs. Simon Guggenheim Fund

The common denominator of these three paintings is the wallpaper: the ways in which its indescribable motif becomes integrated with its content, however, differ in each work. In *Still Life with Spanish Peppers,* the wallpaper echoes and is echoed by the rug. In *Bouquet of Flowers: Irises, Poppies, and Blossoming Cabbage,* fragments of the wallpaper's myriad leaflike motifs seem to be picked up by some of the leaves of flowers; and the leaves—both the decorative leaves on the wallpaper and the real/ painted leaves in the vase—seem to cast a shadow or project themselves onto the tablecloth. At the same time, they all echo each other, thus creating a pictorial buzz which animates the entire surface of the canvas. In *Bouquet of Flowers* things go wild; in a manner partly reminiscent of Cézanne's or Gauguin's still lifes the leaves become detached, going off from their own stems to associate themselves with the wall motif. Unlike Cézanne, though, Pissarro here differentiated the colors, so that the leaves of the still life remain green—almost; while the "leaves" of the wall composition are gray-mauve. The result is more readable, less confusing than in some of Cézanne's still lifes. In Pissarro's work the paint stops the confusion, while emphasizing the chasm between painting and reality. Equally, however, Pissarro's is less believable; in Cézanne's works each element can be identified as either still-life leaf or wallpaper leaf.

Pissarro's second son, Georges, was friendly in those years with a contemporary of his, Henri Matisse. *Bouquet of Flowers* was dated 1900. Issues that were going to be dealt with in Matisse's *Red Studio* (fig. 324) eleven years later were not altogether alien to Pissarro's late still lifes. Equally, one might say that these still lifes, be they Matisse's or Pissarro's, each in their own special idioms, verified once more the fact that "La beauté est toujours bizarre."

325

Still Life with Spanish Peppers. 1899

Oil on canvas, 21½ x 25¼" (55.1 x 66 cm)
Private collection, Texas (PV 1069)

326

Portrait de C. Pissarro. 1873

Oil on canvas, 21½ x 18" (55 x 46 cm)
Musée d'Orsay, Paris (PV200)

Portraits

As we saw in his peasant figure compositions, Pissarro was always wary of sentimentality, of having his figures "say" too much, horrified at "orange-blossom art which makes delicate women swoon," convinced as he was that "the art that is most corrupt is sentimental art."[6] As a result Pissarro scarcely developed the portrait genre, in which it is virtually impossible to ignore the expression, the "sentiments" of the sitter.

Pissarro, however, continually portrayed himself (figs. 326 and 338–40) and his close family in all media. In the 1860s he showed them in simple domestic situations, frequently, his wife nursing a baby. One can trace his first drawing of Julie and a baby to 1863 or 1865, *Mother and Child* (fig. 327), where the young Julie (born in 1838) is depicted in profile and looks down at her child—Lucien or Jeanne. There is also a wash over charcoal, *Maternity* (fig. 328), precisely dated "January 26, 1872," and therefore executed in Louveciennes, shortly after the end of the Franco-Prussian War. Georges, who was born November 22, 1871, was the fourth child to whom Julie

Opposite top:

327

Mother and Child. 1863 or 1865

Pencil on paper, 14½ x 10⅝" (37.1 x 27.3 cm)
Leslie J. Sacks and Joseph Wolpe Fine Art

328

Maternity. 1872

Wash over charcoal, 11¾ x 8⅞" (30.2 x 22.8 cm)
Private collection

Opposite bottom:

329

Nurse and Child. c.1881 or 1884

Ink over conté crayon, dimensions unknown
Private collection

330

Mother and Child. 1878

Pencil and charcoal, 11 x 14½" (28.2 x 37.2 cm)
Private collection, New York (study for PV 1325)

Above:

331

Mother and Child. 1878

Tempera and gouache, 31½ x 25¼" (81 x 65 cm)
Sotheby's, New York (PV 1325)

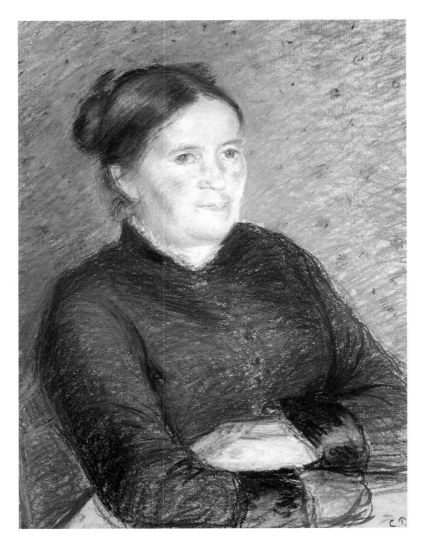

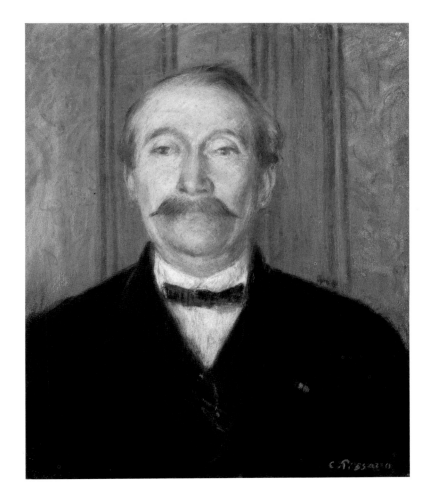

Opposite:

332

Portrait of Madame Pissarro. 1883

Pastel, 23¼ x 18¼" (61 x 47 cm)
Private collection (PV 1565)

333

Portrait of Félix Pissarro. 1881

Oil on canvas, 21½ x 18" (55 x 46 cm)
The Tate Gallery, London (PV 550)

334

Portrait of Cézanne. 1874

Oil on canvas, 28¾ x 23¼" (73 x 59.7 cm)
Collection Laurence Graff (PV 293)

335

*Route de Gisors: The House of Père Gallien.
Pontoise.* 1873

Oil on canvas, 16½ x 12¾" (42.3 x 32.7 cm)
Whereabouts unknown (PV 206)

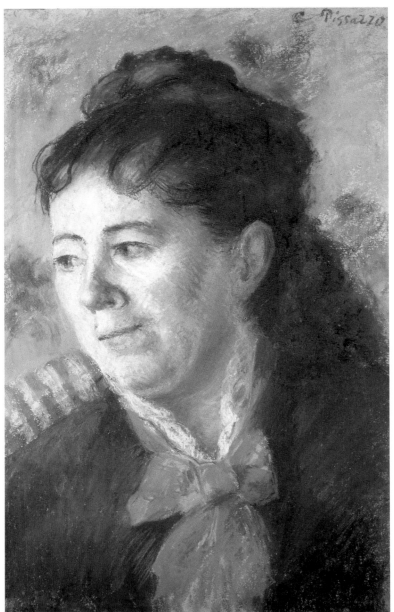

336

Portrait of Père Papeille. Pontoise. c. 1874

Pastel, 21½ x 18" (55 x 46 cm)
Private collection (PV 1523)

337

Portrait of Madame F. Estruc. c. 1874

Pastel, 18 x 11⅜" (46 x 29 cm)
Collection Achim Moeller Fine Art, New York
(PV 1521)

gave birth (a third child, Adèle-Emma, had died a few weeks after she was born, in 1870). The precision of the date on this wash is very unusual. Pissarro scarcely ever signed a drawing, and almost never would he date one. This suggests that this drawing was most likely a gift, possibly to his wife, for Julie eagerly preserved her husband's works. The woman holding the baby seems to be a nurse, an indication that Pissarro, now aged forty-two, was becoming independent of his mother's financial support, and could afford an extra servant. What is striking about this work is the combined economy of means and the profound delicacy and subtlety in the application of the medium.

The cycle went on, as often as new children were born. Although a quantity of drawings is lost, a drawing of a mother and a child, *Mother and Child* (fig. 330), can be dated precisely as it was a preparatory work for the tempera and gouache dated 1878 (fig. 331). The drawing with its broad treatment, its fairly large format, and its swift lines, indicates that Pissarro was clearly thinking of a larger, more thoroughly worked-out composition: the tempera version. The drawing represents almost nothing of the background furniture, save for a bare outline of a door and the back of a seat. A slight smile is outlined on Julie's lips; her expression is much sterner in the rich, thickly encrusted tempera work. Indeed, he managed to produce a group of works that display no sentimentality at all. Pissarro repeatedly tackled this traditional theme, as in the drawing *Nurse and Child* (fig. 329), c.1881 or 1884.

Pissarro made few portraits of his wife, who apparently was not a willing or complaisant model. *Portrait of Madame Pissarro* (fig. 332) represents nevertheless one superb icon among the portraits executed by the artist. It is documented in a letter addressed to Lucien and can therefore be precisely dated. On April 10, 1883, Pissarro complained about the personal reaction of the sitter to this superb portrait: "I am doing a portrait of your mother in pastel, it would seem that it does not look like her, it looks too old, too red, not delicate enough; in a word, that's not it. That doesn't surprise me: you know the one I did previously, with quite heightened features; this was praised by everybody; yet this was not it either."[7] In this portrait the rich, dense oil pastel has been applied with considerable intensity and care to evoke in most simple terms the tenderness, the intimacy, the admiration binding the artist to the sitter. There is more to this work than one can say: a certain oddity, or tension; the sitter was unused to such exacting sitting sessions, while offstage the buzzing and compelling reality (children, garden, worries) demanded her constant attention. The background in the pastel gives little away of this, except a sense of animation and movement; it also underlines the importance of the background motif (of the wallpaper), a theme to which Pissarro gave particular importance in the portrait of his third son: *Portrait of Félix Pissarro* (fig. 333), born in July 1874.

Backgrounds became particularly important components of Pissarro's portraits and still lifes from the 1870s onwards. This was certainly true of *Portrait of Cézanne* (fig. 334), where the background includes a caricature, at the left, of Adolphe Thiers, the premier; at upper right, a caricature of Courbet from *Le Hanneton*, seemingly looking down upon Cézanne; and lower right, a painting by Pissarro himself, *Route de Gisors: The House of Père Gallien, Pontoise* (fig. 335). This background is indicative not so much of the impact of Courbet upon Pissarro's art or of the importance of caricature but, more to the point, of the correlation with his own

previous work: the portrait being executed, and the caricatures pinned up on his studio wall, which were given more prominence than even his own work. This juxtaposition of caricature and painting, between the cartoon of Courbet and Cézanne, points to the humor of the whole scene: art as conceived by Pissarro and Cézanne was concerned with knocking over conventions and clichés established and transmitted by pontificating authorities. But what is the point of testing this self-righteous pontificator if one is not capable of irony towards oneself, as well, or towards one's closest friends?

The irony displayed in Cézanne's portrait contrasts markedly to much earlier, more conventional portraits. It is probable that a similar irony animates two portraits of about the same period: *Portrait of Madame F. Estruc* (fig. 337) and *Portrait of Père Papeille, Pontoise* (fig. 336). The latter is a notable deviation from Pissarro's practice of almost never executing portraits of anyone but close relatives (Madame Estruc was Pissarro's sister-in-law) or close friends. This portrait is clearly that of an official, in a typically bourgeois interior, discreetly displaying a red ribbon, symbol of the Légion d'Honneur; he is on the fringe of Pissarro's world. As in Cézanne's portrait, however, Papeille's would need little exaggeration to turn into caricature, and one cannot be too sure whether the sitter is serious or is about to burst into laughter.

The lush and sensitive treatment of the pastel in these two portraits reveals an aspect of Pissarro's art that was comparable to that of Renoir. In the letter where he mentioned his wife's portrait, Pissarro went on to remark that Renoir was having a "superb exhibition," and compared himself to Renoir: "I will look rather feeble, dull, and sad, after so much splendor! At any rate, I have tried my best."[8] His portraits certainly carry some marks of self-depreciation, and one can find gentle signs of self-irony, or of tenderness and doubt, in some of his best, and latest, self-portraits: *Portrait of C. Pissarro* (fig. 338), *Portrait of C. Pissarro Painting* (fig. 339), or *Self-Portrait* (fig. 340).[9]

No irony is to be observed in one group of works—his portraits of his first daughter, Jeanne (born 1865, died 1874). She was frequently ill and convalescing during her short life. His paintings of her—*The Artist's Daughter* (fig. 342), *Portrait of Minette* (fig. 345), *Portrait of Jeanne with a Fan* (fig. 343), *Girl Seated with a Doll* (fig. 344), and the small pastel *Portrait of Jeanne-Rachel (Minette)* (fig. 341)—are perhaps the most deeply moving works that he executed—not because one knows that Jeanne died when she was nine years old, but because of the intense and deep dialogue being carried on between father and daughter, a daughter whose brief childhood, hampered by disease, she gave over to her father, looking at him painting, looking at him as a painter and as a father. The unfathomable questions in her wide searching eyes make these paintings deeply touching.

As his younger children grew up, Pissarro painted them in turn: *Portrait of Félix Reading* (fig. 346), *Portrait of the Artist's Son Ludovic-Rodolphe* (fig. 347), and *Portrait of Paulémile* (figs. 348 and 349). His second daughter, also called Jeanne, born in 1881, much later in life sat for her father for two sumptuous and lavishly executed canvases, *Portrait of Jeanne* (fig. 350) and *Jeanne Reading* (fig. 351).

Often, the Pissarro children are depicted reading—both Jeannes, Paul-Emile, and Félix. Pissarro himself was an avid reader of political philosophy and literature and

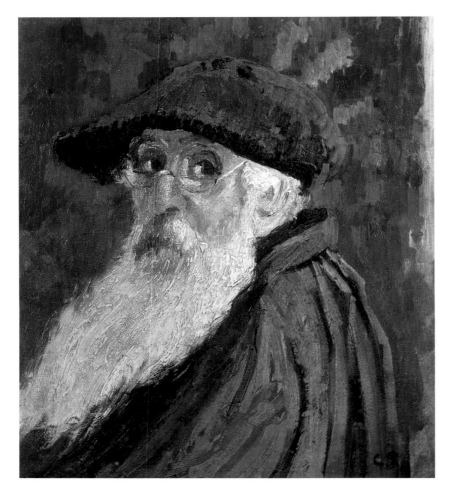

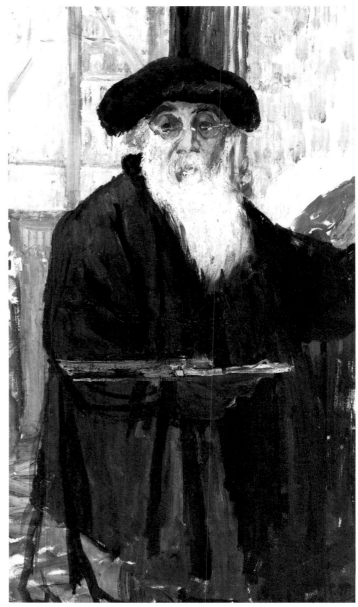

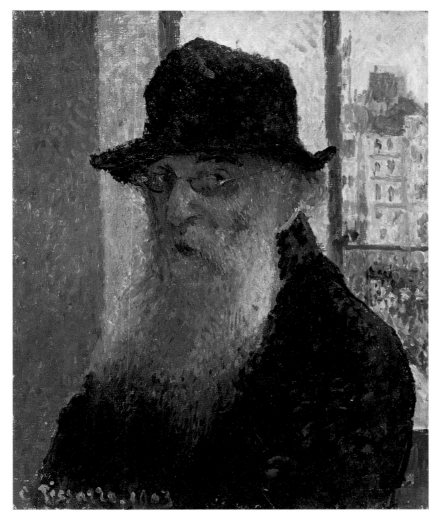

338

Portrait of C. Pissarro. c. 1900

Oil on canvas, 13½ x 12½" (35 x 32 cm)
Private collection (PV 1114)

339

Portrait of C. Pissarro Painting. c. 1900

Oil on canvas, 20¾ x 12" (52 x 31 cm)
Dallas Museum of Art, The Wendy and Emery
Reves Collection (PV 1115)

340

Self-Portrait. 1903

Oil on canvas, 16 x 13" (41 x 33 cm)
The Tate Gallery, London (PV 1316)

341

Portrait of Jeanne-Rachel (Minette). 1872

Pastel, 8⅛ x 5¼" (21 x 14.5 cm)
Collection Robert Ettinger

342

The Artist's Daughter. 1872

Oil on canvas, 28¾ x 23⅝" (73 x 60.6 cm)
Yale University Art Gallery. John Hay Whitney
Collection (PV 193)

343

Portrait of Jeanne with a Fan. c. 1873

Oil on canvas, 21⅞ x 18⅛" (56.1 x 46.5 cm)
Ashmolean Museum. Oxford (PV 232)

344

Girl Seated with a Doll. c. 1872-73

Gouache, dimensions unknown
Whereabouts unknown (PV 1322)

345

Portrait of Minette. c. 1872

Oil on canvas, 18 x 14" (46.2 x 35.9 cm)
Wadsworth Atheneum, Hartford. The Ella Gallup
Sumner and Mary Catlin Sumner Collection
(PV 197)

346

Portrait of Félix Reading. 1893

Oil on canvas, 18 x 15" (46 x 38 cm)
Private collection (PV 828)

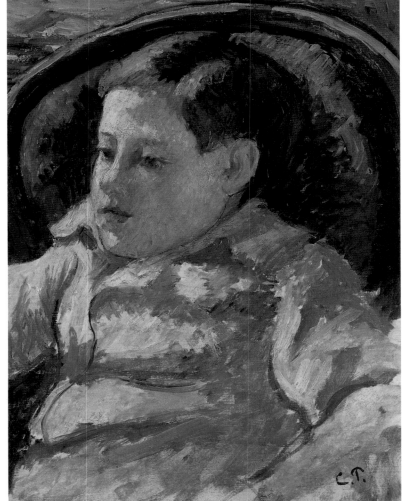

347

Portrait of the Artist's Son Ludovic-Rodolphe.
c. 1885–88

Watercolor, 12¼ x 9¾" (31.1 x 24.6 cm)
Private collection

348

Portrait of Paulémile. c. 1894

Oil on canvas, 13½ x 10½" (35 x 27 cm)
Private collection (PV865)

349

Portrait of Paulémile. c. 1899

Oil on canvas, 25¼ x 21" (65 x 54 cm)
Collection Joel and Carol Honigberg, Chicago
(PV1067)

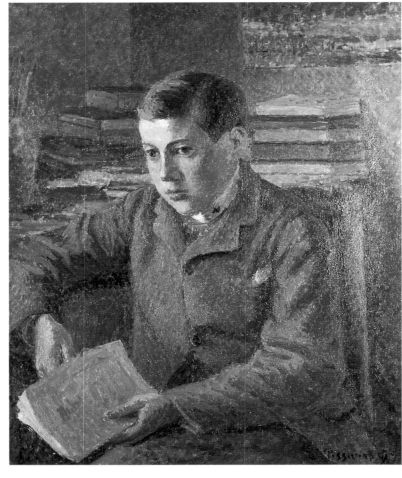

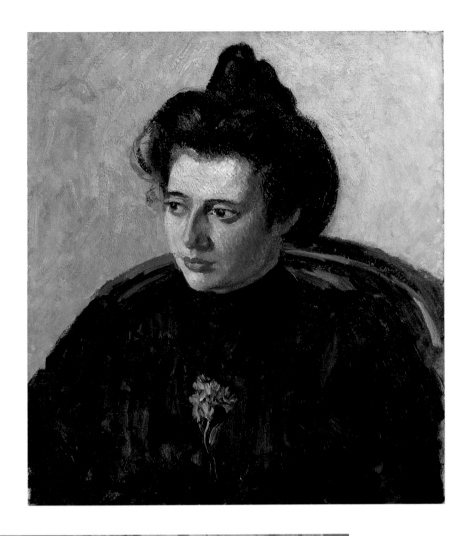

350

Portrait of Jeanne. c. 1898

Oil on canvas, 25¼ x 21" (65 x 54 cm)
Fondation Rau pour le Tiers-Monde, Zurich
(PV 1065)

351

Jeanne Reading. 1899

Oil on canvas, 21½ x 25½" (55.1 x 654 cm)
Private collection (PV 1111)

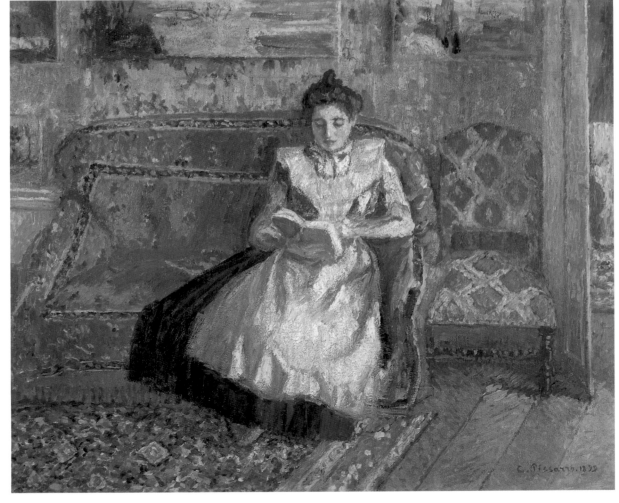

subscribed to numerous journals and periodicals. He once wrote to Mirbeau: "Every day I rest by reading. I find that my eyesight is all the better after having gone through a book that I enjoyed."[10] He shared this passion for books with his children; he also showed them his passion for painting, and all of them went on to become painters in their own right. And he showed them as well his unfailing practice of dissociating reading from painting. Painting is not illustrating a text, or a context, he believed, and writing about painting is an almost impossible task, since, as he wrote to Durand-Ruel, "The writer should assimilate the artist; or rather his ideas, his way of understanding things; he should also move in his circle. Only after a while, with his own observations, will he manage to create a work that will mean something."[11] As an example of someone who had accomplished this, Pissarro cited Zola's writings on Manet to Durand-Ruel, although Pissarro had elsewhere warned Lucien about the difficulty of writing on Manet or any other artist: "The painter's works will reveal more about the man than whatever the journalist can come up with."[12]

This sentence could serve aptly as an epigraph for Pissarro's work, as well. In a way, his work constructed his life. His portraits, almost exclusively of his children, set the tempo of his biography; one feels here that the artist paints with his pulse throbbing, but without sentimentality.

ACKNOWLEDGMENTS

*I*n the process of researching and writing this book, I received help from more individuals than I can start to account for in these lines. I wish to express the huge debt I owe to all the collectors who allowed me to reproduce their paintings. Without them, their patience, generosity, and hospitality, this book would not exist. I thank them greatly.

I have received considerable help, support, and unpublished material from gallery owners, art advisers, and auctioneers: Günther Abels; William Acquavella and the staff of his gallery, and in particular, Jean Edmonson; Brian Balfour-Oates; William Beadleston and his associates, Susan Seidel and Mimi Balderston; Nicolas Beurret; Marc Blondeau and his assistant Anne London; Reinhold Cassirer; Gérard Champin and Francis Lombrail of Champin, Lombrail, Gautier; Eunna Chung of the Unna Gallery; Maxwell Davidson III; Yozo Doi; Josée-Lyne Falcone; Dr. Marianne Feilchenfeldt; Walter and Maria Feilchenfeldt; Lindsey Findlay of the David Findlay Gallery; Peter Findlay and his assistant Gabrielle Grieve; Kazuo Fujii; Thomas Gibson; Richard Green; Harriet Griffin; the staff of the Hammer Gallery: Kevin Anderson, Howard Shaw, Iris Cohen, and of course, Richard Lynch; Tokushichi Hasegawa of the Nichido Gallery; Waring Hopkins and Alain Thomas; Mr. Hirano; Christiane Inmann-Wieser; Naoya Inoue of the Taimei Gallery; Suzanne Julig of Hirschl and Adler; Shigeki Kameyama; Arda Kassabian of Phillips Auctioneers; Gaynor Tregoning of Leggatt Brothers; Guy Loudmer and his librarian, Pascale Krausz; Daniel Malingue and his librarian, Perrine Leblanc; Ryuichiro Mizushima of Wildenstein, Tokyo; his father, Tokuzo Mizushima, of the Fujikawa Galleries; Takae Miyawaki of Art Salon Takahata; Jennifer Pepper of Achim Moeller Fine Art; Robert C. Moeller III; Takao Mori; J. N. Napier-Ford; Christian Neffe and his assistant Kate Daniels of J.P.L. Fine Arts; Martha Parrish; David, Giuseppe, and Ezra Nehmad; Angela Nevill; Jill Newhouse; Sadao Ogawa of the Yayoi Gallery; Ruth O'Hara and her assistant, Pamela Emerson; Harunobu Okada; Katia Pissarro; Lionel and Sandrine Pissarro and their assistant, Véronique; Heidi Römer; Angela Rosengart; Leslie J. Sacks and Joseph Wolpe; Manuel Schmit; Franklin Silverstone; Louis Stern; E. V. Thaw; Kevin Vogel of the Valley House Gallery; William Weston and his assistant, Emma Chambers.

From Christie's International, I would like to thank in particular: James Roundell and Michael Findlay, together with the Hon. Charles Alsopp, John Lumley, Maria Reinshagen, Annette Bühler, Franck Giraud, Diana Kunkell, Liz Holland, Kate Fleet. From Sotheby's, I am very indebted to Michel Strauss, John Tancock, Alex Apsis, as

well as David Nash, Dr. Jörg Wille, Ully Wille, Marc Rosen, Melanie Clore, Helen Zaphyropoulos, Asya Chorley, Lucy Dew, Sarah Annis. I would also like to thank Judy Murphy, Rob Grosman, Tom Cashin, Cynthia Vimond, Melissa Dinger, and Eliot Woolf for facilitating my research at various stages of this project.

My research on the early history of Pissarro's work through the art market proved invaluable for this project. I would like to thank especially Roland Balaÿ, and Nancy Little and Melissa de Medeiros, who hugely facilitated my work at the Knoedler Library. My warm gratitude to Elaine Rosenberg for all her help and kindness. My deep thanks to Janet Salz for her wonderful generosity. At Alex Reid & Lefevre, London, Desmond Corcoran and Martin Summers patiently answered all my inquiries and generously allowed me to consult their archives; my thanks also to Jackie Cartwright. In London, I owe a profound debt, too, to the late Nicholas and Andy Tooth, who made every possible effort to facilitate access to the Arthur Tooth Archives. In France, my gratitude goes to the Bernheim-Jeune Archives, and in particular to Guy-Patrice Dauberville. At the Durand-Ruel Archives, Caroline Durand-Ruel Godfroy, together with France Daguet, always answered all my questions and correspondence. At the Wildenstein Library, in New York, Ay-Whang Hsia was more than generous with her time and photographic documents. I am very grateful to Daniel Wildenstein and Guy Wildenstein for making themselves available to answer my questions.

Hortense Anda-Bührle; Caroline Beamond; Anne Brody (curator of The Robert Holmes à Court Collection); Dr. Hans Brunner; D. Burkland; Lady Sarah Churchill; Robert Clémentz (director of the Fondation Rau pour le Tiers-Monde); Vida Crane; John H. Bryan, as well as Kathleen Egan and Kim Marx, of the Sara Lee Corporation; Susan Ginsburg; André El-Zenny; Lady Ivry Freyberg; Joan Golfar; Ted Gott; Marla H. Hand; Paul and Ellen Josefowitz; Diane Kelder (curator of the LeFrak Collection); Gwendoline Keywood; Kyriacos Koutsomallis; Yasmine Louati; Shawn McIntosh; Ruth Mueller; Rebecca Natanson; Diane O'Connell; Juan Ignacio Parra; Jill Rittblatt; Cecilia Sampaio; Bertha Saunders; Jeannette Sheehan; Karin Sokolove; Lesly J. Spector; Barbara M. Steinegger; the late André Testard; Alice Victor; Lady Weir; MaLin Wilson; Akihiro Yoshizawa; Marke Zervudachi have all contributed much effort and time to this project. I am deeply indebted to them.

Museum colleagues and scholars have patiently supported this project and I am grateful to them: at the Royal Academy, London, Norman Rosenthal and MaryAnne Stevens, as well as Sara Gordon and Miranda Bennion; my sincere thanks to John Sunderland at the Witt Library, London, for his generosity; my thanks also to William Henning of the Arkansas Arts Center; in Basel, I have learned a great deal from Christian Geelhaar at the Kunstmuseum; my thanks as well to K. Hess and to Dr. Jörg Zutter also at the Kunstmuseum Basel; at the Israel Museum, Jerusalem, I thank Stephanie Rachum and Martin Weyl; I am most indebted to Philip Conisbee at the Los Angeles County Museum of Art for the wonderful discoveries in and around the museum; my thanks to Alison Zucrow, his assistant; to Brian A. Dursum and Denise Gerson at the Lowe Art Museum, University of Miami; to Andrea Wooden, Deanna Cross, and Susan Stein at The Metropolitan Museum of Art, New York; to Anna Eugenia Canakis, Jorge A. Lorenzzutti, and Daniel E. Martínez of the Museo Nacional de Bellas Artes de Buenos Aires; to Susan Campbell, France Duhamel, and

Michael Pantazzi of the National Gallery of Canada, Ottawa; to Jennifer L. Otte and Alison Goodyear of the Philadelphia Museum of Art; special thanks to Joseph Rishel for his efforts in uncovering some vital works and for his indomitable humor; my thanks to Anne Goodchild, of the Graves Art Gallery; Inna Orn of the Pushkin State Museum; Rosalind Freeman of the National Museum of Wales; Charles Moffett of the National Gallery of Art, Washington; John Leighton of the National Gallery, London; Margaret Lynn Ausfeld of the Montgomery Museum of Fine Arts; Dr. Helmut R. Leppien of the Hamburger Kunsthalle and Julia Waldmann of the Kunstverein Hamburg; Dennis A. Gould, Michael Hammer, and Mary Anne Sears of the Armand Hammer Foundation; Lynn Green of the Southampton City Art Gallery; Janice T. Driesbach of the Crocker Art Museum; Joan Brickley of the Cleveland Museum of Art; Barbara Shapiro of the Museum of Fine Arts, Boston, for her invaluable help; Heather Haskell and Richard C. Mühlberger of the Museum of Fine Arts, Springfield, Mass.; Graham Langton of the Tate Gallery Publications; Nancy A. Petersen of the Timken Art Gallery; Rainer Krauss of the Kunstsammlungen zu Weimar in the former DDR; Shinusuke Kishi of The Ueno Royal Museum; Dr. Eva-Maria Preiswerk-Lösel as well as Dr. Florens Deuchler and Mr. German at the Langmatt Foundation; Arlette Loglisci of the Fondazione Thyssen-Bornemisza; Judith Durrer of the Kunstmuseum Bern; at the Dallas Museum of Art, Kevin Comerford and Diane Flowers and Liza Skaggs helped considerably with this project; Richard Brettell is to be credited for many of the surprises found in this book; my thanks also to Toyochiyo Machida of the Ibaragi Prefectural Art Museum; to Paula Hicks of The National Gallery of Ireland; to Sally Dummer of the Ipswich Museums and Galleries.

I wish to thank my professors at the Courtauld: John Golding and Christopher Green and also John House, Bob Ratcliffe, Belinda Thomson, Richard Thomson, and Kathleen Adler. I will not forget the late Ralph Shikes, who probably knew more about Pissarro's life than anybody I have known. My thanks to his co-author, Paula Harper. My earliest debt goes to John Rewald, who first opened my eyes to the multifarious diversity of Pissarro's art and has always patiently answered my questions since. Many thanks to Richard Brettell and Christopher Lloyd, who have published more widely on Pissarro in the last two decades than anybody else and shared their own discoveries with utter generosity. I am also very grateful to Anne Thorold and Janine Bailly-Herzberg. My thanks to the late Sir Lawrence Gowing, and also to Richard Shiff, Martha Ward, Christopher Campbell, and Nancy Locke, for discussing various points of this manuscript and to Tzvetan Todorov, Luc Ferry, and Alain Renaut for discussing ideas related to this project.

I owe a lot to all those who helped me with various aspects of this manuscript: Abigail Willis, Louise Scalia, Tessa Whitley, Tamae Yoshikawa, Lulu Sinclair, Natasha Livit, Véronique Bourgarel, Katarina Alfonso, and Mikako Kato. Claire Durand-Ruel Snollaerts has helped me to make numerous exciting discoveries in France and has taken on the same passion for Pissarro's art. My thanks also to Robert Gordon, who always lent his kind attention to this project.

Equally, I thank all those at Abrams who have endured the massive task of conducting editorial relationships across the ocean: Paul Gottlieb, who immediately shared my enthusiasm for this project, Phyllis Freeman in particular, and Catherine Ruello, Barbara Lyons, and Maria Miller.

NOTES

The following abbreviations have been used throughout these notes. For complete publication data, see the Bibliography.

JBH: Janine Bailly-Herzberg, ed., *Correspondance de Camille Pissarro*

B&L: Richard Brettell and Christopher Lloyd, *Catalogue of Drawings by Camille Pissarro in the Ashmolean Museum*

S&H: Ralph E. Shikes and Paula Harper, *Pissarro: His Life and Work*

P&V: Ludovic-Rodo Pissarro and Lionello Venturi, *Camille Pissarro: son art—son oeuvre*

Introduction

1. Letter to Eugène Murer, 1878, in Janine Bailly-Herzberg, ed., *Correspondance de Camille Pissarro* (Paris and Pontoise, 1980–91), vol.1, p.123 (hereafter cited as *JBH*). See also Alfredo Boulton, *Camille Pissarro en Venezuela* (Caracas, 1966), p.88.
2. *JBH*, vol.4, p.159.
3. Ibid., p.119.
4. Ibid., pp.118–19.
5. Ibid., p.60.
6. Examples of such an approach have abounded in the last two decades. John House, of the Courtauld Institute, for instance, emphasized, in answer to his own revealing question —"What, in the end, is the basic concern underlying Pissarro's art?"—that "the meaning of Pissarro's art was essentially social, its theme the interrelationship between mankind and its environment." Predictably, considering why the artist adopted "varied techniques and methods of formulating" this essential social narrative, the author concluded that the artist was "led" to perform such experiments by "different situations and outside stimuli." The fact that the artist responded in his own way to these stimuli is left unquestioned. What I personally doubt is whether one can explain his art exclusively as a mere response to such stimuli. (Cf. John House, "Camille Pissarro's Idea of Unity," in *Studies on Camille Pissarro*, edited by Christopher Lloyd [London and New York, 1986], pp.31–32.)

An even more telling example can be found in Kathleen Adler's text: "Camille Pissarro: City and Country in the 1890s," in ibid., pp.99–116; there, the principal social narrative "rendered" visually by Pissarro is understood to be that of "a lack of social order"—citing the Los Angeles County Museum of Art's painting *La Place du Théâtre Français* (fig. 311). Note that this narrative, characterized here by Adler with a psychological undertone ("carriages and pedestrians intermingled, going pell-mell about their business with complete disregard for anyone or anything else"), coincides, according to the author, with the concept of anomie forged by Emile Durkheim in 1893. The author admits that "it is tempting to speculate that Pissarro had read Durkheim, although there is no clear evidence to support this." But in any event, "the concept of anomie is now a cliché of urban life and one that Pissarro seems to have understood whether or not he had read Durkheim." The one question that is conspicuously left out of this reflection is: What about the artist's "visual rendering" itself—or more simply and accurately: What about his own act of "painting"? Or is the fact that these paintings were painted merely a superfluous process determined by wholly "outside stimuli"?
7. *JBH*, vol.1, p.267.
8. Ibid., vol.4, pp.267–68.

One:
Beginnings 1830–55: Saint Thomas, Caracas, Saint Thomas

1. *JBH*, vol.1, p.123.
2. Charles Kunstler, *Pissarro—Villes et Campagnes* (Lausanne, 1967), p.12. Translation: *Pissarro: Cities and Landscapes* (New York, [1967]).
3. Rewald, *Pissarro in Venezuela*, p.12. Rewald's interesting observation is substantiated by a letter he mentions; it has never been published.
4. Joachim Gasquet (1873–1921) was the son of Henri Gasquet, who himself was a childhood friend of Cézanne. The younger Gasquet met

Cézanne for the first time in 1896. In the summer of 1912–1913, Joachim, a poet with a rather flamboyant style, transcribed, and occasionally transformed, the contents of his discussions with Cézanne; they were first published in 1921.

5. Quoted in *Conversations avec Cézanne*, edited by P. Michael Doran (Paris, 1978), p. 121.

6. For an excellent analysis of this drawing see Richard Brettell and Christopher Lloyd, *Catalogue of Drawings by Camille Pissarro in the Ashmolean Museum* (Oxford, 1980), p. 5 (hereafter cited as *B&L*).

7. Gustave Flaubert, *Correspondance*, vol. 2 (July 1852–December 1858) (Paris, 1980), p. 5. Quoted in Doran, ed., *Conversations*, p. 113.

8. Doran, ed., *Conversations*, p. 121.

9. Boulton, *Pissarro en Venezuela*, p. 95.

10. John Rewald, *Camille Pissarro in Venezuela* (New York, 1964), p. 22.

11. Ibid., p. 23.

12. *B&L*, p. 6.

13. Ibid., pp. 3–4.

14. A caricature of both artists is reproduced in John Rewald, *The History of Impressionism* (New York, 1973), p. 23. For a detailed assessment of the repercussions of this ongoing opposition see Rewald, chapter 1, pp. 13–36.

15. Ibid., p. 22.

16. Paul Gauguin, *Noa-Noa*, edited by J. Loize (Paris, 1966); quoted in Françoise Cachin, *Gauguin* (Paris, 1968), pp. 152–53. Gauguin, here describing his Maori model, wrote: "She was not particularly pretty, according to our European rules; yet she was beautiful; all her features were combined in a Raphaelesque harmony."

17. For more complete biographical details of Pissarro's last sojourn on Saint Thomas, see Ralph E. Shikes and Paula Harper, *Pissarro: His Life and Work* (New York, 1980), pp. 32–35 (hereafter cited as *S&H*).

Two:
The Early Works in France 1855–69

1. W. S. Meadmore, *Lucien Pissarro: un coeur simple* (London, 1962), p. 21.

2. A very telling example is the painting *Planting Peas* (fig. 210), which Monet wanted to buy for himself; Julie refused to let the painting go, despite the fact that Monet had just loaned the Pissarros a large sum in order to help them to purchase their house. The incident would have resulted in a dispute had Pissarro himself not intervened personally, begging his wife to let Monet have the work; see *JBH*, vol. 3, p. 246. See also the sale catalogue of Julie's estate after her death: the sale, in 1928, included 59 paintings by Pissarro, in addition to works by Cassatt, Cézanne, Delacroix, Manet, Monet, Seurat, and Sisley, which she had kept since her husband's death in 1903.

3. Kermit Champa, *Studies in Early Impressionism* (New Haven, 1973), p. 67.

4. Anton Melbye, some years older than Fritz, was an official artist frequently commissioned by the Danish court; he lived in Paris and was a regular Salon exhibitor, showing dramatic marine scenes. He certainly provided the young Camille with advice and guidance in the beginning. He also probably introduced the younger artist to Corot.

5. This unstable situation was made worse by a housing shortage in France and by added pressure on the Pissarros' rapidly growing family, as evidenced in one of Camille Pissarro's earliest published letters, in *JBH*, vol. 1, p. 58: "You cannot imagine how tough it is to find an accommodation. How shall we cope? Because of the Universal Exhibition, the landlords demand even higher prices—I have no idea where we'll end—and if Mother does not come to my rescue I will be in deep trouble."

6. For a detailed account of the Académie Suisse and the meeting there of Pissarro and Monet, see *S&H*, p. 53, and Kathleen Adler, *Camille Pissarro: A Biography* (London, 1978), pp. 27–29.

7. See Jean-Baptiste Camille Corot, *Le Martinet près Montpellier*, pen and ink over pencil, The Metropolitan Museum of Art, New York, and *La Carrière*, pencil, Ashmolean Museum, Oxford; both drawings are reproduced in *B&L*, pp. 10–11. These authors point out several other, so far unmentioned, artists who influenced Pissarro's work.

8. Ibid., pp. 9–13.

9. *Emile Zola—le bon combat de Courbet aux Impressionnistes*, edited by J. P. Bouillon (Paris, 1974), pp. 107–9.

10. See Champa, *Early Impressionism*, p. 72. The painting by Daubigny is reproduced in his fig. 102.

11. Christopher Lloyd and Anne Distel, in *Pissarro*, Arts Council of Great Britain exhibition catalogue (London and Boston, 1980), p. 72, state: "Pissarro displays highly developed powers of visual analysis in reducing the landscape motif to its basic elements. Certain passages, notably the buildings and the reflections in the water, assume abstract forms when seen in isolation."

12. This work was formerly in the collection of Lucien Pissarro. See *B&L*, p. 114.

13. Lloyd and Distel, *Pissarro*, p. 73.

14. Champa, *Early Impressionism*, p. 73, referring to this picture (fig. 39), notes that "Courbet has superseded Daubigny as the prime object of Pissarro's respect," after asserting that "the painting as a total unit is flat and somewhat featureless by Courbet's standards." Despite Champa's assertion here, Courbet is far behind or, literally, beside the point.

15. Quoted in *S&H*, p. 70, translated from Bouillon, ed., *Zola*, p. 74.

16. See *S&H*, p. 73, and particularly Rewald, *History of Impressionism*, pp. 185–86.

17. See Ludovic-Rodo Pissarro and Lionello Venturi, *Camille Pissarro: son art—son oeuvre*,

vol. 1 (Paris, 1939), entry nos. 55 and 58 (hereafter cited as *P&V*). More recently, however, the question arose again as to which two paintings were exhibited at the 1868 Salon; cf. Lloyd and Distel, *Pissarro*, p. 77: "It is highly probable that the painting was shown in the Salon, but in which year cannot be determined, since Pissarro exhibited a picture entitled *L'Hermitage* in the Salon of 1868 (2016) and in the Salon of 1869 (1950)."

18. This is the first time that the Hermitage group of works of 1867–68 has been reproduced together in color *in extenso*.

19. Richard Shiff, "Review article" [recent Pissarro publications], *The Art Bulletin*, 66, no. 4 (December 1984), p. 686. In this vein, Shiff noted, "Pissarro and Degas exemplify the interpretive dilemma most obviously. They . . . produced series of studies for preconceived thematic statements . . . and were also capable of giving pictures relatively unambiguous allegorical or narrative content."

In contrast, he asserts, "Often, the force of [Manet's or Cézanne's] stylistic innovation overwhelms the illustration: in their idiosyncratic naturalism, these paintings become so strange formally that many viewers fix upon their style and ignore their subject-matter."

20. See, for instance, Lilian R. Furst, "Zola's Art Criticism," in *French 19th Century Painting and Literature*, edited by Ulrich Finke (Manchester, 1972), p. 171, where emphasis has been put on merely the fact that in Zola's texts, "the artist . . . is inevitably reduced to the rank of a mere recorder . . . the emphasis seems to lie, in theory at least, more on the actual seeing than on the 'temperament.'" This is directly contradicted by Zola's text, where he asserts that the "profoundly human originality" of Camille Pissarro's painting lies precisely in "the very temperament of the painter."

21. For a broader account of the ambivalent use of the term "truth" in French art criticism of the nineteenth century, see Richard Shiff, *Cézanne and the End of Impressionism: A Study of the Theory, Technique and Critical Evaluation of Modern Art* (Chicago and London, 1984), pp. 21–26.

22. See *Paul Cézanne: Correspondance*, edited by John Rewald (Paris, 1978), pp. 101–3. Translation: *Cézanne: Letters*, edited by John Rewald (New York, 1985).

23. Meyer Schapiro, *Cézanne* (New York, 1962), p. 10. Italics added.

24. Quoted in Alfred H. Barr, Jr., *Matisse: His Art and His Public* (New York, 1951), p. 38.

25. Rewald, ed., *Cézanne: Correspondance*, pp. 152–53. Translation in Rewald, ed., *Cézanne: Letters*.

26. Ibid., p. 152.

27. Tzvetan Todorov, *Mikhaïl Bakhtine: le principe dialogique* (Paris, 1981), p. 117. Originally quoted in V. N. Voloshinov (M. Bakhtin), *Marksizm i Filosofia yazyka* (Leningrad, 1929). French translation by M. Bakhtin (V. N.

Voloshinov). *Le Marxisme et la philosophie du langage* (Paris, 1977). This pictorial style indeed "introduces the social heterology within the body of a novel." Todorov, *Bakhtine*, p. 119.

28. Maurice Merleau-Ponty, "Eye and Mind," translated by Carleton Dallery, in *The Primacy of Perception*, edited by James M. Edie (Chicago, 1964), p. 182. Bracketed words inserted by the author.

Three:
Louveciennes 1870–72

1. Théodore Duret, "Le Salon de 1870, les Naturalistes; Pissaro [sic]," in *L'Electeur libre* (May 12, 1870), pp. 7–8. This seldom quoted text also appears in *P&V*, p. 25.

2. Richard R. Brettell, *Pissarro and Pontoise: The Painter in a Landscape* (New Haven and London, 1990), p. 6; these two works are *La Route de Versailles à Saint-Germain, Louveciennes, Effet de Neige* (PV 130) and *Route de Versailles à Saint-Germain à Louveciennes* (PV 131).

3. Confusion has sometimes arisen about the complex web of Pissarro's comings and goings among Pontoise, Louveciennes, and London. See, for instance, Anne Schirrmeister's otherwise illuminating essay "The Artist's Limited Edition," in *Camille Pissarro* (New York, 1982), p. 9, where she states that "as soon as the war ended, Pissarro returned to Pontoise."

4. See Brettell, *Pissarro and Pontoise.*

5. Richard Brettell, "Camille Pissarro: A Revision," in Lloyd and Distel, *Pissarro*, p. 19. Brettell was the first to point out this oddity in the catalogue raisonné. He argues:

> It is customary to blame this situation on the Prussian troops who lived in Pissarro's house on the Route de Versailles in Louveciennes during the Franco-Prussian War of 1870 and who reportedly destroyed much of the early work that was stored there. This view is possibly both exaggerated and inaccurate. There are 34 pictures in the official catalogue raisonné which bear a date of 1870 and which in addition represent Louveciennes before the flight to Brittany, and eventually to England, in July 1870.

6. This information is drawn from the meticulous identification of most Impressionist paintings in and around Louveciennes by Jacques and Monique Laÿ (*Louveciennes, mon village* [Paris, 1989]). My profound thanks to Christopher Lloyd for communicating these results.

7. See Gaston Bachelard, *L'Air et les Songes* (Paris, 1943), and particularly the chapter entitled "Les Travaux de Robert Desoille," pp. 129ff.

8. Jules-Antoine Castagnary, "L'Exposition du Boulevard des Capucines. Les Impressionnistes," in *Le Siècle* (April 29, 1874), reproduced in *Centenaire de l'Impressionnisme* (1974), p. 265.

9. Jürgen Habermas, *Der philosophische Diskurs der Moderne: Zwölf Vorlesungen* (Frankfurt, 1985); translation: Frederick G. Lawrence, *The Philosophical Discourse of Modernity: Twelve Lectures* (Cambridge, Mass., 1987), p. 174. It is extremely intriguing to look at these Louveciennes paintings in the light of these findings, i.e., that "the experience that is present 'at the moment' is indebted to an act of representation." (Ibid.) Indeed Pissarro's Louveciennes paintings seem to embody the fact that the perception of a *scène vue* is in itself an act of representation; hence also the notion crucial to incipient Impressionism that a spontaneous visual experience is already an act of temporizing or of deferral. In brief, Pissarro, as he starts gazing at a street scene, already represents it. Gazing at and creating a picture of Louveciennes are inevitably bound together.

10. Pissarro lived at 22, route de Versailles. Renoir lived at no. 12 before moving to Voisins. Degas lived at no. 13, and Monet and Sisley also lived nearby. No other village knew such a high concentration of Impressionists at any other time—except Paris, of course, though Paris is not a village. In fact, Louveciennes is probably the only village where almost all the Impressionists, including Cézanne, painted.

Four:
London 1870–71
The Franco-Prussian War

1. Letter, dated August 27, 1870; see *Mon cher Pissarro, Lettres de Ludovic Piette à Camille Pissarro*, edited by Janine Bailly-Herzberg (Paris, 1985), pp. 33–36. Postscript, pp. 34–35.

2. Letter, dated October 10, 1870, from a private collection, New York. First published in *S&H*, p. 88. (Original French text not cited in *S&H*.)

3. Shikes and Harper give the date November 5 for Adèle-Emma's death. The same error was made in the chronology in *JBH*, vol. 1, p. 31, and was subsequently rectified in Bailly-Herzberg, ed., *Mon cher Pissarro*, pp. 35–36.

4. *S&H*, p. 88. (Original French text not cited.)

5. *JBH*, vol. 1, pp. 63–65. Translation in *S&H*, p. 97, with a few modifications.

6. A letter from Durand-Ruel to Pissarro, dated January 21, 1871. Quoted in Lionello Venturi, *Les Archives de l'impressionnisme*, vol. 2 (Paris and New York, 1939), pp. 247–48. Translation in Rewald, *History of Impressionism*, p. 254. This incipient contact among Monet, Pissarro, and their future dealer has given rise to abundant literature, most of which is summarized in John House, "New Material on Monet and Pissarro in London in 1870–1871," *The Burlington Magazine* 120 (October 1978), pp. 636–42.

7. Rewald, *History of Impressionism.* Paul Durand-Ruel had left France as the Franco-Prussian War broke out and sent his stock to London, where he opened a gallery on New Bond Street. Monet and Daubigny had also made their way to London separately, and it was Daubigny who first introduced Monet to Durand-Ruel.

8. *JBH*, vol. 1, p. 174. Translation in *Camille Pissarro: Letters to His Son Lucien*, edited by John Rewald with the assistance of Lucien Pissarro, translated by Lionel Abel, 4th rev. ed. (London, 1980), p. 21; with slight modifications by the author.

9. Letter from Pissarro to Wynford Dewhurst, dated 1902. Quoted in Rewald, ed., *Letters to Lucien*, p. 355, and again in Christopher Lloyd, *Pissarro* (Geneva and London, 1981), p. 48.

10. *Catalogue des Oeuvres Importantes de Camille Pissarro composant la Collection Camille Pissarro*, vol. 4; sale catalogue of the estate of Julie Pissarro, at the Galerie Georges Petit, Paris, December 3, 1928.

11. I am grateful to Sir Martin Reid for sharing his detailed topographical knowledge of the area where this previously unpublished painting was executed, i.e., between the Norwood Junction (right) and Crystal Palace (lower level) station. The train that can be seen in the *drawing* is on the West End of Crystal Palace Railway; cf. *B&L*, p. 117.

12. Previously mistakenly titled *Church of Westow Hill, Snow.*

13. Cf. Sir Martin Reid's article "Camille Pissarro. Three Paintings of London of 1871: What Do They Represent?" *The Burlington Magazine* 119 (April 1977), pp. 253–61. Also Reid's article "The Pissarro Family in the Norwood Area of London, 1870–1: Where Did They Live?" in *Studies on Camille Pissarro*, edited by Christopher Lloyd (London, 1986). Cf. in particular the last paragraph on "Lower Norwood," now West Norwood, where Pissarro lived.

14. Habermas, *Diskurs*, p. 60.

15. Ibid.

16. Ibid. Marxism cannot attempt to apply a deterministic mode of explanation to works of art—be it simplistic or dialectic—without falling prey to various types of reductions: privileging only certain types of icons (trains, for instance) that seem relevant to a historicist reading; relinquishing formal analyses as inessential or reactionary, or both; excluding the notions of liberty and subjectivity; and therefore never asking what the forms created may mean to the artist. In the last instance, that type of interpretation is utterly incapable of reconstructing the internal logic of any given work of art, or of an *oeuvre*, since ultimately, the artist, like all of us, is nothing but "the personification of certain economic categories, and the support of interests and relations of a given class." (Karl Marx, preface to the last edition of *Das Kapital*.)

Offsetting the type of functionalist approach applied to Pissarro of late, it may be tempting to juxtapose Pissarro's attitude to the Nietzschean stance that proclaimed the complete collapse of all "worlds of truth"—i.e., of any system, be it theological or dialectical, ac-

cording to which everything and anything must make sense. Looking at Pissarro's London output, there is no single, monolithic system of reference left. In Nietzschean terms, this destruction of all truth systems, contemporary with the death of God, leaves room for a reappraisal of art, understood as the only field where the possibility of error is glorified rather than condemned: art indeed cultivates appearances; there, no truth, no reality prevails, but the singular, and ceaselessly changing viewpoint of the irretrievably singular artist's persona; no stable values, no absolutes, no law, of course, can regulate the flux, ceaselessly varied, of the artist's creation. Art, for Nietzsche, has more value than truth has. As he laconically put it in *The Birth of Tragedy*, "The only possible life: art. Otherwise, you turn your back away from life." Of this statement, Pissarro, in London, would have certainly not disapproved.

Needless to say, however, trying to make a Nietzschean out of Pissarro would be as absurd as to claim that he was a pictorial accountant of the Industrial Revolution.

Five:
Pontoise and Auvers 1872–82
Impressionism

1. Doran, ed., *Conversations*, p. 121.
2. See Brettell, *Pissarro and Pontoise*, in particular the chapter titled "Omissions and Admissions."
3. See John Rewald, *Cézanne* (New York, 1986), p. 268, for a precise and essential chronology.
4. Comparative list of the participation, or lack thereof, of Cézanne and Pissarro in the Impressionist exhibitions:

	Cézanne	Pissarro
1874	3 paintings	5 paintings
1876	——	12 paintings
1877	16 works	22 paintings
1879	——	38 paintings
1880	——	10 paintings, 1 fan, and 9 sets of prints
1881	——	11 paintings, 17 gouaches and pastels
1882	——	24 paintings, 10 gouaches, and 1 tempera
1886	——	20 paintings, pastels, gouaches, and etchings

5. This search, as demonstrated by Brettell, consisted of "admissions" and "omissions" resulting from a complex selective process.
6. *JBH*, vol. 4, p. 121.
7. Shiff; see chapter 2, n. 19, supra.
8. See the excellent article by Robert Simon, "Cézanne and the Subject of Violence," *Art in America* (May 1991), pp. 120ff.
9. Ibid.

10. Ambroise Vollard, *En écoutant Cézanne, Degas, Renoir* (Paris, 1938), p. 22.
11. Ibid., p. 17.
12. Ibid., p. 20.
13. *JBH*, vol. 2, p. 383.
14. Ibid. This rejection of school theories and dogmatism echoes Kant's restriction: "There can be no objective rule of taste that determines with a concept what is beautiful."
15. Quoted by Joachim Gasquet in Doran, ed., *Conversations*, p. 135.
16. *JBH*, vol. 1, p. 183.
17. Ibid., p. 225.
18. Doran, ed., *Conversations*, p. 148. Also see the same allusion to the "tireless Pissarro" who communicated his taste for work to Cézanne (ibid., p. 65). According to Emile Bernard, Cézanne was such a workaholic that on the very day of his mother's burial, he could not join the funeral procession as he had to go paint outdoors.
19. This precisely recalls Kant's fundamental antinomy of taste as embodied by the following question: "How can one maintain the idea of a possible universal taste without this principle of common sense negating subjectivity?" Cf. Luc Ferry in *Homo Aestheticus, L'Invention du Goût à l'Age Démocratique* (Paris, 1990), p. 118.
20. Doran, ed., *Conversations*, p. 135.
21. Ibid., p. 21.
22. *Camille Pissarro: Lettres à son fils Lucien*, edited by John Rewald (Paris, 1950), pp. 100–101.
23. Barbara Shapiro, *Camille Pissarro: The Impressionist Printmaker* (Boston, 1973), Introduction.
24. *JBH*, vol. 1, p. 264.
25. Ibid., p. 80.
26. Rewald, ed., *Cézanne: Correspondance*, p. 146. Translation: Rewald, ed., *Cézanne: Letters*.
27. Paraphrasing Maurice Blanchot, *Le Livre à venir* (Paris, 1959), one could say that throughout Pissarro's Pontoise work, a place (space) was created where nothing ever took place but the place (p. 91). Blanchot put it in terms which could aptly apply to these works: "The force of poetic communication does not arise from the fact that it would have us immediately participate in things, but that it would give them to us out of their own reach" (p. 86).
28. Ibid., p. 88.

Six:
Montfoucault

1. Bailly-Herzberg, ed., *Mon cher Pissarro*, p. 63.
2. Ibid., p. 116.
3. *B&L*, p. 17.
4. *P&V*, vol. 1, p. 26.
5. Ibid., p. 27.
6. *JBH*, vol. 1, p. 203.
7. Ibid., p. 95.
8. Ibid., pp. 95–96.
9. Quoted in Kunstler, *Villes et Campagnes*, p. 18. Robert Herbert's remarkable analysis of the role and significance of Millet's peasant im-

agery clearly shows how it is distinct from Pissarro's own:

Millet's importance to history is not that he provided us with a pictorial commentary on rural life, but that he created a memorable art. His work was a powerful force because it drew together past art and present aspiration, melted in the crucible of a rare talent . . . far from being a simple transcription of what lay around him, Millet's rural naturalism was a compound of literary predilection, nostalgia for the past, an instinctive humanitarianism, and a profound pessimism. It was also a compound of religious and mythological themes transposed into secular actuality. (Herbert, "City versus Country: The Rural Image in French Painting from Millet to Gauguin," *Artforum* 8 [February 1970], p. 48.)

10. *JBH*, vol. 1, p. 158.
11. *JBH*, vol. 2, p. 169.
12. *P&V*, vol. 1, p. 49.
13. Doran, ed., *Conversations*, p. 148.
14. Bailly-Herzberg, ed., *Mon cher Pissarro*, pp. 67–68.
15. Ibid., p. 96.
16. See also chapter 2.
17. *Winter in Montfoucault (Snow Effect)* and *Autumn (Montfoucault Pond)* were shown together in the 1930 centenary exhibition under the same number, as they were considered part of an ensemble. Since the 1950s they have never again been seen together.

Seven:
Figures, Harvests, Market Scenes

1. *JBH*, vol. 1, p. 165.
2. Ibid.
3. Ibid., p. 166. "I am going with the whole family to Madame Piette's house in the Mayenne, where I will find the peasants to my liking."
4. Stéphane Mallarmé, "Crise de vers," *Oeuvres complètes* (Paris, 1945), p. 363.
5. *JBH*, vol. 1, p. 264.
6. Arthur Baignères, *La Chronologie des arts et de la curiosité* (April 10, 1880), in Charles S. Moffett, et al., *The New Painting: Impressionism 1874–1886*, exhibition catalogue (San Francisco and Geneva, 1986), p. 329.
7. Gustave Goetschy, *Le Voltaire* (April 6, 1880), in ibid.
8. Silvestre, *La Vie moderne* (March 11, 1882), in ibid. p. 410.
9. *Paris-Journal* (March 7, 1882), in ibid.
10. John House, "Camille Pissarro's *Seated Peasant Woman*, the Rhetoric of Inexpressiveness," in *Essays in Honor of Paul Mellon*, edited by John Wilmerding (Washington, D.C., 1986), p. 160.
11. Ibid., p. 158. Huysmans here directly challenges House's views, written a hundred years later, in which he refers to Camille Pissarro's "almost exclusive concentration on female peasants."
12. Moffett, *The New Painting*, p. 408. Here again, Huysmans establishes the facts against House's

inaccurate and incomplete remarks: "The gestures he depicts are rarely active and rarely specify a particular activity." (House, "Rhetoric of Inexpressiveness," p. 158.)

13. *JBH*, vol. 1, p. 158.

14. Gustave Flaubert, *L'Amour de l'art* (Paris, 1987), pp. 62–63. There is even a passage in another of Flaubert's letters—of which Pissarro was an avid reader—that could almost apply word for word to describe several of Pissarro's figure paintings: "From all of this, landscapes and the riffraff, there arises within you a serene reverie, which shifts its gaze without stopping on one thing or another. . . . Filled with sunsets, the rustling of streams and foliage, and with scents, with woods and flocks, with memories of human figures in all positions and expressions in the world, the soul, withdrawn in itself, silently smiles through its digestion." (Flaubert, *Correspondance*, vol. 2, p. 290, in J. P. Richard, *Littérature et Sensation* [Paris, 1954], p. 179.)

15. *JBH*, vol. 3, p. 149.

16. Ibid. This essential letter was unfortunately misinterpreted when translated by House ("Rhetoric of Inexpressiveness"), who understood "cela" as referring to the figure, whereas "cela" (neutral demonstrative pronoun) unmistakably designates the picture or the work. House presumably confused "cela" (it, that) for "celle-là" (she, this lady). Consequently, the danger that the picture should suffer from "médiocrité" was misunderstood as "She is not suffering from her poverty." Subsequently, House glossed over his own misunderstanding, "Pissarro's problem here was to show that the woman's reverie was about the human condition, and not about her own lowly material circumstances"—the last three words paraphrasing House's own mistranslation of "médiocrité" by "poverty."

17. Ibid., vol. 2, p. 169.

18. Ibid., p. 64.

19. Ibid., p. 270.

20. Ibid., p. 351.

21. Ibid., p. 102.

22. G.-A. Aurier, "Le Symbolisme en Peinture—Paul Gauguin," *Mercure de France 2* (March 1891), pp. 155–65. See the illuminating article by Belinda Thomson, "Camille Pissarro and Symbolism: Some Thoughts Prompted by the Recent Discovery of an Annotated Article," *The Burlington Magazine* 124 (January 1982), pp. 14–23.

23. According to Aurier, the Impressionists produced works that were nothing but "the faithful translation of a purely physical impression, a 'sensation,' without any beyond." (Quoted in Thomson, "Pissarro and Symbolism," p. 18.)

24. *JBH*, vol. 3, p. 102.

25. Pissarro's political opinions have often wrongly been confused with Socialism; Pissarro was very wary of the Socialist rut, which he identified with bourgeois reaction: "One must challenge those who, under the pretext of Social-ism, of idealistic art, are not, etc., following, in effect, a movement, but a false one, completely false." (Ibid., p. 103.)

26. Ibid., p. 150.

27. Ibid., p. 169.

28. Ibid., p. 217.

29. Ibid., p. 207.

30. Ibid., p. 220.

31. Ibid., vol. 1, p. 178.

32. Ibid., p. 221.

33. Ibid., p. 183.

34. Ibid., pp. 224–25.

35. Ibid., p. 229.

36. Ibid., p. 230.

37. Ibid., p. 224.

38. Ibid., vol 3, p. 149.

39. Ibid., p. 159. Italics in the original.

40. Ibid., p. 167.

41. Cf. *P&V*, vol. 1, p. 274, no. 1393, where this work is dated c. 1884.

42. *JBH*, vol. 3, p. 219.

43. Ibid.

44. Ibid., p. 220. See also section on Figures.

45. Pierre Francastel, *L'Impressionnisme* (Paris, 1974), p. 20.

46. *JBH*, vol. 1, p. 218.

47. Precedents can be found; i.e., his *September Celebration, Pontoise* (fig. 107).

48. Cf. Richard Thomson, *Camille Pissarro: Impressionism, Landscape and Rural Labour* (London, 1990), pp. 66 and 73.

49. Ibid., p. 66; one reads that "In the market scenes, his [Pissarro's] peasants are seen to play their role in a class structure and in a capitalist economy."

50. Ibid., p. 11; Thomson claims that "by the early 1880s his correspondence reveals Pissarro reading such Socialist newspapers as *Le Libertaire* and *Le Prolétaire*." These two newspapers were anarchist, not Socialist. Further on, one reads that Pissarro's "ideology had crystallized in a commitment to anarchism," and anarchism is described, rather sweetly, as "based on a belief in the innate goodness of human nature, which is corrupted by overbearing social organization." In fact, Pissarro never was a Socialist, and his own readings in anarchism throughout the last two decades of his life reveal a more complex and provocative set of thoughts and concepts than that just described.

51. *JBH*, vol. 2, p. 285.

52. Ibid.

53. *JBH*, vol. 3, p. 186.

54. Ibid.

55. Ibid.

56. Ibid.

57. Ibid., p. 103.

58. Ibid., p. 207.

59. Ibid.

60. Ibid., p. 256.

61. Ibid., p. 63.

62. Pissarro wrote of Daumier, "I would really like to see the exhibition of *La Caricature*, and the Daumiers in particular; just think how he mas-tered his *sensation*, that one" (ibid., vol. 2, p. 227), and of Flaubert, "Yet another great artist and how much he had to sacrifice! it is beautiful; it is great" (ibid., vol. 3, p. 134), and, "Flaubert—what a man! What a mind!—what a difference from Zola. Think how he loved art . . . great art . . . I am all dazzled." (Ibid., p. 141.)

63. See Tzvetan Todorov, *Theories of the Symbol* (Ithaca, 1982), p. 306. This figure of speech is called a paronomy.

64. Cf. Thomson, *Landscape and Rural Labour*, p. 67, ill. 77, of J. Trayer, *The Fabric Market*. But according to Pissarro, "Novelty cannot be found in the subject but indeed in the way to express it." (*JBH*, vol. 1, p. 285.)

65. See the continuous exploration of the same motif in various media, formats, etc., in the watercolors and prints of the rue Cappeville, and in particular, the hand-colored etching *Market at Gisors (Rue Cappeville)* (fig. 21).

66. Rewald, *Pissarro*, p. 134, was the first to mention that X-ray photographs taken of PV615 testify to the number of changes that it underwent. More recently Thomson, in *Landscape and Rural Labour*, p. 70, published the X ray of *La Bouchère* next to an illustration of the painting.

67. As Bakhtin explained about fairs, markets, or carnivals: "As theatrical representation, [they] abolish the dividing line between performers and spectators, since everyone becomes an active participant and everyone communes in [them], which is neither contemplated, nor strictly speaking, performed; it is lived." (Quoted by Annette Michelson, "'Where Is Your Rupture?': Mass Culture and the *Gesamtkunstwerk*," in *October*, 56 [Spring 1991], p. 56.)

68. Cf. Mikhail Bakhtin, *L'Oeuvre de François Rabelais et la culture populaire au Moyen Age et sous la Renaissance* (Paris, 1970).

69. As Bakhtin noted aptly about Rabelais, and as one scarcely could put it better about Pissarro's own market scenes. Ibid., p. 10.

70. In Ferry, *Homo Aestheticus*, p. 132.

Eight:
Neo-Impressionism

1. "At last, I have found my execution." (*JBH*, vol. 1, p. 342); "I work a lot in my head; it is a question now to execute." (Ibid., vol. 2, p. 303.)

2. Ibid., vol. 1, p. 336.

3. Ibid., vol. 2, p. 56.

4. Ibid., vol. 2, p. 303.

5. Ibid., vol. 1, p. 252.

6. These drawings are mentioned in ibid., vol. 2, p. 91.

7. This is a replica of a painting of Pontoise and of a motif also executed by Cézanne (now at the Fogg Art Museum, Harvard University, Cambridge, not illustrated).

8. See John Rewald, *Seurat: A Biography* (New York, 1990), p. 73.

9. Theodore Reff rightly pointed out the impor-

tance of Cézanne's work for the formation of Neo-Impressionism: "The neo-impressionists, although far more consistent than Cézanne in their rationalization of both color and touch, may have derived from him a heightened awareness of the canvas as a surface to be covered with tiny strokes." (Reff, "Cézanne's Constructive Stroke," *Art Quarterly* 25 [Autumn 1962], p. 214.) Signac had bought a painting by Cézanne (V 311) circa 1885 and later acknowledged Cézanne's importance: "In juxtaposing by clear square touches without regard for imitation or virtuosity, the various elements of the separate colors, he [Cézanne] more closely approached the methodical divisionism of the neo-impressionists." (Ibid.) Confirming this analysis, Pissarro described some works by his son Georges as "still-lifes . . . daringly begun, a little like the old Cézannes, and quite divided." (*JBH*, vol. 3, p. 23.)

10. Ibid., vol. 1, pp. 293–94.

11. In a significant letter to Durand-Ruel, Pissarro explained the tenets of his new theory: "To seek a modern synthesis by methods based on science, that is, based on the theory of colors developed by M. Chevreul, on the experiments of Maxwell and the measurements of N. O. [*sic*] Rood; to substitute optical mixture for the mixture of pigments; in other words, the separation of tones into their constituent elements, for this type of optical mixture stirs up luminosities more intense than those created by mixed pigments." Pissarro, however, concluded this theoretical explanation with an important practical note, "In my opinion, the only originality consists in the character of the drawing and in the special vision of each artist." (Rewald, *Seurat*, p. 73.) See *JBH*, vol. 2, p. 75. This note is important because it reintroduces, within these theoretical considerations, the problem of individual creation and originality at the core of the rigorous framework of this scientifically oriented system.

12. Quoted in Roger Caillois, *Approches de l'imaginaire* (Paris, 1974), p. 28. Pissarro expressed exactly the same advice to his son, "Don't lose natural feeling . . . and little by little acquire science." (*JBH*, vol. 2, p. 305.)

13. See the exhibition catalogue *Seurat* (Paris, Réunion des Musées Nationaux, and New York, The Metropolitan Museum of Art, 1991), in which Robert Herbert wrote, "If one wants to discover the complete artist, both a poet and a technician, we have to redefine Seurat's science." (P. 22.)

14. Furthermore, the systematic orders of Pissarro's Neo-Impressionist work (i.e., the relational combination or the order of succession between various works, forming a kind of homogeneous pictorial chain) consist in certain types of repetitions. Thus, Pissarro's work possesses a property that Roman Jakobson identified as an essential component of poetical language, a tendency towards repetition: "The form of a word can be apprehended only as it

is a regular and repeated part of a given linguistic system." (In "Modern Russian Poetry: Velimir Khlebnikov," *Major Soviet Writers*, edited by Edward J. Brown [Oxford and New York], 1973, p. 77.) And: "On every level of language the essence of poetic artifice consists in recurrent returns." (In his "Grammatical Parallelism and Its Russian Facet," *Language in Literature*, ed. by Krystyna Pomorska and Stephen Rudy [Cambridge, Mass., 1987], p. 145.)

See also the study of Jakobson's poetics by Todorov in *Theories of the Symbol*, pp. 271–84.

Nine:
Late Landscapes

1. On this particular point, cf. *JBH*, vol. 2, p. 334, which quotes from Gustave Geffroy's preface for the catalogue of the Pissarro exhibition organized by Théo van Gogh at Boussod and Valadon in 1890. Geffroy writes not only of Pissarro's pictorial representation and of his idiosyncrasies but also of:

a whole life of dedicated studies, of knowledge acquired day after day. He may well have experienced some trouble for a while as he groped along for a new way to fragment color and to distribute light; some (a few) of his pictures then may well have confused those who liked his delicately robust talent; but if so, this did not last long. . . . His works presently exhibited testify to the evolution that he attempted, as well as to that accomplished by him. The problem set by the Neo-Impressionists was to fix the impression of a dominating color, as fragmented with the help and hindrance of reflections and complementary colors. The artist solved this problem in his own way, without recourse to the dot system. He stopped mixing colors on the palette; instead, he gathered onto the canvas the fragments to be mixed while preserving their separateness; his intention was that the fusion of colors should happen inside the eye of the observer, and he has almost always conducted the various phases of his work so as to obtain the intended result. As for the dot, the colorful spot, there is none of it. On the contrary, the painter has considerably varied his brushwork, producing large streaks of tempera which follow the direction of the objects, or adjusting the shape of each brushstroke to the shape of these objects, as in his oil paintings.

2. *P&V*, vol. 2, pp. 174–88. These figures reflect only the works known to Ludovic-Rodo Pissarro and Lionello Venturi in 1939. To these should be added the works in the supplement to the catalogue raisonné by John Rewald.

3. *JBH*, vol. 2, p. 341. Even as early as 1886, Pissarro complained, "I am working hard, but

how time consuming! . . . you would not believe that it takes me three or four times longer to finish a canvas or a gouache. . . . I am losing my mind." (Ibid., p. 74.)

4. Ibid., vol. 3, p. 111.

5. See ibid., vol. 2, p. 35 (1886): "I hope that we shall manage without the old Impressionists"; and ibid., p. 80: "We no longer get on. . . . It is well over with the Impressionists . . . our role will be very simple: to act alone!"; and ibid., p. 137, "Monet and Renoir are snubbing me." Reciprocally, Pissarro then found Monet's pictures "somewhat black," Renoir's work "incomprehensible," and Sisley's "very skillful, quite fine, but absolutely off!" (Rewald, ed., *Lettres à Lucien*, p. 146.)

6. *JBH*, vol. 2, p. 292.

7. Rewald, ed., *Lettres à Lucien*, p. 156, and *JBH*, vol. 2, p. 194. The same letter is published in each book with a different order of paragraphs.

8. See *JBH*, vol. 3, p. 21, "If only I could exhibit them [my watercolors]! But you think that this would cost too much to arrange: I have 161 of them. Georges thinks they are much more beautiful than my painting." See also ibid., pp. 81 and 161.

9. See ibid., p. 337.

10. *Peasants near the Walnut Tree, Eragny* (PV787, not illustrated) represents the development of the trees surrounding the walnut tree over this seven-year period.

Ten:
Travels and Series Campaigns

1. Georges, who had married his cousin Esther Isaacson, had a son, Tommy, born August 31. Tragically, Esther died two days after giving birth. Lucien, who had married Esther Bensusan, had a daughter, Orovida, born October 2.

2. See chapter 4 on London and the Franco-Prussian War.

3. *JBH*, vol. 3, p. 248.

4. Ibid., p. 227.

5. Ibid., p. 228.

6. Ibid., vol. 2, p. 270.

7. See Roland Barthes's definition: "A poetical word can never be false because it is a totality; it shines with infinite freedom and is set to cast its rays towards a thousand undefined and possible relationships." (*Le Degré zéro de l'écriture* [Paris, 1953], p. 70.)

8. My thanks to Christopher Lloyd for this very useful information.

9. For a broader discussion of the pictorial dialogue between Monet and Pissarro around Rouen, see Joachim Pissarro, *Monet's Cathedral: Rouen 1892–1894* (London and New York, 1990), pp. 12ff.

10. Quoted in Pissarro, *Monet's Cathedral*, p. 12. Also in *JBH*, vol. 1, p. 243.

11. Of which Turner had also executed a drawing referred to by Pissarro in his correspondence. *JBH*, vol. 1, pp. 248–49 and 252.

12. *JBH*, vol. 1, pp. 240–41; Rewald, ed., *Lettres à Lucien*, pp. 60–63; translation, partly revised by Joachim Pissarro, in Rewald, ed., *Letters to Lucien*, pp. 42–43.

13. Flaubert, *Correspondance*, vol. 1, p. 396.

14. Letter from Flaubert to Huysmans, where Flaubert protests against the "beautiful object."

15. *JBH*, vol. 4, pp. 266–67.

16. *JBH*, vol. 3, p. 256.

17. Pissarro phrased this paradox in another letter (*JBH*, vol. 1, p. 262): "Do not forget that one must be nothing but oneself. But one is not oneself without efforts."

18. P. G. Hamerton, "The present state of the fine arts in France: IV—Impressionism," *Portfolio*, 22 (February 1891), pp. 72–73. Quoted in John Rewald, *Camille Pissarro* (New York, 1963), p. 143.

19. *JBH*, vol. 4, p. 168; also quoted in Rewald, *Camille Pissarro*, p. 144.

20. According to a saying of the time, the newly created Avenue de l'Opéra did little but enlarge and embellish the perspective enjoyed by the concierge of the Hôtel du Louvre. Cf. Walter Benjamin, "Passages," in *Paris, capitale du 19ᵉ siècle* (Paris, 1989), p. 57.

21. The catalogue raisonné title of this work is *The Pont Neuf, The Statue of Henri IV, Morning*, whereas clearly the projected shadows indicate that this is an early afternoon scene.

Eleven:
Interiors: Still Lifes, Portraits

1. Although this painting was dated "around 1870" by Ludovic-Rodo Pissarro, I am inclined to ascribe a later date to it, c. 1872–73.

2. See the penetrating text on this work by Marc S. Gerstein, *Impressionism: Selections from Five American Museums* (New York, 1989), p. 142. Gerstein evokes here "the angled, projecting elements that establish recession; the contrasting play of shapes, textures and visual effects — rough : smooth, opaque : transparent, simple : complex, concave : convex, closed : open, standing : hanging, horizontal : vertical" —which organize the painting into "a tight-knit asymmetrical arrangement and carefully calculated internal rhythms." Cf. also Christopher Campbell, "Pissarro and the Palette Knife," *Apollo*, 136, no. 369 n.s. (November 1992).

3. A technique whose consistency in Pissarro's work was discovered by M. Charles de Couessin and which he called "réserve de matière" (withholding the paint). The impact of this technique on the art of Cézanne and Gauguin was considerable. (Unpublished lecture, Musée d'Orsay, Paris, January 1989.)

4. *JBH*, vol. 3, p. 164.

5. See Richard R. Brettell, *An Impressionist Legacy, the Collection of the Sara Lee Corporation* (New York, 1990), p. 20.

6. *JBH*, vol. 1, pp. 266–67.

7. Ibid., p. 191.

8. Ibid.

9. More so than in the magnificent *Portrait of C. Pissarro* (PV 200, not illustrated).

10. *JBH*, vol. 3, p. 150.

11. Ibid., vol. 1, p. 353.

12. Ibid., p. 201.

SELECTED BIBLIOGRAPHY

Adler, Kathleen. *Camille Pissarro: A Biography.* London: B. T. Batsford, 1978.

Aurier, G.-A. "Le Symbolisme en peinture—Paul Gauguin." *Mercure de France 2*, March 1891.

Bachelard, Gaston. *L'Air et les songes.* Paris: José Corti, 1943. Translation: *Air and Dreams: An Essay on the Imagination of Movement.* Dallas: The Dallas Institute Publications, 1988.

Bailey, Colin B., Joseph J. Rishel, and Mark Rosenthal, with the assistance of Veerle Thielemans. *Masterpieces of Impressionism and Post-Impressionism: The Annenberg Collection.* The Philadelphia Museum of Art, in association with Harry N. Abrams, New York, 1989.

Bakhtin, Mikhaïl. *L'Oeuvre de François Rabelais et la culture populaire au Moyen Age et sous la Renaissance.* Paris; Gallimard, 1970. Translation: *Rabelais and His World.* Trans. Helene Iswolsky. Bloomington: Indiana University Press, 1984.

Barr, Alfred H., Jr. *Matisse: His Art and His Public.* New York: The Museum of Modern Art, 1951.

Benjamin, Walter. "Passages." In *Paris, capitale du 19ᵉ siècle.* Paris: Du Cerf, 1989.

Blanchot, Maurice. *Le Livre à venir.* Paris: Gallimard, 1959.

Borzello, F., and A. L. Rees, eds. *The New Art History.* London: Camden Press, 1986.

Boulton, Alfredo. *Camille Pissarro en Venezuela.* Caracas: Editorial Arte, 1966. Translation: *Pissarro in Venezuela.* New York: Center for Inter-American Relations and J. B. Watkins, 1968.

Brettell, Richard R. "Camille Pissarro: A Revision." In *Pissarro.* London: Arts Council of Great Britain; Boston: The Museum of Fine Arts, 1980.

——. *Pissarro and Pontoise: The Painter in a Landscape.* New Haven and London: Yale University Press, 1990.

Brettell, Richard R., and Christopher Lloyd. *Catalogue of Drawings by Camille Pissarro in the Ashmolean Museum.* Oxford and New York: Oxford University Press, 1980.

Brettell, Richard R., and Joachim Pissarro. *The Impressionist and the City: Pissarro's Series Paintings.* New Haven and London: Yale University Press, in association with the Dallas

Museum of Art, the Philadelphia Museum of Art, and the Royal Academy of Arts, London, 1992.

Cachin, Françoise. *Gauguin.* Paris: Hachette/Pluriel, 1968.

Caillois, Roger. *Approches de l'imaginaire.* Paris: Gallimard, 1974.

Cézanne, Paul. *Conversations avec Cézanne.* Ed. P. Michael Doran. Paris: Macula, 1978.

——. *Paul Cézanne: Correspondance.* Ed. John Rewald. Paris: B. Grasset, 1978. Translation: *Cézanne: Letters.* 5th rev. ed. New York: Hacker Art Books, 1985.

Champa, Kermit. *Studies in Early Impressionism.* New Haven and London: Yale University Press, 1973.

Daulte, François. *Le Centenaire de l'Impressionnisme.* Tokyo: Jomiuri Shimbun, 1974. Exhibition catalogue.

Distel, Anne, Christopher Lloyd, et al. *Pissarro.* London: Arts Council of Great Britain; Paris: Musées de France; Boston: The Museum of Fine Arts, 1980. Exhibition catalogue.

Ferry, Luc. *Homo Aestheticus: L'Invention du Goût à l'Age Démocratique.* Paris: Bernard Grasset, 1990.

Ferry, Luc, and A. Renaut. *Système et critique.* Brussels: Ousia, 1984.

Flaubert, Gustave. *Gustave Flaubert—correspondance.* Ed. Jean Bruneau. Vol. 2. *July 1851–December 1858.* Paris: Gallimard, 1980.

——. *L'Amour de l'art.* Paris: Ressouvenances, 1987.

Francastel, Pierre. *L'Impressionnisme.* Paris: Denoël, 1974.

Furst, Lillian R. "Zola's Art Criticism." In *French 19th Century Painting and Literature.* Ed. Ulrich Finke. Manchester: Manchester University Press, 1972.

Groys, Boris. *Staline: oeuvre d'art totale.* Ed. Yves Michaud; trans. Edith Lalliard. Nîmes: J. Chambon, 1990. Translation: *The Total Art of Stalinism: Avant-Garde, Aesthetic Dictatorship, and Beyond.* Trans. Charles Rougle. Princeton: Princeton University Press, 1992.

Habermas, Jürgen. *Der philosophische Diskurs der Moderne: Zwölf Vorlesungen.* Frankfurt: 1985. Translation: *The Philosophical Discourse*

of Modernity: Twelve Lectures. Ed. and trans. Frederick G. Lawrence. Cambridge: MIT Press, 1987.

———. The Structural Transformation of the Public Sphere (An Inquiry into a Category of Bourgeois Society). Trans. Thomas Burger with the assistance of Frederick Lawrence. Cambridge: MIT Press, 1989.

Hauser, Arnold. The Social History of Art. 1951. Reprint. 4 vols. New York: Random House, 1985.

Herbert, Robert. "City versus Country: The Rural Image in French Painting from Millet to Gauguin." Artforum 8, February 1970.

House, John. "New Material on Monet and Pissarro in 1870–71." The Burlington Magazine 120, October 1978.

———. "Camille Pissarro's Idea of Unity." In Studies on Camille Pissarro. Ed. Christopher Lloyd. London: Routledge & Kegan Paul, 1986.

———. "Camille Pissarro's Seated Peasant Woman, the Rhetoric of Inexpressiveness." In Essays in Honor of Paul Mellon. Ed. John Wilmerding. Washington, D.C.: National Gallery of Art, 1986.

Jakobson, Roman. "Modern Russian Poetry: Velimir Khlebnikov." In Major Soviet Writers: Essays in Criticism. Ed. Edward J. Brown. Oxford and New York: Oxford University Press, 1973.

———. "Grammatical Parallelism and Its Russian Facet." In Language in Literature. Ed. Krystyna Pomorska and Stephen Rudy. Cambridge, Mass: Harvard University Press, 1987.

Jarvis, J. A. Camille Pissarro (Noted Painter from the Virgin Islands). Charlotte Amalie, Saint Thomas, U.S.V.I.: The Art Shop Press, 1947.

Jean, Raymond. Cézanne, la vie et l'espace. Paris: Du Seuil, 1986.

Kunstler, Charles. Pissarro: villes et campagnes. Lausanne: International Art Books; Paris: SPADEM, 1967. Translation: Pissarro: Cities and Landscapes. New York: French and European Publications, [1967].

Laÿ, Jacques and Monique. Louveciennes, mon village. Paris: Imprimerie de l'Indre, 1989.

Lloyd, Christopher. Pissarro. Geneva: Editions d'Art, Albert Skira; London: Macmillan, 1981.

———. "Camille Pissarro at Princeton." Record of the Art Museum, Princeton University 41, no. 1 (1982).

———, ed. Studies on Camille Pissarro. London: Routledge & Kegan Paul, 1986.

Mallarmé, Stéphane. "Crise de vers." Oeuvres complètes. Paris: Gallimard, 1945.

Meadmore, W. S. Lucien Pissarro: un coeur simple. London: 1962.

Melot, Michel. "La Pratique d'un artiste: Pissarro graveur en 1880." Histoire et Critique des Arts 2, June 1977.

Merleau-Ponty, Maurice. L'Oeil et l'esprit. 1964. Reprint folio. Paris: Gallimard, 1990. Translation: "Eye and Mind." In The Primacy of Perception. Northwestern University Studies in Phenomenology and Existential Philosophy, ed. James M. Edie. Chicago: 1964.

Michelson, Annette. "'Where Is Your Rupture?' Mass Culture and the Gesamtkunstwerk." October, Spring 1991.

Moffett, Charles S., et al. The New Painting: Impressionism 1874–1886. Exhibition catalogue. San Francisco: The Fine Arts Museums; Geneva: R. Burton, 1986.

Piette, Ludovic. Mon cher Pissarro: Lettres de Ludovic Piette à Camille Pissarro. Ed. Janine Bailly-Herzberg. Paris: Valhermeil et Association Les Amis de Camille Pissarro, 1985.

Pissarro, Camille. Catalogue des Oeuvres Importantes de Camille Pissarro composant la Collection Camille Pissarro. Vol. 4. Sale catalogue of the estate of Julie Pissarro, at the Galerie Georges Petit, Paris, December 3, 1928.

———. Camille Pissarro: lettres à son fils Lucien. Ed. John Rewald. Paris: Albin Michel, 1950. Translation: Camille Pissarro: Letters to His Son Lucien. 4th rev. ed. Ed. John Rewald with the assistance of Lucien Pissarro. Trans. Lionel Abel. London: Routledge & Kegan Paul, 1980; Santa Barbara and Salt Lake City: Peregrine Smith, 1981.

———. Correspondance de Camille Pissarro. Ed. Janine Bailly-Herzberg. 5 vols. Paris: Presses Universitaires de France; Pontoise: Valhermeil, 1980–91.

Pissarro, Joachim. Monet's Cathedral: Rouen 1892–1894. London: Pavilion; New York: Alfred A. Knopf, 1990.

Pissarro, Ludovic-Rodo, and Lionello Venturi. Camille Pissarro: son art—son oeuvre. 2 vols. Paris: Paul Rosenberg, 1939.

Reff, Theodore. "Cézanne's Constructive Stroke." Art Quarterly 25, Autumn 1962.

———. "Pissarro's Portrait of Cézanne." The Burlington Magazine 109, November 1967.

Reid, Sir Martin. "Camille Pissarro: Three Paintings of London of 1871: What Do They Represent?" The Burlington Magazine 119, April 1977.

Rewald, John. Camille Pissarro. New York: Harry N. Abrams, 1963.

———. Camille Pissarro in Venezuela. New York: Hammer Galleries, 1964.

———. The History of Impressionism. 4th rev. ed. New York: The Museum of Modern Art, 1973.

———. Cézanne. New York: Harry N. Abrams; Paris: Flammarion, 1986.

———. Seurat: A Biography. New York: Harry N. Abrams; London: Thames and Hudson, 1990.

Richard, Jean-Pierre. Littérature et sensation. Paris: Du Seuil, 1954.

———. Poésie et profondeur. Paris: Du Seuil, 1955.

Schapiro, Meyer. Cézanne. New York: Harry N. Abrams, 1952.

Schirrmeister, Anne. Camille Pissarro. New York: The Metropolitan Museum of Art, 1982.

Shapiro, Barbara S. Camille Pissarro: The Impressionist Printmakers. Boston: The Museum of Fine Arts, 1973.

Shiff, Richard. Cézanne and the End of Impressionism. Chicago and London: The University of Chicago Press, 1984.

———. "Review article" [recent Pissarro publications]. The Art Bulletin 66, December 1984.

Shikes, Ralph E., and Paula Harper. Pissarro: His Life and Work. New York: Horizon Press, 1980.

Thomson, Belinda. "Camille Pissarro and Symbolism: Some Thoughts Prompted by the Recent Discovery of an Annotated Article." The Burlington Magazine 124, January 1982.

Thomson, Richard. Camille Pissarro: Impressionism, Landscape and Rural Labour. London: The South Bank Centre and The Herbert Press, 1990.

Todorov, Tzvetan. Mikhaïl Bakhtine: le principe dialogique. Paris: Du Seuil, 1981.

———. Théories du symbole. Paris: Du Seuil, 1977. Translation: Theories of the Symbol. Ithaca: Cornell University Press, 1982.

Venturi, Lionello. Les Archives de l'Impressionnisme. Vol. 2. Paris and New York: Durand-Ruel, 1939.

Zola, Emile. Emile Zola—le bon combat de Courbet aux Impressionnistes. Ed. Jean-Paul Bouillon. Paris: Hermann, 1974.

INDEX

All works are by Camille Pissarro unless otherwise indicated. Text references are in roman type: references to pages on which illustrations appear are in *italics*.

Abreuvoir de Montfoucault, L' (Pond at Mont-foucault), 146, 147, 151; *148*
"absolute liberty," 163, 202
Académie des Beaux-Arts, 7
Académie Suisse, 41, 74, 90, 153
All Saints' Church, Upper Norwood, 80, 86; *81*
 studies for, 80; *81, 82*
Angelus (Millet), 147, 160
Apple Picking at Eragny, 194, 198; *196*
Apple Trees in a Field, 234, 236; *235*
Apple Trees, Sunset, Eragny, 237; *240*
Arosa, Gustave, 95
Artist's Daughter, The, 283; *285*
Artist Sketching a Camping Scene, An, *24*
Aurier, Georges-Albert, 161
Autumn, 94–95; *101–2*
Autumn: Montfoucault Pond, 146, 147, 151; *148*
Auvers, 88–135, 150
Avant-port de Dieppe, L' (Inner Harbor of Dieppe), 260, 266; *258*
Avant-port et Anse des pilotes, Le Havre, L' (Inner Harbor and Pilots' Jetty, Le Havre), 266–67; *265*
Avenue de l'Opéra, L', 261; *262*
Avenue, Sydenham, The, 79; *77*
Aveugles, Les (Maeterlinck), 161

Bachelard, Gaston, 61
backgrounds, in portraits and still lifes, 275, 282–83; *280*
 wallpaper as
 in portraits, 282–83; *280*
 in still lifes, 275
Bakhtin, Mikhail, 56
Banks of the Marne in Winter, The, 48, 50, 52, 65; *47*
Banks of the Oise in Pontoise, 16, 110–11; *108*

Barbizon painters, 41, 76
Bather in the Woods, 170
Bathers, 161; *168*
Bazincourt, 225, 228, 234, 236
Bedford Park. See *View Across Stamford Brook Common*
Bensusan, Esther, 248
Bernard, Paul-Albert, 199
Berneval, 241
Big Walnut Tree at Eragny, The, 237; *238*
Bing, Siegfried, exhibition, 160
Boïeldieu Bridge at Rouen, Misty Weather, The, 253; *254*
Boïeldieu Bridge at Rouen, Sunset, The, 253; *255*
Bonington, Richard Parks, 252
Bonnard, Pierre, 8
Bonne, La (The Maidservant), 16, 41; *14*
Boulevard de Clichy, Winter, Sunlight Effect, 261; *262*
Boulevard des Italiens, Afternoon, 260–61; *259*
Boulevard des Italiens, Morning, Sunlight, 260–61; *259*
Boulevard Montmartre, Spring, 260, 266; *261*
Boulton, Alfredo, 25
Bouquet of Flowers, 274; *274*
Bouquet of Flowers: Chrysanthemums in a China Vase, 268, 271; *269*
Bouquet of Flowers: Irises, Poppies, and Blossoming Cabbage, 268, 274, 275; *270*
Bracquemond, Félix, 107
Brettell, Richard, 58, 60
Brickyard at Eragny, Sunset, The, 217; *220*
Brickyard at Eragny, The, 217; *219*
bridges, 12, 242, 249; *244*
 in Rouen series, 253, 256, 260; *251, 254, 255*
Brittany, 74
Butcher, The, 202, 210, 211; *200*

Café au Lait, 156, 215; *158*
 study for, 156; *158*
Calf Market at Gisors, 203; *206*
Campfire Scene, *26*
Caracas, 7, 16, 19, 25–37, 198
Caracas, Treescape, 27; *29*
Cardplayers in Galipán, 30; *36*

caricature
 in market scenes, 203, 209–10; *15, 201, 206, 208, 209*
 in portraits, 282–83; *280*
Carnot, Sadi, President, 248
Carousel, The, 190; *191*
Cassatt, Mary, 107
Castagnary, Jules-Antoine, 70
catalogue raisonné, 43, 60, 224
cathedrals, in series, 252, 253, 260; *258*
Cézanne, Hortense, 90
Cézanne, Paul, 8, 12, 19, 25, 27, 30, 41, 52–53, 56, 61, 72, 88, 90–91, 94–95, 105–6, 109, 115, 121, 136, 146, 147, 150, 217, 220, 237, 271, 275, 282–83
 Louveciennes, 72; *73*
 The Meadow of Les Mathurins at Pontoise (L'Hermitage), 91, 94, 95; *96*
 The Path from the Ravine, Viewed from L'Hermitage, 95, 115; *106*
 Portrait of Cézanne (Pissarro), 282; *280*
Champfleury, 203
Champigny-sur-Marne, 39
Charing Cross Bridge, London, 242, 249; *244*
Chelsea Bridge, 242, 249; *244*
Chesneau, Ernest, 156
Chestnut Trees at Louveciennes, Spring, 66, 69–70; *67*
Chevreul, Eugène, 221
Chintreuil, Antoine, 41
Christian Symbolism, 199
Colet, Louise, 25
color, Cézanne's use of, 90, 94
Conquête du Pain, La (Kropotkin), 163
Constable, John, 45
Corner of Les Halles, A, 202; *206*
Corot, Camille, 37, 41, 43, 90, 156
Côte des Boeufs at L'Hermitage, near Pontoise, The, 121; *135*
Côte du Jallais, Pontoise, La, 115; *130*
Cottages at Auvers, 115; *131*
Courbet, Gustave, 41, 95, 150, 282–83
Cowgirl, The, 157, 160
Cowgirl at Eragny, 160; *166*
 study for, 160; *167*
Cowgirl, Eragny, 217, 221; *216*
Cowgirl, Pontoise, 171
Cowherd on the Route du Chou, Pontoise, A, 111; *112*
Crystal Palace, The, 86; *87*
Cubism, 56

Daubigny, Charles-François, 41, 45, 47–48, 51, 90; *46*
Daumier, Honoré, 90, 95, 203
Degas, Edgar, 7, 11, 12, 27, 52, 88, 106–7, 109, 147, 183, 186, 194, 198, 199, 202, 210, 211, 212, 224–25
Delacroix, Eugène, 30, 53, 95
"dessin imprimé" ("printed drawing"), 198
Dewhurst, Wynford, 76, 79
diagonal hatching, 19, 27, 30, 37, 43, 90, 220

Dieppe series, 260; *258*
divisionism, 154, 221
 see also Neo-Impressionism
Donkey Ride in La Roche-Guyon, 50; *49*
Donkeys Out to Pasture, 143
Dostoyevsky, Feodor, 211
Duez, Ernest, 199
Dulwich College, London, 86; *85*
Durand-Ruel, Paul, 38, 76, 138, 212, 252, 290
Duret, Théodore, 58, 60, 71, 75, 143, 146–47, 152, 190

eighth Impressionist exhibition (1886), 90, 106, 212
England. *See* London
Entering a Village, 39; *43*
Entering the Village of Eragny, 225; *228*
Entrée du Village de Voisins (Entering the Village of Voisins), 61; *63*
Eragny, 12, 16, 39, 121, 152, 225–41, 242
Eragny, 225; *226*
Eragny, Twilight, 225; *227*
Estruc, Madame F., Portrait of, 283; *281*
Excursion au Mont Avila—Venezuela, 24
exhibitions. *See* Impressionist exhibitions; Salons

Farm at Montfoucault, 142; *141*
Faure, Jean-Baptiste, 53, 56
Female Figure in a Hat Holding a Fowl, with a Study of Her Head in Profile, 207, 209; *208*
Fields at Berneval, Morning, The, 241; *241*
Fields at Eragny, 225; *229*
fifth Impressionist exhibition (1880), 107, 156
Figure couronée (Crowned Figure) (Lucien Pissarro), 160
Flaubert, Gustave, 25, 157, 190, 203, 256, 257
Flock of Sheep, Eragny, The, 180
Flock of Sheep in a Field After the Harvest, Eragny, 194, 198; *193*
Flood in Pontoise, 114–15; *117*
Flood, Saint-Ouen-l'Aumône, The, 114–15; *117*
Flood, Twilight Effect, Eragny, 234; *234*
Foire autour de l'église Saint-Jacques, Dieppe, La (The Fair at the Church of Saint-Jacques, Dieppe), 260; *258*
Fond de L'Hermitage, Le (The Woods of L'Hermitage), 121; *132*
Foot Bath, The, 170
Fourges, 39
Francastel, Pierre, 194
France. *See* series paintings; Pissarro, Camille: travels; under names of towns
Franco-Prussian War, 43, 60, 74, 75, 76, 105, 277
Frederick David, April 12, 1852, 19, 22; *20*
Frost, View from Bazincourt, 228; *231*
Frost, Young Peasant Making a Fire, 183, 217, 221; *171*
Fruit Merchant, 30; *32*

Gachet, Paul, Dr., 88, 90
Garden at Pontoise, The, 115; *120*
 study for, 115; *121*
Gardener, Afternoon Sun, Eragny, The, 178
Gardener, The (Old Peasant with Cabbage), 182
Gardens of L'Hermitage, Pontoise, The, 51–52; *54*
Gasquet, Joachim, 19
Gauguin, Paul, 8, 37, 153, 157, 161, 163, 275
Girl in a Field with Turkeys, 180
Girl Seated with a Doll, 283; *286*
Girl Sewing, 169
Girl Tending a Cow in a Pasture, 115, 156; *126*
Girl Washing Plates, 174
Gisors, 199, 203
Gisors Market, The, 203; *201*
 Compositional Study for, 203; *201*
Gisors, New Section, 90, 220; *92*
Glaneuses, Les (The Gleaners), 194, 199; *195*
Goetschy, Gustave, 156
Gogh, Theo van, 215
Gogh, Vincent van, 90
Gowing, Lawrence, Sir, 56
Grain Market at Pontoise, 203; *207*
Groves of Chestnut Trees at Louveciennes, 66, 69–70; *67*
Guillaumin, Armand, 136, 217

Hamerton, P. G., 260
Hampton Court Green, 242; *245*
harbors, in series, 252, 253, 260, 266–67; *253, 258, 265*
harvest scenes, 2, 143, 183–99, 210
Harvest, The, 194, 210; *2, 193*
Haussmann, Georges-Eugène, Baron, 260
Hawkins, Louis Welden, 12
Hay Harvest, Eragny, The, 194; *195*
Haymakers at Eragny, 221; *223*
Haymakers Resting, 188, 190; *189*
Haymaking at Eragny, 183; *185*
Haystack, Pontoise, The, 111, 114, 115; *113*
Head of a Seated Woman, 37; *36*
Hermitage. *See under* L'Hermitage
Hermitage at Pontoise, The, 51; *51*
Hermitage, Effect of Snow, The, 121; *133*
Histoire de la Caricature (Champfleury), 203
House in the Fields, Rueil, The, 121; *134*
House in the Forest, The, 70–71; *71*
Huysmans, Joris-Karl, 147, 157, 256, 257

Ile Lacroix in Rouen, L', 252; *250*
Impressionism, 7, 8, 12, 25, 37, 58, 80, 83, 88–135, 183
 aim of, 90
 definition of, 194
 light and, 70–71

pictorial concerns of, early, 91
Pissarro and Cézanne and, 88, 90–91, 94–95,
 105–6, 165, 186
rural work and, 186
series works in, 253
see also sensation
Impressionist exhibitions, 8, 90, 107, 271
 third (1877), 271
 fifth (1880), 107, 156
 seventh (1882), 156, 157
 eighth (1886), 90, 106, 212
industrial pictures, 80
Ingres, Jean-Dominique, 30, 53
interiors, 268–90
 portraits, 277–90
 still lifes, 268–76

Jallais Hills, Pontoise, The, 51–52, 61; *50*
Jardin du Carrousel, Le, 261; *265*
Jardin du Louvre, Morning, Gray Weather, 261;
 264
Jeanne Reading, 283; *289*
Jeune Fille à la baguette, paysanne assise
 (Country Girl with a Stick, Seated Peasant),
 157, 215; *159*
John of the Cross, Saint, 268, 271
Jour et la Nuit, Le, 106–7

Kelly, Ellsworth, 53
Kensington Gardens, London, 242, 249; *246*
Kew Gardens, 236
Kew Gardens: Path Between the Pond and the
 Palm House, 236, 248, 249; *235*
Kew Green, 242; *246*
kiosk-*pissoir,* 266; *265*
kitchen gardens, 12, 114, 115, 237; *118, 119*
Kitchen Gardens, Pontoise, 115; *119*
Kneeling Woman, 173
Knocke Windmill, Belgium, The, 248; *247*
Kropotkin, Petr Alekseyevich, Prince, 163

Landscape: The Harvest, Pontoise, 115; *125*
Landscape at Les Pâtis, Pontoise, 1867, 51–52;
 57
Landscape at Lower Norwood, 79–80; *78*
Landscape—Fields, Eragny, 237; *238*
Landscape, Gray Weather at Eragny, 237, 241;
 240
Landscape near Louveciennes, 66, 69; *68*
Landscape near Pontoise, the Auvers Road, 111;
 112
Landscape Under Snow, Upper Norwood,
 79–80; *79*
Landscape with a White Horse in a Meadow,
 L'Hermitage, 115, *118*
Landscape with Cowgirl and Cows, 160; *166*

Landscape with Factory, 44–45; *45*
Landscape with Rocks, Montfoucault, 139, 142,
 150; *137*
Landscape with Strollers Resting Under Trees,
 70–71, 111, 114; *70*
La Roche-Guyon, 39
La Roche-Guyon, 39, 43; *40*
Latouche, Louis, 138
La Varenne-Saint-Hilaire, View from Champigny,
 39; *42*
La Varenne-Saint-Maur, 39
Le Havre series, 265, 266–67
Letter to Georges Viau, 194, 198; *197*
Lettre à d'Alembert (Rousseau), 211
L'Hermitage, 51–52, 53, 56–57, 61, 88, 91, 111, 115,
 121
 see also under *Hermitage*
L'Hermitage at Pontoise, 51–52, 53, 56, 111, 115;
 54, 119
light, 72
 Impressionism and, 70–71
 Neo-Impressionism and, 221
 in Pontoise works, 110, 121; *89, 108*
line, color and, 27, 30, 53, 56
"literary painting," 11–12
Little Bridge, Pontoise, The, 121; *134*
Little Country Maid, The, 183; *184*
London, 12, 16, 60, 74–87, 215, 242
Lordship Lane Station, 80, 86; *84*
Louveciennes, 12, 16, 58–73, 74, 75, 76, 88, 90,
 94, 95, 277
 Impressionism and, 71, 72
Louveciennes, 69, 72; *68*
Louveciennes (Cézanne), 72; *73*
Louvre, 18
Louvre, Afternoon, Rainy Weather, The, 266;
 265
Louvre, Morning, Sun, The, 264
Lovers' Meeting, 22; *23*
Lovers Seated at the Foot of a Willow Tree, 178
Lovers' Well, The, 22; *21*
Luce, Maximilien, 8, 90

Madame Charpentier and Her Children (Renoir),
 154
Maeterlinck, Maurice, 161
Mallarmé, Stéphane, 154
Manet, Edouard, 52, 58, 95, 212, 290
manière grise, 109
Man with a Stick, 194, 198; *197*
Marché aux cochons, foire de la Saint-Martin,
 Pontoise, Le (Pig Market, Saint-Martin Fair,
 Pontoise), 217; *214*
Marché de Pontoise, Le (The Market at
 Pontoise), 16; *17*
March Sun, Pontoise, 115; *122*
Mare à Ennery, La (The Pond at Ennery), 115; *132*
Maria, Honfleur, La (Seurat), 252; *251*
Market at Gisors (Rue Cappeville), 30; *31*
Market at Gisors, The, 16, 209, 210; *15*
Market at Pontoise, 210, 217; *209, 214*
Marketplace, Gisors, 209, 210; *208*

market scenes, 12, 16, 30, 56, 183, 198–211
 Impressionism and, 202
 Neo-Impressionism and, 217; *214*
 see also under *Market*
Marne at Chennevières, The, 45, 47–48, 50–51,
 65; *46*
Martin, Martin-Ferdinand, "Le Père," 138
Marx, Karl, 199
Maternity, 277, 282; *278*
Matisse, Henri, 8, 53, 121
 Red Studio, 275; *275*
Meadow at Eragny, The, 228; *230*
Meadow of Les Mathurins at Pontoise, The
 (L'Hermitage) (Cézanne), 91, 94, 95; *96*
Melbye, Anton, 39
Melbye, Fritz, 19, 25, 27, 41
memory, impression after, 165, 194, 198
Mère Larchevêque, La, 156
Mère Presle, Montfoucault, La, 142, 146; *144*
Merleau-Ponty, Maurice, 57
Millet, Jean-François, 143, 147, 156–57
 Angelus, 147, 160
Mirbeau, Octave, 157, 160, 290
Mirbeau's Garden, the Terrace, Les Damps
 (Eure), 236; *236*
Moisson de Montfoucault, La (The Harvest at
 Montfoucault), 136, 142, 143; *137*
Monet, Claude, 27, 39, 41, 61, 72, 76, 79, 152, 156,
 212, 224–25, 237, 252, 260
 Road to Versailles at Louveciennes, Snow
 Effect, 16; *62*
"monotype," 198
Montfoucault, 60, 74, 75, 76, 136–51, 152
Montfoucault, 142; *142*
Montfoucault Pond, Winter Effect, The, 150, 151
Montmartre, 12, 39
Montmorency, 39
Montmorency, 39; *40*
Mother and Child
 (1863 or 1865) 277; *278*
 (1878) pencil and charcoal, 282; *278*
 (1878) tempera and gouache, 282; *279*
Mottez, Victor, 95
Mourey, Gabriel, 257
Murer, Eugène, 7, 8

Nap, Peasant Lying in the Grass, Pontoise, The,
 160; *164*
Native Women Washing, Saint Thomas, 22, 25;
 23
nature
 drawing from, 165, 186, 194
 love of, 199, 202
 Neo-Impressionism and, 224
 transformations of, 237; *238*
Near Sydenham Hill, 80, 86; *83*
Neo-Impressionism, 8, 16, 90, 106, 183, 188, 212–
 23, 224–25, 227, 237, 249; *184, 214, 218*
 use of dots in, 212–23, 225
Normandy, 39
Nude, 153; *153*
Nurse and Child, 282; *278*

O

Old Houses at Eragny, 217; *176*
Osny, 152, 225
Outskirts of Louveciennes, the Road, 61, 69, 71; *63*
Outskirts of Pontoise, Grouettes Hill, 115; *124*

P

"painter's painting," 11, 12
Papeille, Père, Portrait of, Pontoise, 283; *281*
Paris, 7, 8, 12, 16, 18, 37, 38–39, 41, 60, 90, 121, 138, 153, 249
 series paintings of, 12, 260–61, 264, 266; *259, 261, 262, 263, 265*
Passy, 18
Pasture, Sunset, Eragny, 228; *232*
Path from the Ravine, Viewed from L'Hermitage, The (Cézanne), 95, 115; *106*
Path of L'Hermitage at Pontoise, 115; *127*
Pâtis, Pontoise, Le, 43; *44*
Paysage d'Eragny, 217; *216*
Paysage près de Pontoise, 115; *125*
Paysage sous bois à L'Hermitage (Woods and Undergrowth at L'Hermitage), 107, 109; *107*
Pea Harvest, The
 (1880) 183; *185*
 (1885) 183; *185*
Pear Trees in Bloom at Eragny, Morning, 217; *213*
Peasant Gathering Grass, 176
Peasant Girl with a Stick, 194, 198; *197*
peasant life, depiction of, 56
 in figure paintings and studies, 152–82, 198
 in harvest scenes, 183–98
 in market scenes, 198–211
 in Montfoucault works, 136–51
 see also under *Peasants*
Peasants Chatting in the Farmyard, Eragny, 179
 study for, *177*
Peasants in the Fields, Eragny, 188; *187*
Peasants Resting, 156, 157; *159*
Peasant Untangling Wool, 142, 146; *140*
Peasant Woman at Gate, 182
Peasant Woman I, Studies of a, 164
pencil drawings. *See* Pissarro, Camille: drawings
Pension Savary, 18
Père Melon Resting, Le, 153–54, 156, 188; *155*
Père Melon Sawing Wood, Le, 153, 154, 156; *155*
Picabia, Francis, 8
Picking Apples
 (1881) 194, 198, 217; *196*
 (1886) 194, 198, 217; *196*
Picking Apples, Eragny, 194, 198; *196*
Picking Peas
 (1880) 156; *158*
 (1887) 183, 188, 217, 221; *184*
 see also under *Pea*
Picking Peas, Eragny, 188; *188*
Picnic, The, 190; *189*
Piette, Ludovic, 74, 138, 142, 146, 147, 150
 family, 60, 74, 136, 138, 142, 147, 152
Piette's House at Montfoucault, 139; *139*

Piette's Kitchen, Montfoucault, 146
Pine Trees at Louveciennes, The, 66; *66*
Pissarro, Adèle-Emma (daughter), 75, 282
Pissarro, Alfred (son), 37
Pissarro, Camille
 and anarchy, 13, 105, 199, 202, 248
 in art, 160–61, 163
 autonomy and, 257, 260
 and atheism, 13
 birth, 18
 color
 brush and palette knife for, 56
 in late landscapes, 236–37; *230, 231, 235, 236*
 line and, 53, 56
 in London works, 249
 in Montfoucault works, 136, 139, 150; *132, 149*
 Neo-Impressionism and, 217, 221
 in Paris series, 264, 266
 in Pontoise works, 110–11; *108*
 in still lifes, 268, 275
 death, 105, 266
 drawings, 19, 22, 25–27, 30, 37, 41, 43–45, 79, 80, 86, 146, 186; *20, 21, 23, 24, 26, 28, 32, 33, 36, 78*
 dreaming, depiction of, 160, 161, 163, 165
 education, 18, 74
 Académie Suisse, 41, 71, 74, 90, 153
 Pension Savary, 18
 family, 8, 12–13, 18–19, 27, 37, 60, 74–75, 76, 142, 242; *9*
 on Pissarro as artist, 22, 37
 Pissarro as art tutor to, 186
 portraits of, 12, 277, 282, 283, 290; *278, 279, 280, 285, 286, 287, 288, 289*
 figures, 12, 37, 41, 121, 152–82, 198, 268; *167–82*
 in late landscapes, 237, 241; *240*
 in London works, 249
 in market scenes, 211
 in Montfoucault works, 139, 142, 146–47; *137, 140, 141, 142, 144, 148*
 in Paris works, 16; *14, 16*
 genre subjects, 136, 143, 146–47; *140, 144*
 heads, late procedures in drawing, 209; *208*
 and kitsch, 199
 landscapes, 12, 30
 late, 224–41
 in Pontoise, 111, 114, 115; *113, 114, 122*
 see also under *Landscape*; Pissarro, Camille: rural scenes; urban scenes
 marriage, 13, 38, 74–75, 248
 see also Pissarro, Julie Vellay (wife)
 mediums
 gouache, first use of, 143
 Neo-Impressionism and, 183, 188, 217; *184, 214, 215, 216, 218*
 see also Pissarro, Camille: drawings
 perspective, 61, 80
 Donkey Ride in La Roche-Guyon and, 50; *49*
 in late landscapes, 236, 237
 in London works, 86; *77, 83, 84, 85, 87*
 in Louveciennes works, 61, 65–66; *62, 63, 64, 66*
 in market scenes, 210

 The Marne at Chennevières and, 47–48, 50; *46*
 in Pontoise works, 110, 111; *108, 110*
 printmaking, 10–11, 106–7, 109
 rural scenes, 39, 41, 114–15, 268
 see also Eragny; L'Hermitage; Louveciennes; Montfoucault; Pontoise
 simplicity, 25
 in Caracas works, 37
 in early works, 19, 22; *20*
 in figure paintings, 154, 156, 161
 in French works, 39
 Neo-Impressionism and, 217
 in series works, 256
 in still lifes, 268, 271
 sociology, interest in, 257
 space, 109
 in Montfoucault works, 136, 139, 147; *132*
 in Pontoise works, 121
 structure, 69
 Louveciennes works and, 71
 travels, 242–67
 Belgium, 242, 247, 248
 London, 242–47, 248–49
 see also series paintings
 tropical plant studies, 27; *29*
 work ethic, 8, 105, 147, 183, 186
 Caracas works and, 26
 entertainment and, 190
 harvest scenes and, 183
 rural scenes and, 186, 188, 190
Pissarro, Félix (son), 142, 248, 282, 283
 photograph of, *9*
 portraits of, *280, 287*
Pissarro, Frédéric (father), 12–13, 18, 38
Pissarro, Georges (son), 8, 60, 186, 190, 194, 275, 277, 282
Pissarro, Jeanne (daughter; 1865–1874), 38, 75, 142, 277, 283
 portraits of, *278, 285, 286*
Pissarro, Jeanne (daughter; b. 1881), 283
 photograph of, *9*
 portrait of, *289*
Pissarro, Julie Vellay (wife), 13, 74–75, 76, 277, 282
 portraits of, *278, 279, 280*
Pissarro, Lucien (son), 8, 11, 38, 75, 76, 90, 106, 157, 160, 165, 186, 194, 215, 220, 242, 248, 252, 257, 277, 282, 290
 Figure Couronée (Crowned Figure), 160
 photograph of, *9*
 portrait of, *278*
Pissarro, Ludovic-Rodolphe (son), 43, 51, 283
 photograph of, *9*
 portrait of, *288*
Pissarro, Paulémile (son), 283
 photograph of, *9*
 portraits of, *288*
Pissarro, Rachel (mother), 12, 13, 38, 75, 90
Pissarro and Melbye's Studio, 27; *29*
Place du Théâtre Français, La, 261; *263*
Planting Peas, 183; *184*
Plowman, The, 115; *128*
Pointillism. *See* Neo-Impressionism
politics, 13, 257
 capitalism, 199

in France, 242, 248
 market scenes and, 199, 202, 211
 in Saint Thomas, 18
 see also Pissarro, Camille: and anarchy
Pond at Montfoucault, 146, 151; *148*
Pont Neuf: A Winter Morning, The, 25, 261, 264,
 266; *265*
Pontoise, 12, 16, 39, 58, 60, 61, 88–135, 136, 138,
 139, 142, 143, 146, 147, 150, 151, 152, 153, 154,
 199, 203, 217, 225, 237, 268
 Impressionism and, 90
 school of, 136
Pontoise, Banks of the Oise, 109, 110–11; *108*
Pontoise, Les Mathurins (Former Convent), 91,
 110; *93*
*Port près de la Douane, à Rouen, La (The Port
 near the Customs House at Rouen)*, 252; *253*
Portrait de C. Pissarro, 271, 277; *277*
Portrait of C. Pissarro, 277, 283; *284*
Portrait of C. Pissarro Painting, 277, 283; *1, 284*
Portrait of Cézanne, 282, 283; *280*
Portrait of Félix Pissarro, 282; *280*
Portrait of Félix Reading, 283; *287*
Portrait of Jeanne, 283; *289*
Portrait of Jeanne-Rachel (Minette), 283; *285*
Portrait of Jeanne with a Fan, 283; *285*
Portrait of Madame F. Estruc, 283; *281*
Portrait of Madame Pissarro, 282; *280*
Portrait of Minette, 283; *286*
Portrait of Paulémile
 (1894) 283; *288*
 (1899) 283; *288*
Portrait of Père Papeille, Pontoise, 283; *281*
Portrait of the Artist's Son Ludovic-Rodolphe,
 283; *288*
portraits, 1, 277–90
 family, 282–83; *280; 280, 285–89*
 friends, 282–83; *280–81*
 self, 271, 277, 283; *1, 277, 284*
*Potager et arbres en fleurs, printemps, Pontoise
 (Kitchen Gardens and Trees in Bloom,
 Spring, Pontoise)*, 115; *118*
Potato Harvest, The
 (1874) 115, 217; *126*
 (1886) 217, 220; *215*
Potato Market, Boulevard des Fossés, Pontoise,
 203, 207; *204*
Poultry Market at Gisors, 207, 210; *205*
Poultry Market, Gisors, The, 203; *201*
Poultry Market at Pontoise, The, 209, 210; *208*
Poultry Market, Pontoise, 209–10; *209*
*Printemps à Louveciennes (Spring in Louve-
 ciennes)*, 60–61, 65; *59*
Proudhon, Pierre-Joseph, 13, 199, 248
Puvis de Chavannes, Pierre, 12

Quays at Rouen, The, 252; *251*

Rabbit Warren at Pontoise, Snow, 115; *125*

Rabelais, François, 210, 211
railroad, 80, 83, 86, 88, 121; *78, 83, 84, 89*
 see also under *Railroad*
*Railroad Crossing at Les Pâtis, near Pontoise,
 The*, 88, 121; *89*
Railroad to Dieppe, 221; *222*
realism, 58, 60
Red Sky, Bazincourt, 228, 234, 236–37; *233*
Red Studio (Matisse), 275; *275*
religion, Pissarro and, 13, 248
 parents and, 12–13
 see also Pissarro, Camille: and anarchy
Renaissance, 52
Renoir, Pierre-Auguste, 27, 61, 72, 202, 211, 283
 Madame Charpentier and Her Children, 154
 A Road in Louveciennes, 72; *73*
Rewald, John, 25
Ridge at Le Chou, Pontoise, The, 115; *125*
Riverbanks in Pontoise, 111; *110*
Road: Rain Effect, The, 61, 71; *62*
Road in Louveciennes, A (Renoir), 61, 72; *73*
Road to Louveciennes, 65; *65*
*Road to Louveciennes, at the Outskirts of the
 Forest, The*, 69; *69*
Road to Rocquencourt, The, 65–66, 69; *66*
Road to Saint-Cyr at Louveciennes, The, 61; *63*
Road to Saint-Germain, Louveciennes, 61; *59*
Road to Versailles at Louveciennes, Snow Effect
 (Monet), 61; *62*
Road to Versailles at Louveciennes, The
 (1870, Foundation E. G. Bührle Collection) 61,
 69, 71; *64*
 (1870, Sterling and Francine Clark Institute) 61;
 63
Ronde, La
 (tempera) 190, 191, 194; *192*
 (watercolor over black chalk on pink paper)
 190–91; *192*
Rood, Ogden, 221
*Roofs of Old Rouen, Gray Weather, The (La
 Cathédrale)*, 260; *258*
Rose + Croix, 199
Rouen, 12, 249
 series paintings of, 12, 249, 250, 252–53,
 256–57, 260, 266; *250, 251, 253, 254,
 255, 258*
Rousseau, Jean, 211
Route de Bussy, 22; *21*
*Route de Gisors: The House of Père Gallien,
 Pontoise*, 282–83; *280*
Route de Louveciennes, La, 71–72; *72*
*Route de Sydenham, Londres, La (The Avenue,
 Sydenham, London)*, 79, 86; *77*
Route d'Osny, La, 121, 225; *133*
Rue de la Citadelle, Pontoise, 115; *122*
Rue de l'Épicerie, Rouen, La, 260; *258*

*Saint-Antoine Road at L'Hermitage, Pontoise,
 The*, 91, 94; *96*
Saint-Ouen-l'Aumône, 90
Saint Thomas, 7, 12–13, 18–23, 25, 26–27, 37, 41,
 153

Saint Thomas Gris-Gris, 27; *29*
Salon des Indépendants, 212
Salons, 7, 11, 25, 37, 90, 95, 157, 161, 198, 199, 210,
 214
 of 1864, 41
 of 1865, 41, 45
 of 1868, 51–52
 of 1870, 58
 of 1879, 154
Schapiro, Meyer, 52–53
Schlegel, Friedrich von, 221
seasons
 Cézanne's treatment of, 94
 Pissarro's treatment of, 94–95; *97–104*
Seated Goosegirl, 169
Seated Peasant, Sunset, 160, 165; *162*
 studies for, 160, 165; *163*
Seated Peasant Woman, 160; *165*
Seated Shepherdess
 Sketch, 160, 165; *163*
 study for, 160, 165; *163*
Self-Portrait, 277, 283; *284*
self-portraits, 277, 283; *1, 277, 284*
self-transformation, 212, 214–15
sensation, 16, 91, 156, 186, 198
 anarchy and, 161
 in Caracas works, 37
 Cézanne on, 105
 dreaming and, 163, 165
 Impressionism and, 194
 late landscapes and, 237; *238*
 Neo-Impressionism and, 224, 225
 series and, 257, 260
 Socialism and, 199
Sente du Chou, Pontoise, La, 115; *123*
sentimentality, Pissarro's rejection of, 13, 16, 22,
 139, 160–61, 199, 261, 277; *21, 23, 139*
September Celebration, Pontoise, 111, 114, 115; *114*
series paintings, 72, 268
 concept of, 252, 256–57
 Dieppe, 260; *258*
 Le Havre, 266–67; *265*
 Paris, 12, 260–61, 264, 266; *259, 261, 262,
 263, 265*
 Rouen, 12, 249, 250, 252–53, 256–57, 260,
 266; *250, 251, 253, 254, 255, 258*
 still lifes, 274–75; *270, 274, 276*
Serpentine, Hyde Park, Fog Effect, The, 242,
 249; *243*
Seurat, Georges, 8, 90, 249, 252
 La Maria, Honfleur, 252; *251*
 Neo-Impressionism and, 217, 220, 221
seventh Impressionist exhibition (1882), 156, 157
Sheaves of Wheat, 194, 198; *194*
Shepherdess, 167
Shepherdess and Sheep in Landscape, 182
Shepherdess Bringing in the Sheep, 217; *177*
Siesta, Eragny, The, 8, 10, 160; *11*
Signac, Paul, 8, 90
 Neo-Impressionism and, 217, 220, 221
Silvestre, Armand, 156
Simon, Robert, 94, 95
Sisley, Alfred, 27, 72
Snow Effect at L'Hermitage, 115; *129*
Snow Effect in Montfoucault, 142; *145*

Socialism, 199, 202
"Socialist realism," 199
Spring, 94–95; *97–98*
Stalinist artists, compared to Salon artists, 199
Standing Female Nude I, 161; *168*
Standing Female Nude II, 161; *168*
Steen, Jan, 30
Still Life, 268; *270*
Still Life: Apples and Pears in a Round Basket, 271; *272*
still lifes, 12, 268–76, 282–83
Still Life with Apples, 271; *272*
Still Life with Spanish Peppers, 274, 275; *276*
Studies of a Peasant Woman II, 182
Study of a Mule, 22; *20*
Study of a Peasant in Open Air (Peasant Digging), 175
Study of a Seated Man, 30, 37; *36*
Study of Figures at a Market, 30; *32*
Study of River Landscape with Boats, 48; *49*
style. *See* techniques
Summer, 94–95; *99– 100*
Sunset at Eragny, 225, 228, 236; *230, 232*
Sunset at Valhermeil, near Pontoise, 115; *127*
Symbolism, 8, 157, 163

techniques, 8, 10–11
 brushwork, 8, 10, 60, 94, 271
 Cézanne versus Pissarro and, 94
 diagonal hatching, 19, 27, 30, 37, 43, 90, 220
 gouache
 first use of, 143
 Neo-Impressionism and, 183, 188, 217; *184, 214, 218*
 in London paintings, 86; *83, 84, 85*
 in market scenes, 201, 203, 207; *204, 206*
 modeling, 56
 in Montfoucault works, 143, 146, 147, 150–51; *137, 149*
 in Neo-Impressionism, 212–23, 224
 palette knife, 94
 color and, 56
 in Montfoucault works, 150–51
 in Pontoise works, 109–14, 121
 use of shadows
 in French drawings, 43
 in Louveciennes paintings, 66–67, 69–71; *66, 67, 68, 70, 71*
 see also Pissarro, Camille: color

Telegraph Tower in Montmartre, The, 39; *41*
Theory of Colors (Rood), 221
third Impressionist exhibition (1877), 271
Toulouse-Lautrec, Henri de, 183, 202, 211
town and country themes. *See* Pissarro, Camille: rural scenes; urban scenes
Trees and Figures, 30; *33*
Turner, J. M. W., 252
Twilight, Eragny, 225; *226*
Two Girls, 178
Two Peasant Men Working, 188; *187*
Two Studies of a Young Boy with Faint Indications of a Female Figure, 22; *20*
Two Studies of Female Figure with Head Turned, Right Hand on Hip, 211; *210*
Two Women Chatting by the Sea, Saint Thomas, 39; *42*
Two Young Peasants Chatting Under the Trees, Pontoise, 157; *159*
Two Young Peasant Women, 30; *35*

Upper Norwood, Crystal Palace, 8, 10, 86; *10*
Upper Norwood, London with All Saints' Church, studies of, 80, 86; *82*
urban scenes, 39, 260, 268
 see also London; series paintings

Vaillant, Auguste, 242, 248
Valmondois, 90
Vase of Flowers, 271, 274; *273*
Velázquez, Diego, 52
Vellay, Julie. *See* Pissarro, Julie Vellay (wife)
Venezuela. *See* Caracas
Venturi, Lionello, 43
Veronese, Paolo, 52
View Across Stamford Brook Common, 242, 249; *243*
View from My Window, Eragny, 221; *222*
View from Upper Norwood, 79–80; *78*
View of Bazincourt, Sunset, 228, 236; *231*
View of L'Hermitage, Jallais Hills, Pontoise, 51–52, 53, 56; *55*
View of Marly-le-Roi, 65; *65*
View of Osny near Pontoise, 115, 225; *129*
View of Pontoise
 (1867) 43, 44–45; *44*

(1873, oil on canvas) 114; *116*
 (1873, pen and watercolor) 114; *116*
View of Pontoise, the Wooden Train, 88, 109; *89*
View of Rouen (Cours-la-Reine), 252; *254*
View of Rouen, Saint-Sever, Morning, 253, 256; *255*
Village of Gloton, The (Daubigny), 45, 47–48; *46*
Village Street, Auvers-sur-Oise, 115; *131*
Village Street (Pontoise), 30, 51–52; *34*
Voisins, 61
Vollard, Ambroise, 12, 91
Vue de Rouen—Route de Bon Secours, 252; *250*
Vuillard, Edouard, 58

Walnut and Apple Trees in Bloom at Eragny, The, 237; *239*
Whistler, James, 58
Winter, 94–95; *103–4*
Winter at Montfoucault, Snow Effect, 146, 147, 150–51; *149*
Winter Scene, 79–80; *78*
Wölfflin, Heinrich, 56
Woman and Child at the Well, 172
Woman Breaking Wood
 (1890, gouache) 171
 (1890, oil on canvas) 183, 217, 221; *171*
Woman Carrying Pitcher, 16, 39; *6*
Woman Digging, 173
Woman Gathering Grass, 176
Woman in Front of a Mirror, 217, 221; *218*
Woman Playing a Musical Instrument, 203; *206*
Woman Sewing, 169
Woman with a Goat, 181
Women Pulling Up Grass, 173
Wooded Landscape on Saint Thomas, 27; *28*
Woods of Saint-Antoine, Landscape at Pontoise, The, 115; *128*

Young Peasant with Straw Hat, 156

Zola, Emile, 45, 50–51, 52, 290

PHOTOGRAPH CREDITS

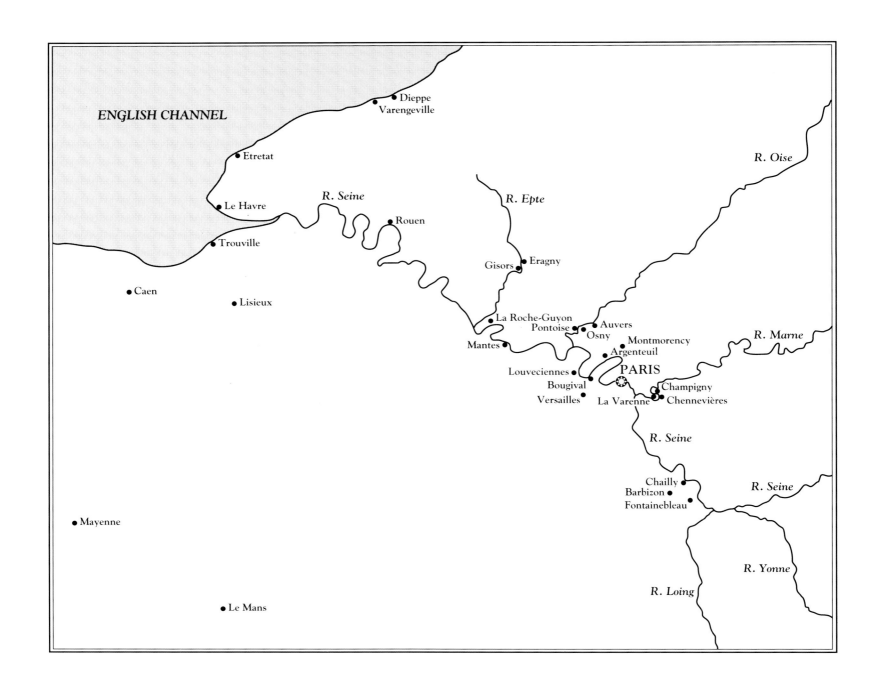

ENGLISH CHANNEL

R. Oise

• Dieppe
Varengeville

• Etretat

R. Seine

R. Epte

• Le Havre

• Rouen

• Trouville

• Gisors • Eragny

• Caen

• Lisieux

• La Roche-Guyon
Pontoise • • Auvers
Osny
• Montmorency
Mantes • • Argenteuil
Louveciennes • PARIS
Bougival • • Champigny
Versailles La Varenne • Chennevières

R. Marne

R. Seine

• Chailly
Barbizon •
Fontainebleau

R. Seine

• Mayenne

R. Yonne

R. Loing

• Le Mans

Sites in France Where Pissarro Painted